Interpretation of Aerial Photographs

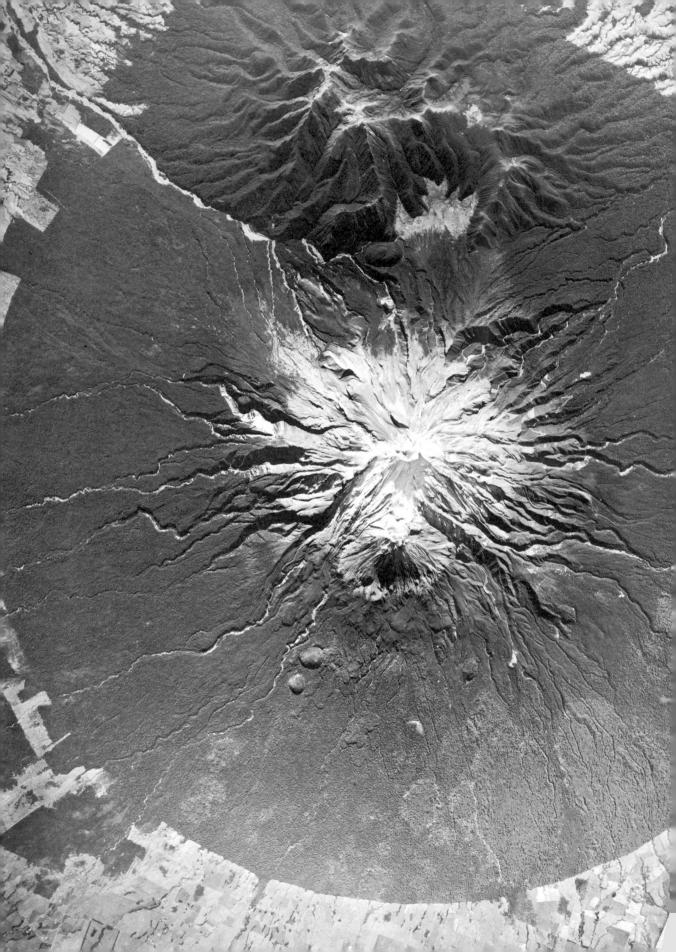

Third Edition

Interpretation of Aerial Photographs

Thomas Eugene Avery

Cover photo: Low oblique view of Rothenburg, a medieval walled city in West Germany. This type of photographic documentation can be extremely valuable in the preservation and restoration of historic buildings and related landmarks. Courtesy Carl Zeiss, Oberkochen.

Frontispiece: Mount Egmont, New Zealand, a snow-capped cone rising 2,520 m above sea level. The boundaries of Egmont National Park are defined as a 9.65-km radius from the central cone; the circular pattern thus results from the contrast between native vegetation and cultivated farmland. Photographed from an altitude of approximately 9,100 m by New Zealand Aerial Mapping, Ltd.

Copyright © 1977, 1968, 1962 by Thomas Eugene Avery Printed in the United States of America Library of Congress Catalog Card Number 76-9253 ISBN 0-8087-0130-4

All rights reserved. No part of this book may be reproduced in any form whatsoever, by photograph or mimeograph or by any other means, by broadcast or transmission, by translation into any kind of language, nor by recording electronically or otherwise, without permission in writing from the publisher, except by a reviewer, who may quote brief passages in critical articles and reviews.

0 9 8 7

This book was set in Melior by Typographic Arts. The editors were Robert E. Lakemacher and Ann Seivert. The cover was designed by Joan Gordon; the layout was done by Cindy Anderson; new drawings were done by Mari Ansari. The book was printed by the Colwell Press and bound by Midwest Editions, Inc.

To Philip R. Wheeler

Preface

In recent years, notable advancements have been made in the development of thermal and microwave sensors, earth-orbiting reconnaissance satellites, and automated image-scanning devices. Nevertheless, conventional optical imagery in the hands of human interpreters remains the working standard against which other systems tend to be evaluated. Therefore, as with the two earlier editions, this volume is devoted mainly to the "nuts and bolts" of human photographic interpretation.

This third edition includes new sections on flight planning, land-cover mapping, archeology, and nonphotographic sensors. All chapters have been revised or updated, and suggested problems are now provided at the end of every chapter. The appendix has been expanded to include metric conversion tables and a model outline for a short course in photo interpretation

and remote sensing.

The International System of Units (metric system) has been emphasized throughout the text. English units of measure are used only when logical metric units and illustrative examples were unavailable. This should cause a minimum of difficulty, because cameras, films, and photogrammetric equipment have been calibrated in metric units for decades. As in the previous editions, many stereopairs have been purposely reoriented (e.g., with south at the top of the page) to make shadows fall toward the observer and thereby facilitate stereovision.

My primary objective has been to provide an interesting and readable introduction to photographic interpretation that will also serve as a useful reference handbook. Suggestions for future editions, including diagrams, illustrations, and problems, would be welcomed at any time.

Acknowledgments

I want to thank Robert G. Merrifield of Texas A & M University and Charles O. Minor of Northern Arizona University for their support during the preparation of this third edition. For contributions relating to technical matters, the following persons were particularly helpful:

James R. Anderson and Richard E. Witmer, U.S. Geological Survey
Piet van Asch and Don Trask, New Zealand Aerial Mapping, Ltd.
R. D. Bratton, National Aeronautics and Space Administration
Kenneth M. Campbell, Alberta Remote Sensing Center
Douglas E. Grant, Texas A & M University
Laurens C. Hammack, Arizona State Museum
Thomas R. Lyons, National Park Service
Robert D. Miles, Purdue University
Thomas Schafer and R. E. Kauffman, Abrams Aerial Survey Corporation
John J. Welsh, Eastman Kodak Company

Contents

	Photography, Films, and Filters 1
2	Orientation and Study of Aerial Photographs 21
3	Photo Scale and Stereoscopic Parallax 43
4	Stereograms, Shadow Heights, and Areas 63
	Flight Planning 81
	Planimetric and Topographic Mapping 101
	Nonphotographic Imaging Systems 125
8	Land Information Systems and Land-Cover Mapping 155
9	Prehistoric and Historic Archeology 179
10	Agriculture and Soils 205
11	Forestry Applications 227
	Landforms and Physiographic Features 259
	Engineering Applications and Mining Patterns 297
	Urban-Industrial Patterns 321
15	Air Intelligence and Military Target Analysis 345
1	Glossary of Photogrammetric Terms 375
	Approximate Conversions for Metric and English Units 381
3	Sample Short-Course Outline 383
	389
	34567890112345 1012345 12

Chapter 1

Photography, Films, and Filters

Remote sensing and interpretation

This book is concerned with remote sensing, i.e., with the detection, identification, and analysis of objects or features through the use of imaging devices (sensors) located at positions remote from the subjects of investigation. In other words, remote sensing may be regarded as reconnaissance from a distance—and that distance may range from a few metres to thousands of kilometres. More specifically, this volume centers on the branch of remote sensing that is concerned with the acquisition and interpretation of aerial photographs.

The process of image interpretation is highly dependent on the capacity of the mind to generalize. To learn to identify objects on aerial imagery, one needs to study known features on many photographs so that the characteristic clues of shape, size, tone, pattern, shadow, and texture become automatically associated with particular subjects. Eventually, mental processes permit the conscious abstraction of key features from known objects so that such information may be applied to the recognition of unknown objects.

The International System of Units

For many years, cameras, films, and photogrammetric equipment have been calibrated in metric units. Therefore, wherever feasible, the International System of Units (SI) has been used for numerical examples in this book. (In accordance with SI practice, the American word meter will be spelled metre.) In some instances, tabular material has been presented in both metric and English units; conversion tables are included in the appendix.

With the International System of Units, there are seven base units and two supplementary units that encompass all measurement problems; all other SI units are derived from these fundamental units. For example, area is measured in square metres (or square kilometres), vehicle speeds in kilometres

per hour, and density in kilograms per cubic metre.

Each metric unit is related to another by multiples or submultiples of 10. For instance, there are 10 millimetres (mm) in 1 centimetre (cm), 100 centimetres in 1 metre (m), and 1,000 metres in 1 kilometre (km). Another advantage of SI units is that multiples and submultiples of various quantities are named according to a system of numerical prefixes. Thus a millimetre is 1/1,000 of a metre, while a kilometre is equal to 1,000 metres. The more common prefixes are listed here.

Prefix	Symbol	Meaning		
Tera-	Т	One trillion times		
Giga-	G	One billion times		
Mega-	M	One million times		
Kilo-	k	One thousand times		
Hecto-	h	One hundred times		
Deka-	da	Ten times		
Deci-	d	One tenth of		
Centi-	С	One hundredth of		
Milli-	m	One thousandth of		
Micro-	μ	One millionth of		
Nano-	'n	One billionth of		
Pico-	р	One trillionth of		

History of photography

An understanding of the photographic process is essential for full comprehension of photogrammetry and aerial photo interpretation. The origin of photography has been traced back to 1839, when Louis J. M. Daguerre, of Paris, invented a positive-image process for making portraits. The daguerreotype method utilized metal film plates that had been light sensitized with a layer of silver iodide. The early-day camera was often no more than a light-tight box with a pinhole or a simple glass plate comprising the lens. After a picture was taken, the photographic plate was removed from the camera, exposed to fumes of mercury, and then heated to produce a direct-positive image. These positive images, of course, could not be duplicated.

A few years after Daguerre's technique had been developed, an Englishman, William H. Fox-Talbot, introduced the negative-positive process that continues in use today. The early 1840's also witnessed a reduction in camera exposure time from several minutes to a few seconds. This was made pos-

sible by the development of new lenses and the discovery of the superior light sensitivity of photographic plates coated with silver chloride and, later, silver bromide. For all practical purposes, the photographic techniques devised by Fox-Talbot remained basically unchanged for more than a hundred years.

The simple camera

In design and function, a camera is not unlike the human eye. Each consists of an enclosed chamber with a lens at one end and a light-sensitive film (retina) at the other. The lens gathers light rays reflected from given objects and transmits them in an orderly fashion back to the light-sensitive area. A shutter assembly serves to regulate the amount and duration of light reaching the film when an exposure is made (Figure 1-1).

When a camera is focused at infinity, the distance from lens to film is known as the focal length, and the area in which the film is held flat during an exposure is referred to as the focal plane. Shutters may be positioned behind the lens, between elements of the lens, or in the focal plane immediately in front of the film. The focal plane shutter is analogous to a slitted curtain drawn across the area where the film is positioned. Intensity and length of exposure can be changed by variation of the width of the curtain slit and the tension of a spring-driven roller. Between-the-lens shutters are commonly characterized by a series of overlapping metal "leaves" that are rapidly opened and closed by an intricate gear chain (Figure 1-2). The diameter of the lens opening (effective aperture) can be varied by adjustment of a second set of thin, metal blades which comprise the iris diaphragm.

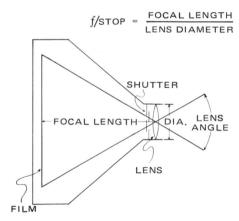

Figure 1-1. Nomenclature of a simple camera.

Figure 1-2. Camera lens with between-thelens shutter. Note shutter-speed and f/stop settings. Courtesy Calumet Manufacturing Co.

Relative apertures

The ratio of the camera focal length to the diameter of the lens opening is known as the f/stop, an expression used to designate the relative aperture setting or "speed" of a lens system. For example, a camera with a focal length of 40 mm and a lens diameter of 10 mm at full aperture would have an f/4 lens. If the aperture were 20 mm instead of 10 mm, the lens rating would be f/2; conversely, a 5-mm aperture with a 40-mm focal length would result in a lens rating of f/8. Thus the smaller the f/rating, the "faster" the lens, i.e., the more light admitted through the lens opening.

While the focal length of a camera is normally fixed, the iris diaphragm can be used to regulate the effective aperture, with accompanying changes in f/stop values. When an f/4 lens is "stopped down" to f/8, it simply indicates that the effective diameter of the lens opening has been cut in half. More explicitly, the area of the lens opening is only one-fourth as large. Similarly, a lens setting of f/16 admits only one-fourth as much light as a setting of f/8

and only one-sixteenth as much as a setting of f/4.

A complete system of relative apertures begins at f/1, and multiplication of any aperture by 1.4 (i.e., the square root of 2) yields the succeeding smaller aperture. Thus, the sequence of full-stop increments would be f/1, f/1.4, f/2, f/2.8, f/4, f/5.6, f/8, f/11, f/16, f/22, f/32, f/45, f/64, f/90, f/128, f/180, f/256. Each lens opening in the series transmits one-half as much light as the preceding lens opening (for example, f/5.6 transmits half as much light as f/4). Most lenses do not have a range of openings this great. Sometimes the largest opening for a lens is less than one full f/stop from the next marked lens opening. Examples are f/3.5, f/4.5, and f/6.3.

The more commonly used aperture settings and corresponding shutterspeed ratios are as follows:

Relative aperture or f/stop			enings 5.6				enings 64
Index number for shutter speed	r spe	eds -		 32			peeds 1,024

These relationships are well known to most camera enthusiasts. Simply stated, changes in aperture settings must be accompanied by adjustments of shutter speeds if a constant exposure is desired. For instance, a lens setting of 1/100 second at f/4 admits the same amount of light as a setting of 1/25 at f/8 or 1/400 at f/2. These paired relationships are the basis for light value systems featured on many cameras; when the iris diaphragm is coupled with the shutter-speed selector, a change in either value results in an automatic adjustment of the other.

Camera viewing angles

The angle of view encompassed by a camera lens is a function of the focal length and the diagonal measure of the film negative. When these two distances are approximately equal, the angle is roughly 45° to 50°, and the lens is referred to as normal angle. The distinction between normal and wide lens angles is somewhat arbitrary. For aerial cameras, lens angles of up to 75° are considered normal, those with angles of 75° to 100° are termed wide angle,

and those that exceed 100° are designated ultrawide. As will be seen later, the choice of a proper camera focal length and lens angle is of prime impor-

tance in planning photographic surveys.

Lenses may vary from a single curved piece of glass to multielement, distortion-free designs that are little short of optical perfection. A thorough evaluation of camera lenses is beyond the scope of this volume, but it should be noted that lens quality is the major factor to be considered in the purchase or use of any camera.

Photographic film

Photographic film is ordinarily composed of a cellulose acetate or polyester base that has been coated on one side with a light-sensitive layer known as the emulsion. On the other side of the film base is the anti-halation backing, a light-absorbing dye that prevents the formation of halos around bright images. A simplified film cross section is illustrated in Figure 1-3. The prime ingredient in the film emulsion is metallic silver, generally in the form of silver halide crystals suspended in a gelatin vehicle. During the split second when the camera shutter is open, light reaches the emulsion and a latent image of the scene viewed is recorded on the film. The image is made visible to the human eye by subsequent processes of film development and printing.

Figure 1-3. Simplified cross section of photographic film, greatly enlarged.

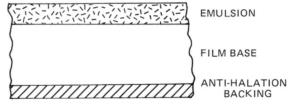

Emulsions for photographic films possess varying degrees of sensitivity to light waves, and knowledge of a particular film's "speed" is essential to obtaining a correct exposure. "Slow" films may require bright sunshine or artificial light for proper exposure, while "faster" films permit good pictures under minimal light conditions. A disadvantage of high-speed film, however, is that resultant negatives and prints are apt to be excessively grainy, i.e., coarsely textured.

In the United States, the American Standards Association rates each film emulsion on a relative scale of light sensitivity. The A.S.A. exposure index, as it is called, provides a uniform classification system that can be applied easily under changing light intensities. Black-and-white films most commonly used have exposure ratings of 50 to 300, although extremes may range from around 8 to 1,000. The larger the A.S.A. rating, the greater the sensitivity of the emulsion. Many black-and-white aerial films are rated at 80 to 200, and such speeds provide a reasonable latitude of exposure with a minimum of graininess. In West Germany and other European countries, film speeds are rated on a D.I.N. (Deutsche Industry Norm) scale of sensitivity. Most camera exposure meters provide settings for either A.S.A. or D.I.N. film ratings. As noted in later sections, however, aerial films are not usually rated according to these sensitivity scales.

Developing and printing

When a roll of exposed film is removed from a camera, it must be protected from light, extremes of temperature, and humidity until it is processed. Briefly, the step-by-step darkroom procedure in the production of a film negative is as follows:

- Developing: Immersion of film in a chemical solution to produce the photographic image recorded during exposure. Image highlights take the form of heavy metallic silver deposits; medium tones are characterized by lighter silver deposits. Negative tones are the reverse of those on a positive print.
- Short-stop: Immersion of film in dilute acetic acid to stop the developing reaction.
- 3. Fixing: Removal of unaffected silver salts from the emulsion.
- 4. Washing: Agitation in running water to remove all processing chemicals.
- 5. **Drying:** Hanging of film on clips and drying by natural air circulation or in special film-drying ovens.

Positive prints are produced by a series of steps similar to those followed in film development. A sheet of sensitized photographic paper is placed over the negative and "exposed" by light from underneath. The exposed paper is then subjected to a developing solution, followed by a short-stop bath, fixing, washing, and drying. If a hard, high-gloss photographic surface is desired, the print is dried on heated stainless steel rollers or platens, a process known as ferrotyping.

Resolution and spectral sensitivity

Among the image characteristics contributing to the recognition of features on aerial photographs are qualities that are dependent on the type of photographic film selected, the type of filter used, and the season of exposure. Of special interest here are the factors of resolution and light sensitivity of the film.

Resolution, or resolving power, refers to the sharpness of detail afforded by the combination of film qualities and the camera lens system. In photographic terms, it is commonly expressed as the maximum number of lines per millimetre that can be resolved or seen as individual lines. Any magnification beyond that required to make the line-count for the resolution of the final print will only decrease the image quality and interpretation possibilities of the photographs.

The light sensitivity of a film implies more than an indication of its "speed," or exposure index. Of additional importance is the range of light wavelengths to which the film responds. Light wavelengths are measured in micrometres, and the portion of the spectrum visible to the human eye includes wavelengths of about 0.4 to 0.7 μ m (Figure 1-4). However, film emulsions may be sensitized to a wider or narrower span of wavelengths to produce varying tonal contrasts on the finished print.

It is apparent that the image quality or photographic tone is dependent on both the spectral reflectance of an object and the degree of film sensitivity to different wavelengths of reflected light. Thus, if it is desired to differentiate between various types of healthy vegetation, a knowledge of foliage reflec-

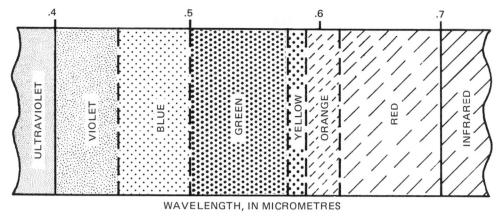

Figure 1-4. Schematic diagram of the visible spectrum. Color divisions are for illustrative purposes only; hues actually blend continuously from one wavelength to another.

tance characteristics under varying light conditions is essential (Figure 1-5). Photo interpreters are ordinarily limited to two basic types of black-and-white film (panchromatic and infrared) and two variants of color emulsions (conventional color and infrared color). Nevertheless, when these films are correctly exposed through proper filters, a wide range of light sensitivity can be made available for producing desired tonal contrasts.

Haze filters for black-and-white films

Aerial films are usually exposed through haze-cutting filters placed in front of the camera lens. Such filters are essential, because small dust and moisture particles in the air scatter light rays, preventing distant images from registering on the film. Scattering of light rays also destroys fine detail on the photographs. The effect of haze increases with the height of the air column that must be penetrated; therefore, the effect of haze is significantly greater in high-altitude photography. Due to their short wavelengths, blue light rays are scattered to a much greater extent than green and red rays. A yellow or "minus-blue" filter reduces the effect of haze by absorbing the short rays and transmitting only the longer wavelengths to the film. Because haze-cutting filters remove part of the available light, longer film exposures are required. The ratio of the increased exposure to the normal exposure is known as the filter factor.

The following tabulation includes several colors of filters that might be used for black-and-white photography. Filter factors will range from 1.5 to 4, depending on prevailing light and atmospheric conditions.

Filter color	Colors of light absorbed		
Medium yellow	Violet, most blue		
Deep yellow	Violet, all blue		
Blue	Red, some yellow, some green		
Green	Red, some blue		
Red	Violet, blue, and most green		

Haze filters for color films

Filters used with color films are different from those employed with black-and-white emulsions, because all colors of light must be taken into consideration. Scattering of the short, invisible wavelengths of ultraviolet light increases the haze effect on color film; thus, a desirable filter should absorb all ultraviolet and as much blue light as required for a correctly balanced color transparency. Such filters are usually colorless (ultraviolet) or pale yellow (minus-blue).

As a rule, haze filters for color films are less dense than those for blackand-white films; this is essential for maintaining a proper color balance. If excessively dense filters are used, aerial color transparencies may assume an overall hue similar to that of the filter. And, since excessive filtration of color film reduces the contrast of all other hues normally present, filters must be carefully selected and employed. Where ultraviolet filters are used, they will ordinarily have a filter factor of 1; i.e., their density will not require exposure increases.

Panchromatic film

The principal film used for aerial mapping and interpretation in Anglo-America is panchromatic, a black-and-white negative material having approximately the same range of sensitivity as that of the human eye. Standard speed panchromatic film provides reasonably good tonal contrast, a wide exposure latitude, satisfactory resolving power, and low graininess. Pan film, as it is called, has slightly higher than normal sensitivity to red light, thus permitting greater speed through haze filters (Figure 1-6).

Images on panchromatic photographs are rendered in varying shades of gray, with each tone comparable to the density of an object's color as seen by the human eye. Panchromatic film is superior for distinguishing objects of truly different colors, but its lack of high sensitivity to green light makes separation of vegetative types (e.g., tree species) difficult. A yellow haze filter is generally used for exposures on panchromatic film.

High-speed versions of standard panchromatic aerial films are also available (e.g., Kodak Tri-X Aerographic film), and these are intended for exposure under lesser light conditions. These films typically are about twice the speed of standard panchromatic aerial films. They are exposed through similar haze filters and, except for increased graininess, produce comparable tonal renditions.

Infrared film

Infrared black-and-white film is primarily sensitive to blue-violet, red, and near-infrared light radiations. It is sometimes exposed through red filters; thus, exposures can be made by red and near-infrared wavelengths only. This type of photography is best described as near-infrared, for most exposures utilize only a small band of infrared wavelengths ranging from about 0.7 to 0.9 μm .

It has been generally assumed that the gray tones on infrared film result from the degree of infrared reflectiveness of an object rather than from its true color. According to this theory, broad-leaved vegetation is highly reflec-

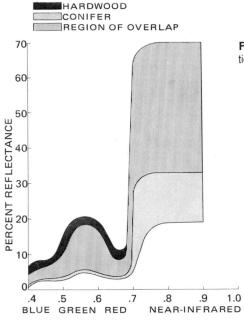

WAVELENGTH, IN MICROMETRES

Figure 1–5. Generalized reflectance pattern from vegetation. Courtesy P. A. Murtha and Canadian Forestry Service.

Figure 1-6. Approximate wavelength sensitivities of four common aerial film emulsions. Courtesy P. A. Murtha and Canadian Forestry Service.

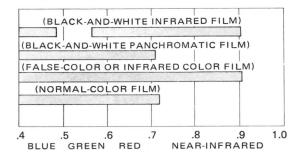

WAVELENGTH, IN MICROMETRES

tive and therefore photographs in light tones; coniferous or needle-leaf vegetation tends to absorb infrared radiation and consequently registers in much darker tones. Whether this reasoning represents a true cause-and-effect relationship is somewhat uncertain. Nevertheless, the characteristic vegetative tones rendered on this film make it especially valuable for delineating timber types and for detecting camouflage when noninfrared reflective green paint or cut vegetation has been used.

Bodies of water absorb infrared light to a high degree and usually register quite dark on the film (unless they are heavily silt laden). This rendition is useful for determining the extent of river tributaries, tidal marshes, shorelines, and canals. On the other hand, the dark tone often inhibits detection of such underwater hazards as reefs, shoals, and channel obstructions. In some cases, the unusual tonal rendition of infrared photography blends light objects such as dirt roads with light-toned vegetation. Furthermore, the dark (black) shadows on infrared prints are a source of annoyance in the interpretation of ground detail.

Infrared photography normally penetrates haze better than panchromatic photography, but it will not penetrate extremely dense haze or moist clouds. When infrared film is exposed through yellow haze filters, the resulting compromise in tonal contrast is sometimes referred to as modified infrared. Exposure with red filters greatly increases contrast, especially among types of vegetation, but often at some sacrifice of image sharpness. Figure 1-7 illustrates comparative panchromatic and infrared photography of an area in West Germany. Close inspection of these exposures confirms the fact that neither film has a clear-cut superiority over the other. When a choice of the two emulsions is available, the selection will depend mainly on the objectives of interpretation.

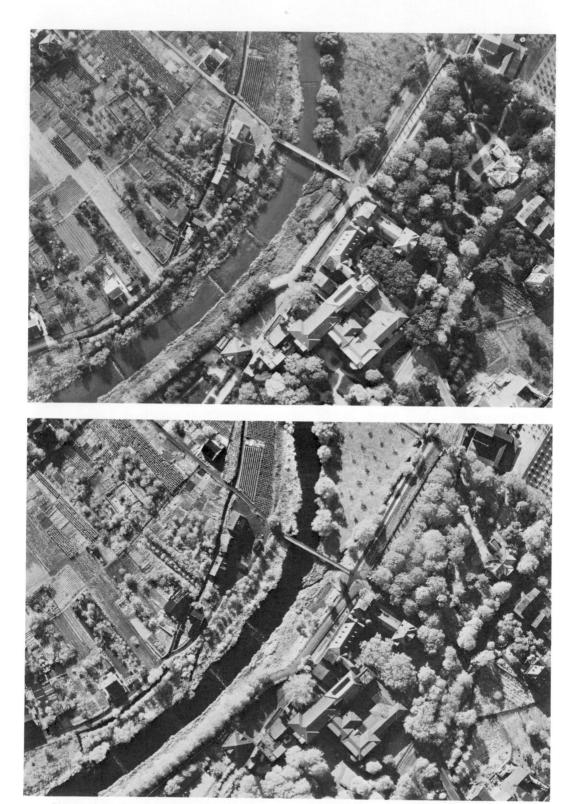

Figure 1–7. Panchromatic (top) and infrared photography of Ahrweiler, West Germany. Scale is about 1:2,500. Courtesy Carl Zeiss, Oberkochen.

Color films

Aerial color films are of three basic types—color-positive, infrared color, and color-negative. In this text, the term *color* refers to conventional color, or normal-color, film emulsions. With black-and-white films, contrasting gray-scale tones, along with size and form, provide the chief clues in object identification. Color film offers the two additional qualities of hue (color) and chroma (strength of color) as aids to interpreters. And it is generally believed that the human eye can discriminate fifty to a hundred times as many color combinations as gray-scale values.

Photo interpreters concerned with natural resources such as vegetation types, landforms, rock types, and water quality find color films much easier to work with than black-and-white emulsions. There are many documented instances where the added dimension of color has improved interpretation reliability while reducing the amount of time required for photo analysis and inference.

Aerial color positives

Most color-positive films are reversal color emulsions of the subtractive type; they are sensitized to three primary colors: blue, green, and red. When properly exposed and processed, they provide positive transparencies with a natural color rendition that closely approximates the original scene as viewed by the human eye. Today's color films have faster speeds, better definition, and less granularity than films of previous years.

Color film has a limited exposure latitude as compared with black-and-white emulsions, and it is preferably exposed under conditions of bright sunlight. Without the correct exposure and proper filter, pictures are likely to be of poor quality. Color film is especially valuable for identifying soil types, rock outcrops, and industrial stockpiles. It also has good qualities of water-penetrability and is therefore valuable for subsurface exploration, hydrographic control, and delineation of shoreline features.

Since the largest single cost item in obtaining new aerial photography is that of aircraft operation, color photography is not excessively expensive as compared with black-and-white photography. Although film and processing costs are greater, these factors are not normally significant in terms of the total cost of a photographic survey.

Infrared color or camouflage-detection film

Infrared color is a false-color, reversal film. It was originally designed to emphasize the difference in infrared reflection between live, healthy vegetation and visually similar objects painted with infrared-absorbing green paints to simulate the color of foliage. The emulsion is sensitive to green, red, and infrared radiation. A yellow filter is used to absorb blue wavelengths of radiation. Infrared color film has exceptionally good haze-penetrating capabilities.

When the film is processed as recommended, the resulting transparencies display colors that are false for most natural features. The utility of this film in camouflage detection is obvious. Natural deciduous foliage appears magenta or red, while pseudo-foliage painted green shows up as blue or purple.

Camouflaged targets are most easily detected by comparison of pictures on this film with conventional color transparencies.

Although infrared color film was originally developed for locating targets of military importance, it has proven quite useful for the identification of tree species or cover types, a task that requires information on the infrared reflectivity of various types of foliage. There is a near similarity in visual color between deciduous and evergreen trees. However, since healthy deciduous trees seem to have a higher infrared reflectivity than healthy evergreens, there are distinct differences between the colors of these tree groups as seen on infrared color film.

Infrared color is valuable for detecting losses of plant vigor that may result from insect attacks, diseases, soil salinity, and other factors. Diseased deciduous vegetation presumably reflects less infrared radiation and may first appear in darker red or nearly black tones. For plants affected by moisture loss, infrared reflectance is reduced while the visible portion of the spectrum remains unchanged; here the infrared color film shows stressed leaves as a lighter red to white color. In some cases, plants under stress show up on this film before symptoms of decadence or death are visible on the ground.

Evergreen plants (e.g., conifers) that are unhealthy will usually exhibit different tonal characteristics than deciduous plants. Loss of infrared reflectance usually does not show up before visible signs of death occur. Dying needles of conifers, which appear yellow-green on conventional color transparencies, may assume a pink hue on infrared transparencies. Yellow trees appear whitish, and yellow-red and red trees show up yellow on infrared color film.

Aerial color negatives

Color prints, black-and-white prints, color diapositives, black-and-white diapositives, or color transparencies can all be produced from aerial colornegative film. All of these products can be processed as enlargements, reductions, or contact-scale photographs.

With this photographic system, the interpreter has an opportunity to select a variety of end results from one aerial exposure. The versatility of color negatives makes them especially popular with geographers, foresters, and natural resource managers who desire color photographs for office interpretation as well as conventional black-and-white contact prints for field use.

Multispectral photography

From the preceding discussions of aerial films, it may be concluded that no single film emulsion serves all purposes. Instead, the varied tones and patterns produced by different ranges of film sensitivity complement each other, and the maximum amount of information can be extracted only when several types of imagery covering a given subject are interpreted in concert.

The technique of simultaneously obtaining aerial imagery from more than one spectral band is called multispectral reconnaissance. This type of photography can be acquired by use of special multilens cameras or by mounting of two or more cameras (each carrying a different film emulsion) in the same aircraft. Such photographic coverage takes maximum advantage of the dif-

ferences in tonal contrasts of terrain objects as imaged in varying bands of the electromagnetic spectrum. As an example, two objects that are difficult to separate on a film sensitized to a certain spectral band may show up in contrasting tones when photographed in another spectral band.

Aerial exposure index

Because of the smaller range in subject luminance, atmospheric haze conditions, and other factors, the characteristics of aerial scenes differ considerably from those of ordinary ground views. As a result, the speed criterion used in the sensitometry of aerial films is different from the A.S.A. or D.I.N. ratings assigned to conventional roll and sheet films. The following definitions are quoted from the *Kodak Aerial Exposure Computer* (anonymous, 1970), published by Eastman Kodak Company, a manufacturer of aerial films:

Aerial exposure index for black-and-white negative aerial films is defined as 1/2E, where E is the exposure (in meter-candle-seconds) at the point on the toe of the characteristic curve where the slope is equal to 0.6 of the measured gamma. Aerial film speed for black-and-white negative aerial films is defined as 3/2E, where E is the exposure (in meter-candle-seconds) at the point on the characteristic curve where the density is 0.3 above base plus fog density.

The two-dial Kodak Aerial Exposure Computer provides the aerial photographer with a quick and convenient means of determining the exposure parameters for Kodak black-and-white and color aerial films anywhere in the world. Of course, proper exposure will still depend, to some extent, on the aerial photographer's judgment of such factors as atmospheric haze conditions, amount of tolerable image motion, and selection of filters. For example, the photographer must remember to take the filter factor into account when determining the exposure setting for an aerial camera equipped with an antivignetting filter.

The development of photogrammetry

Photogrammetry is defined as the science of obtaining reliable measurements of objects from their photographic images. The word photogrammetry is derived from three Greek roots meaning "light-writing-measurement." Odd as it may seem, aerial photographs and photogrammetric principles were employed in mapping and military reconnaissance before the Wright brothers' first historic flight in 1903. In the early 1850's Aimé Laussedat, a French army engineer, conducted a series of experiments with aerial photographs taken from kites and captive balloons. Although the work was later abandoned without notable success, Laussedat has often been referred to as the father of photogrammetry. During this same time period, a French photographer named Nader managed to obtain weak aerial images from the gondola of a balloon. His "flight altitude" was reported as 80 m above ground.

Captive-balloon photography (Figure 1-8) proved highly utilitarian during the American Civil War when General McClellan employed this innovation to make photomaps of Confederate positions in Virginia. During the period from 1890 to 1910, new techniques in terrestrial photogrammetry were devised, and the U.S. Geological Survey used a panoramic camera for contour

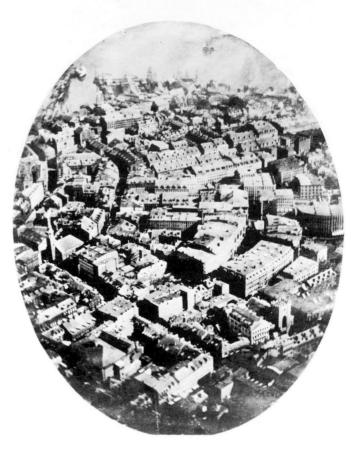

Figure 1-8. This 1859 picture of Boston Harbor, made by J. W. Black, was one of the first aerial photographs taken in the United States. The exposure was made from a captive balloon at an altitude of about 365 m. Courtesy General Aniline and Film Corp.

mapping in Alaska. In 1906, George R. Lawrence made some aerial "news" pictures of San Francisco stricken by earthquake and fire. Using a giant camera suspended from seventeen kites, he exposed some of the largest negatives (about 48 by 122 cm) ever taken from an aerial platform.

By 1910, the airplane could fly at a speed of around 108 km per hour (58 knots), and the first aerial movies were taken from Wilbur Wright's aircraft by a Pathé news cameraman. However, it was World War I that brought together the airplane, improved films, and a real need for aerial photography and photo interpretation. Aerial reconnaissance is so much a part of today's national defense systems that it is difficult to believe that some military strategists opposed the concept at the start of the First World War.

Prior to the First World War, many of the airphotos used in mapping were oblique views, i.e., exposures made with the camera aimed at an angle to the vertical (Figure 1-9). In the ensuing years, however, emphasis was shifted toward greater use of stereoscopic coverage with vertical photography. In the early 1920's, government agencies began to use aerial photography in map compilation, and several private survey firms were founded. Some of these pioneer corporations are still flourishing today.

The 1930's saw the formation of the Agricultural Adjustment Administration in the U.S. Department of Agriculture and the beginning of this agency's extensive photographic coverage of farmlands and rangelands. The Geological Survey began to rely more heavily on aerial photographs in topographical surveying, and the creation of the Tennessee Valley Authority gave

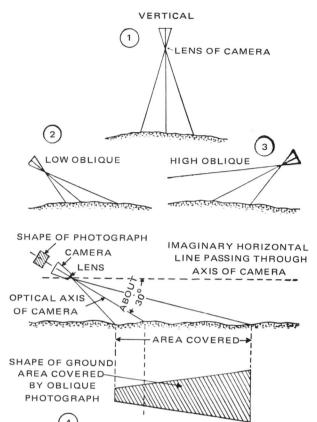

Figure 1-9. Orientation of aerial camera for vertical and oblique photography. Courtesy U.S. Department of the Army.

new impetus to an expanding program of federal mapping. During this same period, the U.S. Forest Service demonstrated the feasibility of using airphotos for timber type mapping on the national forests. And, of course, similar developments were taking place in other countries of the world.

The development of photo interpretation

Photo interpretation may be defined as the identification of objects on airphotos and the determination of their meaning or significance. The art of photo interpretation was a little-known skill in America prior to 1939 and the advent of World War II. Within the following five or six years, however, countless military decisions were based on intelligence reports derived from aerial reconnaissance missions. After the war, many air intelligence specialists converted their new-found knowledge of photographic interpretation into diverse civilian applications.

During the past three decades, the nonmilitary uses of aerial photography have continued to multiply. Today, photo interpretation techniques are used on such diverse projects as monitoring the changing water levels of lakes and reservoirs, assessing crop diseases, locating new highway routes, assessing real estate, and mapping archeological sites. In this same period, significant technical developments have been made in aerial cameras, optical systems, film emulsions, aircraft, and earth-orbiting reconnaissance satellites (Figures 1-10 and 1-11).

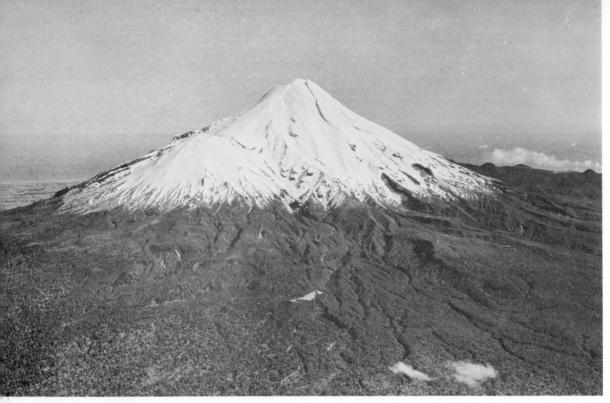

Figure 1–10. High oblique aerial view (horizon included) of Mount Egmont, New Zealand. Compare with frontispiece. Courtesy New Zealand Aerial Mapping, Ltd.

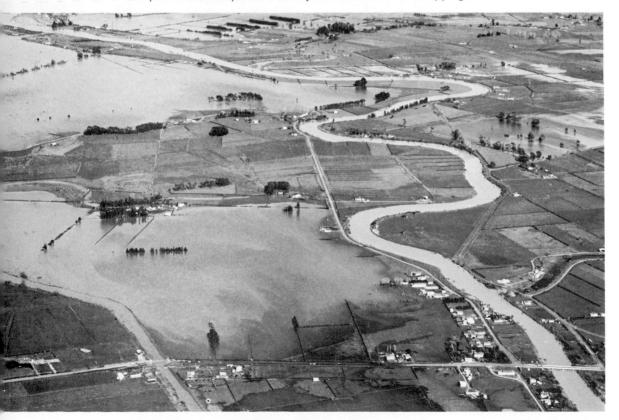

Figure 1–11. Low oblique aerial view (horizon not shown) of a flooded area near Whakatane, New Zealand. Courtesy Aero Surveys (New Zealand), Ltd.

Training and additional information

Most colleges and universities, along with various military organizations, offer formal courses in photogrammetry, photo interpretation, or air intelligence. In most instances, college instruction is at elementary or intermediate levels, and courses are commonly found in departments of forestry, geology, geography, civil engineering, and earth sciences. Historically, offerings in advanced work have centered more on metrical photogrammetry than on photographic interpretation.

On an international basis, one of the widely recognized seats of photogrammetric training is the International Institute for Aerial Survey and Earth Sciences. Information on the various courses offered by the Institute may be obtained at this address:

International Institute for Aerial Survey and Earth Sciences Boulevard 1945 P.O. Box 6 Enschede, The Netherlands

Photogrammetria, the official journal of the International Society of Photogrammetry, is edited and published under the auspices of the Institute.

In the United States, additional information on photo interpretation techniques may be obtained from articles published monthly in *Photogrammetric Engineering and Remote Sensing*. Subscriptions to this journal may be purchased through this address:

American Society of Photogrammetry 105 North Virginia Avenue Falls Church, Virginia 22046

In Canada, a national program in remote sensing is coordinated by the Department of Energy, Mines, and Resources in cooperation with other agencies of the national government, provincial remote sensing centers, industries, and universities. These groups have periodically sponsored special international symposia on aerial surveying and photo interpretation.

A Canadian Journal of Remote Sensing began publication in 1975. Information regarding subscriptions may be addressed to:

Canadian Aeronautics and Space Institute Commonwealth Building, 77 Metcalfe Street Ottawa, Ontario, Canada K1P 5L6

Problems

- 1. Draw a series of circles that are scaled to represent several f/stops for a camera lens, e.g., f/2, f/4, f/8, f/16, and f/32. Then assign a shutter speed to one lens setting and compute shutter speeds for all other f/stops.
- 2. List three or four commercially available films and their corresponding A.S.A. or D.I.N. exposure ratings. What are the recommended shutter

speeds and f/stops for these films under conditions of bright sunlight and strong shadows?

Name of film	A.S.A. or D.I.N. rating	Shutter speed	f/stop

3. Study a set of paired panchromatic and infrared black-and-white photographs. Make a list of features that can be recognized and compare the tonal differences of these features on the two photographs. Tabulate as follows:

Feature identified	Panchromatic tone	Infrared tone	Preferred film and comments
	10110	toric	and comments
N/O			
*			

4. Repeat the procedure outlined in the previous question for a set of paired color and infrared color photographs.

Feature identified	Conventional color	Infrared color	Preferred film and comments		
-					

References

- American Society of Photogrammetry. 1968. Manual of color aerial photography. Banta Publishing Co., Menasha, Wis. 550 pp., illus.
- Anonymous. 1973. Specifications and characteristics of Kodak aerial films. Eastman Kodak Co., Rochester, N.Y. Publication M-57, 4 pp. (Periodically revised.)
- ——. 1970. Kodak aerial exposure computer. Eastman Kodak Co., Rochester, N.Y. Publication R-10, 6 pp.
- ——. 1969. Optical formulas and their application. Eastman Kodak Co., Rochester, N.Y. Publication AA-26, 6 pp., illus.
- Avery, T. E. 1970. Photo interpretation for land managers. Eastman Kodak Co., Rochester, N.Y. Publication M-76, 26 pp., illus.
- Fritz, Norman L. 1974. Available color aerial photographic materials. *Photogram-metric Engineering* 40:1423-25.
- Land, Edwin H. 1959. Experiments in color vision. *Scientific American* reprint, W. H. Freeman and Co., San Francisco. 14 pp., illus.
- Murtha, P. A. 1972. A guide to air photo interpretation of forest damage in Canada. Forest Management Institute, Canadian Forestry Service, Ottawa. Publication 1292, 62 pp., illus.
- Streb, Jack M. 1969. Photography from the air—Then and now. In Kodak photo information book AE-87, Eastman Kodak Co., Rochester, N.Y. 72 pp., illus.
- U.S. Department of the Army. 1969. Lenses and the f/system. U.S. Army Engineer School, Fort Belvoir, Va. Lesson file, pp. 1-9.
- U.S. Department of Commerce. 1972. The International System of Units (SI) Government Printing Office, Washington, D.C. National Bureau of Standards, Special Publication 330, 42 pp.

Chapter 2

Orientation and Study of Aerial Photographs

The interpreter's task

Because photo interpretation often involves a considerable amount of subjective judgment, it is commonly referred to as an art rather than an exact science. Actually, it is both. The interpreter must know how to use the scientific tools and methodology of the photogrammetric engineer; yet these objective findings must often be supplemented with deductive reasoning to supply a logical answer to the perennial question "What's going on here?"

The skilled interpreter must have a large store of information at hand to perform this exacting task adequately. He or she should have a sound general background in geography, geology, forestry, engineering, and other disciplines oriented toward the study of natural and cultural features. Complex features are rarely identified as a result of quick stereoscanning. Thus, the interpreter who knows which features to expect in a given locality, as well as those not likely to occur, can make a more positive identification in a shorter period of time.

Under certain circumstances, the mental processes of deduction and association may permit "detection" of objects not actually visible on the photographs, e.g., a buried pipeline or a camouflaged military airfield. The value of experience and imagination can hardly be overemphasized, for the interpreter who does not recognize an unusual object when standing alongside it cannot be expected to identify a similar feature on a small-scale print (Figure 2-1). Of course, there are situations, particularly in military intelligence work, where photographic limitations or a lack of associated information preclude positive identification of objects. In such cases, the terms probable and possible are customarily used to qualify the interpreter's findings.

While the cartographer or photogrammetric engineer is normally interested only in up-to-date mapping photography, the interpreter's job can often be made easier when comparative coverage is available. Comparative or sequential coverage refers to two or more sets of imagery of the same area

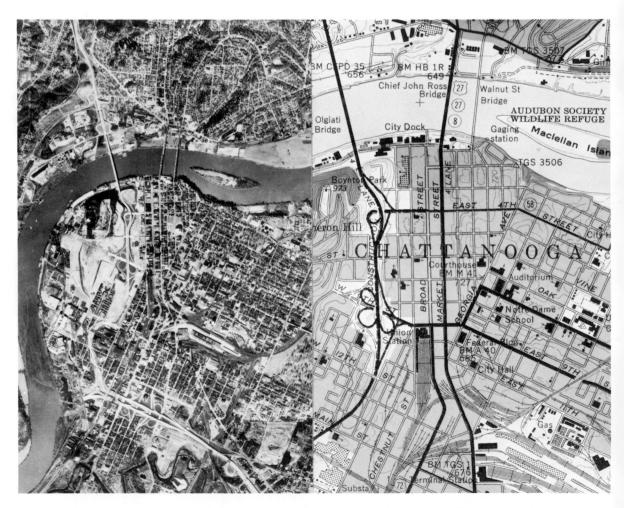

Figure 2–1. Portion of a vertical photograph and of a topographic map of Chattanooga, Tennessee. Photo scale is about 1:48,000; map scale is 1:24,000. Courtesy Tennessee Valley Authority.

taken at different times. With favorable timing of photographic flights, changes in land use may be readily detected, and activities that might otherwise pass unnoticed may be readily identified.

Principles of object recognition

Most persons have little difficulty in recognizing features pictured on oblique photographs, for such views appear relatively "normal" to the human eye. On the other hand, a vertical or near-vertical view from an altitude of several thousand metres can be quite confusing, particularly for individuals who have never ridden in an airplane (Figure 2-2). An experienced aerial photo interpreter exercises mental acuity as well as visual perception and consciously or unconsciously must evaluate several factors in identifying features on vertical photographs. Prominent among these are:

Shape. This characteristic alone may serve to identify some objects. Examples include a highway "cloverleaf" intersection, an airfield, or a football stadium.

Size. Both relative and absolute sizes are important. Thus a superhighway will not be confused with a rural road, or a small residence with an apartment building. Size, of course, is a function of the photographic scale.

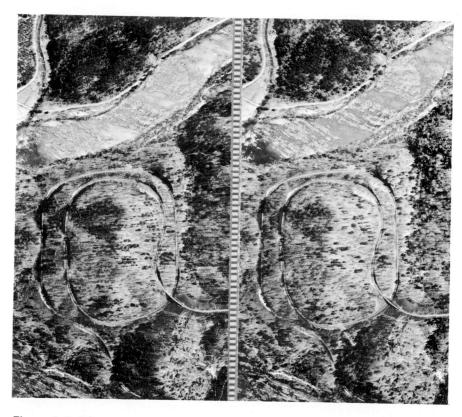

Figure 2-2. This unusual loop was designed to reduce the grade for tracks of the L. & N. railroad in Polk County, Tennessee. Scale is about 1:15,840. What are the key identification clues for recognizing such features? Courtesy Tennessee Valley Authority.

Photographic tone. Objects of different color have different qualities of light reflectance and, therefore, register in varying shades or tones on a photograph. Obvious examples include quartz sand versus dark topsoil, cultivated versus fallow fields, or coniferous versus broad-leaved tree crowns.

Pattern. If the spatial arrangement of trees in an orchard is compared with that of natural vegetation, a contrast in patterns will be evident. As another example, a pattern produced by contour plowing might reveal information on topography, type of soil, or the nature of the crop being cultivated.

Shadow. A truly vertical photograph of a tall smokestack or an isolated oil derrick might present a difficult identification problem, except for the characteristic shadows cast by these objects. By the same token, shadows (e.g., alongside tall buildings or beneath dense canopies of vegetation) may also be offensive to the interpreter because they obscure ground detail.

Topographic location. Relative elevation, including drainage features, can be an important clue in predicting soil conditions or the probability of encountering a particular vegetative association. The natural occurrence of willow trees on floodplains or river sandbars supplies a good example.

Texture. The degree of coarseness or smoothness exhibited by photo images can be a useful key to identification. Texture, just like object size, is directly correlated with photo scale. Contrast the texture of grass with that of a cornfield, or the texture of saplings with that of large, overmature trees.

Checklist of typical features

In the identification of unfamiliar features on vertical photographs, it has been found that the power of suggestion is often beneficial to beginning interpreters. Accordingly, the following checklist has been prepared to illustrate the kinds of features commonly encountered in the study of aerial photographs. The groupings according to ten general categories are somewhat arbitrary; therefore, a given feature might logically be assigned to more than one of the classifications shown.

Forests and rangelands

Coniferous forests
Hardwood forests
Mixed coniferous and hardwood forests
Forest plantations
Herbaceous rangeland
Shrub and brush rangeland
Mixed rangeland
Tundra

Agricultural features

Cultivated crops (e.g., corn)
Contour plowing or terraced cropland
Irrigated crops (specify type)
Orchards (specify type)
Vineyards
Improved pastures
Fences or hedgerows
Barns or silos
Baled hay or shocked wheat
Livestock or wild game
Greenhouses
Nurseries
Abandoned or fallow fields

Mining and excavation

Strip mines (e.g., coal)
Placer mines (e.g., gold)
Open-pit mines (e.g., copper)
Sand and gravel excavations
Rock quarries
Oil-drilling and development operations
Channel-dredging operations
Land-clearing operations

Water and natural shoreline features

Shorelines and beaches
Coastal bays and inlets
Swamps or marshes
Floodplains or deltas
Permanent rivers or streams
Inland lakes or ponds
Sandbars or mud flats
Lime sinks or potholes

Physiographic and geologic features

Active glaciers
Cirques or cliffs
Eskers or drumlins

Talus slopes and alluvial fans Gully erosion Sheet erosion Volcanic lava flows or cones Rock outcrops Hogbacks Anticlines and synclines Faults and dikes

Urban-residential patterns

Apartment houses Mobile homes Garages Schools (specify type) Churches and cemeteries Parks or playgrounds Statues or monuments Civic or recreational centers Shopping centers Downtown business districts Gas stations Automobile dealerships Mobile home dealerships Motels or hotels Drive-in theaters Country clubs

Swimming pools Golf courses Tennis courts Football fields Other athletic fields Race tracks

Auto junkvards Prisons County rest homes

Hospitals

Industrial and utility features Electrical power plants

Electrical power substations Steel towers for electrical lines Cleared rights-of-way Buried pipelines Sewage disposal plants Water purification plants Petroleum or chemical industries Petroleum products storage tanks Sawmills and lumber yards Pulp and paper mills Furniture-manufacturing plants

Automobile-manufacturing plants Steel or other metal industries Cement block-manufacturing plants Ready-mixed concrete plants Stockyards or meat-packing plants

Transportation and communication features

Four-lane, divided highways Three-lane, paved highways Two-lane, paved highways Graded, nonsurfaced roads Woods roads or Jeep trails Traffic circles and interchanges Overpasses and underpasses

Railroads

Railroad terminals Bus terminals Trucking terminals

Airports

Radio or TV transmission towers

Radar antennas

Railroad coal-dumping spurs

Boat docks and piers

Engineering structures

Dams (describe type of material) Bridges (describe type of material)

Road cuts and fills

Levees

Athletic stadiums Fire lookout towers

Water tanks

Canals or drainage ditches

Reservoirs Ferry landings

Military and defense installations

Post headquarters Barracks and residences Temporary encampments Ammunition dumps Rifle or artillery ranges Tanks Warships Shipyards and drydocks Missile test sites Operational missile bases

Airfields and planes

Radar installations

Photo interpretation keys

A photo interpretation key is a set of guidelines used to assist interpreters in rapidly identifying photographic features. Keys are valuable as training aids for neophyte interpreters and as reference or refresher material for more experienced personnel. Depending on the method of presenting diagnostic features, photo interpretation keys may be grouped into two general classes—selective keys and elimination keys.

Selective keys are usually made up of typical illustrations and descriptions of objects in a given category, e.g., industries. They are organized for comparative use; the interpreter merely selects the key example that most nearly coincides with the feature to be identified. By contrast, elimination keys require the user to follow a step-by-step procedure, working from the general to the specific. One of the more common forms of elimination keys is the dichotomous type. Here, the interpreter must continually select one of two contrasting alternatives until he or she progressively eliminates all but one item of the category—the one being sought.

When available, elimination keys are sometimes preferred to selective keys. On the other hand, elimination keys are more difficult to construct, and their use may result in erroneous identifications if the interpreter is forced to choose between two unfamiliar image characteristics. Studies have revealed no significant difference between results from the two types of keys as long

as the material within each key is well organized.

The determination of the type of key and method of presentation to be used depends on (1) the number of objects or conditions to be recognized and (2) the variability normally encountered within each classification. As a general rule, keys are much more easily constructed and applied in identifications of man-made features than for natural vegetation and landforms. For reliable interpretation of natural features, training and field experience are often essential to ensure consistent results.

Three-dimensional photography

In many instances, it is entirely feasible to use single, vertical photographs for the recognition or classification of specific features. The principal disadvantage of the technique, however, is that only two dimensions (length and width) of most objects can be perceived. This is the equivalent of using only one eye, an effect referred to as monocular vision. The all-important third dimension of depth perception is provided only when objects are viewed with both eyes. Here, the converging lines of sight from each eye are transmitted to the brain, and the result is binocular or stereoscopic vision.

One can quickly compare "one-eyed" versus stereoscopic vision by viewing a distant object, first with a telescope and then with binoculars having equal magnification. There is also the "coin-on-a-table" trick. If one eye is covered and only the coin's edge is seen from the level of the tabletop, it becomes quite difficult to place a forefinger directly on top of the coin. When

one has both eyes open, the difficulty vanishes.

While almost everyone possesses and automatically employs stereoscopic vision, there have been a number of fairly successful business enterprises based on the somewhat startling effects of exaggerated three-dimensional pictures. In the early 1900's, the stereopticon or "periscope" was almost a standard fixture in American parlors. This instrument, shown in Figure 2-3, was used in viewing paired photographs that had been taken from slightly different camera positions. The stereopticon allowed each eye to see only one print, thus creating the illusion of depth for the viewer. A stereopair of the Rock of Gibraltar is shown in Figure 2-4. Although the corresponding images are rather widely separated, persons experienced in stereo viewing may be able to see this scene three-dimensionally without the aid of special instruments.

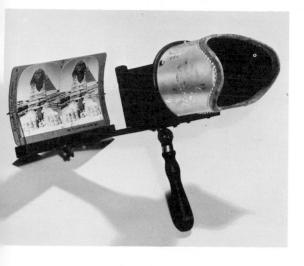

Figure 2-3. Old-fashioned parlor stereoscope. Note stereopair of the Sphinx. Courtesy Keystone View Co.

Figure 2-4. Example of paired photographs that produce a three-dimensional picture when viewed through a parlor stereoscope. View shows the Rock of Gibraltar at the southern tip of Spain. Courtesy Keystone View Co.

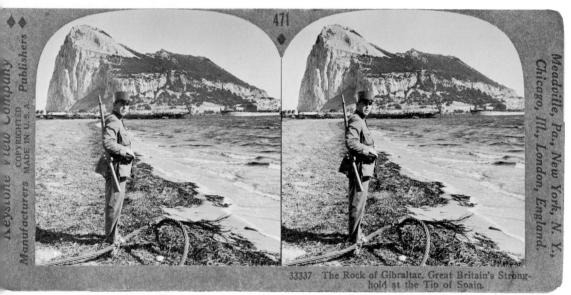

Three-dimensional motion pictures were popular for brief periods during the 1930's and again in the early 1950's. Two cameras were used to photograph each scene; both views were then projected on theater screens through polarized or red and blue-green lenses. Each patron was issued a pair of viewing spectacles to provide "fusion" of the projected images into a three-dimensional picture. Today, the emphasis on wider and wider movie projection screens is partially an attempt to create an illusion of depth without the necessity of two film projectors and special eyeglasses for the audience.

Stereophotography has also enjoyed periodic revivals of popularity among camera hobbyists. A few years ago, 35-mm stereo cameras with dual lens systems were marketed by several leading camera manufacturers (Figure 2-5). The decline of interest in three-dimensional color slides may be partially attributed to (1) the fact that hand viewers can be used by only one person at a time and (2) the fact that audience projection equipment is quite expensive by comparison with that required for conventional color slides.

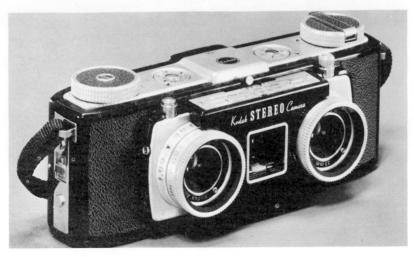

Figure 2–5. Stereo camera for making three-dimensional color slides. Courtesv Eastman Kodak Co.

When objects farther than 400 to 500 m away are viewed by unaided eyes, the special ability of depth perception is essentially lost. At such distances, lines of sight from each eye converge very little; in fact, they are nearly parallel when the eyes are focused on the horizon. If the human eye base (interpupillary distance) were increased from the normal 60 to 66 mm, the perception of depth could be greatly increased. In a manner of speaking, this feat can be accomplished through aerial photography. From an airplane in level flight, overlapping camera exposures are made at intervals of several hundred metres. When any two successive prints are viewed through a simple stereoscope, each eye "occupies" one of the widely separated camera stations. This "stretching" of the human eye base results in a greatly exaggerated three-dimensional photograph for study and interpretation (Figures 2-6 and 2-7).

Photo interpretation equipment

Equipment essential to one interpreter may be of limited value to another, but anyone who uses aerial photographs regularly will probably find that this list closely approximates minimum needs.

Lens stereoscope, folding pocket type

Stereometer or parallax bar for measuring object heights

Engineer's scale, graduated to 0.5 mm or 0.02 in.

Drafting instruments, drawing ink, triangles, and protractor

Drop-bow pen and pencil set

Fountain pen for use with drawing ink

China-marking pencils or water-soluble inks

Tracing paper, vellum, drafting tape, and lens-cleaning tissue

Solvent and cotton swabs for cleaning photos

Needles for point-picking

Proportional dividers

Magnetic or spring clipboard for holding stereopairs

Illuminated tracing table or fluorescent desk lamp

Dot grids or polar planimeter for area measurements

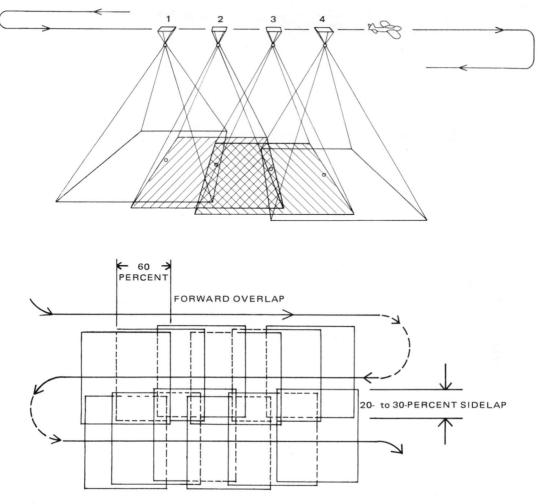

Figure 2-6. Aerial camera stations are spaced to provide for a 60-percent forward overlap of aerial photographs along each flight line and a 20- to 30-percent sidelap for adjacent lines.

Several of the items listed may be improvised. One can build a good tracing table by installing several fluorescent tubes in a desk drawer and then covering the top with double-weight, frosted, or "flashed-opal" glass. To eliminate the need for fastening down stereopairs with drafting tape, an efficient holder can be made with a few ordinary magnets and a sheet of steel measuring about 30 by 40 cm. Individuals with extensive interpretation and mapping duties may find it desirable to acquire more specialized equipment, such as a mirror stereoscope, a vertical sketchmaster, a reflecting projector, or stereoplotting devices. Functions of these items are detailed in sections that follow.

Types of stereoscopes

The function of a stereoscope is to deflect normally converging lines of sight so that each eye views a different photographic image. Parlor stereoscopes accomplished this by the placement of a thin prism before each eye.

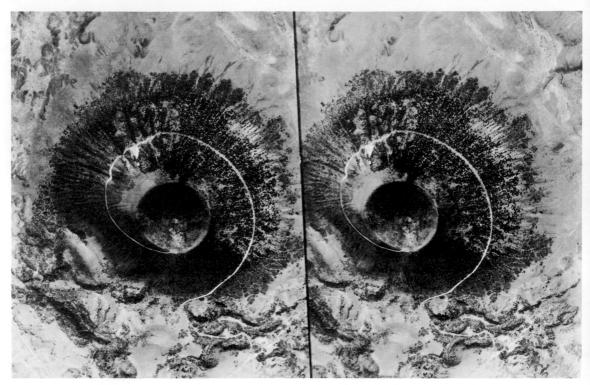

Figure 2-7. Stereogram of an extinct volcanic cone, Mount Capulin, New Mexico. Scale is about 1:20,000. Courtesy U.S. Department of Agriculture.

Ordinarily, no magnification was involved, but the result was a sharply defined, if occasionally distorted, three-dimensional picture.

Instruments used today for the three-dimensional study of aerial photographs are of three general types, namely, lens stereoscopes, mirror or reflecting stereoscopes, and zoom-type, magnifying stereoscopes. Lens stereoscopes utilize a pair of simple magnifying glasses to keep the eyes working independently and to keep their lines of sight approximately parallel. Photographs are viewed at a distance roughly equal to the focal length of the lenses, i.e., the height of the instrument legs.

Most lens stereoscopes have a magnifying power of two to three diameters. They are inexpensive and relatively durable and can be quickly folded for field use or storage. The lens stereoscope pictured in Figure 2-8 has a fixed interpupillary distance of 65 mm and 2.8X lenses; other suitable makes are available, and many feature adjustable interpupillary settings. The primary drawback to lens stereoscopes is that only one-third to one-half of a standard print overlap can be studied stereoscopically at one time. However, the low cost and portability of such devices ensure their continued popularity among photo interpreters.

Reflecting stereoscopes provide a view of the entire overlap zone through a system of prisms or first-surface mirrors that effectively increase the interpupillary distance from about 65 mm to anywhere from 160 to 220 mm. Most basic models afford no magnification, but 3X to 8X binocular attachments are available as options. The greater the enlargement, however, the smaller the field of view. Reflecting stereoscopes, being rather specialized instruments,

are produced in a variety of designs and price ranges. One type is illustrated in Figure 2-9.

Zoom magnifying stereoscopes are highly versatile, desk-type instruments that are normally intended for office interpretation (Figure 2-10). The asset of variable magnification can be paired with a capability for 360° optical image rotation of each optical system. This feature is ideal for studying uncut

roll film where there is drift or crab in the line of flight.

Stereoscopic lenses, prisms, and other optics should be protected from dust or corrosion and should be cleaned only with optical lens cloth or tissue. Mirror stereoscopes, vertical sketchmasters, and other devices having firstsurface mirrors also require delicate handling. Because these mirrors are silvered on the reflecting surface, they are easily corroded by fingerprints or perspiration. First-surface mirrors should be cleaned only in accordance with the manufacturer's instructions.

Stereo viewing without instruments

Persons with normal vision and eyes of equal strength can often develop a facility for stereoscopic vision without the necessity of special aids or devices. With practice, some individuals can learn to keep lines of sight from each eye parallel and still bring images into focus. Stereoscopic fusion is aided by practice of the "sausage" exercise sketched in Figure 2-11. The eyes are focused on a distant object as the forefingers are brought slowly into the line of vision. The farther apart the fingers when the "sausage" begins to form, the more nearly parallel are the lines of sight.

Another means of "forcing" each eye to see a different image is to place a card upright between left- and right-hand views of a stereopair such as that shown in Figure 2-7. In practice, most persons easily master the art of keeping the lines of sight parallel; the primary difficulty is that of maintaining this condition while bringing the two different images into focus. In the case of the three-dimensional motion pictures discussed earlier, stereoscopic fusion was assisted by the use of polarized spectacles (vectograph principle), or by the viewing of images projected in complementary colors through eyeglasses having lenses of the opposite complementary colors (anaglyph principle). Stereoscopic prints based on these two concepts can be constructed for specialized illustrations, and instruments such as the Kelsh plotter utilize the anaglyph principle to create a three-dimensional model for contour mapping.

Preparing photographs for stereo viewing

Photographic flights are planned so that prints will overlap about 60 percent of their width in the line of flight and 20 to 30 percent between flight strips. For effective stereo viewing, prints must be trimmed to the nominal size of 23 by 23 cm, preserving the four fiducial marks at the midpoints of each edge. Then the principal point (PP) or optical center of the photograph is located by alignment of opposite sets of fiducial marks with a straightedge. A light cross is drawn at the photo center and a fine needle hole picked at the intersection.

Next is the location of conjugate principal points (CPP) on each photograph, i.e., the points that correspond to principal points of adjacent photos. The lens stereoscope is adjusted to the proper interpupillary distance, and

Figure 2–8. Pocket-type lens stereoscope for viewing overlapping pairs of aerial photographs. Stereoscope and prints are held firmly to portable steel table by magnets. Courtesy Carl Zeiss, Oberkochen.

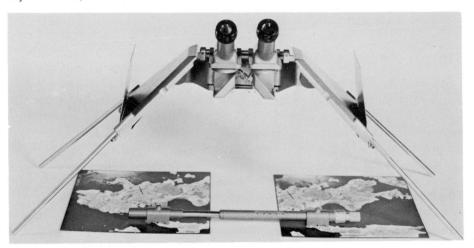

Figure 2-9. Mirror stereoscope with inclined magnifying binoculars. Positioned on the photographs is a stereometer for measuring object heights. Courtesy Wild Heerbrugg Instruments, Inc.

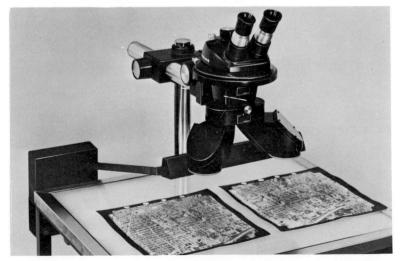

Figure 2-10. Zoom stereoscope with variable magnification ranging from 2.5X to 20X. The instrument is adapted for viewing of prints or transparencies of two sizes—13 by 13 cm or 23 by 23 cm. Courtesy Bausch and Lomb, Inc.

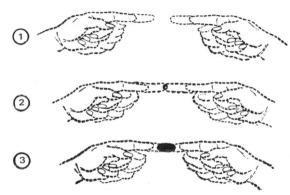

Figure 2-11. The "sausage" exercise is a helpful technique for developing the facility of stereoscopic vision with unaided eyes. Courtesy U.S. Department of the Army.

the first two photographs from a given flight line are arranged so that gross features overlap. Image shadows should be toward the observer; if they fall away from the viewer, there is a tendency to see relief in reverse. One photograph is clipped down, and the adjacent photograph is moved in the direction of the line of flight until corresponding images on each print are about 5.5 cm apart. The lens stereoscope is placed over the prints parallel to the line of flight so that the left-hand lens is over the left photograph and the right-hand lens is over the same image on the right-hand photograph. The area directly under each lens should then appear as a three-dimensional picture.

The movable photograph should next be fastened down. While viewing the three-dimensional picture, the observer places a needle on the unmarked print until it appears to fall precisely in the hole picked for the PP. This locates the CPP, although a monocular check should be made before the print is permanently marked. This procedure is repeated for all photographs; each will then have one PP and two CPP's, except that prints falling at the ends of the flight lines will have only one CPP. When all points have been verified, they should be marked with an inked circle.

Flight lines are located on each print by aligning the PP's and CPP's. The edges of the aligned circles should be connected with a finely inked line. Because of lateral shifting of the photographic aircraft in flight, a straight line will rarely pass through the PP and both CPP's on a given print (Figure 2-12). The photo base length for each stereo overlap is the average of the distance between the PP and CPP on one photograph and the corresponding distance on an overlapping print. This value should be measured to the nearest 0.5 mm and recorded on the back of each overlap. There will be two average base lengths for each print, i.e., one for each set of overlapping flight lines.

Aligning prints for stereoscopic study

Stereoscopic study is beneficial to individuals having eyes of approximately equal strength and will not induce eyestrain or headaches if the photographs are aligned properly at all times. A print is selected and clipped down with shadows toward the viewer. The adjacent photograph is placed with its CPP about 5.5 cm from the corresponding PP on the first photograph. With flight lines superimposed, the second photograph is positioned and clipped down. The stereoscope is placed with its long axis parallel to the flight line and with the lenses over corresponding photo images. In this way, an overlapping strip 5.5 cm wide and 23 cm long can be viewed when the stereoscope is moved up and down the overlap area (Figure 2-13).

With the photos still clipped down, the prints can be flipped into reverse position with the opposite photo on top. This presents another area of the overlap for stereo viewing. In order to study the narrow strip between, one must curl the edge of one print upward or downward and move the stereoscope parallel to the flight line until the "hidden area" comes into view.

Proper use of the stereoscope

Beginning photo interpreters should be especially careful to cultivate proper stereoscopic viewing habits. Some of the more important rules to be observed are as follows:

- 1. Make certain that the photographs are properly aligned at all times, preferably with shadows falling toward the viewer.
- 2. Be careful to keep the eye base and the long axis of the stereoscope parallel to the flight line at all times.
- 3. Maintain an even, glare-free illumination on the prints or transparencies being studied and arrange for a comfortable sitting position.
- 4. Keep the stereoscope lenses clean, properly focused, and separated to the correct interpupillary distance. For most individuals, interpupillary distance is about 62 to 64 mm.
- 5. At the beginning, do not attempt to use the stereoscope more than thirty minutes out of any given one-hour period.

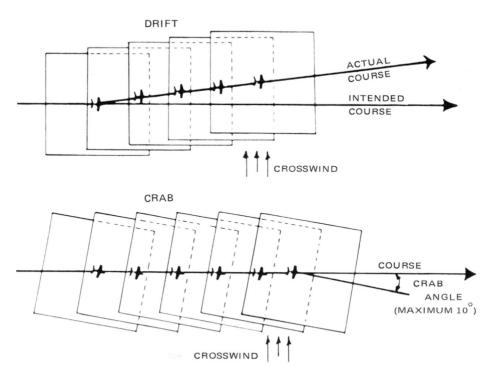

Figure 2–12. If crosswinds are encountered during flight, the photographic airplane may be blown off course, causing an alignment defect known as drift. The pilot can avoid this by heading the airplane slightly into the wind. If the photographer does not adjust the camera to counteract this condition, a skewed or crabbed photograph results. Excessive drift or crab may reduce overlap to an undesirable level. Courtesy U.S. Army Engineer School.

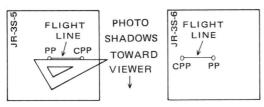

PRELIMINARY PHOTO ORIENTATION

Figure 2–13. Method of aligning contact prints of 23 by 23 cm for viewing with a lens stereoscope. Principal points are denoted as PP; conjugate principal points are marked CPP.

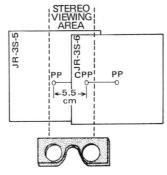

FINAL PHOTO ALIGNMENT

Special problems affecting stereovision

Interpreters who have difficulty in mastering the use of the stereoscope should be cognizant of the following factors that may affect stereovision:

- 1. A person's eyes may be of unequal strength. If one normally wears eyeglasses for reading and closeup work, one should also wear them when using the stereoscope.
- 2. Poor photographic illumination, misaligned prints, or uncomfortable viewing positions may result in eye fatigue.
- 3. Illness or severe emotional stress may create sensations of dizziness in one using a stereoscope.
- 4. An erroneous reversal of left and right prints will often cause a pseudo-scopic view; i.e., topography will appear reversed. A similar image may be created if shadows fall away from the observer rather than toward the viewer as recommended.
- 5. Objects that change positions between exposures (i.e., automobiles, trains, boats) cannot be viewed stereoscopically.
- 6. In areas of steep topography, scale differences of adjacent photographs may make it difficult to obtain a three-dimensional image.
- 7. Dark shadows or clouds may prohibit stereoscopic study by obliterating detail on one photograph.
- 8. Individuals who have continued difficulties in using the stereoscope should not attempt to master the art of stereoscopic vision with unaided eyes.

Care of aerial photographs

In using and handling aerial photographs, one must exercise special care to protect the emulsion surface. Exposure to direct sunlight or excessive moisture should be avoided, and prints should not be marked upon when damp. If drafting tape is to be removed, it should be pulled slowly toward the edge of the print; otherwise, the emulsion may be peeled off. As long as the surface is free from cracks, photographs may be cleaned with carbon tetrachloride or a damp sponge. Prints subjected to heat, even that produced by a desk lamp, have a natural tendency to curl. For this reason, aerial photographs should always be stored flat and under a moderate amount of pressure.

Problems

- 1. Position a lens stereoscope over the Zeiss stereoscopic vision test chart shown in *Figure 2-14*. Then rank the details within rings 1, 2, 3 and 6, 7, 8 in height order (highest = 1, second highest = 2, and so on).
 - 1. () Triangle
 - () Square
 - () Point
 -) Marginal ring
 - 2. () Flanking mountains
 - () Marginal ring
 - () Spotting mark and central mountain
 - 3. () Square
 -) Cross
 - () Marginal ring
 - () Circle, lower left
 - () Circle, upper center
 - 6. () Circle, lower right
 - () Circle, upper left
 - () Circle, lower left
 -) Marginal ring
 - () Circle, upper right
 - 7. () Black circle
 -) Black triangle
 - () Flag with ball (black)
 - () White triangle
 - () Marginal ring
 - () Tower with cross and ring
 - () White rectangle
 - () Black rectangle
 - Double cross with arrowhead
 - 8. () Marginal ring
 - () Steeple and the two triangles

Figure 2-14. Stereoscopic vision test chart. Courtesy Carl Zeiss, Oberkochen.

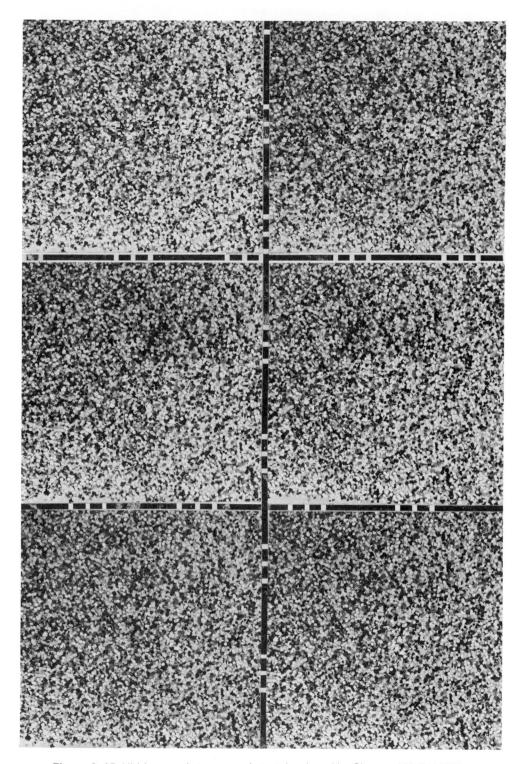

Figure 2–15. Hidden word stereoscopic test developed by Sims and Hall (1956).

2.	Position a lens stereoscope over the hidden word stereograms shown in Figure 2-15. What words appear in the three views?						
	Top view						
	Middle view						
	Bottom view						
3.	Obtain four or more overlapping aerial photographs of your local area. At least two flight lines should be represented. Write your name on the back of each print. Following previous instructions, trim each print, locate principal points (PP) and conjugate principal points (CPP). Double-check to verify precise location; points picked incorrectly will appear to "float" or "sink" with respect to surrounding terrain. When available, a set of older prints should be used for practice in point-picking.						
	With a drop-bow pen, circle each PP and CPP. Ink flight lines and record average photo base length for each overlap as directed; you will use these values later in computing object heights from parallax measurements. P values						
	Arrange prints in mosaic fashion and observe direction of flight lines and orientation of shadows. If time of day is not shown, estimate the time of day (early morning, midday, late afternoon). Obtain the exact time and record on first and last prints in each flight line. Time of day						
	· · · · · · · · · · · · · · · · · · ·						
4.	Record the following data for your own prints:						
	a. Date(s) of photography						
	b. Organization for which photos were originally flown						
	c. Project symbol, film roll, and exposure numbers						
	d. Film-filter combination used						
	e. Approximate scale of photography						
	f. Camera focal length (if shown on prints)						
	g. Average ground elevation of local area (above sea level)						
5	. Arrange prints in mosaic fashion and measure: a. Average forward overlap percent						
	h Average sidelan percent						

ь.	quadrangle sheet. With an engineer's scale and protractor, measure the following:					
	a. Compass bearing of flight line 1 degrees					
	b. Compass bearing of flight line 2 degrees					
	c. Was the intended flight course north-south or east-west?					
7.	Check print alignment in each flight line. The combination of crab and drift should not exceed 10 percent of the print width for any three consecutive photographs. Record as a percentage of print width affected:					
	Line 1 percent Line 2 percent					
8.	Inspect all of your photographs closely and determine whether any of the following "defects" appear. Write print numbers opposite the applicable description.					
	Excessively long shadows					
	Shadows fuzzy due to overcast sky					
	Poor tonal contrast					
	Blurred print detail, especially in corners					
	Chemical streaks or stains					
	Emulsion scratches or cracks					
	Clouds or cloud shadows					
	Smoke or smog (industrial areas)					
	Excessive snow cover on ground					
	Floodwaters obscuring ground detail					
	Inadequate or incorrect print titling					
	Excessive forward overlap (over 65 percent)					
	Deficient forward overlap (less than 50 percent)					
	Excessive sidelap (over 45 percent)					
	Deficient sidelap (less than 15 percent)					
	Improper print alignment					
	Tilted photographs (check ends of flight lines)					
9.	On a 23-by-23-cm sheet of transparent cellulose acetate or heavy vellum, draft a point-designator grid such as that pictured in Figure 2-16. Set up your own prints for stereoscopic study with the point-designator grid carefully taped over the right-hand print so that grid midpoints are aligned with the four photo fiducial marks. Then refer to the checklist of typical features and write down (by grid location) as many items as you can identify. Following the name of each feature, indicate a level of confidence for the identification, i.e., confirmed, probable, or possible. Tabulate information as follows:					

Grid location	Feature identified	Confid	dence rel

Figure 2–16. A point-designator grid for use as an overlay on contact prints of 23 by 23 cm. Small squares should be about 1 cm or 0.5 in. on a side.

Answers: Zeiss stereoscopic vision test

- 1. (3) Triangle
 - (2) Square
 - (4) Point
 - (1) Marginal ring
- 2. (2) Flanking mountains
 - (1) Marginal ring
 - (3) Spotting mark and central mountain
- 3. (4) Square
 - (3) Cross
 - (2) Marginal ring
 - (1) Circle, lower left
 - (5) Circle, upper center
- 6. (5) Circle, lower right
 - (3) Circle, upper left

- (4) Circle, lower left
- (2) Marginal ring
- (1) Circle, upper right
- 7. (4) Black circle
 - (3) Black triangle
 - (5) Flag with ball (black)
 - (8) White triangle
 - (1) Marginal ring
 - (7) Tower with cross and ring
 - (9) White rectangle
 - (6) Black rectangle
 - (2) Double cross with arrowhead
- 8. (1) Marginal ring
 - (2) Steeple and the two triangles

Answers: Hidden word stereoscopic test

Top view: FATHER—SUN Middle view: SOFT—SMOOT

Bottom view: FIR

References

American Optical Company. 1957. A-O, H-R-R pseudoisochromatic plates. 2nd ed. American Optical Co., Buffalo, N.Y. 15 pp.

Hatch, C. R., and F. H. Kung. 1972. Computer-drawn stereograms. *Journal of Forestry* 70:489, illus.

Howard, John A. 1970. Aerial photo-ecology. Faber and Faber, London. 325 pp., illus. Julesz, Bela. 1974. Cooperative phenomena in binocular depth perception. American Scientist 62:32-43, illus.

Moessner, Karl E. 1954. A simple test for stereoscopic perception. U.S. Forest Service, Central States Forest Experiment Station. Technical Paper 144, 14 pp., illus.

Seymour, Thomas D. 1957. The interpretation of unidentified information—A basic concept. *Photogrammetric Engineering* 23:115–21.

Sims, W. G., and Norman Hall. 1956. The testing of candidates for training as airphoto interpreters. Forestry and Timber Bureau, Commonwealth of Australia, Canberra. 12 pp., illus.

Wyllie, G. S., and F. B. Reeves. 1971. Stereograms as training aids. Photogrammetric Engineering 37:839-42, illus.

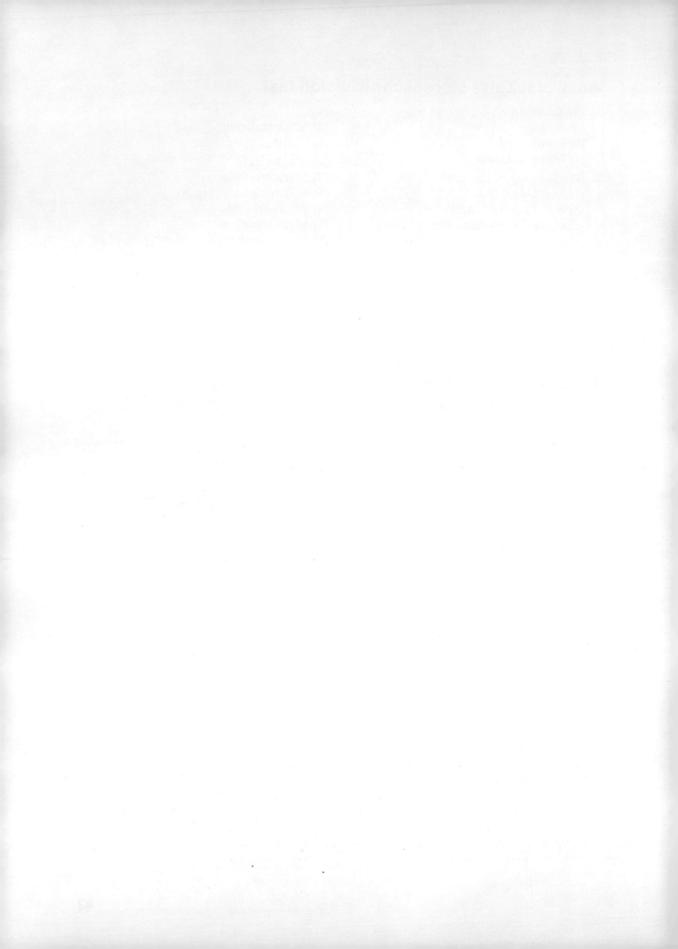

Chapter 3

Photo Scale and Stereoscopic Parallax

Scale from focal length and altitude

As illustrated in Figure 3-1, the scale of a vertical aerial photograph is a function of the focal length of the camera lens and the height from which the exposure is made. The vertical aerial photograph presents a true record of angles, but measures of horizontal distance are subject to variation because of changes in ground elevations or flight altitudes. The nominal scale (e.g., 1:15,840) is representative only of the datum, an imaginary horizontal plane passing through a specified elevation above mean sea level (MSL). To make accurate measurements of distance, area, or height, it is necessary to determine, as nearly as possible, the exact photographic scale.

Cameras used for aerial photography may have focal lengths ranging from 50 to 610 mm (2 to 24 in.). The more commonly employed aerial cameras have focal lengths of 153, 210, or 305 mm (6, 8.25, or 12 in.). A knowledge of the focal length, along with the altitude of the photographic aircraft, makes it possible to determine the representative fraction (RF) or natural scale:

$$RF = \frac{Camera focal length (m)}{Altitude above ground datum (m)}$$

For example, with a camera focal length of 210 mm (0.21 m), a flight altitude of 2,500 m above MSL, and an average ground elevation of 400 m, the representative fraction would be computed as follows:

RF =
$$\frac{0.21}{2,500 - 400} = \frac{0.21}{2,100} = \frac{1}{10,000}$$
 or 1:10,000

It will be noted that the solution of this relationship requires that both numerator and denominator be in the same units (metres in this particular example). It is also emphasized that the computed scale of 1:10,000 will be precisely obtained *only* as long as the land surface is uniformly 400 m above sea level. If the elevation decreases, the photographic scales will be smaller; conversely, if higher topographic features are encountered, photo scales will be increased, because the land will have "moved closer" to the camera.

Aircraft flying heights are usually determined from altimeters that record barometric pressure and translate this information into height above sea level. The precision of such readings can vary considerably due to changes in air temperature and other factors. To improve on the accuracy of such instrumentation, Canada's National Research Council and Forest Management Institute have developed and tested a radar altimeter for use in low-altitude aerial photography.

The principal objective of the radar altimeter system is the precise measurement of aircraft-to-ground distance, irrespective of intervening vegetation. Over flat terrain, tests indicate that flying heights can be determined to within ± 1 percent (probability level of 0.95) for altitudes of 240 to 1,100 m—the range desired for low-level photography. Over irregular terrain, the absolute error is about ± 6 m for the same altitudinal range.

Scale from photo/ground distances

While the preceding method of deriving photo scale is theoretically sound, it often happens that either camera focal length or the exact flight altitude is

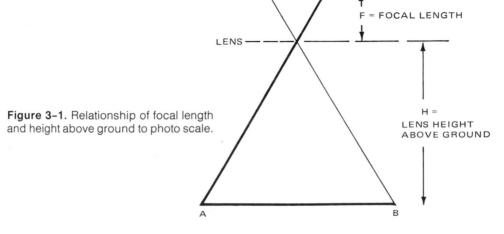

unknown to the interpreter. As a result, scale is more often calculated from the relationship between a photo measurement and a measured (or mapderived) ground distance:

$$RF = \frac{Photographic distance between two points (m)}{Ground distance between same points (m)}$$

As an example, the distance between two road intersections might be measured on a vertical photograph as 60 mm, or 0.06 m. If the corresponding ground distance is measured as 1,584 m, the representative fraction would be computed as:

$$RF = \frac{0.06}{1,584} = \frac{1}{26,400} \text{ or } 1:26,400$$

In the application of this technique, the two points selected for measurement should be diametrically opposed so that a line connecting them passes near the principal point (PP). If the points are also approximately equidistant from the PP, the effect of photographic tilt upon the scale determination will be minimized. To avoid the necessity of expensive ground surveys, terrain distances are often computed from reliable maps and substituted for measured ground distances in the foregoing relationship.

Scale approximations can also be made by use of objects or features of known ground dimensions, such as athletic fields, railway gauges, or aircraft wingspans. However, since the percentage of error increases as the measured distance decreases, very small objects are apt to produce sizable errors in such scale calculations.

In most instances, it is not essential to calculate the scale of every photograph in a flight line. Where the topography is relatively steep, measurements may be made on every third or fourth print; in flat terrain, even fewer checks are required.

Table 3-1 lists conversion factors for a wide range of photographic and map scales. Comparisons of identical photographic images at different scales are shown in Figure 3-2.

Image displacement on aerial photos

On an accurate planimetric map, all features are depicted at their correct horizontal positions, and the observer thus has a truly vertical view of every detail shown. This standard cannot be met by aerial photographs, however, because of various sources of distortion or image displacement. Objects pictured on aerial photographs may fail to register in their correct plane positions because of (1) optical or photographic deficiencies, (2) tilting of the camera lens axis at the instant of exposure, or (3) variations in local relief.

The meaning of optical distortion is well understood by anyone who has gazed through the sharp curvature of a "wrap-around" auto windshield, or stared at his or her image in a doubly convex carnival mirror. When optical distortion is due to an inferior camera lens, the recorded images are displaced radially toward or away from the principal point of the photograph. Image distortions may also be induced by faulty shutters, film shrinkage, or failure of the film-flattening mechanism in the camera focal plane. Fortunately for the photo interpreter, such difficulties rarely occur. Modern

Table 3-1. Scale Conversions for Maps and Vertical Photographs

	Representative fraction (scale)	1:1,000 1:2,000 1:3,000 1:4,000 1:4,000 1:10,000 1:15,000 1:25,000 1:50,000 1:75,000 1:100,000	Method of calculation*
	Acres per square inch	0.16 0.64 1.43 2.55 3.99 15.94 35.87 63.77 63.77 99.64 398.56 896.75 1,594.22	(ft/in.) ² 43,560
	Inches per mile	63.36 31.68 21.12 15.84 12.67 6.34 4.22 3.17 2.53 1.27 0.84	63,360 RFD
	Feet per inch	83.33 166.67 250.00 333.33 416.67 833.33 4,166.67 6,250.00 8,333.33	RFD 12
	Hectares per square centimetre	0.01 0.09 0.16 0.25 1.00 2.25 4.00 6.25 25.00 56.25 100.00	(m/cm) ² 10,000
	Centimetres per kilometre	100.00 50.00 33.33 25.00 20.00 10.00 6.67 5.00 2.00 1.33	100,000 RFD
	Metres per centimetre	10 20 30 40 40 100 150 250 250 500 750 1,000	RFD 100
	Representative fraction (scale)	1:1,000 1:2,000 1:3,000 1:4,000 1:5,000 1:15,000 1:25,000 1:50,000 1:75,000	Method of calculation*
-1			- 1

 * RFD refers to the representative fraction denominator.

Figure 3-2. Stereograms of an urban-industrial area. Assuming that the scale of the lower stereogram is 1:6,000, compute the scales for the other two views. Courtesy Abrams Aerial Survey Corp.

camera systems in the hands of experienced flight crews have all but eliminated this source of image displacement.

A tilted photograph presents a slightly oblique view rather than a truly vertical record. Almost all aerial photographs are tilted to some degree, for the perfect aerial camera stabilizer has yet to be developed. The focus of tilt displacement is referred to as the *isocenter*, a point occurring at the "hinge" formed by the tilted negative and an imaginary horizontal plane. Images are displaced radially toward the isocenter on the upper side of a tilted photograph and radially outward or away from the isocenter on the lower side. Along the axis of tilt, there is no displacement relative to an equivalent untilted photograph. For these reasons, scale checks should make use of measurements between points located at the same elevation and on opposite sides of the print center. In this way, errors due to tilt (which may be present but not apparent) tend to be somewhat compensating.

The exact angle and direction of tilt are rarely known to the interpreter, and precise location of the isocenter is therefore a tedious process. Furthermore, the presence of small amounts of tilt often goes undetected. As only the central portions of most contact prints are used for interpretation, photographic tilt amounting to less than 2 or 3 degrees can usually be ignored without serious consequences. In such cases, it is assumed that the isocenter coincides with the easily located principal point.

The most significant source of image displacement on aerial photographs is relief, i.e., differences in the relative elevations of objects pictured. Relief displacement is by no means limited to mountains and deep gorges; all objects that extend above or below a specified ground datum have their photographic images displaced to a greater or lesser extent. Skyscrapers, houses, automobiles, trees, grass, and even people are affected by this characteristic (Figure 3-3). An aerial photograph completely devoid of relief displacement is difficult to visualize. Perhaps the closest approximation would be a vertical photograph of a calm water surface (e.g., Lake Tahoe) or an unmarred land-

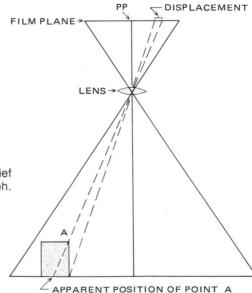

Figure 3–3. Schematic representation of relief displacement on a single, vertical photograph.

scape such as the Utah salt flats.

Effects of relief displacement

The underlying cause of relief displacement can be traced to the perspective view "seen" by a camera lens pointed straight down toward the earth's surface. If a single exposure is precisely centered over a tall smokestack, the photographic image will appear merely as a doughnut-shaped ring, perhaps not unlike that of an open-topped cistern only a few metres high. There is little image displacement here, for this is the one point where the camera lens affords a truly vertical view. By contrast, suppose another smokestack occurs near the edge of the print. In this instance, the camera eye looks more at the side of the smokestack than "down the barrel." The recorded image thus appears to lean radially outward from the center of the photograph. More specifically, displacement is radial from the nadir, a point that also coincides with the principal point on truly vertical photographs. It can be stated that objects projecting above a specified datum are displaced radially outward from the nadir, while those below the datum are displaced radially inward toward the nadir. Irrespective of the direction of displacement, a line drawn from the nadir through a displaced image will pass through the true horizontal position of the object.

An outstanding example of relief displacement is illustrated in Figure 3-4. In the left-hand view, the transmission line is almost directly under the camera lens. Therefore, relief displacement is minimized, and the right-of-way appears in its true ground configuration as a nearly straight line. In the right view, however, the transmission line was imaged near the edge of the photograph. As a result, the distance from the nadir, coupled with large topographic changes, has caused the right-of-way to be displaced into a non-linear feature.

The meteoritic crater pictured in Figure 3-5 furnishes an example of relief displacement for images below ground datum. With an engineer's scale, it can be verified that corresponding images at the bottom of the crater are farther apart than those at the rim surface (ground datum). Thus the two images of the 175-m depression are displaced toward their respective nadirs (off the left and right print margins).

In summary, it may be concluded that the amount of relief displacement is directly correlated with the actual height (or depth) of an object and its distance from the nadir. Tall objects pictured near the edges of prints will exhibit maximum displacement. Displacement is affected also by the flight altitude and hence by the focal length of the camera used. At a given photo scale, a 150-mm focal length will result in twice as much image displacement as a 300-mm focal length, because the former will be taken from one-half the altitude of the latter. While relief displacement constitutes a source of error in measuring horizontal distances on aerial photographs, it is this same characteristic that makes it possible to study overlapping prints stereoscopically. This point can be easily demonstrated with two prints made from the same negative; a three-dimensional view is unattainable due to a lack of relative image displacement.

Thus, the goal of the aerial surveyor is to make certain that there is sufficient image displacement to assure three-dimensional study and yet to avoid the excessive distortions that prevent stereoscopic fusion. Since the amount of relief itself cannot be controlled, this objective must be accomplished by manipulations in flight altitudes and camera focal lengths. When it is desired to increase the exaggeration of the third dimension, as in relatively flat ter-

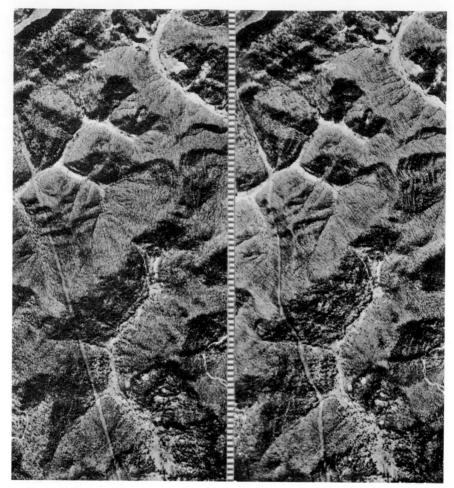

Figure 3-4. Stereogram illustrating the displacement of a transmission line due to relief. Location is Bell County, Kentucky; scale is about 1:36,000. Courtesy Tennessee Valley Authority.

rain, a shorter focal length is commonly specified. Conversely, in extremely mountainous country, a longer lens might be used, because excessive displacement makes stereoscopic viewing uncomfortable.

Measuring heights of displaced objects

The exaggerated displacement of tall objects pictured near the edges of large-scale, vertical photographs sometimes permits accurate measurement of object heights on single prints. This specialized technique of height evaluation is feasible provided that:

- 1. The principal point can be accepted as the nadir position.
- 2. The flight altitude above the base of the object can be precisely determined.
- 3. Both the top and base of the object are clearly visible.
- 4. The degree of image displacement is great enough to be accurately measured with available equipment, e.g., an engineer's scale.

When all of these conditions can be met, object heights may be determined by this relationship:

Height of object (ho) =
$$\frac{d}{r}$$
(H)

where: d is the length of the displaced image,

r is the radial distance from the nadir to the top of the displaced image,

H is the aircraft flying height above the base of the object.

Measurements of d and r must be in the same units; H is expressed in the units desired for the height of the object. For example, if it is assumed that the photograph in Figure 3-6 was taken from an altitude of 914 m, the tank heights might be computed as follows:

Tank A: ho =
$$\frac{4.5 \text{ mm}}{59.5 \text{ mm}}$$
 (914) = 69 m

Tank B: ho =
$$\frac{9.5 \text{ mm}}{127 \text{ mm}}$$
 (914) = 68 m

Thus both tanks are about the same height. The accuracy of height determinations by this technique is dependent upon vertical (nontilted) photographs, precise values for flying heights, and very careful measurement techniques. If any of these factors is open to question, resulting heights must be regarded as approximations only. In the calculation for tank B, for example, a measurement of 9.0 mm instead of 9.5 mm for the length of the displaced image would change the resulting object height from 68 m to only 65 m.

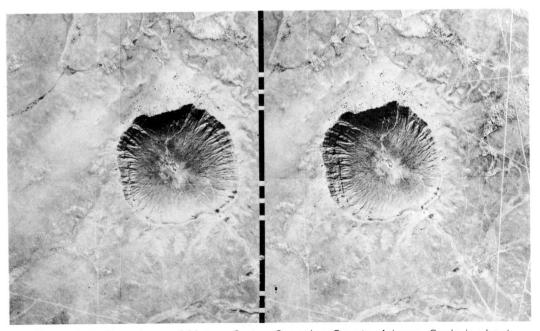

Figure 3-5. Stereogram of Meteor Crater, Coconino County, Arizona. Scale is about 1:40,000. The crater is approximately 1,265 m across and 175 m deep. Courtesy U.S. Department of Agriculture.

Figure 3-6. Industrial area, pictured at a scale of about 1:6,000. The tanks marked A and B are the same height; tank B shows more image displacement because it is farther from the nadir. Courtesy Abrams Aerial Survey Corp.

Stereoscopic parallax

If a nearby object is observed alternately with the left and right eye, its location will appear to shift from one position to another. This apparent displacement, caused by a change in the point of observation, is known as parallax. Parallax is a normal characteristic of overlapping aerial photographs, and it is the basis for three-dimensional viewing. The apparent elevation of an object is due to differences in its image displacement on adjacent prints.

Two measures of parallax must be obtained when object heights are being determined on stereoscopic pairs of photographs. Absolute stereoscopic parallax (x-parallax) is the sum of the distances of corresponding images from their respective nadirs. It is always measured parallel to the flight line. Differential parallax is merely the difference in the absolute stereoscopic

parallax at the top and the base of the object being measured. The basic formula for determining object heights or differences in elevation from parallax measurements is:

Height of object (ho) =
$$(H)\frac{dP}{P+dP}$$

where: H is the height of the aircraft above the ground datum,

P is the absolute stereoscopic parallax at the base of the object being measured,

dP is the differential parallax.

The height of the aircraft (H) should be expressed in the units desired for the object height. This will usually be metres or feet. Once a precise photo scale has been ascertained, the flight altitude can be found by multiplication of the RF denominator by the camera focal length. Absolute stereoscopic parallax (P) and differential parallax (dP) must be in the same units. Ordinarily, these units will be millimetres and hundredths or inches and thousandths, depending on the calibration of the parallax device used for measurements. Since both metric and English instruments may be encountered, examples that follow illustrate both types of calculations.

Average photo base length

For reasons of convenience and ease of measurement, the average photo base length of a stereopair is commonly substituted as the absolute stereoscopic parallax (P) in the solution of the parallax formula. This procedure produces reasonably accurate results if:

- 1. Photographic tilt is less than 3 degrees.
- 2. Both negatives of the stereopair were exposed from the same flight altitude.
- 3. Both nadirs, or principal points, are at the same ground elevation.
- 4. The base of the object to be measured is at essentially the same elevation as that of the principal points.

Under these circumstances, y-parallax, or displacement at right angles to the flight line, is considered nonexistent. Furthermore, principal points can be substituted for nadir locations in measurements of absolute stereoscopic parallax.

Variations in the elevation of the two principal points of a stereopair will result in differing measurements of corresponding base lengths. In such instances, the use of the average photo base length supplies an estimate of the absolute stereoscopic parallax for an imaginary datum midway between the actual principal point elevations. A more serious situation is presented when the elevation at the base of the object being measured differs by more than 50 to 100 m from that of the principal points. Here, a new value should be calculated for absolute stereoscopic parallax:

- 1. Set up the stereopair for normal viewing. Flight lines should be superimposed and images separated about 5.5 cm. Both prints should be firmly fastened down to avoid movement.
- 2. Measure the distance between the two principal points to the nearest 0.5 mm.

3. Measure the distance (parallel to the flight line) between corresponding images on the two photographs at or near the base of the desired object. Subtract this distance from that obtained in step 2 to obtain the absolute stereoscopic parallax at the base of the object.

Direct measurements of parallax

Differential parallax (dP) is usually measured stereoscopically with a parallax wedge or parallax bar (stereometer) that incorporates the "floating-mark" principle. However, the concept of differential parallax can best be illustrated by direct scale measurement of heavily displaced images, and the stereopair of the Washington Monument (Figure 3-7) supplies an ideal example. The nominal photo scale of 1:4,800 is first corrected to an exact scale of 1:4,600 at the base of the monument. Since a 12-in. camera focal length was used, the flying height above ground (H) is 4,600 ft.

Average photo base length (P) for the stereopair is 4.40 in. Absolute stereoscopic parallax at the base and top of the monument is measured parallel to the line of flight with an engineer's scale; the difference (2.06-1.46 in.) is dP, the differential parallax of the displaced images. (Because the monument has the shape of an obelisk, measurements were made at the midpoint of the base and vertically above this position at the pyramidal top.) Substituting the foregoing values into the parallax formula, we have:

ho =
$$(4,600) \frac{0.60}{4.40 + 0.60} = 552 \, \text{ft}$$

This is an unusually precise estimate, for the actual height of the monument is 555.5 ft (about 169 m). Had the nominal scale of photography (1:4,800) been used instead of the corrected scale, the height would have been computed as 576 ft, an error of 21 ft. Errors of similar magnitude would result from inaccurate parallax measurements. Thus, the necessity for precision can hardly be overemphasized.

A diagrammetric explanation of differential parallax is shown in Figure 3-8. If a flying height of 3,000 m and an average photo base length of 80.5 mm are assumed for this illustration, the tree height would be computed as:

ho =
$$(3,000) \frac{0.52}{80.50 + 0.52} = 19.2 \text{ m}$$

Functions of stereometers

The interpreter must recognize that the degree of stereoscopic parallax encountered on small-scale (high-altitude) photography is often much less than that illustrated by Figures 3-7 and 3-8. Therefore, differential parallax is usually measured under the stereoscope with a parallax wedge or stereometer, because a precise determination by direct measurement is virtually impossible.

If a small dot is inked at precisely the same location on both prints of a stereopair, the two dots will merge into one when viewed through a stereoscope. Had one pair of dots been placed on level ground and another pair on top of a tree or building, each pair would merge into a single mark; the first pair would appear to lie at ground level, while the second pair (being slightly closer together) would appear to "float" in space at the elevation of the object

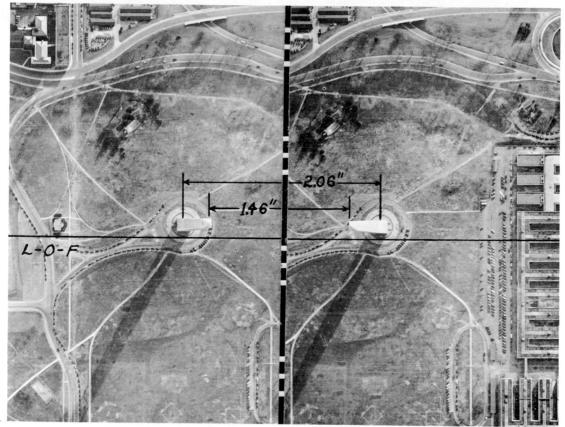

Figure 3-7. Stereopair of the Washington Monument, Washington, D.C. Note displacement of images parallel to line of flight (L-O-F) and measurements for determination of differential parallax. Scale is 1:4,600 at the base of the monument.

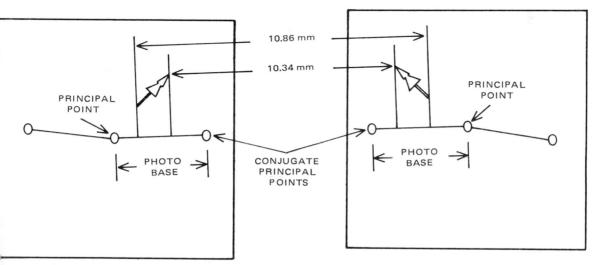

Figure 3-8. Direct measurement of differential parallax for a heavily displaced tree image. Note that base and height measurements are made exactly parallel to the photo base or line of flight. The differential parallax (dP) is 0.52 mm.

on which the dots were inked. If the distance between each pair of corresponding dots can be precisely measured, the algebraic difference will be a measure of differential parallax. The function of a stereometer is to measure such changes in parallax that are too small to be determined by direct linear scaling.

The parallax wedge

An inexpensive device often used for measuring differential parallax is the parallax wedge. The basic design, usually printed on transparent film or glass, consists of two rows of dots or graduated lines beginning about 2.5 in. apart and converging to about 1.8 in. apart. Graduations on the wedge are calibrated for making parallax readings to the nearest 0.002 in.

In use, the parallax wedge is placed over the stereoscopic image with the converging lines perpendicular to the line of flight and then shifted until a single fused line of dots is seen sloping downward through the stereo model. If corresponding images are separated by exactly 2 in., a small portion of the wedge centered around the 2-in. separation of converging lines will fuse and appear as a single line. The line will appear to "split" above and below this section. Using the fused line of graduations, and counting the number of intervals between the point where a graduation appears to rest on the ground and the point where another graduation appears to "float" in the air at the same height as the top of the object, one then obtains the differential parallax.

In Figure 3-9, for example, the difference in parallax (dP) between the ground and the highest roof level of the building might be read as ten intervals on the wedge, or 0.020 in. Assuming a flight altitude (H) of 5,400 ft and a photo base length (P) of 1.850 in., one determines the building height as follows:

ho =
$$(5,400)$$
 $\frac{0.020}{1.850 + 0.020}$ = 58 ft

Figure 3-9. Parallax wedge correctly oriented over a stereogram of a large, flat-roofed building. Graduations on right-hand side indicate the separation of the converging lines to the nearest 0.002 in.

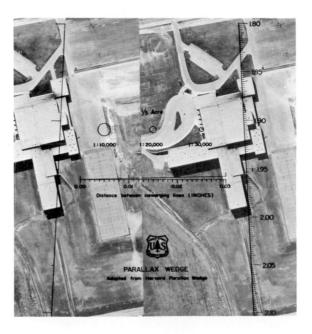

The parallax bar or stereometer

Many interpreters prefer the parallax bar to the wedge, because the floating dot is movable and thus easier to place on the ground and on the tops of objects. Stereometers of two different types are illustrated in Figures 3-10 and 3-11.

The typical parallax bar has two lenses attached to a metal frame that houses a vernier and a graduated metric scale. The left lens contains the fixed reference dot; the dot on the right lens can be moved laterally by means of the vernier. The bar is placed over the stereoscopic image parallel to the line of flight. The right-hand dot is moved until it fuses with the reference dot and appears to rest on the ground, and the vernier reading is recorded to the nearest 0.01 mm. Then the vernier is turned until the fused dot appears to "float" at the elevation of the object being measured. A second vernier reading is taken, and the difference between the two readings is the differential parallax (dP). This value can be substituted in the parallax formula without conversion if the absolute parallax (P) is also expressed in millimetres. Calculations are handled as in the metric example previously cited for Figure 3-8.

Precision of height determinations

Precision in measurement of object heights depends on a number of factors, not the least of which is the individual's ability to perceive stereoscopic parallax. It is also apparent that measurement precision will be improved when objects are clearly imaged on high-resolution, nontilted photographs of known scale, flight altitude, and photo base length.

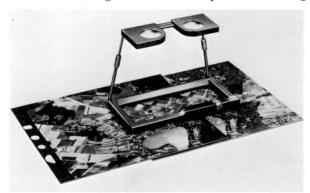

Figure 3-10. Lens stereoscope with attached stereometer. The knurled cylinder can be revolved to move the right-hand lens and create a floating dot. Courtesy Carl Zeiss, Oberkochen.

Figure 3-11. Mirror stereoscope with inclined magnifying binoculars and an attached stereometer for measuring heights of objects. Courtesy Carl Zeiss, Oberkochen.

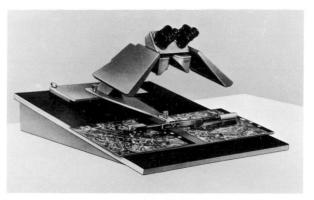

It is generally believed that skilled interpreters can detect and measure parallax differences of 0.05 mm (0.002 in.) when using the simple parallax devices discussed in this chapter. If these values are accepted as minimum measurement units, then the precision of height determinations will be solely dependent on the flying height of the aircraft and the average photo base length.

Provided stereoscopic fusion is not hampered by excessive image displacements, the precision of height measurements will improve as forward overlap and aircraft flying height are decreased (overlap should not be reduced to less than 50 percent, of course). This concept is illustrated by Tables 3-2 and 3-3, which were derived for various photo bases (i.e., overlaps) and flying heights by iterative solutions of the parallax formula. The tables are presented in both metric and English units for application with either stereometers or parallax wedges.

Table 3-2.
Precision of Height Measurements for Parallax Intervals of 0.05 mm

Average photo base (P), in milli-	Average forward overlap as a	Flying	g height (H) 1,000	above gro 2,000	ound, in me 5,000	etres 10,000
metres	percentage*	Obj	ect heights	, in metres	per 0.05 m	ım
70	70	0.36	0.71	1.43	3.57	7.14
75	67	0.33	0.67	1.33	3.33	6.66
80	65	0.31	0.62	1.25	3.12	6.25
85	63	0.29	0.59	1.18	2.94	5.88
90	61	0.28	0.56	1.11	2.78	5.55
95	59	0.26	0.53	1.05	2.63	5.26
100	57	0.25	0.50	1.00	2.50	5.00
105	54	0.24	0.48	0.95	2.38	4.76
110	52	0.23	0.45	0.91	2.27	4.54

^{*}Assumes photographs of 23 by 23 cm. Values for object heights were derived by solution of the parallax formula as presented elsewhere in this chapter.

Table 3-3.

Precision of Height Measurements for Parallax Intervals of 0.002 in.

Average photo base (P),	Average forward overlap as a	Flyi 1,000	ing height (2,000	H) above (5,000	ground, in f 10,000	eet 20,000
in inches	percentage*	C	bject heig	hts, in feet	per 0.002 i	n.
2.7	70	0.74	1.5	3.7	7.4	14.8
2.9	68	0.69	1.4	3.4	6.9	13.8
3.1	66	0.64	1.3	3.2	6.4	12.9
3.3	63	0.61	1.2	3.0	6.1	12.1
3.5	61	0.57	1.1	2.8	5.7	11.4
3.7	59	0.54	1.1	2.7	5.4	10.8
3.9	57	0.51	1.0	2.6	5.1	10.2
4.1	54	0.49	1.0	2.4	4.9	9.8
4.3	52	0.46	0.9	2.3	4.6	9.3

^{*}Assumes photographs of 9 by 9 in. Values for object heights were derived by solution of the parallax formula as presented elsewhere in this chapter.

Interpreters should be conscious of the following points as a means of improving the precision of height measurements.

- 1. High-contrast (or color) exposures may improve object clarity and therefore make ground and top readings less tedious and more definitive.
- 2. Black-and-white positive transparencies used over a light table are greatly superior to ordinary prints for all types of measurements.
- 3. Individual interpreters often have much greater confidence (and ability) with a specific type of parallax-measuring device as compared to another type.
- 4. In rough terrain, calculation of the exact scale and flying height for each overlap is desirable. For objects on high ridges or in deep ravines, it is better to compute new values for absolute stereoscopic parallax than to use the average photo base length.
- 5. Once a pair of photographs has been aligned for stereo viewing, they should be fastened down to prevent movement. A slip of either exposure between readings at the base or top of an object will result in large errors.
- 6. To avoid single measurements of high variability, it is recommended that several parallax readings be made for each object and the results averaged. Rest periods are desirable between measurements of the same objects.

Problems

1. Compute the scale for your own set of aerial photographs from ratios of several photo and ground distances. (Ground distances may be derived from reliable maps, from the lengths of known features, such as ground survey lines, or from direct field measurements.) Record below:

Description of line	Ground distance	Photo distance	RF
	,		
	Aver	age scale (RF)	
2. Refer to Table 3-1	and convert your aver	rage scale to the followi	ng units:
	m/cm	or ft/in.	
		n or in./mi	
	ha/cm	² or acres/in. ²	

	the flyin	g heig	ht above	MSL	:			
	hs and c ground m	onver	t to grou	nd dis	stances. Th	en check	thes	your local se distances reasons for
Desc	cription of f	eature			Photo-derive		G	round check
flying heig	hs. Dete ght. Thei	ermine n solve	e the exc e the par	act sca callax	ale of your formula to	prints b determi	efore ne (a	on your own e computing) the change on per 0.002
				hoto bo	os longth (D)	Ohanna	in hoic	
Stereo	Height in metres	in feet	in millim		se length (P)	per 0.01 m		per 0.002 in. dF

6. Locate several objects such as trees, buildings, or smokestacks within the overlap zones of your photographs. Select features that are not likely to have changed since your exposures were made. Measure their heights with a stereometer (floating mark device) and record below. If feasible, check these heights by ground measurement for a comparison of results.

Stereo overlap number	Description of object	dP	Photo height	Ground check	Difference (+or-)
			*		
					-
	7,				
	1 '				
	3 4				
	A CONTRACTOR				
	9 ²				

References

- Avery, T. E. 1971. Two cameras for parallax height measurements. *Photogrammetric Engineering* 37:576.
- ——. 1966. Forester's guide to aerial photo interpretation. Government Printing Office, Washington, D.C. U.S. Department of Agriculture, Agriculture Handbook 308, 40 pp., illus.
- Methley, B. D. F. 1970. Heights from parallax bar and computer. *Photogrammetric Record* 6 (35): 459-65.
- Moessner, Karl E., and Grover A. Choate. 1966. Terrain slope estimation. *Photogram-metric Engineering* 32:67–75, illus.
- Nielsen, U. 1974. Description and performance of the forestry radar altimeter. Forest Management Institute, Canadian Forestry Service, Ottawa. 17 pp., illus.
- Schut, G. H., and M. C. van Wijk. 1965. The determination of tree heights from parallax measurements. *Canadian Surveyor* 19:415–27, illus.

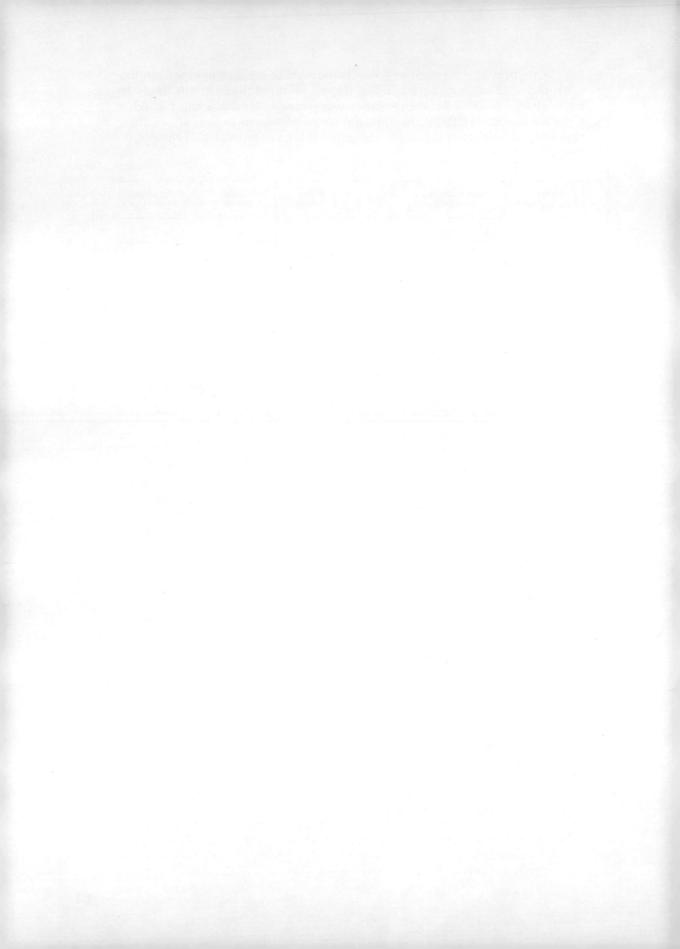

Chapter 4

Stereograms, Shadow Heights, and Areas

Aerial stereograms

One of the best ways for an interpreter to build a file of reference material is to prepare sample stereograms for various classes of objects pictured on aerial photographs. Once a representative set of stereograms has been compiled, the interpreter can easily organize the material into a formalized selective or elimination key. Vertical, oblique, or terrestrial photographs can be used for stereograms; in some cases, two or more views may be combined in the same illustration (Figure 4-1).

One can make stereograms by cutting out left-hand and right-hand views from overlapping photographs and mounting them in correct orientation on heavy card stock. Aerial stereograms are preferably prepared from single-weight, glossy prints. For maximum utility, all features in a given category (e.g., tree species, landforms, industries) should be pictured on prints of the same scale, made from the same film type and in the same season. When a set of stereogram cards have been indexed by subject and geographic region, they can be valuable for training purposes and for identifying similar features on subsequent aerial surveys.

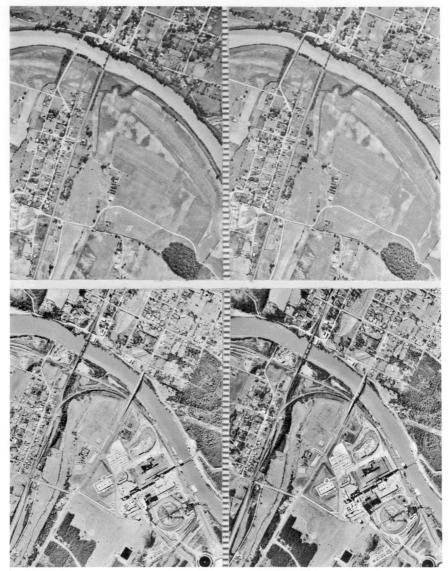

Figure 4-1. Comparative vertical stereograms illustrating land-use changes in the vicinity of Calhoun, Tennessee. The top view was made in 1937; the lower view was made in 1967. Scale is approximately 1:24,000. Courtesy Tennessee Valley Authority.

The following step-by-step procedure has been found useful in the preparation of aerial stereograms from contact prints of 23 by 23 cm:

- 1. Determine the geographic locale of the prints from maps or photo index sheets; record all photographic data that might be lost after prints are trimmed. Then, clean all print surfaces thoroughly.
- 2. Locate principal points and conjugate principal points; pinpoint with fine needle holes.
- 3. Draw in flight lines for the overlapping pair; use a sharpened chinamarking pencil or a soft lead pencil so that the lines may be easily removed later. Measure and record the average photo base length.

- 4. Delineate the desired view within a space about 5.5 cm wide as measured along the flight line. Enclose this view with parallel lines drawn exactly at right angles to the flight line (Figure 4-2). Transfer the identical view to the overlapping print by using a stereoscope. Draw these lines with a hard pencil so as to indent the emulsion surface.
- 5. Orient prints with shadows falling toward observer; then mark the delineated portions to be cut as left (L) or right (R).
- 6. Recheck all items (steps 1 through 5). Be sure you have recorded the following data before cutting out views:
 - a. Locality—county, state, etc.
 - b. Project symbol, roll and exposure numbers
 - c. Print scale
 - d. Date and time of photography
 - e. Average photo base length
 - f. Camera focal length
 - g. Agency responsible for photography, such as U.S. Department of Agriculture
- 7. Cut out the two views on a sharp paper cutter and align flight line (be sure to check left and right notations). Tape the two views about 1.5 to 2 mm apart by using a strip of transparent tape on underside. Check stereoscopic fusion and alignment with a lens stereoscope.
- 8. Trim the stereopair in height to fit a standardized format such as a card reference file. Mount on card with rubber cement or gum arabic and record data from step 6 on the back of the card.

Ground stereo cameras

Ground stereophotography is most easily accomplished by means of a dual-lens stereo camera equipped with negative film. However, stereo cameras are produced by only a few manufacturers around the world. Those most recently marketed in North America have a 35-mm film format, while a model made in the U.S.S.R. uses number 120 (about 70-mm) roll film. Focal lengths of the paired lenses are usually about 30 to 40 mm for the 35-mm cameras and about 50 to 75 mm for the larger-format cameras.

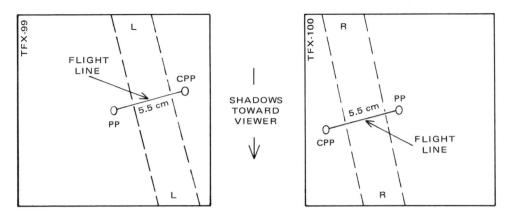

Figure 4–2. Method of delineating stereogram cutouts on prints of 23 by 23 cm. The 5.5-cm viewing width may be varied slightly, provided it does not exceed the observer's interpupillary distance.

A typical stereo camera has two lenses of identical focal length arranged on parallel axes and separated by an "average observer's" interocular distance, i.e., by about 65 mm. This arrangement is based on the theory that the ideal condition for orthostereoscopy requires a separation of camera lenses and stereo viewing lenses that is identical to the observer's interpupillary distance. If stereograms are made with the camera focused at infinity, the focal length of the stereoscopic viewing lenses should also be the same as the focal length of the camera lenses. All these conditions are seldom achieved, but slight departures are discernible only to the most critical observers.

Improvised stereo cameras

When stereo cameras are not available, one can make three-dimensional photographs by (1) mounting two identical cameras together on a planetable or level tripod and equipping them for simultaneous shutter release or (2) using a single camera to make two separate pictures from paired exposure stations.

In either case, it is essential that both photographs of a stereopair have the same base line; this condition is met only when the cameras are level in a lateral direction. If a camera is tilted laterally, each view might be trimmed separately so that vertical lines of the scene are vertical in the picture, but each then has a different base line. For this reason, cameras should be mounted in a frame or on a base that can be precisely leveled. Furthermore, the axes of the lenses must be exactly parallel; either convergence or divergence will introduce a distortion of parallax, resulting in difficult stereoscopic fusion and/or observer eyestrain.

Single-lens or twin-lens reflex cameras with a 70-mm film format are ideal for ground stereophotography, for the resulting overlap zone of 55 to 65 mm provides an optimum image separation for viewing with lens stereoscopes. The views in Figure 4-3 were made with two twin-lens reflex cameras mounted together on a common base and equipped with a dual cable release for the shutters. In these stereograms, an increase in the lens separation to about 15 cm for the upper view and about 30 cm for the lower view greatly exaggerated the three-dimensional effect.

Ground stereograms from single cameras

Ground stereograms can be made with a single camera when the scene being imaged remains stationary for the required interval between exposures, i.e., for several seconds. Objects in the overlap area that move between exposures (clouds, autos, windblown foliage) will not form satisfactory three-dimensional images, because their motion creates artificial parallax.

The basic geometry of overlapping views obtained with a single camera is illustrated by Figure 4-4. As previously outlined, care must be exercised to maintain a level, straight base line and absolute parallelism of lens axes. A level plane-table thus provides an ideal camera platform. The addition of a box-type slide (for parallel movement of the camera between left and right exposures) and a graduated scale (for controlling the camera base length) completes the apparatus.

The three-dimensional effect (parallax) of a given scene will be heightened if the camera base length is increased, i.e., if the amount of overlap is

Figure 4-3. Ground stereograms of Forest Research Institute, Rotorua, New Zealand (above), and a residence in Freiburg, West Germany (below). Views were made simultaneously with two Zeiss Super Ikonta cameras.

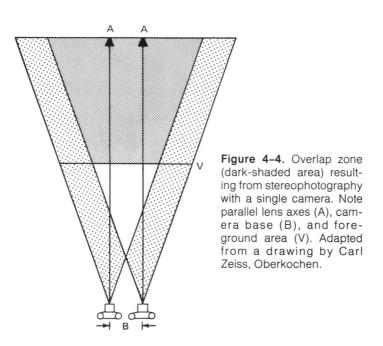

decreased. For objects of limited relief, the recommended base is about onetenth the distance to the foreground; with scenes of pronounced relief (e.g., landscapes), a base of about one-twentieth of the distance to the foreground is likely to produce better results. For any given camera and subject, of course, the optimum base length is best obtained by experimentation.

As exposures are made, notes should be taken on whether left-hand or right-hand exposures were taken first on the film roll. The resulting pairs of prints should be mounted so that images are correctly separated for the stereoscope being used. To avoid troublesome y-parallax (vertical parallax), the two views should also be aligned so that corresponding images are at an identical distance from the upper or lower edge of the card mount. Ground stereograms are especially useful for supplementing vertical (aerial) stereograms in photo interpretation keys and training exercises.

Systematic filing of stereograms and aerial imagery

Organizations that accumulate large files of annotated stereograms may experience difficulty in locating reference illustrations on short notice. In many cases, the mounting of these stereograms on standard edge-punched cards provides a solution to the problem of filing, indexing, and relocating selected aerial views. Stereogram cards may be numerically coded according to subject matter, geographic region, scale, season, date of photography, type of film, or other classifications. Once coded and notched, all cards in a particular category can be retrieved through a simple system of mechanical sorting with a wire needle. Fifty to a hundred cards can be handled per sort, and the system is well suited for stereogram files containing random mixtures of several hundred reference cards.

Stock cards may be purchased in several standard sizes from office supply houses. Various digital arrangements are available, and special "fields" or code groupings can be printed directly on the cards. A complete coding and indexing system is outlined in an article by the author (see references).

The most promising solution for the systematic filing and retrieval of aerial imagery appears to be miniaturization. It is technically feasible to copy 23-by-23-cm film frames onto microfilm or microfiche and still recover most of the image detail when the smaller frames are enlarged back to the original negative size. One approach is exemplified by the Recordak microfilm system developed some years ago (Figure 4-5). Although this particular format has not been widely adopted, various elements of such automated image storage and retrieval systems are used in many film libraries and repositories.

Shadow method of height determination

It has been previously shown that the heights of objects pictured on aerial photographs can be determined from image displacement on single prints or by measurement of parallax differences on stereopairs. Under rather specialized conditions, heights may also be computed from measurements of shadow lengths. First, objects must be vertical, i.e., perpendicular to the earth's surface; second, shadows must be cast from the true tips rather than from the sides of objects; and third, shadows must fall on open, level ground where they are undistorted and easily measured (Figure 4-6).

/	ROLL	FRAME	DATE	TOD	SCALE	COUNTY	STATE
$\overline{}$,		10 1441 47	1200	1.104		D.C

THE **FRECORDAK** AIR-PHOTO MICROFILM SYSTEM with <u>New</u> recordak direct duplicating film

introduced at the ASP—ACSM Convention Washington, D.C.

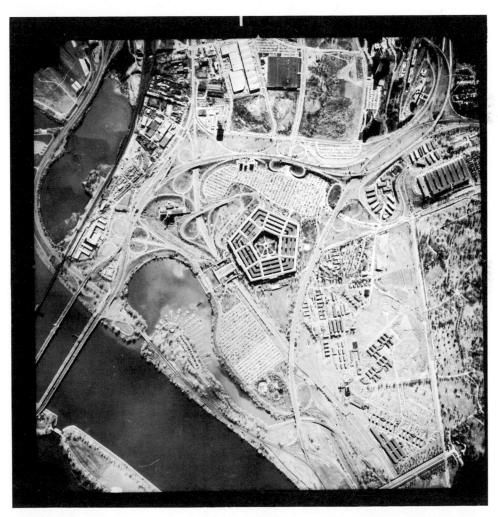

Figure 4–5. Airphoto microfilm system, with the smaller film frame incorporated into a standard, machine-sort data card. The aerial photograph of the Pentagon in Washington, D.C., was produced directly from the microfilm. Courtesy Eastman Kodak Company.

Because of the great distance between the sun and the earth, the rays of the sun are essentially parallel throughout the small area shown on a vertical aerial photograph. Thus, at any given moment the length of an object's shadow will be directly proportional to its height. Figure 4-7 illustrates the trigonometric relationship involved in determining object heights from shadow measurements. Angle a in this diagram is referred to as the angular elevation of the sun; the tangent of this angle multiplied by the shadow length provides a measure of object height. Therefore, the basic problem is the determination of the true value of angle a. The sun's elevation cannot be measured directly, because it changes every hour of every day throughout the year. On the other hand, it may be easily computed if sharply defined objects of known height can be found on the photographs. For example, if a radio antenna known to be exactly 100 m tall casts a shadow 75 m long on level ground, the tangent of angle a can be found through transposition of the equation in Figure 4-7:

$$\tan a = \frac{\text{Height of object}}{\text{Shadow length}} = \frac{100}{75} = 1.333$$

Other shadows can then be measured on the same stereopair and their lengths multiplied by 1.333 to give the heights of corresponding objects. For accurate results, shadows should be carefully measured to the nearest 0.1 mm or less. This can be done with special micrometer devices or magnifying monoculars.

Other things being equal, the precision of shadow-height measurements is highly dependent on the scale of photography; i.e., precision improves with larger scales because of more accurate shadow measurements. An added complication is that of determining the point from which the shadow is cast by a tall object. This problem is illustrated by a comparison of various types of shadows, as shown in Figure 4-8.

Computing the sun's angular elevation

The foregoing technique of determining the angular elevation of the sun works well where the heights of one or two objects are known or can easily be checked. When this method of computation is not feasible, however, the sun's elevation can be calculated by a more complex procedure requiring the use of special astronomical tables, i.e., a solar ephemeris. Such tables may be obtained from manufacturers of surveying equipment, from military installations, or from astronomical observatories.

Basic information needed is (1) month and day of photography, (2) time of photography (the nearest hour), (3) latitude and longitude of photography, and (4) exact scale of photography. The angular elevation of the sun (angle a in Figure 4-7) is determined from this equation:

$$\sin a = (\cos x) (\cos y) (\cos z) \pm (\sin x) (\sin y)$$

where: angle x is the sun's declination or latitude on the day of photography, corrected to Zulu Time (GMT) and read from a solar ephemeris,

angle y is the latitude of photography,

angle z is the hour angle, or the difference in longitude between the position of the sun and the locality of photography

The algebraic sign in the equation is plus from March 21 through September 23 and minus from September 24 through March 20 in the Northern Hemisphere; signs are reversed for the Southern Hemisphere. When the sine of angle a has been found, the angle itself is read from a table of trigonometric functions; then the tangent is determined for use in shadow-height conversions. To simplify solution of the equation, special computing forms have been developed by Johnson (1954). The technique is also detailed in the military Image Interpretation Handbook (1967).

For reliable height measurements, new values for angle a should be computed for each hour of the day, for each day of photography, and for significant changes in the geographic location of photography. Although most interpreters prefer to use the parallax method of height determination, the shadow technique furnishes a valuable alternative when stereopairs of photographs are not available.

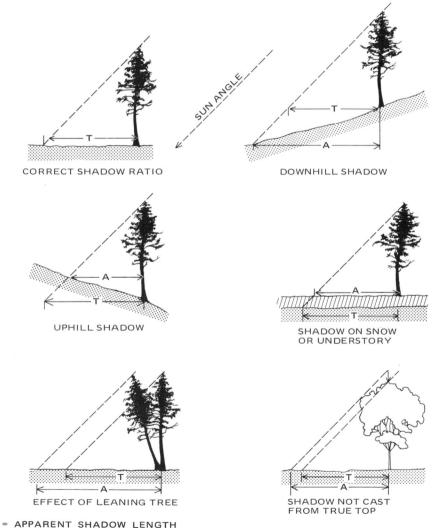

T = TRUE SHADOW LENGTH

Figure 4-6. Illustration of various factors affecting the length of shadows cast by trees or similar objects.

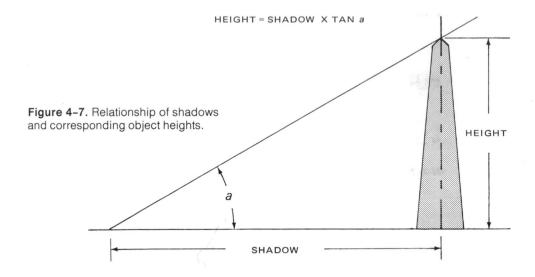

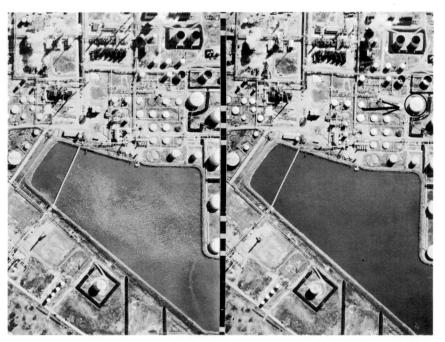

Figure 4-8. Stereogram of an oil refinery in the midwestern United States. Scale is about 1:7,920. Compare shadows of cylindrical tanks to those cast by tall smoke-stacks.

Object counts

In certain photo interpretation activities, the ability to distinguish and count individual objects is of prime importance. Automobiles may be counted in traffic studies, trees in forest inventories, or ships and tanks in military operations. As a rule, man-made objects having some degree of uniformity (e.g., telephone poles) are more easily counted than natural features of the same size (e.g., dense stands of trees). The principal factors affecting counting accuracy are:

Size and shape of objects
Scale and resolution of photography
Spatial arrangements of objects
Tonal contrasts between objects and associated backgrounds
Type of image material (e.g., transparencies versus prints)
Type of film emulsion (e.g., black-and-white versus color)
Use of stereopairs versus single frames for making counts

In Figure 4-9, for example, individual railroad crossties and highway pavement cracks could be distinguished on the original prints of stereograms B and C. Where large numbers of objects are closely spaced, counts are commonly made on sample plots of predetermined size. Plot tallies are then expanded on the basis of the total area involved.

Compass bearings

Vertical and near-vertical photographs present reliable records of angles; therefore, compass bearings or azimuths may be measured directly on prints with a simple protractor (Figure 4-10). Flight lines usually run north-south or east-west, but the edges of prints are rarely oriented exactly with the cardinal directions. For this reason, a line of true direction must be established before bearings can be accurately measured. Such reference lines can be plotted from existing maps or located directly on the ground by determination of the bearing of any straight-line feature.

In Figure 4-11, the highway at the top of the print was established as a due north-south reference line. To determine the bearing of the buried pipeline (in direction of arrow), the included angle was measured with a protractor as 29°. Thus, the pipeline bears 29° east of due south. Expressed more conventionally, it has a bearing of S 29° E or an azimuth of $180^{\circ} - 29^{\circ} = 151^{\circ}$.

A quick indication of compass direction on aerial photographs can also be obtained from imagery over airports. Runways are numbered according to their magnetic compass direction (azimuth); the compass heading is determined to the nearest 10 degrees, and the zero is dropped. Thus, in Figure 4-12, the runways have magnetic azimuths of approximately 160°, 220°, and 280°. At their opposite ends, these same runways would carry the numbers 34, 04, and 10, respectively. Where the local magnetic declination is known, lines of true compass direction may be approximated from runway numbers.

Area measurements

Areas and distances are preferably measured on reliable base maps when accurate results are essential. On the other hand, reasonably precise area estimates can be made directly on contact prints in regions of level to gently

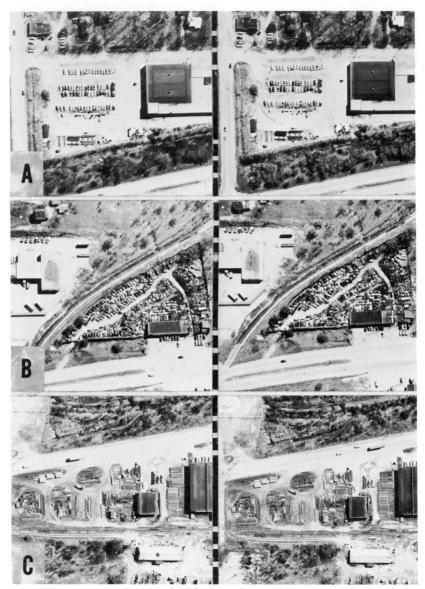

Figure 4-9. Three stereograms showing the effect of object size, shape, and arrangement on an interpreter's ability to count individual items. Automobiles in a parking lot are pictured at A, wrecked cars at B, and various stacks of structural materials at C. Scale is about 1:6,000. Courtesy Abrams Aerial Survey Corp.

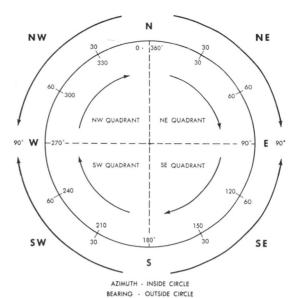

Figure 4–10. Relationship of compass bearings and azimuths. Courtesy U.S. Department of the Army.

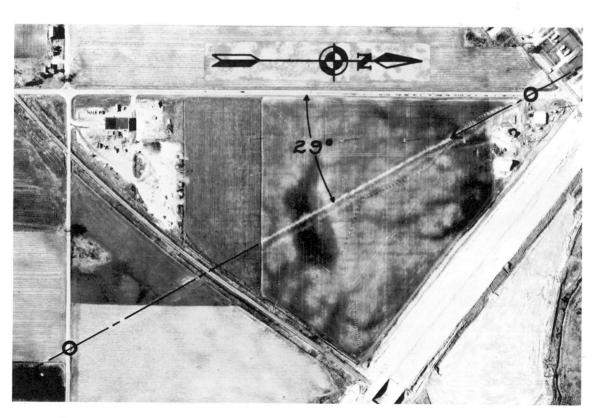

Figure 4-11. Measurement of the compass bearing of a buried pipeline. Scale is about 1:6,000. Courtesy Abrams Aerial Survey Corp.

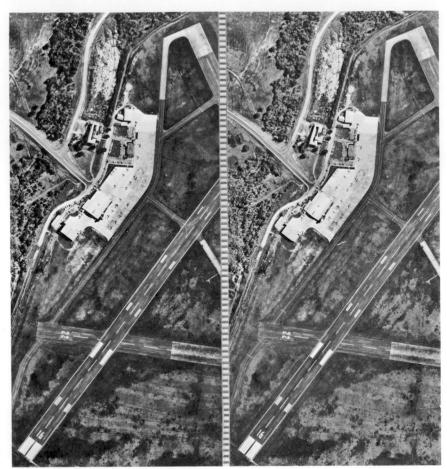

Figure 4–12. Airport runways are numbered according to their magnetic compass direction. Shown here are runways 16, 22, and 28. Photo scale is about 1:10,000. Courtesy Texas Forest Service.

rolling topography. The reliability of such estimates is dependent on the precision with which photo scales and area conversion factors are determined. Where topographic changes exceed 100 m or so, large errors will be incurred unless new conversions are computed for each significant variation in land elevation. This point may be verified by an inspection of the area conversions previously listed in *Table 3-1*. The principal devices used for area measurement are dot grids, polar planimeters, and transects.

Dot grids

Dot grids are transparent overlays with dots systematically arranged on a grid pattern (Figure 4-13). Thus, dot grids and graphical methods of area determination are based on the same principle; dots representing squares or rectangular areas are merely counted in lieu of the squares themselves. The principal gain enjoyed is that fractional squares along tract boundaries are less troublesome, for the nondimensional dot determines whether or not the square is to be tallied. If an area is mapped at a scale of 100 m/cm, this is equivalent to $10,000 \, \text{m}^2/\text{cm}^2$, or $1 \, \text{ha/cm}^2$. Thus, on a grid having four dots per

Figure 4-13. Dot grid with approximately ten dots per square centimetre (sixty-four dots per square inch).

square centimetre, each dot will represent 0.25 ha. The simple conversion is represented by this relationship:

$$\frac{Number of ha/cm^2}{Number of dots/cm^2} = ha/dot$$

The number of dots to be counted depends on the grid intensity, the map or photo scale, the size of area involved, and the desired precision. Grids in common use may have from four to more than a hundred dots per square centimetre. For tracts of 500 to 1,000 ha, it is generally desirable to use a dot-sampling intensity that will result in a conversion of about 0.2 to 1.0 ha/dot.

Greater precision may be attained by derivation of an average dot count based on several random drops of a grid over the same area. Each unbiased drop of the systematic grid may be regarded as a simple random sample of one; thus ten random drops would provide n-1, or 9, degrees of freedom for purposes of calculating the statistical precision of the area estimate.

Planimeters

A planimeter is composed of three basic parts—a weighted polar arm of fixed length, a tracer arm hinged on the unweighted end of the polar arm, and a rolling wheel that rests on the map and to which is attached a vernier scale.

In use, the pointer of the instrument is run around the boundaries of an area in a *clockwise* direction; usually, the perimeter is traced two or three times for an average reading. From the vernier scale, the area in square centimetres (or other units) is read directly and converted to the desired area units on the basis of map or photo scale (*Table 4-1*). Prolonged use of the planimeter is tedious, and a steady hand is essential for tracing irregular boundaries.

It is often useful to check planimeter estimates of area by comparisons with dot grid estimates, and vice versa. Relative accuracy of the two methods can be compared through the measurement of a few tracts of known area. Since individual preferences vary, it may also be informative to compare the time required for alternative estimation techniques. In the hands of skilled persons, dot grids and planimeters are generally regarded as devices of comparable precision.

Table 4-1. Conversions for Several Units of Area Measurement

Square feet	Square chains	Acres	Square miles	Square metres	Hectares	Square kilometres
4,356 43,560 27,878,400 107,638.7 10,763,867	1 10 6,400 24.7104 2,471.04	0.1 1 640 2.47104 247.104	0.000156 0.0015625 1 0.003861 0.386101	404.687 4,064.87 2,589,998 10,000 1,000,000	0.040469 0.404687 258.9998 1	0.000405 0.004047 2.589998 0.01

Transects

The transect method is essentially a technique for proportioning a known area among various types of land classifications, such as forests, cultivated fields, and urban uses. A graduated scale is aligned on the photos so as to cross topography and drainage at right angles. The length of each type along the scale is recorded to the nearest desired unit, e.g., 5 mm. The interpreter develops proportions by relating the total measure of a given classification to the total linear distance. For example, if ten equally spaced, parallel lines 15 units long are tallied on a given photograph, the total transect length is 150 units. If woodlands are intercepted for a total measure of 30 units, this particular type classification would be assigned an area equivalent to 30/150, or one-fifth of the total area. The transect method is simple and requires a minimum of equipment. For deriving area proportions on photo index sheets, special transparent overlays can be improvised for location of transect lines.

Problems

1. Prepare several aerial stereograms to illustrate a particular subject category or a variety of terrain features. The checklist presented here may be used to evaluate the quality of these stereograms.

Charifications shouldist		Stereogra	m numbe	r
Specifications checklist	1	2	3	4
Subject properly centered				
Views properly cut out				
Left and right orientation correct				
Shadow orientation correct				
Image separation distance				
Vertical alignment (y-parallax)				
Quality of mounting, etc.				
Quality of lettering or inking				
Adequacy of title data				
Overall appearance and utility			,	

- 2. Devise and test your own camera system for making ground stereograms. Then obtain at least four ground stereograms to supplement existing aerial stereograms in your files. Explain how you determined the ideal ratio between camera base and distance to subject foreground.
- 3. Obtain several overlapping photographs of an accessible local area. By ground measurement of two or more tall objects whose shadows fall on level ground, compute an average value for the tangent of the angular elevation of the sun.

Description of object	Object height	Shadow length	tan a
	<u> </u>		

Average value _

- 4. Use the ratio derived from ground measurements in problem 3 to estimate the heights of several other objects from their shadow lengths.
- 5. Compute the angular elevation of the sun by the equation method outlined in this chapter. Compare the value derived for the tangent of angle a with that obtained from field measurements. Discuss advantages and disadvantages of the two methods of calculation for use in shadow-height determinations.
- 6. Using your own photographs, select several land parcels of irregular shape and determine their areas by using both a planimeter and an appropriate dot grid. Record results in the table below and compare differences obtained.

Description of area	Area by planim- eter (average of three readings)	Area by dot grid (based on three random drops)	Difference in area

References

- Anonymous. 1957. The needle sort instruction manual. Business Forms, West Hartford, Conn. 14 pp., illus.
- Avery, T. E. 1967. All sorts of stereograms. Photogrammetric Engineering 33:1397—1401, illus.
- Barrett, James P., and James S. Philbrook. 1970. Dot grid area estimates: Precision by repeated trials. *Journal of Forestry* 68:149–51, illus.
- Chester, G. S. 1965. A method of preparing an edge-punched card literature reference file. Forestry Chronicle 41(2):207–14, illus.
- Cravat, Harland R., and Raymond Glaser. 1971. Color aerial stereograms of selected coastal areas of the United States. U.S. Department of Commerce, Government Printing Office, Washington, D.C. 93 pp., illus.
- Johnson, Evert W. 1954. "Shadow-height" computations made easier. Journal of Forestry 52:438-42, illus.
- Singh, R. S., and J. P. Scherz. 1974. A catalog system for remote-sensing data. *Photogrammetric Engineering* 40:709–20, illus.
- U.S. Departments of the Army, the Navy, and the Air Force. 1967. Image interpretation handbook, Vol. I. Government Printing Office, Washington, D.C. 7 chapters plus appendix, illus.

Chapter 5

Flight Planning

Contract aerial photography

Although many persons rely largely on existing aerial photographs for interpretation and mapping, such coverage may be unsuitable because of age, season, film-filter combination, or scale. As a result, there is considerable interest in the purchase of special-purpose photography contracted through aerial survey firms. And, even though a commercial firm may have the technical expertise to handle almost any type of photographic mission, the interpreter may still be responsible for defining project objectives, drawing up preliminary specifications or flight plans, estimating costs, and determining whether the finished product meets interpretation requirements.

In return for an investment that may amount to many thousands of dollars, the resource manager or land planner expects to receive high-quality imagery that is uniquely suited to particular interpretation needs. To achieve this goal, the interpreter must define the exact project objectives, become familiar with photographic specifications and contracts, and negotiate only with reputable aerial survey companies. Without the interpreter's close

attention to these considerations, special-purpose flights are unlikely to prove cost-effective.

Names and addresses of aerial survey companies can be obtained locally through consulting engineers, city managers, or interpretation specialists at various universities. Addresses and activities of many companies in Anglo-America are also described annually in a yearbook issue of *Photogrammetric Engineering and Remote Sensing*. In choosing among several prospective companies, the purchaser is advised to request photographic samples from each; such image samples provide useful guides to the quality of work that may be expected.

Purchasers who feel unqualified to evaluate sample photography should retain the services of a special consultant to assist in drawing up photographic specifications, defining areas to be covered, and inspecting the completed imagery. All contract specifications and special requirements should be thoroughly discussed by buyer and contractor prior to actual flights. A few extra days of advance planning will sometimes alleviate the need for reflights and help prevent disputes arising from definitions of stereoscopic coverage, exposure quality, image contrast, or film-processing deficiencies. Aerial photographs that fail to supply the quantity and quality of information desired cannot be considered inexpensive by any standard.

Flight altitudes and focal lengths

The range of photographic scales available is defined by the operating ceilings of available aircraft and the various camera focal lengths that are employed. For most nonmilitary photography, upper altitudinal limits might be regarded as around 20,000 m (65,000 ft) above MSL, a level that can be achieved by such planes as the U-2 (Figure 5-1). For fixed-wing aircraft, the lower limit might be arbitrarily defined as around 300 m (1,000 ft) above ground, depending on topography, special hazards, and air safety regulations.

Aerial survey cameras are manufactured in a wide array of focal lengths and film formats. For example, in the standard 23-by-23-cm negative format, Zeiss mapping cameras are available with the following focal lengths:

Camera focal length, in millimetres	Maximum angular field, in degrees	Ground coverage at 1,000 m above ground, in square kilometres
85	125	7.32
153	93	2.27
210	75	1.20
305	56	0.57
610	30	0.14

If we now match the shortest focal length with the upper aircraft ceiling, and vice versa, the range of photographic scales available (allowing for terrain elevations of up to 3,000 m) might be computed as follows:

Figure 5-1. The U-2 high-altitude research plane. Courtesy Lockheed Aircraft Corp.

RF =
$$\frac{0.085}{20,000 - 3,000} = \frac{1}{200,000}$$
 or 1:200,000
RF = $\frac{0.610}{300} = \frac{1}{492}$ or 1:500

In practice, the range of scales actually employed is usually somewhat less, namely, from about 1:1,000 to 1:125,000. Where simultaneous coverage at two different scales is desired, certain aircraft can be fitted with two or more aerial cameras (Figure 5-2).

Area coverage and relative costs

Camera focal length is a critical contract specification because it determines the aircraft altitude that must be maintained in order for exposures of the desired scale to be obtained. Also, its direct effect on the image displacement of objects photographed controls the degree of three-dimensional exaggeration that the interpreter sees when viewing the exposures stereoscopically. Selecting an optimum scale/focal length combination is therefore an item of direct interest to the image interpreter.

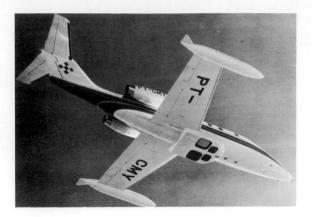

Figure 5-2. Dual aerial camera installation in a jet aircraft. Courtesy Gates Learjet, Inc.

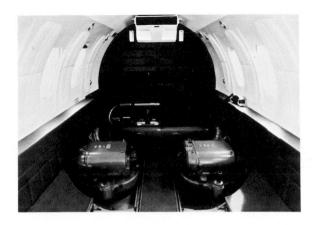

It is generally desirable to specify the smallest photo scale that will meet the requirements of a given project; this approach not only tends to lower costs but also reduces the number of stereo models that must be handled by interpreters. When a photographic scale is doubled, as from 1:20,000 to 1:10,000, approximately four times as many exposures will be required to cover the same area. Consequently, photographic scale and tract size are two of the principal factors affecting the cost of special aerial surveys.

Costs of contract aerial photography are also affected by such considerations as the required timing (season and sun angle) for flights, film-filter specifications, accessibility of the project area, prevailing weather conditions, and fluctuations in the business activities of aerial mapping companies. Since any quotation must reflect a set of fixed conditions, it is not surprising that there have been few published accounts of photographic prices.

Table 5-1 lists the approximate number of exposures required for several photographic scales and tract sizes; it also includes relative cost indexes for black-and-white photography. Although these ratios are based on information from reputable aerial survey companies, they are merely averages that will not apply in all situations. It should be emphasized that the index numbers are relative values only and not actual prices. For example, the cost index value in the first cell of the table (25 km² @ 1:5,000) is taken as unity (1.00) and all other cost estimates would be relative to this value. Average distances between airports and project areas are assumed; the prices for

Table 5-1. Approximate Number of Exposures Required and Relative Costs for Stereoscopic Coverage*

Size	Ne	egative scale: 23	-by-23-cm forma	nt
of area, in	1:5,000	1:10,000	1:20,000	1:40,000
square kilometres	Numb	er of exposures	and cost index v	alues
25	70	18	5	2
	1.00	<u>0.85</u>	0.80	0.70
50	139	36	9	3
	1.60	0.90	0.88	0.80
100	278	71	18	5
	2.60	<u>1.00</u>	<u>0.90</u>	0.83
500	1,389	353	89	23
	8.00	3.20	1.00	0.90
1,000	2,778	705	177	45
	19.50	7.50	2.90	1.30
5,000	13,889	3,522	881	221
	60.00	24.30	10.00	3.90
km²/photo	0.36	1.42	5.68	22.72

^{*}Assumes an effective area of about 142 cm² per exposure. The first value represents the number of exposures required; for each flight line planned, four exposures should be added to the numbers indicated. The second number represents a relative cost index for two sets of black-and-white prints and one set of photo index sheets.

photographic coverage of small tracts may be influenced more by the cost of moving the plane and crew than by the actual flying time involved.

It is worthy of mention that commercial firms prefer to sell a complete "package" of photography, ground control, and finished planimetric or topographic maps instead of merely supplying aerial imagery. Furthermore, there is a trend toward negotiation of contracts and prices in lieu of the "lowest-bidder" approach.

Season of photography

The optimum season for scheduling photographic flights depends on the nature of features to be identified or mapped, the film to be used, the number of days suitable for aerial photography within a given period, and the minimum sun angle or subject illumination required.

Since optimum weather conditions may not prevail during the season when photography is desired, it may be necessary to ascertain the average number of "photographic days" for a locality during each month of the year. A photographic day is defined as one with 10 percent cloud cover or less; this kind of information may be obtained from periodic reports issued by local weather services. Other factors being equal, aerial surveys are likely to be less expensive in areas where sunny, clear days predominate during the desired photographic season.

Another consideration in selecting the season for aerial photography is the project objective, i.e., the specific information to be extracted from the

photographs. On the basis of generally divergent objectives, users of aerial photographs may be arbitrarily divided into two main groups—those engaged in topographic mapping, urban planning, or evaluation of terrain features and those primarily concerned with assessment of vegetation or management of wildland areas. The first group, typified by cartographers, civil engineers, and geologists, would be likely to schedule photography during seasons when tree foliage does not obscure the landscape. By contrast, persons in the second category tend to prefer photographs made during the growing season, when the vegetative cover is fully developed. This second group would include foresters, plant ecologists, and range managers.

For topographic mapping, photography is usually taken either in the spring or the fall, when deciduous vegetation is absent and the ground is essentially free of snow cover. Only during these periods can terrain features be adequately distinguished and contours precisely delineated. As differences in vegetation are rarely of significance, mapping photographs are commonly made on panchromatic film. Similar coverage would be specified by geologists interested in stratigraphic mapping and by engineers concerned with proposed highway routes. Although summer photography may suffice in an emergency, dense canopies of foliage greatly inhibit the efficient evaluation of ground detail, thereby increasing total project costs.

Interpreters interested in vegetation analyses will ordinarily specify aerial photography made during the growing season, particularly when deciduous plants constitute an important component of the vegetative cover. When it is essential that deciduous trees, evergreens, and mixtures of the two groups be delineated, either infrared black-and-white or infrared color film is frequently specified. In regions where evergreen plants predominate, however, panchromatic film or conventional color film may be used with equal success.

Several research projects involving black-and-white photography of forest areas have indicated that the best timing for infrared coverage is from midspring to early summer—after all trees have produced some foliage but prior to maximum leaf pigmentation. Successful panchromatic photographs of timberlands can be made throughout the year, but in the northern United States, and in Canada, the best results have been obtained in late fall—just before deciduous tree species such as aspen or tamarack shed their leaves. For a brief period of perhaps two weeks' duration, foliage color differences will provide good photographic contrasts between most of the important timber species in this region.

Time of day

Time of day is an important contract specification, because the angle at which the sun strikes the earth's surface affects not only the quantity of light being reflected to the aerial camera but also the spectral quality of light. In clear weather, for example, solar illumination depends on latitude (it drops off as latitude increases), season of the year, and hours before or after local apparent noon. Since heavily vegetated lands are poor light reflectors, they should usually be photographed within two hours of local apparent noon. This is especially important when color films are exposed. It will be noted that solar altitude is one of the prime factors incorporated into the Kodak Aerial Exposure Computer (see Chapter 1).

A detrimental consequence of selecting the wrong season/time-of-day combination is a phenomenon known as hotspot or sunspot. A loss of photographic detail results when a straight line from the sun through the camera lens intersects the terrain inside the area of photo coverage. At the center of the hotspot is a no-shadow point caused by the direct return of light rays to the camera lens; the effect is a washed-out (overexposed) circular area of perhaps 2 or 3 cm in diameter where all image detail is essentially lost. Hotspot is most likely to occur with high sun angles, at lower latitudes, and with wide-angle camera lenses. After the season and latitude of photography have been determined, it is possible to calculate (and thus avoid) those midday hours when hotspots will be present.

As a general rule, photographic flights in the temperate zones of the world should be scheduled within two to three hours of local apparent noon, provided hotspots can be avoided. This timing assures maximum subject illumination and helps avoid the troublesome effect of long object shadows.

Summary recommendations

Table 5-2 has been prepared to supply a set of guidelines for aerial surveys. These generalized recommendations are based on published reports of varied photo interpretation projects; therefore, they will sometimes reflect the types of coverage that were available rather than optimum specifications. And since individual project objectives will vary from one locality to another, other combinations of films, seasons, and scales may be equally suitable.

The reader is reminded that simultaneous coverage with two or more films often provides superior results to those achieved with any single sensitized material. When the winter season is specified in the table, the absence of snow cover is presumed. And wherever the added cost can be justified, color photography may prove advantageous over black-and-white.

Technical specifications for aerial photography

When the decision to purchase new photography has been made, technical specifications are usually summarized in a formal contract. Such agreements assume a variety of forms, but most of the following items are covered to some degree. Readers interested in additional contract details should refer to sample specifications prepared by various state and federal agencies.

Business arrangements. These include such items as the cost of the aerial survey, the posting of a performance bond, the assumption of risks and damages, a provision for periodic inspection of work, reflights, cancellation privileges, schedules for delivery and payments, and ownership and storage of negatives.

Area to be photographed. Includes tract location, size, and boundaries. These are ordinarily indicated on flight maps supplied by the purchaser.

Type of photographic film and filter. Such items as film emulsion number, exposure rating, and dimensional stability of the film base may be specified.

Negative scale. Maximum scale deviation normally allowed is ±5 percent. The aerial camera. A certified calibration report may be required. Other camera specifications include size of negative format, method of flattening

Table 5-2. Guidelines for Aerial Surveys

Description of task	Film type	Season	Scale
Forest mapping: conifers	Pan	Fall, winter	1:12,000-1:20,000
Forest mapping: mixed stands	IR	Late spring, fall	1:10,000-1:12,000
Timber volume estimates	Pan or IR	Spring, fall	1:5,000-1:20,000
Location of property boundaries	Pan	Late fall, winter	1:10,000-1:25,000
Measurement of areas	Pan	Late fall, winter	All scales
Topographic mapping; highway surveys	Pan	Late fall, winter	1:5,000-1:10,000
Urban planning	Pan	Late fall, winter	1:5,000-1:10,000
Automobile traffic studies	Pan	All seasons	1:2,500-1:6,000
Surveys of wetlands or tidal regions	IR	All seasons—low tide	1:5,000-1:30,000
Archeological explorations	IR	Fall, winter	1:2,500-1:20,000
Identification of tree species	Color	Spring, summer	1:600-1:5,000
Assessment of insect damages	IR color	Spring, summer	1:600-1:5,000
Assessment of plant diseases	IR color	Spring, summer	1:1,000–1:8,000
Assessment of water resources and pollution	Multispectral	All seasons	1:5,000–1:8,000
Agricultural soil surveys	Color	Spring or fall, after plowing	1:4,000–1:8,000
Mapping of range vegetation	Color	Summer	1:600–1:2,500
Real estate assessment	Color-negative Color-negative Color-negative Color-negative	Late fall, winter	1:5,000–1:12,000
Assessment of industrial stockpile inve		All seasons	1:1,000–1:5,000
Recreational surveys		Late fall, winter	1:5,000–1:12,000
Land-cover mapping		Spring, summer	1:20,000–1:100,000

Adapted from Avery (1970).

film during exposure, type of shutter, focal length, distortion characteristics of lens, and resolving power (Figures 5-3 and 5-4).

Position of flight lines. Lines should be parallel, oriented in correct compass direction, and within a stated distance from positions drawn on flight maps. Lines are usually run north-south or east-west, roughly parallel to the long dimension of the tract.

Overlap. Overlap is usually set at 55 to 65 percent (averaging 60 percent) along the line of flight and 15 to 45 percent (averaging 20 to 30 percent) be-

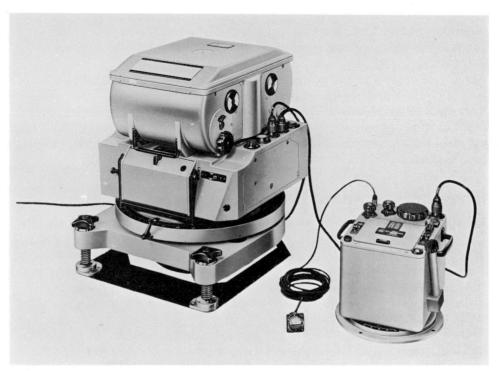

Figure 5-3. Zeiss RMK-A-15/23 aerial camera. Focal length is 15 cm, and negative size is 23 x 23 cm. Courtesy Carl Zeiss, Oberkochen.

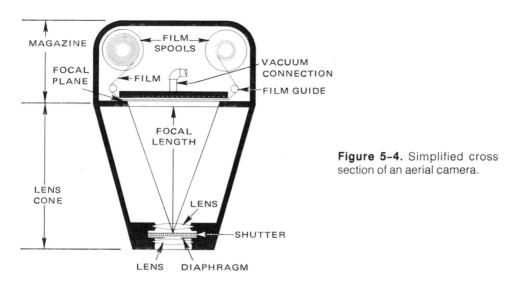

tween adjacent lines. At the ends of each flight line, two photo centers should fall outside the tract boundary.

Print alignment. Crab or drift should not affect more than 10 percent of the print width for any three consecutive photographs.

Tilt. Tilt should not exceed 2° or 3° for a single exposure nor average more than 1° for the entire project.

Time of photography. Both season of year and time of day (or minimum sun angle) are usually specified.

Base maps. If base maps or radial line plots are required, the responsibility for ground control (field surveying) should be established.

Film processing. Included here are procedures for developing and drying of negatives, indexing and editing of film rolls, and type of photographic paper (weight, finish, contrast) to be used.

Quality of negatives and prints. Negatives and prints should be free from stains, scratches, and blemishes that detract from intended use.

Materials to be delivered. Two sets of contact prints (or transparencies) and one set of index sheets are usually supplied. A copy of the original flight log may also be requested. Additional items desired such as enlargements, mosaics, maps, or plan-and-profile sheets should be listed in detail.

Inspection of contract photography

Following completion of a photographic survey, it is customary for a representative of the purchaser to make a technical inspection of all prints, index sheets, and negatives. If the project was awarded to a reputable aerial survey firm at the beginning, the inspection and official acceptance of materials become a mere formality. In other instances, careful study may be required to determine whether the photography meets the standards set forth in the contract specifications.

Infrequent purchasers of aerial photography may have difficulty in evaluating the finished product, because the acceptance or rejection of photographic flights often requires checks of such items as film titling, overlap, scale, and print quality. As a means of translating technical specifications into guides for the neophyte inspector, an itemized inspection checklist as designed by Avery and Meyer (1962) may prove useful.

As a rule, exposures should be dated in the upper left corner; project, roll, and exposure numbers should be shown in the upper right corner of each photograph. Nominal photo scale, as 1:15,000, and local standard time are ordinarily placed at the top of the first and last exposures in each flight line. The center of the photographic flight strip should be within a specified distance of the position plotted on original flight maps. Maximum deviation is usually set at 25 percent of the mean sidelap distance. The inspector should also check to make sure that the compass bearing of each flight line is within 5° of the specified direction and that adjacent lines are within 5° of parallel.

Tilt and scale checks

As mentioned, photographic tilt should not exceed 2° to 3° for a single exposure, nor average more than 1° for an entire project. Tilt is most commonly encountered on prints near the ends of flight lines where exposures are made as the aircraft banks into a turn for the next strip. It is diffi-

cult to detect a small degree of tilt, but excessive amounts are quite evident on photographs of flat terrain having rectangular land subdivisions. In such instances, the oblique camera view results in an apparent convergence of grid patterns and parallel lines.

Because of the time required, photo scale checks are seldom made for individual exposures. Instead, ten or more overlapping prints or transparencies are selected from each flight line for a check of the average scale across an expanded geographic transect. After the exposures have been taped down in mosaic fashion, the distance between two points is carefully measured. Through computation of a simple ratio between the photo measurement and the corresponding distance on the flight map, average print scale can be quickly determined. After allowance is made for variations in local relief, this average should be within ±5 percent of the specified scale.

Assessing print quality

Print quality is usually the most difficult item for an inspector to evaluate because of the lack of standards or criteria of comparison. The inspector must place heavy reliance on subjective judgment in deciding whether a given photographic defect constitutes a reasonable basis for rejection. Some of the photographic "defects" shown in Figure 5-5, for example, may be of minor importance for certain interpretation projects. Although the original exposures may be of high quality, carelessness in printing can produce photographs with poor contrast, stains, or blurred detail. For this reason, film negatives should be available for inspection over a light table. Special techniques in printing will often produce high-quality photographs even when negatives have poor density characteristics.

A sample flight plan

An aerial flight plan is simply a reliable map depicting the area to be photographed, the scale of photography desired, and the proposed location and altitude of flight lines. The final version may be prepared by an aerial survey firm, but it is usually to the purchaser's advantage to draw up a preliminary plan prior to issuing a photographic contract. Topographic quadrangle maps, ranging in scale from 1:20,000 to 1:250,000, are among the best maps available for preparing flight plans. In the United States and Canada, these maps can be purchased at nominal cost from government agencies. The example that follows illustrates the various calculations involved in preparing an aerial flight plan for an area of 20 km east-west by 30 km north-south, or 600 km². Basic information required is as follows:

Desired negative scale: 1:25,000 or 250 m/cm

Scale of base map: 1:50,000 or 500 m/cm

Average ground elevation above mean sea level: 500 m

Average forward overlap: 60 percent

Sidelap: To average approximately 30 percent

Negative format: 23 by 23 cm, or 5,750 by 5,750 m on the ground

Camera focal length: 153 mm or 0.153 m

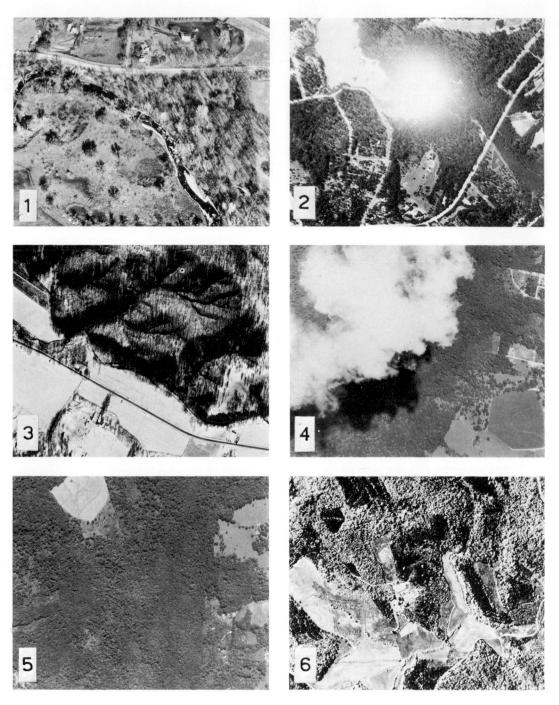

Figure 5–5. Illustration of several factors affecting image quality on aerial photographs: (1) tilted photograph (note oblique view), (2) hotspot or sunspot, (3) snow cover and long shadows, (4) clouds and cloud shadows, (5) insufficient print contrast, and (6) excessive print contrast.

Flight map computations

Items to be computed in preparing the flight plan are:

Flying height above ground datum: Height = focal length × scale denominator, or

$$H = 0.153 \text{ m} \times 25,000 = 3,825 \text{ m}$$

Flying height above mean sea level:

$$3.825 + 500 = 4.325 \,\mathrm{m}$$

Direction of flight lines: North-south, following long dimension of tract.

Number of flight lines: Assuming an average sidelap of 30 percent, the lateral gain from one line to another is 70 percent of the negative format (on the ground) or $0.70 \times 5,750 = 4,025$ m between lines. The number of intervals between lines is found by division of the tract width (20 km or 20,000 m) by 4,025. The result is 4.97 or 5 intervals and 6 flight lines.

Actual (adjusted) ground distance between flight lines: Tract width $(20,000 \text{ m}) \div 5 \text{ intervals} = 4,000 \text{ m}$ between lines.

Actual (adjusted) percentage of sidelap:

Sidelap percentage =
$$\frac{\text{Negative width (m)} - \text{Spacing (m)}}{\text{Negative width (m)}}$$
 (100)
Sidelap percentage = $\frac{5,750 - 4,000}{5,750}$ (100) = 30.4%

Map distance between flight lines (map scale is 500 m/cm):

$$\frac{1 \text{ cm}}{500 \text{ m}} = \frac{\text{X cm}}{4,000 \text{ m}}$$
; X = 8.00 cm between lines on map

Ground distance between exposures on each line: Assuming an average forward overlap of 60 percent, the spacing between successive exposures is 40 percent of the negative format (on the ground), or $0.40 \times 5,750 = 2,300$ m between exposures.

Map distance between exposures on each line:

$$\frac{1 \text{ cm}}{500 \text{ m}} = \frac{X \text{ cm}}{2.300 \text{ m}}$$
; X = 4.60 cm between exposure centers on map

Number of exposures on each line: Number of intervals between exposures is found by division of tract length (30 km or 30,000 m) by 2,300 = 13.04 intervals. This will require 14 exposures inside the area, assuming that the first exposure is centered over one tract boundary. In addition, 2-extra exposures are commonly made at the ends of each flight line; thus, a total of 14 + 2 + 2 = 18 exposures would be taken on each flight line.

Total number of exposures required to cover entire tract: $6 \text{ lines} \times 18 \text{ exposures}$ posures per line = 108 exposures.

The calculation procedures and interval/sidelap adjustments employed here (i.e., for direction and number of flight lines, actual ground distance between flight lines, and actual percentage of sidelap) will result in the two exterior flight lines being centered precisely over the tract boundaries. Thus, there will be a safety factor to ensure boundary coverage, since exposure locations are planned to overlap the boundaries by 50 percent.

Taking your own photographs

If oblique or near-vertical photographs taken with small-format cameras are sufficient for supplementary coverage of project areas, the do-it-yourself approach provides an alternative for limited types of aerial surveys. Highwing monoplanes offer good side visibility and low stalling speeds; such aircraft can be rented (with pilot) at reasonable hourly rates. Under certain circumstances, it may be permissible to remove the aircraft door on the passenger's side to obtain even better visibility during flights.

For oblique exposures taken through aircraft windows, standard press cameras work quite well. When cameras must be exposed to the aircraft slip-stream, however, rigidly designed lens systems should be used instead of those with folding bellows. Surplus military-reconnaissance cameras can sometimes be rented or purchased, but most scientists seem to prefer conventional 35-mm or 70-mm formats because films are readily available and inexpensive and cameras can be equipped with interchangeable lenses and motorized film drives. Furthermore, imagery in these two formats can be optically enlarged (e.g., for map revision and updating) by use of ordinary slide projectors.

Cameras with 35-mm or 70-mm formats will commonly have focal lengths ranging from about 50 to 100 mm. If we assume the use of such cameras in fixed-wing aircraft without oxygen equipment, the upper altitudinal limit would be about 3,000 m above mean sea level, and the lower limit about 300 m above ground. If we further assume that terrain elevations will not exceed 1,500 m, the range of negative scales available might be computed by the same procedure outlined earlier in this chapter:

RF =
$$\frac{0.050}{3,000 - 1,500} = \frac{1}{30,000}$$
 or 1:30,000
RF = $\frac{0.100}{300} = \frac{1}{3,000}$ or 1:3,000

This scale range (1:3,000 to 1:30,000) will be entirely adequate for most doit-yourself aerial surveys.

Devising a camera mount

Exposures made with hand-held cameras are satisfactory for oblique views and for spot coverage with a near-vertical camera orientation. However, if continuous strips of overlapping exposures are needed for stereoscopic study, a camera mount must be devised and constructed for best results. It is assumed here that most rented aircraft will not have camera ports or cargo hatches incorporated therein; consequently most improvised camera mounts are designed to hold the photographic apparatus outside the airframe, usually on the passenger's side (Figure 5-6).

Figure 5-6. External aircraft mount designed to accommodate a K-20 camera. Courtesy Auburn University.

Hand-made camera mounts have been designed in a wide array of configurations, since each must be adapted to a particular airframe and camera. To combine light weight with maximum platform stability, most camera mounts are constructed of plywood and aluminum; vibration problems are often minimized by employment of foam rubber shock absorbers. Some of the more desirable attributes of improvised camera mounts are as follows:

- 1. Mount should be capable of attachment to a given airframe with no external modification of the aircraft.
- 2. Mount (or camera) should be equipped for in-flight leveling and flight-path orientation.
- 3. If the camera viewfinder cannot be used, a calibrated sighting tube should be devised to indicate the camera ground coverage at various heights above ground.
- 4. Mount should be constructed for maximum in-flight accessibility to the camera. This is essential for nonautomatic cameras, because it may be necessary to adjust aperture/shutter speeds, to wind film, and to change film cassettes in the air. A long cable release will generally solve the shutter-release problem.
- 5. If the camera mount is likely to affect aircraft flying attitude or performance, it may be necessary to obtain written approval for its use from federal or state aviation authorities. It will also be advisable to check on insurance rates for aircraft, camera, and crew if the plane is operated with the passenger door removed.

Two common problems with low-altitude, do-it-yourself photography are (1) the difficulty in determining exact altitude above ground for scale calculations and (2) poor camera stabilization, which may result in blurred or nonvertical imagery. In spite of these limitations, however, the technique is ideally suited for spot photographic coverage where low costs and exact timing of flights are chief factors of concern.

Low-altitude helicopter photography

The fact that helicopters are capable of horizontal flight at low airspeeds should make them particularly useful for taking large-scale airphotos of spot locations such as mining operations, forest inventory plots, and urban centers. Sharp negatives are feasible at ordinary shutter speeds, and camera recycling time is not so critical as with faster-moving, conventional planes. The principal restriction is the high hourly cost of helicopter operation. Contract rates for helicopter and pilot are usually several times that charged for fixed-wing aircraft.

Among technical difficulties peculiar to low-altitude helicopter photography are (1) limitations of weight and space for photographer and pilot, (2) severe aircraft vibrations, and (3) difficulty of precise determination of altitudes above ground. Weight problems can be partially alleviated by use of lightweight cameras, and vibrations may be minimized if photographs are taken in horizontal flight rather than from a hovering position. However, exact flight altitudes (i.e., photo scales) pose the same problem as with rented, fixed-wing aircraft. Unless the use of a radar altimeter can be justified, there appears to be no simple solution to this problem.

In 1957, the author devised a simple box mount for holding two identical 70-mm cameras and used the device to obtain helicopter stereograms from designated air exposure stations. Camera lenses were separated by about 1 m, the maximum air base practical for the hand-held, manually operated device. Photographs made during this experiment were roughly comparable to those now obtained with 70-mm cameras from fixed-wing aircraft (Figure 5-7).

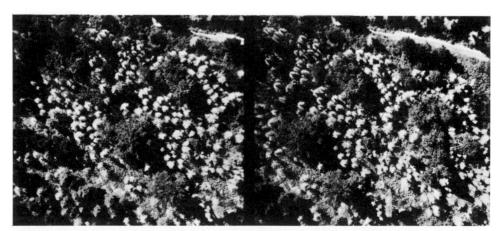

Figure 5-7. Stereogram illustrating dead balsam fir trees (white crowns) killed by the spruce budworm near Ely, Minnesota. Because of the forward overlap, corresponding images on these 70-mm exposures are separated by only about 45 mm. Scale is about 1:1,600. Courtesy U.S. Forest Service Remote Sensing Project, Berkeley, California.

Existing photography: Commercial sources

A wide selection of photographic negatives are held by private aerial survey companies in the United States and Canada. In many instances, prints can be ordered directly from these companies after permission is obtained from the original purchaser. A large share of the available coverage has been obtained on panchromatic film with aerial cameras having 153-mm, distortion-free lenses. As a result, photographs are ideally suited for stereoscopic study because of fine image resolution and a high degree of three-dimensional exaggeration. Scales are usually 1:25,000 or larger for recent photography. In addition to contact prints and photo index sheets, most aerial mapping organizations will also sell reproductions of special atlas sheets or controlled mosaics. These items can be useful for pictorial displays and administrative planning.

Prints purchased from private companies may cost more than those from public agencies, but they are often of higher quality and at larger scales—factors that may offset any price differential. Quotations and photo indexes can be obtained by direct inquiry to the appropriate company. Names and addresses of leading photogrammetric concerns are available in current issues of Photogrammetric Engineering and Remote Sensing.

Existing photography: United States government

Most of the United States has been photographed in recent years for various federal agencies. The key to this photography is available free in map form as the "Status of Aerial Photography in the U.S." Copies may be obtained from:

Map Information Office U.S. Department of the Interior Geological Survey, National Center Reston, Virginia 22092

This map shows all areas of the United States, by counties, that have been photographed by or for the Agricultural Stabilization and Conservation Service, the Soil Conservation Service, the Forest Service, the Geological Survey, the Corps of Engineers, the Air Force, the National Ocean Survey, and commercial firms. Names and addresses of agencies holding the negatives for photographs are printed on the back of the map, and inquiries should be sent directly to the appropriate organization. There is no central laboratory that can furnish prints of all government photography.

As a rule, most photographs purchased through federal agencies range in scale from about 1:12,000 to 1:40,000. Panchromatic film is commonly used, although national forests and adjacent lands may have coverage with infrared black-and-white film. Also, there is an increasing amount of high-altitude color photography (scale 1:60,000 to 1:125,000) available from some agencies.

The age of existing photography usually varies from about two to eight years, with agricultural regions, urban areas, and large reservoirs being rephotographed at the most frequent intervals. Photo index sheets of existing photography (Figure 5-8) can be viewed at local or regional offices of the

Figure 5–8. Portion of an aerial photo index sheet covering tidal marshes and St. Catherine's Island off the Georgia coast. Courtesy U.S. Department of Agriculture.

Agricultural Stabilization and Conservation Service, the Forest Service, or the Geological Survey. Written inquiries may be addressed as follows:

Aerial Photography Field Office ASCS-USDA 2511 Parley's Way Salt Lake City, Utah 84109 Chief, Forest Service USDA Washington, D.C. 20250 EROS Data Center U.S. Geological Survey Sioux Falls, South Dakota 57198

Existing photography: Canadian government

The National Air Photo Library is the central storehouse for the Canadian government's air photography, including the Yukon and the Northwest Territories, and the Provinces of Newfoundland, Labrador, Nova Scotia, Prince Edward Island, Manitoba, and Saskatchewan. Inquiries regarding this photography should be made directly to:

The National Air Photo Library Surveys and Mapping Branch Department of Energy, Mines, and Resources 615 Booth Street, Ottawa, Ontario K1A OE9

Photography obtained specifically for other provinces may be available through various agencies within those provinces. Written inquiries should include a map of the area involved, a statement regarding the proposed use of the photography, and specifications as to whether stereoscopic coverage is desired.

1. Assume you must plan a photographic mission for the area covered by a standard topographic map. Your instructor will supply basic data on photo scale desired, overlap, camera focal length, and so on. Compute the follow-

Problems

	g values by the methods outlined in this chapter:
a.	Flying height above ground datum
	Flying height above MSL
b.	Direction of flight lines
	Number of flight lines
c.	Ground distance between flight lines
d.	Actual percentage of sidelap
e.	Map distance between flight lines

f.	Ground distance between exposures on each line
g.	Map distance between exposures on each line
h.	Number of exposures on each line
	Total number of exposures

- 2. Use the foregoing data to convert the topographic map into a finished flight plan. Show location, direction, and altitude of all flight lines, positions of all exposure centers, actual percentage of sidelap, and so on. Add an appropriate title at the bottom of the map sheet.
- 3. Design and construct a simple camera mount for obtaining low-altitude, vertical exposures from a conventional, fixed-wing aircraft. Provide detailed drawings, specifications, and a bill of materials needed to build the complete apparatus. Then use the device to obtain aerial photographs of a designated area.

References

- Avery, T. E. 1970. Photo interpretation for land managers. Eastman Kodak Co., Rochester, N.Y. Publication M-76, 26 pp., illus.
- ——. 1960. A checklist for airphoto inspections. Photogrammetric Engineering 26:81-84, illus.
- ——. 1958. Helicopter stereo-photography of forest plots. Photogrammetric Engineering 24:617—25, illus.
- ——, and Merle P. Meyer. 1962. Contracting for forest aerial photography in the United States. U.S. Forest Service, Lake States Forest Experiment Station. Station Paper 96, 37 pp., illus.
- Howard, J. A., and H. Kosmer. 1967. Monocular mapping by microfilm. *Photogrammetric Engineering* 33:1299-1302, illus.
- Lund, H. Gyde. 1969. Factors for computing photo coverage. Photogrammetric Engineering 35:61-63.
- Parker, Robert C., and Evert W. Johnson. 1970. Small camera aerial photography— The K-20 system. *Journal of Forestry* 68:152-55, illus.
- Ulliman, Joseph J. 1975. Cost of aerial photography. Photogrammetric Engineering 41:491-97.
- U.S. Department of Agriculture. 1973. Aerial photography specifications. U.S. Department of Agriculture, Agricultural Stabilization and Conservation Service, Washington, D.C. 33 pp., plus appendix, mimeo. (Periodically revised.)
- Woodward, Louis A. 1970. Survey project planning. Photogrammetric Engineering 36:578-83, illus.
- Zsilinszky, Victor G. 1970. Supplementary aerial photography with miniature cameras. *Photogrammetria* 25:27-38, illus.

Chapter 6

Planimetric and Topographic Mapping

Planimetric base maps

In areas of flat terrain where photographic scales can be precisely determined, direct print tracings may serve many useful purposes; nevertheless, such tracings cannot be technically referred to as true maps. Although the vertical aerial photograph presents a correct record of angles, constant changes in horizontal scale preclude accurate measurements of distance on simple overlays. The obvious alternative is to transfer photographic detail to reliable base maps of uniform scale. *Planimetric maps* are those that show the correct horizontal or plan position of natural and cultural features; maps that also show elevational differences (e.g., contour lines) are termed topographic maps.

Construction of an original base map can be an expensive and time-consuming procedure. Therefore, existing maps should be used for the transfer of photographic detail wherever feasible. Topographic quadrangle sheets at scales of 1:20,000 to 1:25,000 provide excellent, low-cost base maps. County maps, often available from state highway departments, may also serve as base maps when a high level of accuracy is not required. They may show

township, range, and section lines in addition to geographic coordinates (longitude and latitude) to the nearest 5 minutes. County maps are usually printed at scales of about 1:100,000 to 1:125,000. Although compass bearings of section lines are not generally shown, such maps are much more reliable than oversimplified plats showing idealized townships and sections oriented exactly with the cardinal directions.

Regardless of the base map selected, some enlargement or reduction is ordinarily required before print detail can be transferred, because differences between photographic and map scales must be reconciled. This may be accomplished optically by use of special instruments to be described later or by reconstruction of the map at the approximate scale of the contact prints. A pantograph may be used to facilitate the drafting process.

General Land Office plats

General Land Office (GLO) plats provide another satisfactory means of compiling planimetric base maps. Most of the United States west of the Mississippi River and north of the Ohio River, plus Alabama, Mississippi, and portions of Florida, was originally subdivided under the U.S. Public Land Survey (Figure 6-1). Township, range, and section lines are often visible on aerial photographs. If enough such lines and corners can be identified, GLO plats can be constructed as base maps from field notes available at state capitals or county surveyor's offices. The accuracy of this method depends upon the number of grid lines and corners that can be pinpointed on the aerial photographs. The basic procedure is as follows:

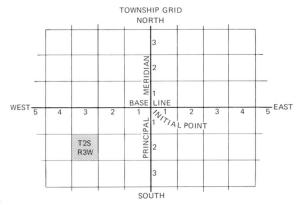

Figure 6-1. Subdivisions of the U.S. Public Land Survey.

6	5	4	3	2	1
7	8	9	10	11	12
18	17	16	15	SECT. 14	13
19	20	21	22	23	24
30	29	28	27	26	25
31	32	33	34	35	36

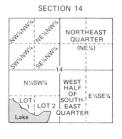

A GLO plat showing sections, quarter-sections, and forties is drawn to the average photo scale from survey field notes. As many of the same lines and corners as possible are pinpointed on the aerial photographs, preferably arranged in a systematic framework throughout the project area. Ownership maps, county highway maps, and topographic quadrangle sheets may be helpful in the identification of such corners. Additional points may be needed. In such cases, the photographs must usually be taken into the field.

When photo interpretation has been completed, the annotated detail is transferred to the plat, one square of the grid being completed at a time. If the plat and photos are of the same scale, transfer can be speeded up by direct tracing over a light table; where scales differ, a proportionate grid system can be used. Photo detail is "forced" into corresponding squares on the base map. Transfer of detail should not be extended outside of the framework of control, because large errors may be introduced.

Map projections

A map projection is merely an orderly system of representing the earth's surface on a plane. Actually the approximately spherical form of the globe cannot be flattened into a map without distortion of shapes or areal relationships occurring. For small areas mapped at moderate scales (e.g., a small county), the curvature of the earth is so slight that distortion is negligible and often ignored. As larger areas (e.g., several counties or an entire state) are encompassed, however, distortion increases and it becomes impossible to represent a portion of the earth's surface precisely on a flat map sheet.

Historically, a large number of map projections have been devised, but only a relatively small number have enjoyed wide usage. There is no one projection that is best for all shapes and sizes of areas; all are designed for special purposes, and the value of a given projection depends on its specific use. Ideally a map projection provides a true representation of both shapes and areas, but, in practice, these two characteristics cannot be obtained on the same map. Projections that retain the true shapes of geographical units are referred to as conformal; those that provide correct area relationships are termed equal-area or equivalent. Other features of an ideal map projection include properties of true distance, true direction, and ease of plotting. Since no projection meets all of these requirements, the properties of three projections commonly used in the middle latitudes will be cited: (1) Mercator. (2) Lambert conformal conic, and (3) polyconic. Descriptions are taken primarily from U.S. Army training manuals.

Mercator projection

This is a mathematically derived projection in which parallels and meridians are projected onto a cylinder tangent to the earth at the equator (Figure 6-2). When the cylinder is laid out flat, the meridians appear as vertical. straight lines. Meridians are evenly spaced and true to scale at the equator or at the selected standard parallel of latitude. (A standard parallel is any parallel along which linear measurements are the same as for a globe of equal scale. A meridian that has this property is called a central meridian.) Lines of latitude are also straight and parallel, but they do not fall at their

Characteristics	Mercator	Transverse Mercator	Oblique Mercator	Polyconic
Parallels	Parallel Straight Lines Unequally Spaced	Curves Concave Toward Nearest Pole	Sine Curves	Arcs of Non-Concentric Circles Equally Spaced on Mid-Meridian
Meridians	Parallel Straight Lines Equally Spaced			Mid-Meridian Straight Other Curved
Appearance of Grid				
Great Circle	Curved Line (Except Equator and Meridians)	Curved Line	Straight Line Along Tangent Line	Approximated by Straight Line Near Mid-Meridian
Rhumb Line	Straight Line	Curved Line	Curved Line	Curved Line
Distance Scale	Mid-Latitude	Mid-Latitude Nearly Constant		Constant for Small Areas, Variable for Larger Areas
Graphic Illustration	Cylinder Tangent at Equator	Cylinder Tangent Across Poles		
Origin of Projectors	Center of Sphere	Center of Sphere	Center of Sphere	Center of Sphere
Distortion of Shapes and Areas	Increases Away from Equator	Increases Away from Meridian of True Scale	Increases Away from Great Circle of True Scale	Increases Away from Mid-Meridian
Navigational Uses	Dead Reckoning and Celestial (Suitable for all Types)	Grid Navigation in Polar Areas	Strip Charts of Great Circle Paths	Ground Forces Maps
Conformality	Yes	Yes	Yes	Not Conformal but is Used as Such on Very Large Scale Maps

Figure 6–2. Characteristics of several map projections. Courtesy U.S. Departments of the Army, the Navy, and the Air Force.

Lambert Conformal	Polar Stereographic	Polar Gnomonic	Gnomonic	Azimuthal Equidistant
Arcs of Concentric Circles Nearly Equally Spaced	Concentric Circles Unequally Spaced	Concentric Circles Unequally Spaced	Conic Sections (Curved Lines)	Curved Lines
Straight Lines Converging at the Pole	Straight Lines Radiating from the Pole	Straight Lines Radiating from the Pole	Straight Lines	Curved Lines
Approximated by Straight Line	Approximated by Straight Line	Straight Line	Straight Line	Straight Lines Radiating from Center
Curved Line	Curved Line	Curved Line	Curved Line	Curved Line
Nearly Constant	Nearly Constant Except on Small Scale Charts	Variable	Variable	True at all Azimuths from Center Only
Secant Cone	Plane Tangent at Pole			No Geometric Application Can be Shown
Center of Sphere	Opposite Pole	Center of Sphere	Center of Sphere	Not Applicable
Very Little	Increases Away from Pole	Increases Away from Pole	Increases Away from Center of Projection	Increases Away from Center
Pilotage and Radio (Suitable for all Types)	Polar Navigation, All Types	Great Circle Navigation and Planning	Great Circle Navigation and Planning	Aeronautics, Radio Engineering and Celestial Maps
Yes	Yes	No	No	No

normally projected positions; instead, they are mathematically spaced to

produce the property of conformality or true shape.

For any small area (e.g., a 1° square), the relation of scale along meridians and parallels is the same as on the globe. Scale changes are slight in the midlatitudes, amounting to only about 3 percent at 30° north or south of the equator. However, since the meridians do not converge, areas in the higher latitudes are greatly enlarged (not distorted) when the equator is used as the standard parallel. Although relatively true shapes are maintained, the map scale is doubly exaggerated at 60° and exaggerated by six times at 80°. Thus, on a Mercator map of the world, Greenland appears larger than South America, although it is actually only about one-ninth as large. Polar regions are at infinity and hence cannot be shown on a Mercator projection.

The Mercator projection, devised around 1569 by a Dutch cartographer, is the oldest and probably the best-known projection in the world because of its continuous use for nautical charts. An outstanding feature of the Mercator is that all straight lines are loxodromes or rhumb lines, i.e., lines of true bearing or azimuth. Since parallels and meridians form a rectangular grid, it is easily plotted. The Mercator is widely used for navigational purposes in the mid-latitudes, and it is the standard projection for Navy hydrographic and

air-navigation charts.

Transverse Mercator projection

The transverse Mercator projection is geometrically equivalent to a cylinder wrapped around the earth and tangent to it, along a meridian, with the origin of projection at the center of the earth. The cylinder is cut lengthwise, opened, and laid flat to produce the map. The projected longitude lines are almost straight and evenly spaced near the tangent meridian but become greatly distorted farther out.

With the transverse Mercator projection, most lines of latitude and longitude are curved lines. The quadrangles formed by the intersection of these curved parallels and meridians are of different sizes and shapes, complicating the location of points and the measurement of directions. To solve this problem, a rectangular grid system may be superimposed upon the projection. Such a grid (a series of straight lines intersecting at right angles) furnishes the map reader with a system of squares similar to the block system of most city streets. The dimensions and orientation of different types of grids vary, but these three properties are common to most grid systems, particularly those adopted by mapping and military agencies:

- 1. They are true rectangular grids.
- 2. They are superimposed on the geographic projection.
- 3. They permit linear and angular measurements.

Universal transverse Mercator grid

The universal transverse Mercator grid (UTM grid) is designed for world use between 80° south latitude and 84° north latitude. As the name implies, it is superimposed over the transverse Mercator projection.

Starting at the 180° meridian of longitude and progressing east, the globe is divided into narrow zones, normally 6° of longitude in width, which are numbered 1 through 60. Each zone has as its east and west limits a meridian

of longitude and one central meridian passing through the center of the grid zone (Figure 6-3). With the intersection of a central meridian and the equator as an origin or starting point, a location could be given by a listing of its linear distance north or south of the equator and east or west of the central meridian for the zone. This, however, would require the use of north, south, east, or west for identification of the direction of the distance or the use of plus or minus values. This inconvenience has been eliminated by numerical values assigned to the origin which permit positive values for all points within a zone.

The value of 500,000 m is assigned to the central meridian to avoid negative numbers at the west edge of the zone. These readings are known as false eastings (Figure 6-4). The values increase from west to east. For north-south values, in the Northern Hemisphere, the equator is 0 m and the numbers increase toward the North Pole. In the Southern Hemisphere, the equator is 10,000,000 m and the numbers decrease toward the South Pole. These are known as false northings. The terms false eastings and false northings apply only to the original preparation of the grid system.

Each regularly spaced line that makes up the UTM grid on a map is labeled with its false easting or false northing value (showing its relation to the origin of the zone). The grid interval is usually 1,000 m for large-scale maps; 1,000 or 10,000 m for medium-scale maps; and 100,000 m for small-scale maps.

Lambert conformal conic projection

This projection, developed by a German mathematician, is derived by the projection of lines from the center of the globe onto a simple cone. The cone intersects the earth along two standard parallels of latitude, both of which are on the same side of the equator. All meridians are converging straight lines that meet at a common point beyond the limits of the map. Parallels are concentric circles whose center is at the intersection point of the meridians. Parallels and meridians cross at right angles, an essential of conformality.

To minimize and distribute scale errors, the two standard parallels are chosen to enclose two-thirds of the north-south map area. Between these parallels, the scale will be too small, and beyond them, too large. If the north-south extent of maps is limited, however, maximum scale errors will rarely exceed 1 percent. Area exaggeration between and near the standard parallels is relatively slight; thus the projection provides good directional and shape relationships for areas having their long axes running in an east-west belt. The Lambert conformal conic is the most commonly used projection for sectional aeronautical charts of the United States.

Polyconic projection

Because of its suitability for large-scale maps of relatively small areas, the polyconic projection is ordinarily of interest to photo interpreters. It is derived by the projection of lines from the center of the earth onto a series of cones, each of which is tangent to a parallel of latitude. The central meridian of the area to be mapped is a straight line along which the linear scale is correct. Parallels are represented by arcs of circles that are not concentric but whose centers all lie in the extension of the central meridian. Distances

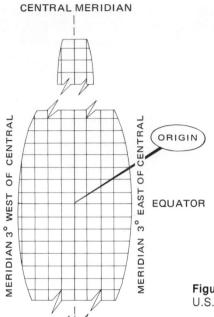

Figure 6-3. A UTM grid zone. Courtesy U.S. Department of the Army.

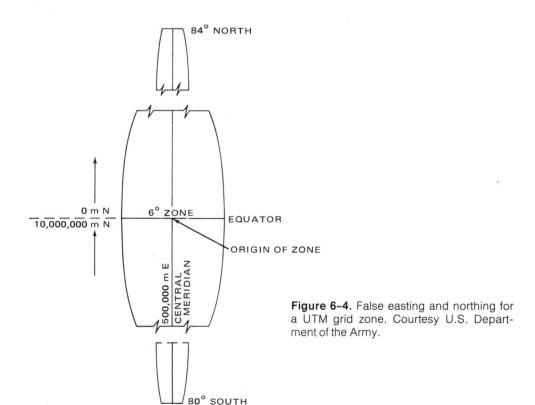

between parallels along the central meridian are proportional to true distances on the earth's surface. Spacings between meridians are similarly proportioned. The projection is neither conformal nor equivalent, but, for

small areas, both qualities are closely approximated.

For large areas, north-south distortion increases rapidly with increasing distance from the central meridian. Because of this, it is customary to limit the width of the projection and to use the central meridian of the area to be mapped as the central meridian of the projection. In short, the projection is best suited to areas whose long axes lie in a north-south direction. The polyconic projection has been used for topographic maps compiled by United States government agencies. Special tables have been computed that permit its use anywhere in the world.

Radial line triangulation

If acceptable planimetric maps cannot be compiled from the foregoing methods, the usual alternative is to construct a new map based on a radial line plot. A radial line plot is a photogrammetric triangulation procedure, usually controlled by ground surveys, by which the photo images are oriented and placed in proper relationship to one another. To a large degree, the field descriptions of available ground control points dictate the nature of the base map constructed. If control points are based on the U.S. Public Land Survey, a GLO plat would be constructed; if they are tied to a state coordinate system, the corresponding rectangular grid would be used; and if locations are described in terms of latitude and longitude, a suitable map projection would constitute the basic plotting framework.

On a vertical or near-vertical photograph, the principal point, isocenter, and nadir are assumed to occupy the same location. Thus a line drawn radially from the principal point to a given object will pass through the true location of the object. Expressed in another way, any displacement of photo images will occur along lines radiating from the center of the photograph. This concept is the basis for the construction of maps controlled by radial

line plots.

The principle of radial line triangulation can be illustrated with any two overlapping prints. If a straight line is drawn from the principal point of each photo through images of the same object, the two lines will intersect at the correct position of the object when the prints are lapped in mosaic fashion with flight lines superimposed. By repetition of this procedure for several selected wing points on each photograph, the entire group of prints can be correctly oriented and tied to a base map. (A wing point is any selected photo feature in the sidelap and overlap zone which can be easily pinpointed on all prints upon which it appears.)

It is presumed here that some of the wing points will also serve as ground control points. Ground control points are most effective when located around the perimeter of the project area, e.g., near the exterior boundaries. Even for small areas, a good radial line plot requires a minimum of one or two ground control points near each corner of the area being mapped, and most of these

points should be common to at least three photographs.

Construction of a radial line plot for a small area (e.g., 25 to 50 km²) is normally accomplished by use of transparent paper templets. Larger radial line plots are preferably constructed by commercial mapping companies that

are fully equipped for handling such work. In these instances, slotted templets may be used (Figures 6-5 and 6-6), or triangulation may be performed directly with first-order stereoplotting instruments.

Constructing a radial line plot

Since the use of transparent paper templets is the least expensive method of making a radial line plot for a small number of photographs, this procedure is outlined here. The same basic steps can be followed when slotted templets are available. At least six overlapping prints (three prints each in

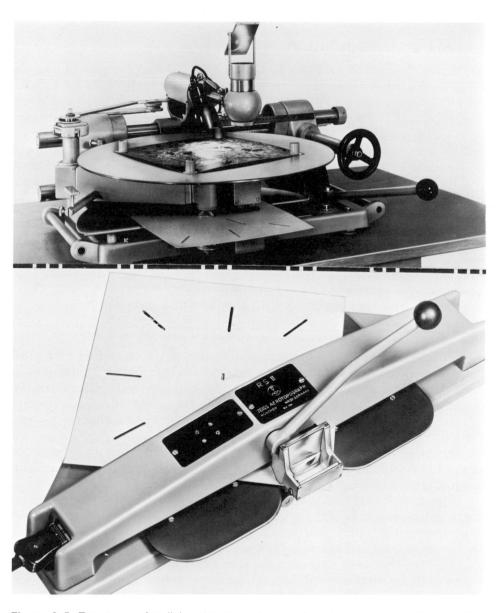

Figure 6-5. Two types of radial secators used for cutting slotted templets. Courtesy Carl Zeiss, Oberkochen.

Figure 6-6. Assembly of slotted templets for a large radial line plot. Each templet represents a 23- by 23-cm aerial photograph. Courtesy U.S. Department of Agriculture.

two adjacent flight lines) are needed. Principal points, conjugate principal points, and flight lines should be located and inked as described in earlier chapters.

- 1. Draw a suitable base map of the project area at the prescribed scale. All ground control points should be precisely plotted on the base map and marked with 5-mm diameter circles. Exact locations of control points may be obtained from ground surveys, GLO plats, or a network of known triangulation stations.
- 2. With a sharp china-marking pencil, outline the boundary of the project area on all photographs. Draw the line just outside the boundaries to avoid obscuring needed detail.
- 3. Pinpoint ground control points on all photographs and mark with 5-mm circles in colored ink (to contrast with PP's and CPP's). At least two, and preferably three, control points should be common to one pair of overlapping prints when the transparent templet method is used.
- 4. Locate wing points (well-defined features easily pinpointed on overlapping prints) near the middle of the sidelap zone and perpendicular to PP's and CPP's. If a control point has already been picked within 2 cm of a planned wing point, the wing point may be omitted. Except for the first

and last photo in each flight line, all prints will have six wing points. These will be common to two, three, four, five, or six overlapping photographs. Mark with 5-mm-diameter inked circles—the same color and size as those used to designate PP's and CPP's.

- 5. Prepare 23-by-23-cm pieces of tracing paper for each photograph. Tape down each print over a light table with the transparent templet on top. Then, using a 4H pencil,
 - a. Pinpoint all PP's, CPP's, control points, and wing points and trace the exact position of flight lines.
 - b. Use a straightedge to align each wing and control point with the PP. Draw radial lines extending about 4 cm on both sides of wing and control points.
 - c. Label each templet by writing the appropriate exposure number aside PP's and CPP's. Wing and control points should carry the same designation on all templets upon which they appear.
- 6. Tape down the base map over a large light table. Assembly of the radial line plot may begin with any transparent templet which includes three control points. (If the slotted method is used, a templet having one or two control points can be positioned first.) Shift templet over top of base map until radial lines drawn through control points precisely intersect the same locations on the map. Fasten down with drafting tape.
- 7. The second templet positioned will be one in the same flight line that overlaps the first. With the common flight line superimposed, the templet is shifted back and forth along the flight line until radial lines representing control points pass through base map positions (just as with the first templet). Intersections of radial lines from wing points will be obtained simultaneously. The second templet is then taped down.
- 8. Remaining templets in the first flight line are added in order of overlap position. When one flight line has been completed, assembly of the adjacent line should begin with the templet having the greatest amount of ground control, and so on. Radial lines from wing points, as well as those from control points, should precisely intersect at the same point. A wing point that appears on six photographs will thus be represented by a sixway "cross" of radial lines. In all instances, flight lines must be superimposed, and the templets may be shifted only along the flight line to yield intersections with radial lines from adjacent templets. The result will be an assembly similar to that shown in Figure 6-7.
- 9. When all templets have been correctly positioned and taped down, use a needle to punch through all PP's, CPP's, and wing point intersections. In this way, all points are located on the base map. Remove templets, mark all transferred points on the map with 5-mm-diameter penciled circles and label with appropriate designations as in step 5c.
- 10. The radial line plot is now complete. Photographic detail may be transferred to the base map with instruments described in the next section.

Transferring detail from single prints

Following completion of photo interpretation and preparation of a radial line plot, the next phase of map compilation is the transfer of photographic features to the base map. Although direct tracings may suffice under special circumstances, it is usually more efficient to use one of several photogram-

Figure 6-7. Diagram of paper templets (left) and assembly into a radial line plot (right).

metric devices designed for this purpose. The two types of instruments most commonly employed for transferring planimetric detail from single prints are camera lucidas and direct or indirect projection devices. Since these instruments do not provide for stereoscopic viewing, the desired features should be annotated on alternate prints prior to the transfer process. (If 23-by-23-cm photographs with 60 percent endlap and 30 percent sidelap are assumed, alternate prints will have effective, or nonoverlapping, areas of about 16 by 18 cm. Only one-half as many prints must be handled during the transfer process if annotations are confined to alternate photographs.)

One of the more common types of camera lucidas is the vertical sketch-master pictured in Figure 6-8. This device employs a full-silvered and a semi-transparent, or semi-silvered, mirror to superimpose photo and map images. The annotated contact print is placed face up on the platform, directly under the large, full-silvered mirror. Photo images are reflected from the large mirror to the semi-silvered mirror in the eyepiece housing. When the interpreter looks into the eyepiece, the semitransparent mirror provides a monocular view of the reflected photo image and the base map simultaneously.

For transfer of photographic detail to the radial line plot, the instrument can be raised or lowered by adjustment of the legs until both map and photograph appear at the same scale. Any combination of three common control or wing points is carefully matched; features that fall within the triangle thus formed are traced onto the base map. The instrument is then shifted and the legs readjusted until three more circles can be superimposed. Planimetric detail is thus transferred, one triangle at a time, until the base map is completed. Photo image displacement due to tilt or topography may result in slightly offset features (e.g., a highway) along common sides of triangles. Such discrepancies must be resolved by "hedging" locations until smooth, continuous lines are obtained.

Most sketchmasters provide for a relatively narrow range of scale changes; the type shown in Figure 6-8 has a scale range of about 0.7X to 1.5X, while the model pictured in Figure 6-9 accommodates changes of 0.4X to 2.8X. Base maps should therefore be drawn at the approximate photo scale when the sketchmaster is used for the transfer of detail.

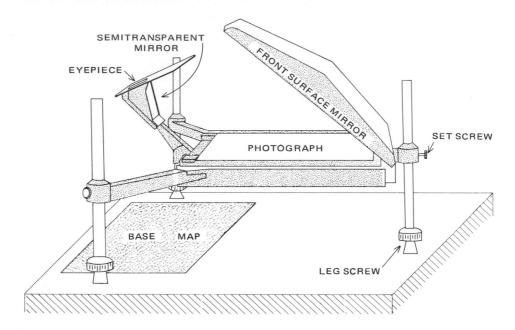

Figure 6–8. Schematic diagram of a vertical sketchmaster. A semi-silvered eyepiece mirror enables the operator to view photograph and map simultaneously.

Image projection devices assume a wide variety of sizes and configurations; many are similar in operation to photographic enlargers. A contact print (or transparency) is placed near a light source and the photo image is reflected (or projected) onto a tracing surface such as a tabletop (Figure 6-10). These types of instruments offer a greater range of scale adjustments and more "elbow room" than vertical sketchmasters; however, they are somewhat less portable and must ordinarily be used in a semidarkened room.

Where aerial imagery is obtained on (or copied onto) 35-mm or 70-mm film frames, ordinary slide projectors provide ideal devices for enlarging and transferring image detail. Instead of projecting the image onto a screen or wall, a favored technique is to mount the projector underneath an ordinary table. The photographic image is projected onto a first-surface mirror inclined at 45° and then reflected upward to the underside of a translucent tracing glass mounted in the tabletop.

The system is simple and economical, since the mirror, mounting hardware, and translucent tracing top are the only specialized items of equipment to be purchased. The slide projector, being unmodified, can be removed and returned to routine use as desired.

Ground control for topographic maps

At the turn of the century, the compilation of topographic maps was largely dependent on field surveys. Such maps now are produced by photogrammetric methods, and fieldwork is limited to obtaining a network of horizontal and vertical ground control required for accurate stereoplotting. Ground control points are carefully located positions that show longitude and latitude or elevation above mean sea level. Horizontal control is needed for correct scale, position, and orientation of the map to be maintained. For this purpose, the grid coordinates of many points within the area to be mapped must be determined by field surveys. Similarly, vertical control is needed for the correct location of contours. Therefore, elevations of many points must also be determined in the field.

Control points become the framework on which map detail is assembled. This framework determines the accuracy with which the positions and elevations of map features may be shown and makes it possible to join maps of abutting quadrangles without a break in the continuity of map detail. The control points are usually marked on the ground by metal tables set in rock or masonry and are shown on maps by appropriate symbols. Some marks serve for both horizontal and vertical control.

Compilation of topographic maps

Typical steps in the production of topographic quadrangles are as follows:

- Vertical photography of the area to be mapped is obtained, usually on panchromatic film. Scale of photography is geared to the desired contour interval and the stereoplotting instrument to be used for map compilation.
- 2. Film is developed and a set of contact prints made for selection of ground control. Horizontal and vertical controls are established by field surveys, and control points are marked on contact prints.
- 3. Glass diapositives (usually 23 by 23 cm) are made from each film negative for use in stereoplotting instruments (Figure 6-11). The positive-image

Figure 6-10. Tabletop reflecting projector for transferring image detail from prints or transparencies. Courtesy Keuffel and Esser, Inc.

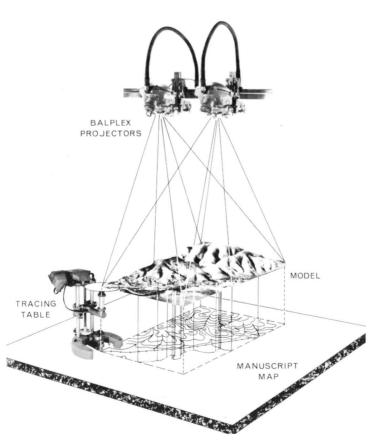

Figure 6-11. Schematic representation of a three-dimensional terrain model provided by stereoplotting instruments. Courtesy Bausch and Lomb, Inc.

plates are oriented in the plotter so that they occupy the same relative positions in space as the original film negatives. Tie-ins to the base map or "manuscript" are established by use of ground control points. The resulting stereoscopic setup is referred to as a stereo model.

4. Contours, drainage, and culture are automatically traced onto the map manuscript by manipulation of a floating dot within the stereo model. When all detail has been transferred from a given stereo model, one diapositive is replaced, and an adjacent model is correctly oriented and tied in to the manuscript by a process known as *bridging*.

The completed manuscript by a process known as bridging.

5. The completed map manuscript is checked for errors and omissions. Detail is then traced onto a polyester film base by a technique known as scribing (Figure 6-12). Separate scribe sheets and negatives are made for each item to be lithographed or printed in a different tone on the finished map (Figure 6-13).

Topographic maps from paper prints

Photo interpreters concerned with topographic mapping are sometimes interested in plotting devices designed for use with paper prints rather than glass diapositives. Representative of this group of instruments is the Zeiss Stereotope, a compact stereoplotter built around a magnifying mirror stereoscope, stereometer (parallax bar), and tracing pantograph (Figure 6-14). The Stereotope is constructed primarily for making topographic maps at scales ranging from 1:25,000 to 1:100,000. With cameras commonly in use and currently obtainable flying heights, the recommended ratio of map scale to photo scale lies roughly between 0.7X and 1.6X.

In use, the floating-mark lenses remain stationary and centered in the field of view, while corrections for x- and y-parallax are made by moving the right-hand photo carriage. Although both photographs remain flat on the special carriages, allowance for tilt can be made by a mechanical computing device that corrects the parallax readings obtained for a given stereopair. The instrument is rugged, compact, and portable. If high-quality, vertical photographs are available on low-shrink papers, accuracy of results will be comparable to that shown in Figure 6-15.

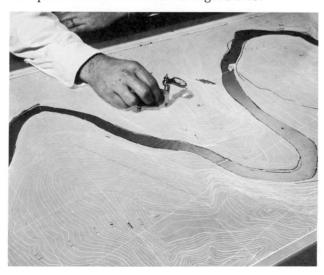

Figure 6-12. The technique of scribing has largely replaced conventional inked draftings in the preparation of finished maps. The polyester film base (scribe-coat) is dimensionally stable and provides lines of high uniformity and sharpness. Maps are reproduced photographically from the scribed manuscript. Courtesy Abrams Aerial Survey Corp.

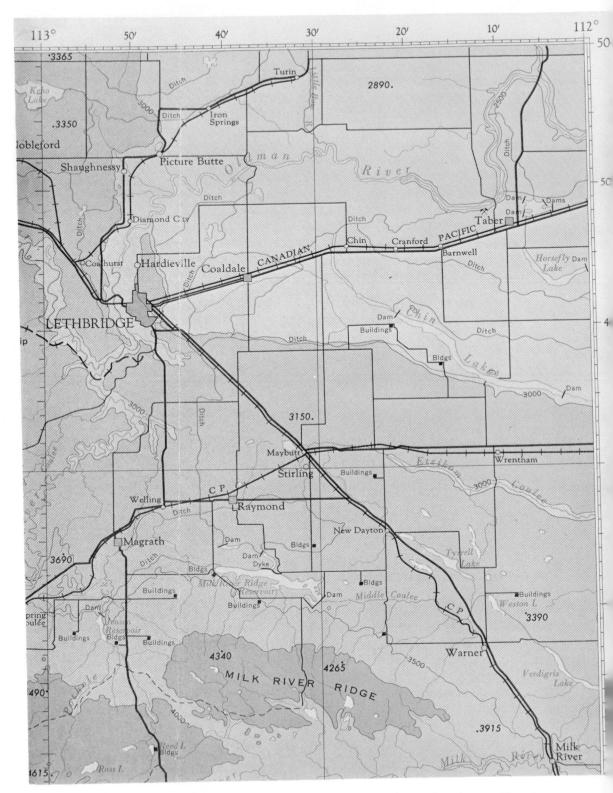

Figure 6-13. Portion of the Cranbrook-Lethbridge topographic quadrangle map. Elevations are in feet; map base is the transverse Mercator projection. Scale is 1:500,000. Courtesy Canada Department of Mines and Technical Surveys.

Figure 6-14. Closeup view of the Stereotope showing movable photo carriages and floating-mark lenses. Courtesy Carl Zeiss, Oberkochen.

The relative accuracy of various stereoscopic plotting instruments is usually expressed in terms of the precision with which contours can be reliably determined. The contour factor (usually termed *C-factor*) of a given plotter, multiplied by the desired contour interval, determines the maximum flight altitude that can be used for compilation of topographic maps of the accepted accuracy standard.

Form lines

Although precise topographic work should not be attempted without instruments specifically designed for drawing contours, approximate form lines can be sketched with a simple stereoscope and stereometer. Form lines are defined as relative contours that are drawn from visual observation to show the general configuration of terrain; thus they do not necessarily represent true elevations nor have a uniform contour interval.

If large-scale photographs of steep terrain are available, interpreters can often differentiate form lines having intervals of 10 to 20 m. Skilled interpreters may delineate these relative contours with only a stereoscope, but it is advantageous to measure several extremes of elevation with a stereometer or parallax bar.

Aerial photo mosaics

An aerial photo mosaic is an assembly of two or more aerial photographs that have been cut and matched together systematically to form a composite view of the area covered by the photographs. The mosaic gives the appearance of a single photograph, producing a complete record of the area. Mosaics

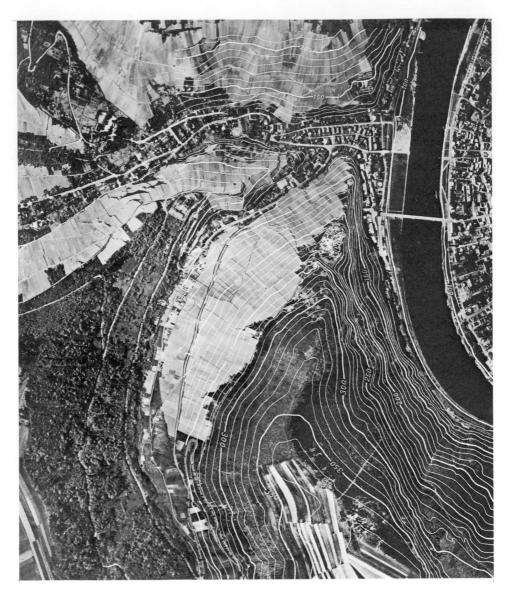

Figure 6-15. Vertical photograph of a German city showing perspective contours plotted with the Stereotope. Scale is approximately 1:10,000; contour interval is about 3 m (10 ft). Courtesy Carl Zeiss, Oberkochen.

are particularly useful for military terrain analyses and for studies of certain natural resources. Source areas for construction materials such as building stone, sand, gravel, and timber can often be determined through the study of mosaics.

Although several categories of mosaics are recognized, most of them can be conveniently grouped into two general classes: controlled and uncontrolled. A controlled mosaic is an assembly of ratioed or rectified prints that are laid to ground control and supplemented by radial line triangulation. With the accuracy required of ratioed or rectified prints, all mismatches of

detail are eliminated, and approximate measurements may be made directly on the mosaic. With an uncontrolled mosaic, photographic detail is matched without the aid of ground control. Only the central area of each photograph is used. Detail is matched with adjacent center areas, and the assembly is pasted to a stable base to form the mosaic. The scale of uncontrolled mosaics is not uniform, so measurements of distances and areas cannot be made upon them.

Preparation of controlled mosaics is an expensive process involving highly trained technicians. It requires prints that match in terms of scale, tone, and freedom from tilt, and the edges of photographs must be bevel cut and sanded before an adhesive is applied to the backing. Therefore, the succeeding discussion is based on a simplified, do-it-yourself method of assembling uncontrolled mosaics, as described by Meyer (1962).

Preparing an uncontrolled mosaic

In the step-by-step procedure that follows, the use of single-weight, contact prints is presumed. Print edges are square cut (not beveled) for a butt-joint assembly. Supplies needed are a metal straightedge, a china-marking pencil, a sharp knife, rubber cement, drafting tape, photographs, and a hardboard base for mounting.

- 1. Photographs are first arranged in flight-line sequence as for the assembly of an ordinary index mosaic.
- 2. Starting with the middle flight line, photographic detail is matched in the center of each overlap area. As each overlapping print is matched, it should be taped down to prevent movement. Photos from adjacent strips are fitted together in a similar manner, priority being given to endlap detail, but also with sidelap detail matching as closely as possible. Close matches are important only in the centers of overlap areas.
- 3. After all photographs have been precisely lapped and taped down, match lines are drawn to delineate the usable or effective area of each print. Such lines are best drawn with a china-marking pencil and a straightedge. Exact positions of match lines depend on photographic detail; lakes, roads, or square parcels of land should not be bisected if this can be avoided by slight shifting of match lines.
- 4. When all endlap and sidelap match lines have been drawn in their final positions, the mosaic is taped to a piece of plywood and made ready for cutting. Once cutting has begun, the mosaic must not be moved. Therefore, it is important that it be firmly attached to the cutting surface and that individual photos be fastened securely to one another. Cutting cleanly through several thicknesses of photos requires a sharp knife and considerable pressure. A knife with a stout handle and replaceable razor-type blade is recommended.
- 5. After they are cut, the effective areas of each print are retained, and each flight line is loosely taped together to keep the component sections in order. Final assembly, beginning with the middle flight line, is accomplished by cementing of the print sections to a sturdy hardboard backing. Although variations in print scale usually preclude perfect matches of detail, the more important cultural features can usually be closely matched if these photo sections are cemented first.

Orthophotography

An orthophotograph is a continuous-tone photo image depicting terrain features in their true plan positions. In other words, geometric distortions and relief displacements are optically removed by an orthoprojection instrument that is connected to a stereoplotter. This specialized instrument scans the stereomodel and rectifies the photographic image (bit by bit) along the scanning lines in one continuous operation.

The rectification of the perspective aerial photograph into an orthophotograph permits the "corrected" imagery to be used as a planimetric map. Orthophotographs may be overprinted onto standard mapping sheets, with the resulting product being referred to as an orthophotoquad. Orthophotoquads meet the same positional accuracy requirements as standard topographic maps. With their abundance of detail not found on conventional line maps, they are useful interim map substitutes for unmapped areas and valuable complements to existing line maps.

Problems

- 1. Construct one of the map projections discussed in this chapter.
- 2. Design and demonstrate the use of an image transfer system for use with single (nonstereo) photographs, e.g., a slide projector and reflecting mirror apparatus.
- 3. Obtain a stereopair of contact prints illustrating pronounced topographic relief for use in form-line sketching.
 - a. Lay off a 1-by-1-cm system of grid points within the overlap zone (mark only on one print).
 - b. Determine the average photo base (P) and flying height (H) of the stereopair for use in obtaining parallax conversions.
 - c. With a simple stereometer, find the lowest elevational plane within the overlap zone. If a lake or river is visible, the lowest water surface may be selected as the reference plane.
 - d. Assuming the selected reference plane to be the equivalent of mean sea level (i.e., zero elevation), measure the elevation of each grid point. Record these values on an overlay traced from the marked photograph.
 - e. Study the gridded area under the stereoscope and sketch in form lines or approximate contours by interpolation between points of known elevation. Supplement the grid points with added measurements, if necessary. Draw trial lines with a pencil so that changes and corrections can be made easily. If a third-order stereoplotting instrument such as the Stereotope is available, contours may be traced directly at a specified contour interval, and the grid points described here may be omitted.
 - f. When discrepancies and irregularities have been resolved, draft a finished overlay of the contoured area. Label each form line with its approximate relative elevation. Add pertinent topographic symbols, scale, and legend.
 - g. On a sheet of cross-section paper, draw a profile representing a transect across the area of greatest elevational change. Indicate the location of the profile line on both photograph and finished overlay.

References

- Giroux, Mary J. 1966. Maps: Basic tools for national growth. Department of Mines and Technical Surveys, Ottawa. 30 pp., illus.
- Meyer, Dan. 1962. Mosaics you can make. Photogrammetric Engineering 28:167-71, illus.
- ——. 1962. A reflecting projector you can build. Photogrammetric Engineering 27:76-78, illus.
- Sibert, Winston. 1972. Role of federal agencies in large-scale mapping. Photogrammetric Engineering 38:239-42.
- U.S. Department of the Army. 1969. Map grid systems. U.S. Army Engineer School, Ft. Belvoir, Va. 50 pp., illus.
- ——. 1966. Introduction to map projections. U.S.-Army Engineer School, Ft. Belvoir, Va. 57 pp., illus.
- U.S. Department of the Interior. 1973. Universal transverse Mercator grid. Government Printing Office, Washington, D.C. Extract prepared by U.S. Geological Survey from Army Field Manual FM 21-26. 10 pp., illus.
- ——. 1972. Topographic maps. Government Printing Office, Washington, D.C. 20 pp., illus.
- ——. 1963. Restoration of lost or obliterated corners and subdivision of sections. Government Printing Office, Washington, D.C. 40 pp., illus.
- Veign, James L., and Francis B. Reeves. 1973. A case for orthophoto mapping. Photogrammetric Engineering 39:1059—63, illus.

Chapter 7

Nonphotographic Imaging Systems

Active versus passive sensors

The sensitivity of conventional cameras (i.e., optical imaging systems) is limited to the visible portion of the electromagnetic spectrum. This narrow segment of the spectrum constitutes only a small part of the total electromagnetic energy. Consequently, interpreters have an interest in nonphotographic imaging systems that operate in the infrared, microwave, and other nonvisible portions of the electromagnetic spectrum. This chapter provides a brief introduction to several of these remote sensing systems.

Instruments for sensing nonvisible wavelengths of electromagnetic radiation are arbitrarily categorized according to the region of the spectrum in which they operate (ranging from gamma rays through radio waves). Some devices function over a sizable spectral band (e.g., from ultraviolet to infrared) and may simultaneously record many channels of data at different wavelengths. Individual types of sensors may be active (providing their own source of illumination), semiactive (depending on illumination from a separate element of the system), or passive (depending on illumination from natural sources, such as solar radiation, or thermal emissions). It is also

necessary to distinguish between nonimaging devices, such as radiometers and spectrometers, and imaging devices, such as thermal infrared scanners and radar systems.

Nonimaging radiation sensors are generally used to measure specific physical quantities associated with segments of the earth's surface or atmospheric paths that fall within the field of view of the instruments. The sensing devices themselves are of several different classes. For example, radiometric instruments measure total power radiated in specified spectral bands from a patch of earth or atmosphere whose dimensions can be accurately determined. Spectrometers are used to determine the distribution of energy received through various spectral regions. In the microwave region, the radar scatterometer measures power returned from the earth's surface as an indication of the reflective or electrical characteristics of the surface. Other types of instruments are also in use.

Radiation and sensor capabilities

Electromagnetic radiation from the sun passes through the atmosphere, falls upon land or water surfaces, and interacts with soils, rocks, water, manmade objects, and vegetation. The nature of the interaction depends on the frequency, intensity, and polarization of the electromagnetic radiation and on the properties of the solid or liquid with which the radiation is interacting. Two general interactions take place: (1) reflection of electromagnetic radiation and (2) penetration or absorption of electromagnetic radiation. Whether most of the radiation is reflected or absorbed depends on the radiation frequency and the physical state of materials that comprise the earth's surface.

A variety of nonphotographic imaging systems has been developed to detect radiation that is reflected or emitted (or both) from terrain surfaces; such sensors operate in arbitrarily defined segments of the electromagnetic spectrum—from the ultraviolet to the microwave region. Thermal infrared and radar sensors function under both day and night conditions, and radar systems are additionally independent of weather conditions—a significant advantage over conventional optical imaging systems. Each type of sensor reacts only to energy bands of specific frequency and wavelength. For example, radar receivers cannot detect visible light, and transmitted microwaves are invisible to infrared scanners. Several categories of sensors are reviewed in the next section.

General types of imaging sensors

Television systems. Television systems cover about the same spectral regions as photographic cameras but have relatively low resolution for a given size of projected image. They may be designed to operate at very low light levels, a capability which may have special value in military applications. The television camera differs from the photographic camera in that the image may be directly viewed on a television screen. Since the data output is in electrical form, the imagery can be transmitted by data link or can be recorded locally or at a distance on video tape or photographic film.

Optical-mechanical scanning devices. Optical-mechanical scanning devices are capable of producing imagery over a wide spectral range that includes ultraviolet, visible, long-and-short infrared, and microwave wavelengths.

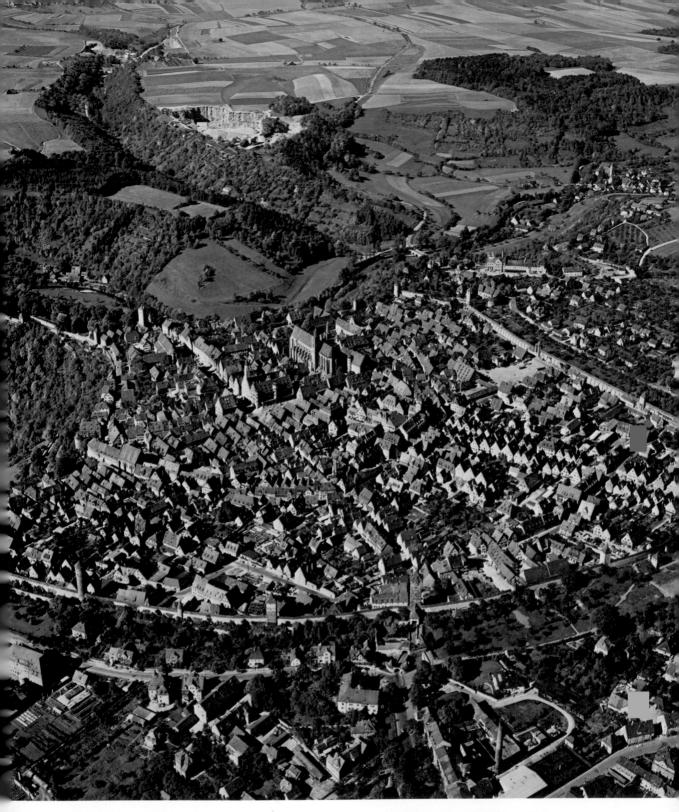

Plate 1. Low oblique view of Rothenburg, a medieval walled city in West Germany. This type of photographic documentation can be extremely valuable in the preservation and restoration of historic buildings and related landmarks. Courtesy Carl Zeiss, Oberkochen.

Plate 2. Agfacolor photograph of Ahrweiler, West Germany. Scale is about 1:2,500. Panchromatic and infrared black-and-white views of this locale appear elsewhere in this book. Courtesy Carl Zeiss, Oberkochen.

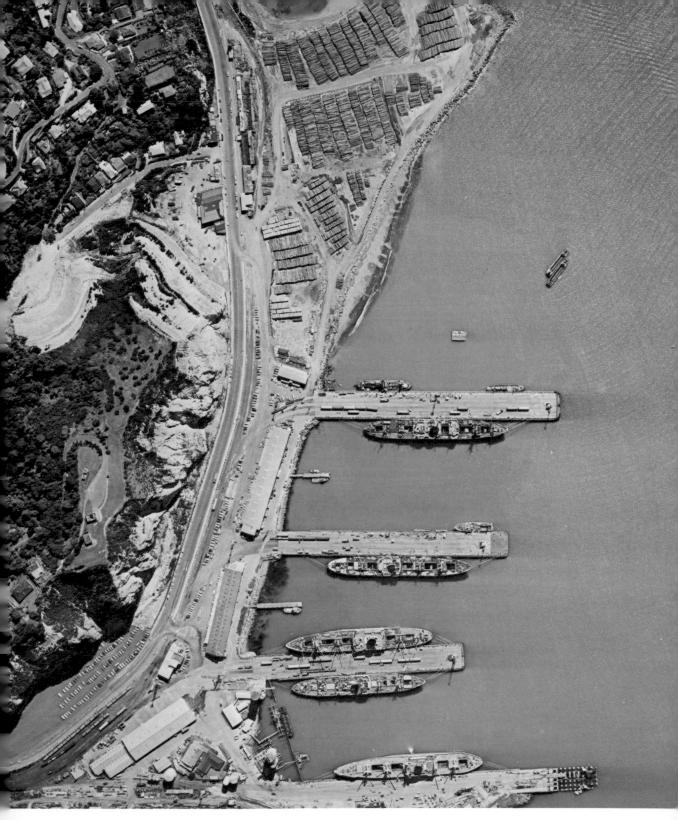

Plate 3. Napier Harbor, in the North Island of New Zealand. Scale is about 1:4,000. The materials stacked on the point of land are pine logs awaiting overseas shipment. Courtesy New Zealand Aerial Mapping, Ltd.

Plate 4. Coastal section of Maui Island, Hawaii, at a scale of about 1:10,000. The smooth, green, carpetlike vegetation is sugarcane in irrigated fields. Courtesy U.S. Department of Commerce, Coast and Geodetic Survey.

Plate 5. Aerial Ektachrome photograph (upper view) and Ektachrome aero infrared coverage (lower view) of two reservoirs in Contra Costa County, California. Blackand-white views of the same area appear elsewhere in this book. Scale is about 1:34,000. Courtesy U.S. Forest Service and University of California.

Plate 6. High-altitude infrared color photograph of Washington, D.C., and vicinity at a scale of about 1:120,000. Courtesy EROS Data Center, U.S. Geological Survey.

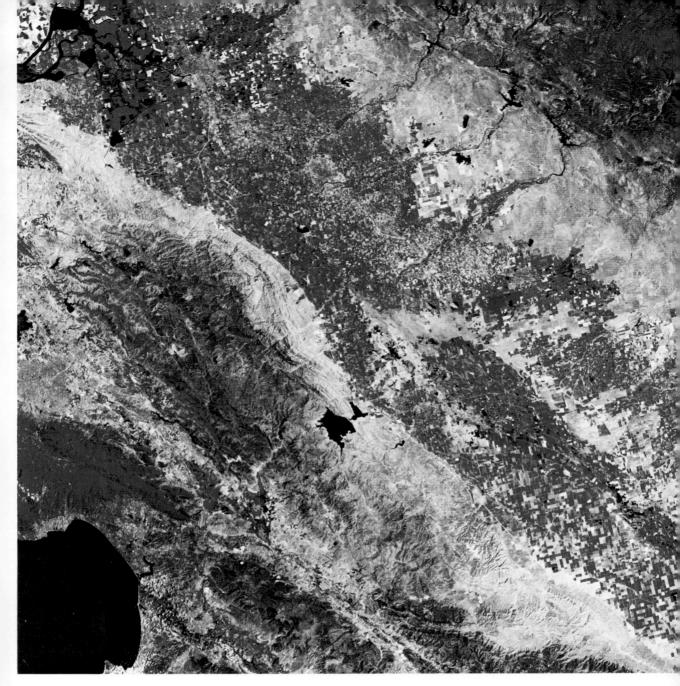

Plate 7. Satellite image of central California, extending from Monterey Bay, in the southwest corner, across the Coast Ranges and the central agricultural valley, and to the Sierra Nevada foothills in the northeast corner. This infrared color composite, at a scale of about 1:1,000,000 was obtained during the month of July from a NASA earth resources satellite. A black-and-white rendition of the same frame appears elsewhere in this book. Courtesy Ralph Bernstein, IBM Corporation.

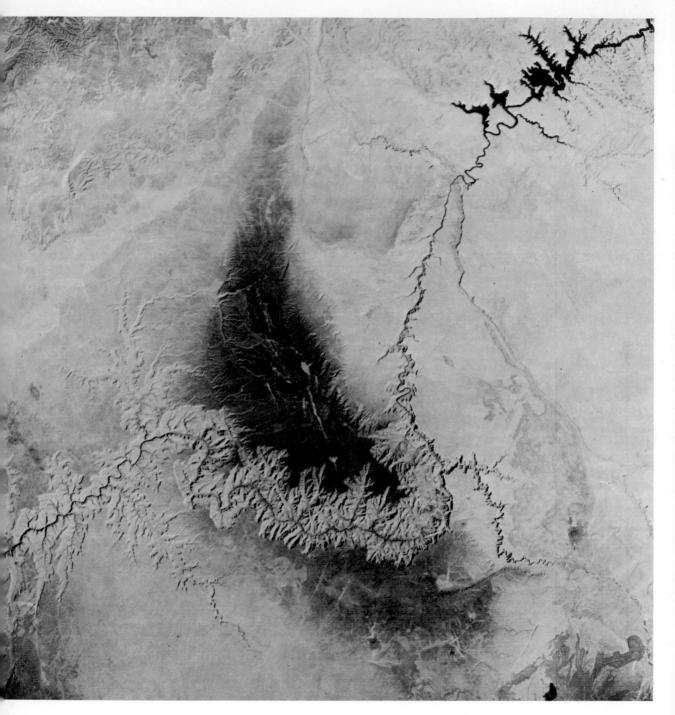

Plate 8. Satellite image of the Grand Canyon of the Colorado River. This infrared color composite includes Lake Powell, in Arizona and Utah, in the northeast corner. The reddish tones in the center denote healthy green vegetation. Scale is about 1:1,000,000. Courtesy EROS Data Center, U.S. Geological Survey.

THE SPECTRAL SIGNATURE OF AN OBJECT IS A REPEATABLE SET OF REFLECTED ENERGY LEVELS AT SPECIFIC WAVELENGTHS

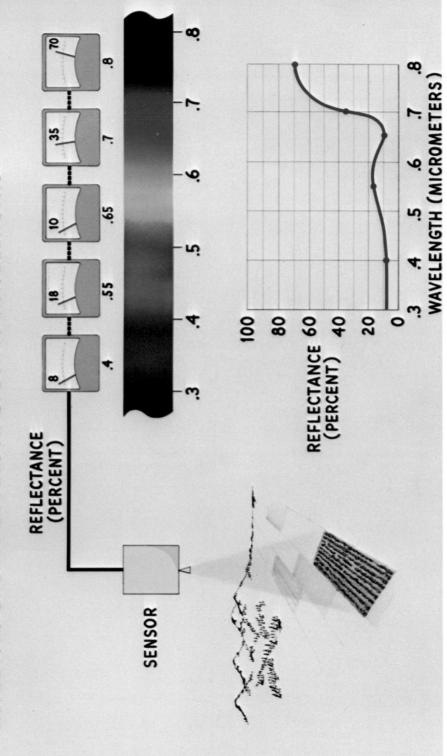

Plate 9. Spectral signature. Courtesy National Aeronautics and Space Administration.

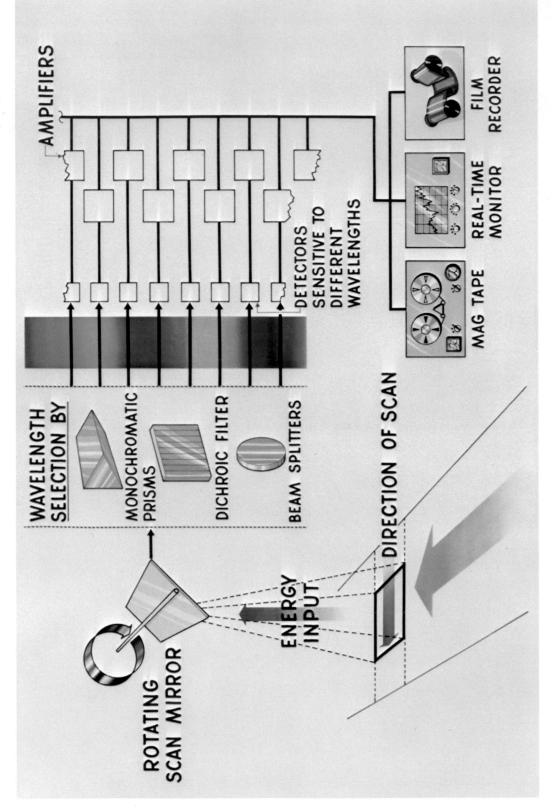

Plate 10. Multispectral scanner. Courtesy National Aeronautics and Space Administration.

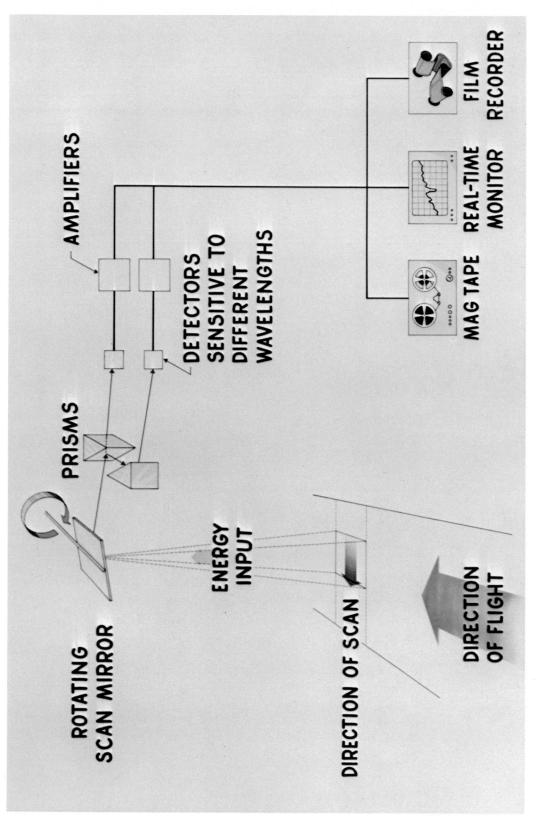

Plate 11. Electro-optical infrared scanner. Courtesy National Aeronautics and Space Administration.

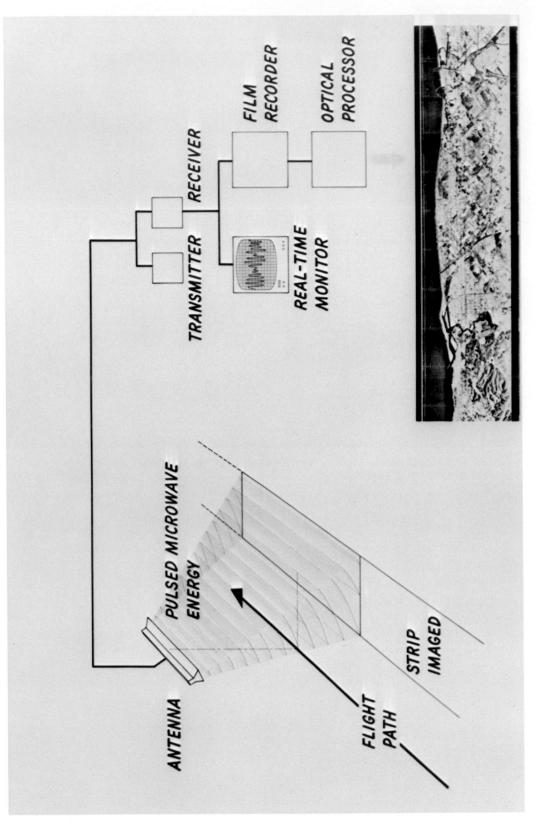

Plate 12. Side-looking airborne radar. Courtesy National Aeronautics and Space Administration.

With this system, information not obtainable with conventional photography can be provided. For instance, the use of infrared can furnish indications of the operation of man-made power sources and can produce thermal maps. Furthermore, its ability to sense data in the ultraviolet, visible, infrared, and microwave bands may make it possible to find a spectral region for discriminating objects that display no detectable differences in the visible band.

Infrared imaging devices. Infrared imaging devices produce recordings of the thermal structure and behavior of the terrestrial and meteorological environment. Experience has shown that terrestrial data in at least two spectral regions or infrared "windows" are often much more useful than in either one alone (Figure 7-1). At the longer wavelengths, the contrast of objects seems to be dependent on emissivity differences in the objects; at shorter wavelengths, contrast appears more dependent on temperature differences of the objects. The surface condition of an object often affects its properties of relative emittance. When measurements are of radiation emitted from objects, a sensing system can be used both day and night.

Radar imagery. Radar imagery provides a comparative measure of the reflection from various components of the earth. Reflected power (radar return) is affected by the aspect of the terrain relative to the beam direction, by the dielectric properties (at the radar frequency) of the material, and (for elements smaller than the resolution limit) by element size. Radar scanning at small angles provides a high degree of detail for complex landforms; the imagery is therefore especially suited for terrain analysis and mapping of areas that are perennially obscured by cloud cover.

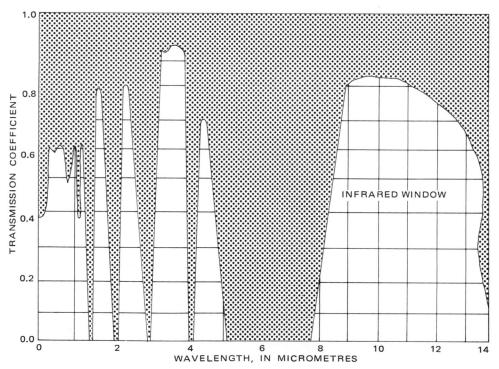

Figure 7–1. Generalized transmission spectra of the atmosphere. Actual transmission will vary from time to time, but most infrared radiation is transmitted in the nonshaded spectral bands, or infrared "windows."

Since signals from nonphotographic sensors are often recorded on photographic film, there is a considerable temptation to make direct comparisons with conventional optical imagery. This temptation should be avoided, for each particular imaging system has its own attributes and limitations. And even the beginning interpreter must learn that infrared photography and thermal infrared imagery are not the same product (Figure 7-2).

In the remainder of this chapter, emphasis is on thermal infrared imagery, airborne radar systems, and scanner imagery transmitted from earth-orbiting spacecraft.

The nature of infrared radiation

The infrared portion of the electromagnetic spectrum lies between the visible and microwave regions (0.78 to $1,000\,\mu\text{m}$). Infrared sensing, or thermal mapping, refers to the detection of remote objects by recording of the amount

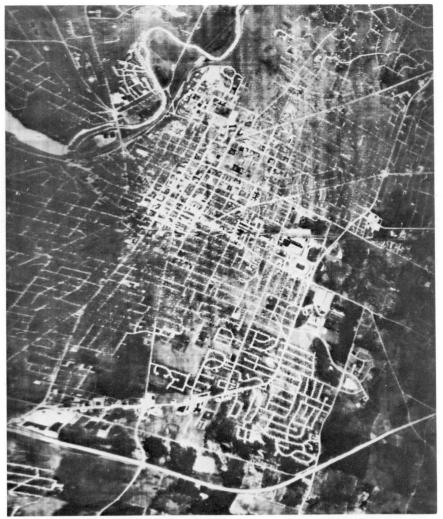

Figure 7-2. Night infrared image (4.5 to 5.5 μ m) over Ann Arbor, Michigan, at a scale of about 1:32,000. Street patterns, a football stadium, and a river show up in light tones, indicating relatively warm surfaces. Courtesy University of Illinois and U.S. Department of Agriculture.

of infrared energy (heat radiation) emitted from various surfaces. Infrared energy is emitted by any material substance having a temperature above absolute zero (-273° C). Therefore, all solid objects from animal life to trees and rocks are sources of infrared radiations.

The infrared radiation emanating from a scene is due to both self-emission from each object within the scene and reflected radiation from the object as a result of illumination from natural sources such as the sun, clouds, moon, and stars. During the daytime, the radiation is predominantly reflected in the spectral region from 0.78 to 3.0 μ m and is mostly self-emitted as wavelengths longer than 4.5 μ m.

Temperature and surface characteristics are the primary factors that govern the emission of infrared radiation; i.e., the radiation emitted by a body at a given temperature is proportional to the characteristics of its surface. A rough surface emits more than a polished surface. Dark-colored objects are usually better emitters than light-colored objects, although some white paints are good emitters in the infrared spectrum. Good absorbers are also good emitters. The property of an object that determines its ability to emit infrared radiation is called emissivity.

Emissivity is a ratio expression of the energy radiated from an object in relationship to a "black body." A black body is, by definition, an object which completely absorbs all radiation incident upon it. The emissivity of a black body is unity. A highly polished surface is an extremely poor radiator and absorber; its emissivity is close to zero. Most surfaces in thermal mapping lie between these two extremes in emissivity. Some materials (e.g., silicon) that are opaque to visible light are relatively transparent to infrared; conversely, bodies of water act as screens that block infrared radiation.

Transmission characteristics of the atmosphere must be considered, since they attenuate the energy radiated from the scene. The major cause of attenuation is water vapor, and the amount of attenuation is proportional to the amount of precipitable water in the path. Many infrared scanners are designed to operate in the spectral bands corresponding to the infrared "windows" of the atmosphere, i.e., within the approximate ranges of 2 to $5\,\mu m$ or 8 to $14\,\mu m$ of emitted or reflected radiation.

Variations in infrared radiation emitted by terrain features are due to differences in either emissivity or temperature, or combinations of both. Emissivity is a basic physical property (often varying with wavelength) which may be determined once and for all. Actual temperature variation is caused by many factors, including the following:

Wind
Heat capacity
Thermal conductivity
Surface-to-volume ratio
Moisture content and the evaporation process
Sky cover and its effect on radiation exchange
Topography and solar history
Elevational differences
Metabolism of plants
Dewfall and precipitation

For solid, nontransparent substances, the sum of reflectivity plus emissivity is unity, so every surface in nature reflects a certain amount of radiation from the surroundings.

Infrared scanners

Although shorter infrared wavelengths may be recorded by conventional photography, highly specialized sensing devices are required for registration of infrared wavelengths longer than 1.0 μ m. An infrared sensor is a scanning device that functions something like a television receiver by producing a nearly continuous image from a series of line scans. Because the terrain is not photographed directly, the term *infrared imagery* is used to describe the final image that is printed onto photographic film.

The line-scanning function is accomplished by means of a rotating mirror that scans the terrain in continuous strips perpendicular to the line of flight. The image from the mirror strikes a "detector" sensitive to infrared radiation (e.g., indium antimonide or mercury-doped germanium). The signal from the sensitive element is electronically amplified and recorded on magnetic tape or displayed as a visual image on a cathode-ray tube. A photographic record can also be obtained.

The film moves across the exposure station at a rate proportional to the aircraft speed-to-altitude ratio, and the result after photographic development is a thermal radiation image of the area flown over. Film density represents effective radiation temperature. Dark tones depict cool thermal signals, and light tones indicate warm or hot areas on a positive image. The width of the scanned strip in the direction of flight is directly proportional to the altitude of the aircraft above the terrain and the total scan angle.

Scale and resolution of infrared imagery

The actual focal length of the infrared (IR) scanner optics does not determine the scale of the recorded imagery. The IR line-scan information is electronically processed and displayed or recorded on film. Just as the size of a television set determines the scale at which the picture is presented, the recorder and film dimensions control the scale of an IR image. The effective focal length of the IR sensor is equal to that of a photographic lens that would produce the same image scale in an aerial camera.

For rectilinear IR imagery, the effective focal length may be combined with flight altitude to yield approximate image scale along and across track. For panoramic IR imagery, the effective focal length permits scale calculation at the nadir or along track only. Formulas for determining the scale of a conventional photographic image may be used to determine the scale of IR imagery if the effective focal length is substituted for the focal length of the camera lens.

IR line-scan imagery has relatively low resolution as compared with conventional optical imagery. With some scanning systems, resolution may be improved as the detector size is reduced; thus very small detector elements may be employed. To ensure adequate collection of infrared emissions, the detector is placed at the focal point of an optical system of large effective aperture.

Other factors affecting image resolution are detector response, electrical bandpass, signal-to-noise ratio, target-to-background contrast, recorder spot size, and uncompensated aircraft motions. Since many IR scanning systems are initially designed for military or intelligence agencies, image resolution capabilities of the more advanced scanners are likely to be treated as classified information.

Thermal resolution is the smallest distinguishable radiometric temperature difference between an object and its background. Hot objects, such as fires or the engines of operating vehicles, do not require high thermal resolution for detection. Some thermal shadows, subsurface water, and other objects have radiometric temperatures only slightly different from those of their backgrounds, however. A thermal resolution of several degrees Celsius may be required in order for these to be effectively detected and identified.

Distortions in infrared imagery

Infrared images often bear strong resemblances to conventional photographs, but they have inherent geometric distortions due to the nature of line scanning. For example, the scanning mirror sweeps an angle on either side of the vertical. Hence, except along the nadir line directly beneath the flight line, the final image is an oblique view of the terrain, and the scale varies with distance from the nadir line. Because the scale along the line of flight may differ appreciably from that across the flight path, precise measurements of images may not be feasible. Infrared imagery may therefore be regarded as more suitable for identification than for purely mensurational uses (Figure 7-3).

Distortions from aircraft motion are from roll, pitch, yaw, and drift. Some scanner systems have gyro stabilization to eliminate the effects of aircraft roll on the imagery. The effect of uncompensated aircraft roll on the imagery is a displacement of objects to the right or left of the center line. Pitch and yaw compress or elongate images. This compression and elongation may vary laterally across the film so that wedging takes place, as in the case of yaw. These distortions are not as noticeable or as frequently encountered as those caused by roll, however.

If there is a crosswind at the time the imagery is made, the aircraft heading and aircraft track may not coincide. Because of this, all points except those at the nadir are skewed in the direction of the aircraft crab. Any turns of the aircraft during the imagery run will cause straight roads parallel to the flight track to appear curved, and straight roads that cross the flight path at oblique angles may appear to be S-shaped.

Interpretation of infrared imagery

It must be remembered that a large proportion of the information recorded on IR imagery is based on thermal radiation characteristics of surfaces rather than on light-reflective (photographic) responses. The amount of infrared energy transmitted is proportional to an object's emissivity and temperature. Unless these factors are understood, the unique advantages of infrared reconnaissance cannot be gained, and interpreters might decide that an infrared image is nothing but aerial photography with poor scale and resolution qualities.

Solar radiant energy provides the principal source of infrared emissions. In daylight, surfaces with a high absorbance for sunlight store up large amounts of heat, while surfaces having high reflectivity for solar radiation absorb very little heat. The temperature that results depends both on the color and on the physical structure of surfaces. A concrete highway will absorb heat at a rapid rate, for example, but its temperature may rise very slowly.

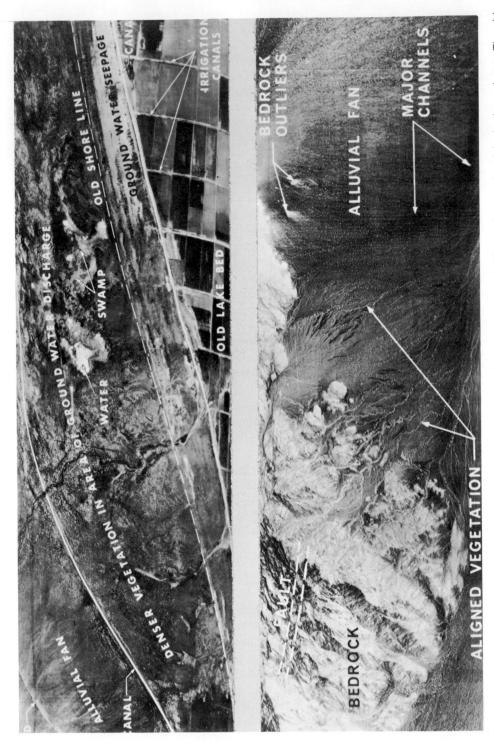

Figure 7-3. Annotated thermal imagery. In the upper view, the contact area of an alluvial fan and an ancient lake bed are shown. The old shoreline is clearly seen; it is the locus for groundwater seepage. The edge of the alluvial fan is covered by much denser vegetation than elsewhere, for this is the area of groundwater discharge. The image shows the discharging groundwater as light areas; such areas may The lower image shows major drainages as darker (moister) areas within a large alluvial fan. Vegetation follows the drainage channels. A not be detectable with conventional photography.

fault is shown cutting the bedrock in the mountains. Courtesy HRB-Singer, Inc.

This is because the heat capacity of concrete is quite high and the thermal connection between a highway and the earth is well established. By contrast, grass and other low vegetation heat up quickly, but their capacities for storing heat are limited. As a result, temperatures of such vegetation tend to follow diurnal changes in thermal conditions.

The following generalized descriptions of terrain features (targets) detectable on IR imagery are taken from the Image Interpretation Handbook,

Vol. I (1967):

Metal Surfaces. Under normal conditions, horizontal surfaces of thin (unheated) bare metal appear black (cold) on night infrared imagery, because metals have much lower emissivities than other substances and emit much less energy. Although such surfaces are good reflectors and will strongly reflect radiation incident on them from the sky, the intensity of sky radiation at night is quite low (particularly on clear nights) and the reflected component also will be weak. It is possible for metal to reflect the radiation from a nearby warm object and thus appear to be warm; however, this does not occur often enough to be significant.

Pavement appears light gray to white (quite warm) in night infrared imagery, because pavement has a good emissivity and is in good thermal contact with the earth, which acts as a constant heat source. The pavement retains more of the heat received from the sun during the day because of its high thermal capacity. This is generally true for all types of pavement, including concrete, asphalt, and blacktop.

Soil. Under normal conditions soil, which includes various types of earth, sand, and rock, appears light gray on night infrared imagery. This results from high emissivity, sun heating during the day, and the high heat capacity of the earth.

Grass appears black (very cold) in night infrared imagery. Grass is unable to draw heat from the earth because of its poor thermal contact with the ground, and it rapidly becomes cold by radiation. For this reason, air temperature at ground level is usually lower at night than at a few feet above ground, a phenomenon known as night inversion of air temperature gradients.

Trees appear medium gray to light gray in tone on night infrared imagery. This tone is believed to be associated with the convective warming of the trees by the air, in conjunction with the night inversion of air temperature. In daytime, the same leaves appear colder than the ground, because the air temperature at treetop height is cooler than at ground level. Shadow areas in the foliage of trees also are cool relative to areas illuminated by the sun.

Water. Under normal circumstances, water ranges in tone from light gray to white on night infrared imagery. This warm tone is the product of its high emissivity and good heat transfer properties. The fluid nature of water allows it to transfer heat by convection as well as by conduction.

The preceding generalizations assume that terrain objects are not artificially heated, i.e., all thermal energy involved arises from sun heating. In this case, the best infrared imagery is acquired under clear skies with no wind. Nonnatural heat sources or man-made sources such as smokestacks, hot transformers, and fires are relatively unaffected in tone by meteorological variables, assuming a clear line of sight.

Some uses of thermal imagery

Experiments have indicated that some plant foliage, especially the leaves of many trees, appears to be similar to black body emitters in the wavelength region of 3.7 to $5.5\,\mu\mathrm{m}$. As a result, leaf temperatures may be remotely measured, or their relative temperatures inferred. Such knowledge can be useful for determining various aspects of plant health, age, and relative water supply or degree of irrigation. In addition, sensors that cover large areas offer the hope of early detection of thermal damage or frost damage to fruit groves.

In the field of geology, infrared imagery is valuable for mapping of seismic fault lines, identification of certain rocks and minerals, conducting of oil surveys, and surveillance of volcanoes. In agriculture, thermal images have been used in identification of crop species and soil types, in detection of crop diseases, in animal censuses, and in determination of the relative moisture content of various soils.

Infrared scanning systems can extract a considerable amount of information from bodies of water. Hot effluents that result in water pollution when discharged into streams or lakes are easily detected because of temperature gradients. In like fashion, cool underground springs that empty into warmer bodies of water may also be discovered through thermal mapping techniques. Critically needed freshwater sources have been found in Hawaii by detailed analysis of thermal surveys.

The two most important advantages of thermal sensors over radar systems are the high spatial resolution achievable with relatively simple designs and the fact that they operate passively (i.e., they do not need to illuminate the ground scene artificially in order to record an image of it). Infrared imagery ideally suited to the detection and mapping of forest fires because of the great contrasts in surface temperatures that accompany such fires. The perimeter and relative intensity of fires, along with the location of separated spot fires, are discernible in daylight or darkness when normal vision from the air is obscured by smoke (Figure 7-4).

Forest fire detection

The function of a forest-fire-detection system is to locate fires before they become large enough to cause significant damage. The general performance requirements for an airborne infrared fire surveillance system have been outlined by Madden (1973). Such a system must:

- 1. Detect a small, latent-stage forest fire in the presence of background temperature extremes.
- 2. Present information in such a way that a photo interpreter can accurately locate the fire.
- 3. Patrol large areas.
- 4. Locate small spot fires adjacent to a large fire.
- 5. Image large fires in such a way that fire perimeters, including smoldering edges and flaming fronts, can be accurately established.
- 6. Locate small, hot fires within a large, burned area during mop-up operations.
- 7. Make near real-time, quality imagery of the area traversed for navigation,

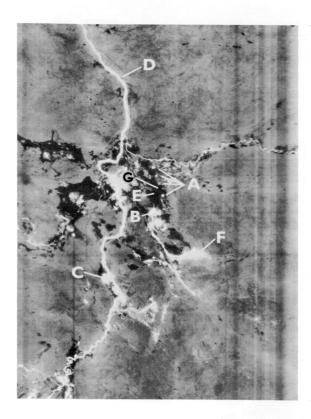

Figure 7-4. Night thermal imagery over Yellowstone National Park. Items marked are: (A) test targets (600°C); (B) Kaleidoscope Geyser; (C) Excelsior Geyser; (D) Fire Hole River (10°C); (E) snowfield (-13.6°C); (F) Hot Lake (52°C); and (G) asphalt road (-9°C). Courtesy Northern Forest Fire Laboratory, U.S. Forest Service.

for in-flight interpretation of fire location, and for fire camp interpretation of a large fire's progress.

The foregoing criteria indicate a need for fire-detection equipment that quickly detects and locates small, latent-stage fires while surveying large forested areas. A system designed by the U.S. Forest Service is shown in Figure 7-5; night infrared imagery of an on-going wildfire is depicted in Figure 7-6.

Capabilities of radar systems

The need for obtaining terrain information accurately under cover of darkness and during adverse conditions has been established during the course of military operations. This requirement is largely fulfilled by radar, a remote sensor that can be used around the clock and in all weather. The term radar is an acronym of the phrase RAdio Detection And Ranging. It is an active system, depending upon the reflection of a radio wave from a distant object. A radio signal is transmitted, and the echo (or signal) reflected from the object is received and processed, providing information about the object, such as its range, direction, and other characteristics.

Radar systems are capable of resolving field patterns and of producing tonal renditions relative to vegetation, drainage, and shoreline features. They can also provide subsurface information and produce the rough equivalent of a photo-reconnaissance mosaic in a single image. Although early radar systems were characterized by poor image resolution, today's

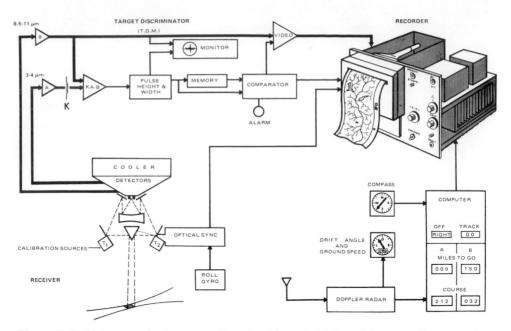

Figure 7-5. Diagrammatic representation of a bispectral infrared fire surveillance system. Courtesy Northern Forest Fire Laboratory, U.S. Forest Service.

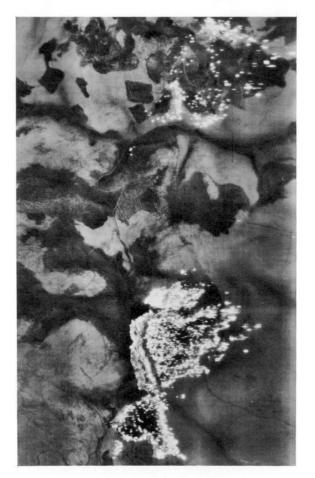

Figure 7-6. Night infrared imagery of a wildfire. Courtesy Northern Forest Fire Laboratory, U.S. Forest Service.

synthetic-aperture microwave systems provide a degree of resolution that approaches that of conventional optical imagery (Figure 7-7).

Radar systems use that portion of the electromagnetic spectrum in which wavelengths are approximately 0.5 cm to more than 100 cm in length. Microwave systems operating at wavelengths longer than 3 cm have the advantage of all-weather, day-or-night capability and are not limited by clouds. Perhaps most important of all, their resolution is not limited by range, an extremely important factor when the distance between the imaging sensor and the scene is great. However, the sizes, power requirements, and complexity of synthetic-aperture radar systems are far greater than those required for optical-frequency equipment.

There are several unique radar capabilities that control display interpretations (Feder, 1960):

- 1. Compositions and conditions below visual rock and soil surfaces can be "read" by analysis of absorbed or modified signal returns.
- 2. Vegetation can be penetrated to yield subsurface information, such as the presence of water under marsh grass.
- 3. The texture of terrain-surface materials down to small gravel size (i.e., as small as one-half the wavelength used) can be imaged. Assuming a radar system that transmits a signal of 0.8 cm wavelength, it is possible to resolve gravel particle interface spacings of one-half this size.

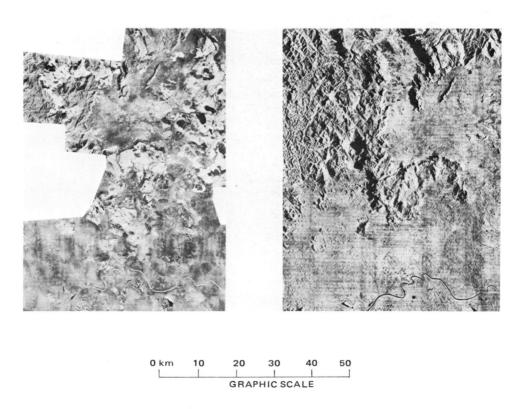

Figure 7–7. Comparison of conventional photography (left) with side-looking airborne radar (SLAR) imagery (right) for an area in Venezuela that is frequently cloud covered. Courtesy Litton Industries and Goodyear Aerospace Corp.

- 4. The moisture content of terrain can be determined when temperature data are available.
- 5. Surface temperature can be determined when the moisture content of terrain materials is known.
- 6. Selected radar bands can be used to read the metallic content of surface and near-surface features. With refined equipment, it is theoretically possible to selectively filter a radar indicator in exploring for iron, bauxite, and the highly ferruginous magnetite sands that commonly also bear titanium, rare earths, and radioactive minerals.
- 7. Terrain properties of snow cover or of features beneath snow cover can be determined.

Radar transmission characteristics

Radar energy travels in straight lines. It moves freely through the atmosphere and through many materials opaque to light. The protective radome which surrounds a radar antenna is made of such a material. Other materials, particularly good electrical conductors, do not permit the passage of radar energy.

Radar images are obtained through microwave energy that is transmitted to the ground by antennas designed to concentrate the energy in a specific beam pattern. The terrain is scanned by the beam, and a portion of the energy is reflected back to an airborne receiver. These echoed signals are displayed on a cathode-ray tube or scope for direct visual interpretation; images may also be continuously recorded on photographic film for later interpretation on the ground.

The narrower the beam width and the shorter the pulse, the smaller the area from which the beam is reflected. The strongest reflections usually occur when the radar beam arrives at right angles to reflecting surfaces. Some materials reflect energy better than others. Of the commonly used structural materials, wood is the poorest reflector and steel the best. Masonry without metal reinforcing is a fair reflector. Lakes, rivers, runways, or similar smooth horizontal terrain features, illuminated by the radar at low angles of incidence, bounce the radar signal as a flat mirror reflects a beam of light, and very little of the radiated energy which strikes them is returned to the radar receiver (Figure 7-8).

One can determine the distance from the radar to an object by measuring the time it takes for a pulse to travel to the object and return and dividing by 2, because the velocity at which the radar pulse travels (speed of light) is constant. The distance so determined is the range from the radar to the target.

Higher frequencies provide better resolution because of their shorter wavelengths. Objects whose dimensions are shorter than one-half of the radar wavelength can rarely be detected.

Plan positive indicator radar

The two general classes of radar displays are referred to as plan positive indicator (PPI) and side-looking airborne radar (SLAR). PPI provides a circular sweep-type display, with the center of the scope representing the position of the aircraft. Images shown in the circle represent terrain features located at varying distances from the transmitter—in all directions to a

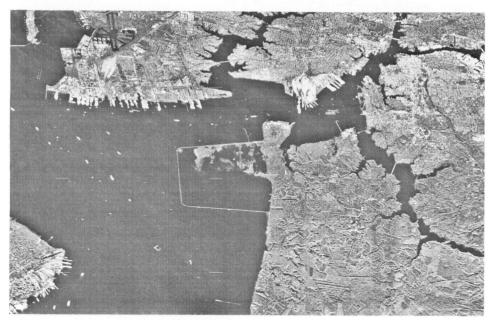

Figure 7-8. SLAR imagery of the Norfolk, Virginia, area. Courtesy Westinghouse Electric Corp.

specified range limit. This range setting is chosen by the operator or established by the design of the equipment. The antenna rotates in a clockwise direction as the transmitted energy is reflected by the terrain features, and detail is recorded on the phosphor-coated scope face by a synchronized electronic trace that duplicates the antenna movement.

The phosphor has a controlled image decay, and the initial portion of the scan retains its characteristics to some extent until the entire 360° rotation is completed. Thus the whole picture is continually visible. This rotation requires a number of seconds, depending on the type of equipment. The aircraft is moving forward during this operation, so each consecutive scan represents a slightly different presentation of detail. Distances can be measured on the presentation by reference to the circular range markers which appear electronically on the indicator. An azimuth ring is mounted around the circumference of the scope so that approximate direction can be determined. Many persons are familiar with PPI radar, because it has been used extensively for military reconnaissance, navigation, air traffic control, and weather forecasting.

Side-looking airborne radar

The basic principles of SLAR systems are the same as those used for PPI radar, except that SLAR generates microwave energy that is transmitted to the terrain in a direction perpendicular to the flight path (Figure 7-9). The time duration between a transmitted pulse and the reception of an "echo" indicates the range of the object, and the amount of energy received indicates the reflectivity of the object.

The simplest SLAR system includes a cathode-ray tube (CRT) upon which a single line is traced for each transmitted pulse. This single line is recorded

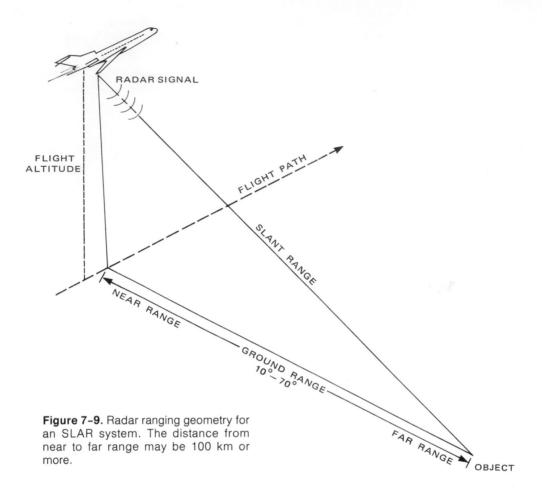

on photographic film as the film is advanced. Successive sweeps of the CRT are recorded in this manner to produce a TV-like raster on the photographic film. If a linear sweep waveform is applied to the CRT, the display will be slant range. To obtain a ground-range display, a hyperbolic sweep waveform must be applied to the CRT.

The photographic records obtained from SLAR systems differ from conventional aerial photography in both the x and y directions. In the direction of the flight line, there is no image displacement due to elevation differences. In the direction perpendicular to the flight line, objects which are higher are displayed closer to the flight lines, whereas in conventional photography higher objects are displaced away from the photo nadir. This difference is illustrated in Figure 7-10 and is a result of the different ways the images are formed. The wavefront of the radar pulse strikes (and is reflected from) the taller object first, and it is therefore recorded as being at a closer range.

The resolution of SLAR is a measure of the minimum separation between two objects that will appear individually on the output imagery. Resolution is described in two directions—as range resolution in the direction of the radiated energy and as azimuth resolution perpendicular to the radiated beam.

Range resolution of SLAR systems is dependent upon pulse duration: the shorter the duration, the better the resolution. The pulse duration cannot be

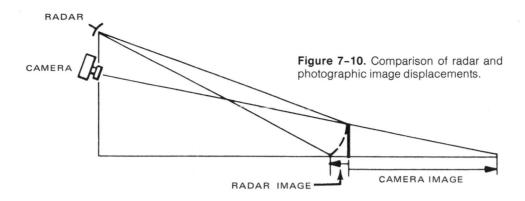

made arbitrarily small, however, because smaller pulse durations require larger peak transmitter power for equal amounts of energy.

Azimuth resolution (along the flight line) is dependent on the beam width of the antenna in some systems; therefore, resolution decreases with range because a larger area of the terrain is illuminated farther away from the flight line. Newer systems known as synthetic-aperture or *coherent* systems employ electronic data-storage and data-processing techniques to achieve azimuth resolution which is fairly independent of range.

Because SLAR operates on the principle of unidirectional "illumination," any surface not illuminated by the beam receives no energy, and hence none can be returned to the system. This void represents a radar shadow, or shadow no-return.

Radar image interpretation

Radar images of the types illustrated here exhibit many similarities to conventional photographic images. However, it must be remembered that the photograph presents an image generated by the visible spectrum and is comparable to the image seen by the human eye looking at the terrain. By contrast, the radar image displays an image generated by the microwave portion of the spectrum. The radar image thus represents the reflectivity characteristics of terrain objects to microwave frequencies. Misinterpretation of images generated with microwave frequencies may occur because objects that appear identical in a photograph may appear completely different at microwave frequencies. The very fact that the objects do appear different in the radar image is the source of the additional unique information available from the radar sensor. Terrain features that are not apparent on the visual photograph often show as pronounced returns on a radar image (Figure 7-11).

Another difference between SLAR imagery and conventional photography is based on the relative position of the aircraft and illumination source with respect to the terrain being imaged. Shadows are presented on photography as a function of both camera position and sun position. Conversely, radar provides its own illumination, and shadows are always created on the side of the object away from the sensor position. The radar is looking at the terrain at a very low incident angle, and the appearance of the shadows in the image is similar to what would be obtained if a camera were aimed vertically down on the terrain, with the sun's illumination striking the terrain at this very low incident angle. Since radar is a ranging device, the compression

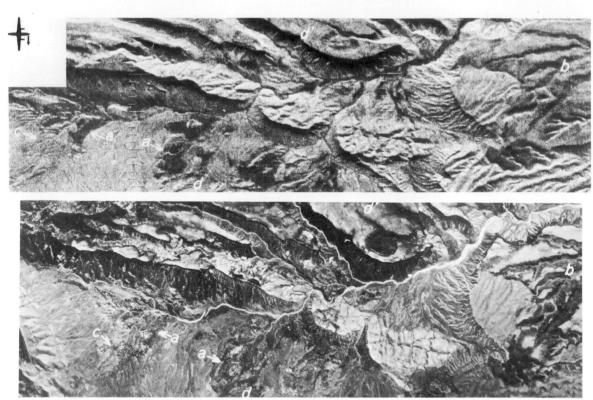

Figure 7-11. SLAR imagery (top) and conventional photography (bottom) of the Cane Springs, Arizona, area. On the radar image, areas a and c contrast with one another and with the more extensive alluvial surface because of differences in surface roughness and dielectric constant. Area a consists of fine-grained dune sand, while area c is characterized by sand mixed with rock fragments.

Lava at b has a uniformly gray scale on radar imagery as opposed to its variable tone on the photograph, because the radar has not recorded the carbonate film characteristic of portions of the lava surface. More pronounced on the radar imagery is the fault (d-d') that bicects the area; enhancement of this feature is due to the absence of signal scattering by the dry, sparse vegetation and the consequent domination of the signal return by terrain characteristics. Courtesy Westinghouse Electric Corp.

of the far range with low oblique viewing angles does not occur as in an angle-dependent device such as the visual camera.

On SLAR imagery, strong or bright signal returns (light tones) are usually indicative of prominent cultural or topographic features. Intermediate energy returns (medium gray tones) may indicate areas of open country or areas of no-return, e.g., the flat and smooth terrain of an airfield. Weaker returns, denoted by black images, commonly indicate the presence of hydrographic features.

Refinements in the identification process may be accomplished by consideration of such image qualities as size, shape, pattern or arrangement, tone, texture, shadows, and relation of images to environment, i.e., location. In a detailed study of image texture, for example, the interpreter might rely upon the patchwork appearance of cultivated field patterns, the characteristic shading effect of bright and dark areas of relief features, and the cardinal point effect of increased brightness of returns from areas where cultural features are predominantly aligned along perpendicular axes.

Where SLAR image scales are carefully determined, approximate measurements of area and distance may be made. And, under certain conditions, the heights of vertical features can be ascertained (La Prade and Leonardo, 1969). Heights of objects are derived from a knowledge of the image scale and the type of sweep employed, i.e., whether slant-range or ground-range sweeps are used.

Imagery from earth satellites

A number of manned spaceflights (e.g., Gemini, Apollo, and Skylab) have provided imagery of the earth as part of their mission objectives. However, the largest proportion of higher-altitude imagery has been obtained through the deployment of unmanned imaging satellites; such satellites (usually on an earth-orbital track) are specifically designed to gather data on weather, military installations, and earth resources in general (Figure 7-12).

Except for some military reconnaissance satellites (see Chapter 15), sensing systems are usually of a nonphotographic configuration; thus ground resolution is often poorer than with purely optical systems. Nevertheless, the synoptic overview and repetitive coverage offered by satellite imagery assure its future for mapmaking and assessment of earth resources.

ERTS/LANDSAT

For civilian interpreters, the earth-orbiting satellites of greatest interest are probably the Earth Resources Technology Satellite (ERTS), launched in 1972 by the National Aeronautics and Space Administration (NASA), and a sister satellite of similar configuration (LAND SATellite, or LANDSAT), placed in orbit during 1975. Others may follow at periodic time intervals, and they will doubtless be identified by different acronyms. Since the two sensor systems are almost identical, they are described here as one and the same.

The scanner satellite operates in a near-polar, circular orbit about 920 km above sea level. It circles the earth every 103 minutes, or fourteen times per day; the pass is from north to south at an angle of 80° retrograde to the equator (Figure 7-13). Each pass covers a region 185 km wide; however, there is some overlap between the preceding and succeeding passes. After eighteen days, or about 252 passes, the satellite returns to the same position. Thus, the earth is imaged, from 82° N latitude to 82° S latitude, every eighteen days. A sun-synchronous orbit was specifically selected for an optimum sun angle. On each north-to-south pass, the satellite crosses the equator at 9:42 A.M. local time.

Sensor systems

The primary remote sensors on board the unmanned satellite are Return Beam Vidicon (RBV) cameras and MultiSpectral Scanners (MSS). The RBV system consists of three cameras, each viewing the same 185-by-185-km area in three different spectral bands.

	Approximate range, in nanometres
Band 1 (blue-green)	475-575
Band 2 (red)	580-680
Band 3 (near-infrared)	690-830

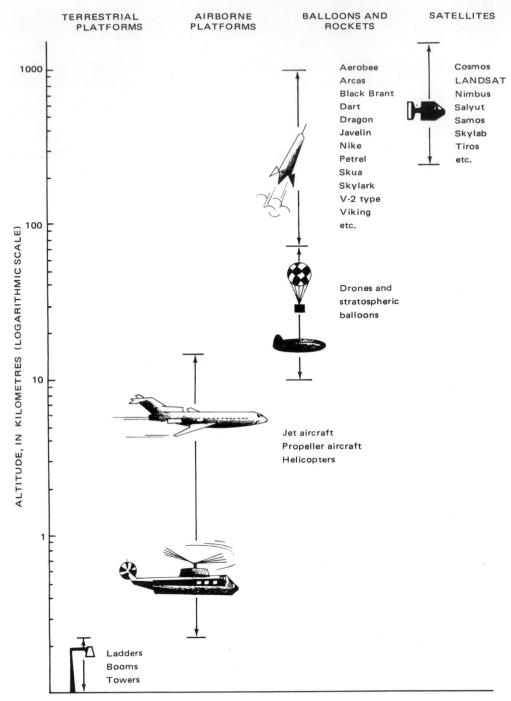

Figure 7–12. Approximate operating altitudes for various remote sensing platforms; such information changes rapidly with technological advances. Adapted from Aldred (1972).

RBV cameras do not contain film. Stored on photosensitive surfaces within each vidicon camera are images which are scanned by an internal electron beam, producing a video picture. Both RBV and MSS images are converted to digital codes and transmitted to earth by electronic means. Then, they may be imaged onto photographic film or interpreted electronically.

The MSS sensor system covers the same ground area as the RBV in four wavelength bands.

	Approximate range, in nanometres
Band 4 (green)	500-600
Band 5 (red)	600-700
Band 6 (near-infrared)	700-800
Band 7 (near-infrared)	800-1,100

RBV and MSS images are available at contact scale (1:3,369,000) on 70-mm film or as positive prints (about 18 by 18 cm) enlarged to a scale of 1:1,000,000. Images can be produced in black and white or as color composites. Ground resolution is a matter subject to considerable debate, but some researchers claim that objects 90 m in diameter or linear features only 15 m wide are easily identified.

Reproductions of imagery may be obtained from several sources. Two of these are:

ASCS-USDA 2511 Parley's Way Salt Lake City, Utah 84109 EROS Data Center U.S. Geological Survey Sioux Falls, South Dakota 57198

Figure 7–13. A typical daily ground trace for orbital satellites of the ERTS/LANDSAT type. Shown are daylight passes only. Courtesy National Aeronautics and Space Administration.

Annotations printed around each image frame list the type of sensor, the band (wavelength) number, the time of exposure, the orbit number, the subangles, the spacecraft heading, the spacecraft altitude, and ground receiving site identification. Several frames are illustrated in this chapter (Figures 7-14 through 7-18).

Automatic image interpretation

The continuing development of nonphotographic sensors which transmit coded data in the form of electronic signals has led to an increased reliance on automated image interpretation. In fact, the sheer volume of image information supplied by reconnaissance satellites makes some forms of automation essential. As a result, the National Research Council (1974) has recommended "that earth resource data processing be converted to all-digital techniques and that the primary archival medium be digital storage." It is evident that automated interpretation techniques will continue to play the dominant role in the analysis of nonphotographic imagery.

Early tests of automatic scanning and pattern recognition equipment have indicated a reliability of about 80 percent in recognition of four basic terrain classes, namely, water, cultivated lands, trees, and urban areas. Further developments in optics-electronics research will probably permit the image interpreter to shift many routine tasks such as land-use classifications to analytically programmed scanning-recording devices. When one considers the single task of analyzing satellite imagery from repetitive coverage of military target areas, the potential value of automatic interpretation systems becomes obvious.

Automatic extraction of information from aerial imagery may be based on (1) scanning systems that search for images having specific shapes and sizes or (2) measurements of textural parameters that indicate density contrasts in the image. Objects such as vehicles, airfields, or storage tanks possess characteristics that are conducive to the use of recognition systems based on size and shape. Terrain types, agricultural crops, and land-use patterns are features that are more likely to be classified according to textural differences, i.e., differences in density as "read" from image-scanning records or digitized data output. Multichannel imagery offers the greatest potential for automated classification of terrain features and vegetation (Figure 7-19).

In recognition of terrain types through automated analysis of image texture, an obvious requirement is that differences in tone or image contrast between terrain classes be greater than differences occurring within a given category. As a result, elementary scanning experiments are aimed toward the differentiation of such obvious features as water, cultivated fields, pastures, and forests. Among devices that show promise for land-use classification is the microdensitometer. The technique of microdensitometry involves measuring either the reflection or transmission density of microscopically small image areas. Automatically recorded results may be presented graphically on a chart or in digitized form for computer reduction and analysis.

Even though tests of automated scanning systems show great promise, there is no immediate prospect of the human photo interpreter's becoming obsolete. Certain scientific image interpretation problems which involve simple images may have practical solutions at today's level of recognition technology. But the fully automatic interpretation of reconnaissance imagery is perhaps a reality only for classified military systems.

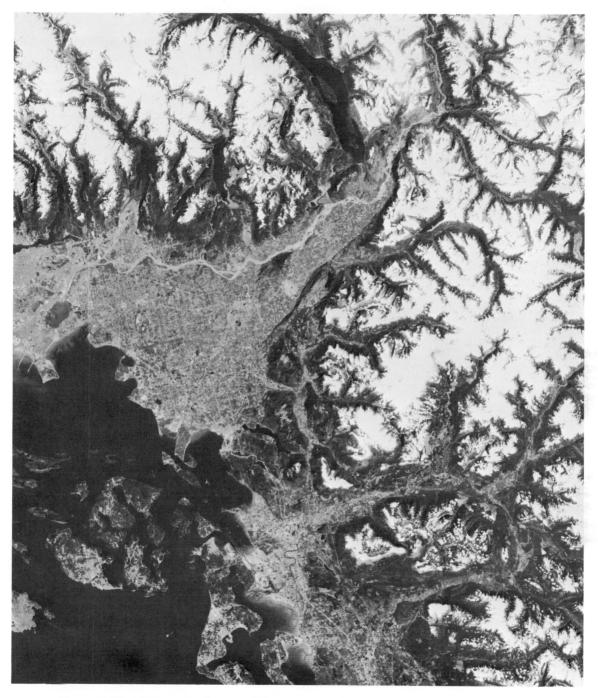

Figure 7-14. MSS satellite image of Vancouver, Canada, with snow at higher elevations. Scale is about 1:1,000,000. Courtesy U.S. Geological Survey.

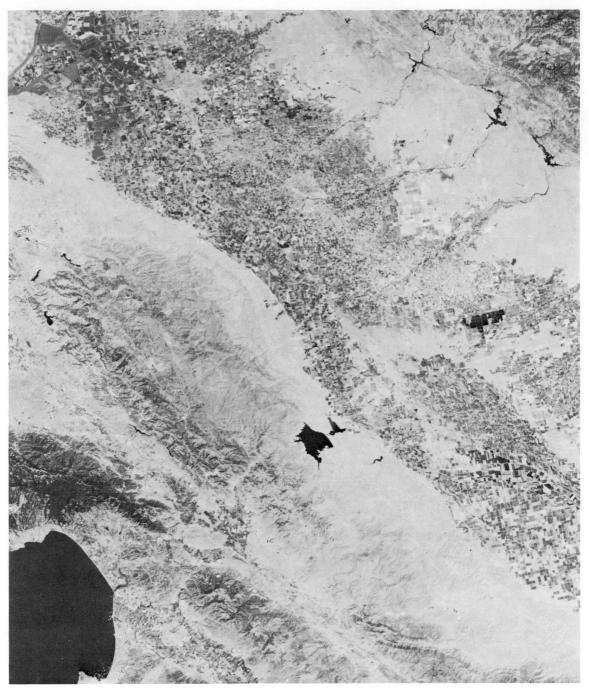

Figure 7–15. MSS (band 5) satellite image of central California. Scale is about 1:1,000,000. Compare with *Plate* 7 and *Figure* 7-16. Courtesy U.S. Geological Survey.

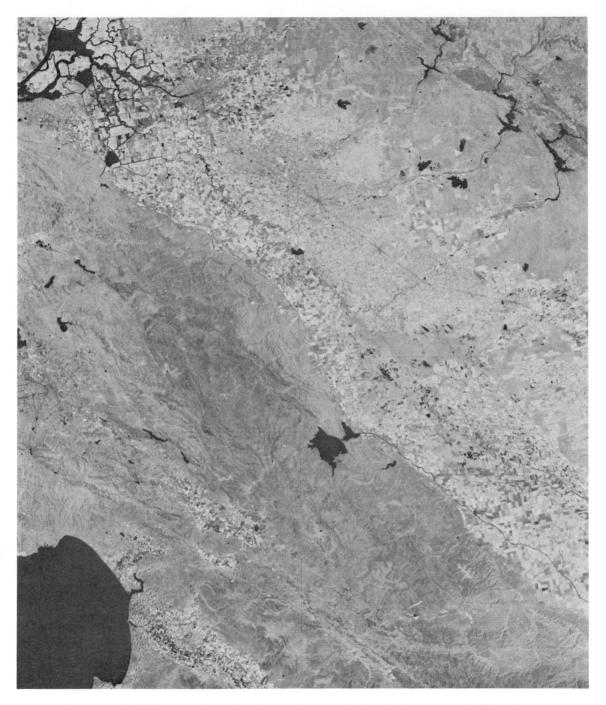

Figure 7-16. MSS (band 7) satellite image of central California. Compare with *Plate* 7 and *Figure 7-15*. Courtesy U.S. Geological Survey.

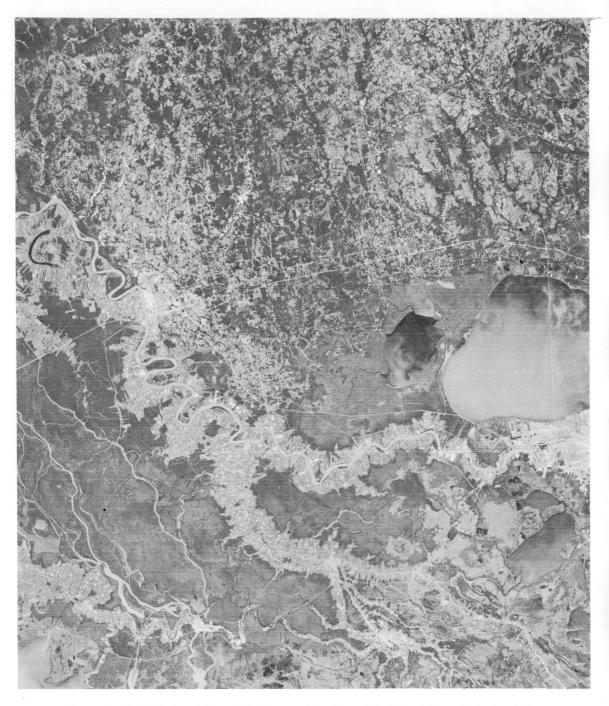

Figure 7-17. MSS (band 5) satellite image of the lower Mississippi River, including Baton Rouge, New Orleans, and Lake Pontchartrain (largest lake). Scale is about 1:1,000,000. Compare with *Figure 7-18*. Courtesy U.S. Geological Survey.

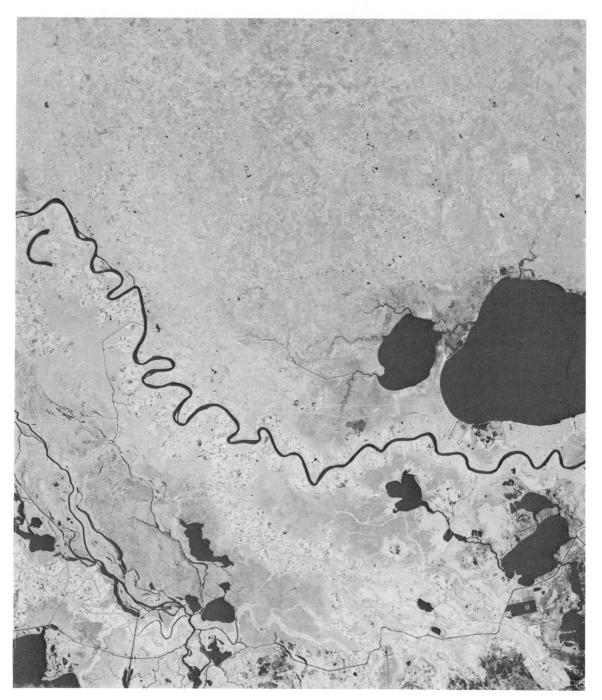

Figure 7-18. MSS (band 7) satellite image of the lower Mississippi River (same view as *Figure 7-17*). Courtesy U.S. Geological Survey.

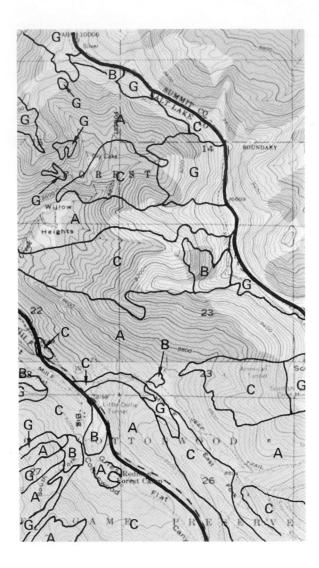

Figure 7-19. Automatic classification of vegetation from MSS imagery. Types are aspen (A), nonvegetation (B), conifers (C), and grass (G). Scale is about 1:36,000. Courtesy Earth Information Services, McDonnell-Douglas Corp.

Problems

- 1. Obtain comparative photographic, thermal, and SLAR imagery of a test area in your region. Beginning with what you regard as the lowest-quality imagery, delineate principal hydrographic features, prominent man-made structures, landforms, vegetative types, agricultural areas, and so on. Then prepare a brief written report of your findings.
- 2. Obtain comparative earth-satellite imagery and conventional optical imagery of a local area. Beginning with the satellite imagery, attempt to classify the dominant terrain features, agricultural patterns, and vegetation types. Repeat the process with aerial photography. Then prepare transparent overlays from each set of imagery for a graphical comparison of results. Verify results by ground checks wherever feasible.

References

Aldred, A. H. 1972. World participation in remote sensing from space. Canadian Forestry Service, Ottawa. 20 pp., illus.

Anonymous. 1967. Side look radar. Westinghouse Electric Corporation and National Aeronautics and Space Administration, Washington, D.C. 46 pp., illus.

Barr, David J., and Robert D. Miles. 1970. SLAR imagery and site selection. Photogrammetric Engineering 36:1155-70, illus.

Bastuscheck, C. P. 1970. Ground temperature and thermal infrared. Photogrammetric Engineering 36:1064-72, illus.

Berlin, G. Lennis, and Gerald G. Schaber. 1971. Geology and radar mosaics. Journal of Geological Education 19:212–17, illus.

Feder, Allen M. 1960. Interpreting natural terrain from radar displays. Photogrammetric Engineering 26:618-30, illus.

Fitzgerald, Ken. 1970. The space-age photographic atlas. Crown Publishers, New York. 246 pp., illus.

Hempenius, Sikke A. 1969. Wall chart of image formation techniques for remote sensing from a moving platform. International Training Centre, Enschede, The Netherlands. 15 pp., illus.

Hirsch, Stanley N. 1971. Application of infrared scanners to forest fire detection. Proceedings of the International Workshop on Earth Resources Survey Systems, Government Printing Office, Washington, D.C., pp. 153–68, illus.

——. 1965. Infrared line scanners—A tool for remote sensing of forest areas. Proceedings of the Society of American Foresters, Detroit, 169–72, illus.

Koopmans, B. N. 1975. Variable flight parameters for SLAR. Photogrammetric Engineering 41:299-305, illus.

Kristof, S. J., and A. L. Zachary. 1974. Mapping soil features from multispectral scanner data. *Photogrammetric Engineering* 40:1427–34, illus.

LaPrade, George L., and Earl S. Leonardo, 1969. Elevations from radar imagery. Photogrammetric Engineering 35:366-77, illus.

Madden, Forrest H. 1973. Performance requirements for airborne infrared forest fire surveillance equipment. U.S. Forest Service, Intermountain Forest and Range Experiment Station. Research Note INT-167, 7 pp., illus.

Maugh, Thomas H., II. 1973. ERTS: Surveying earth's resources from space. Science 180:49-51, illus.

———. 1973. ERTS (II): A new way of viewing the earth. Science 180:171–73, illus.

Murtha, P. A. 1972. Thermal infrared line-scan imagery for forestry? Forest Management Institute, Canadian Forestry Service, Ottawa. Information Report FMR-X-45, 46 pp., illus.

National Aeronautics and Space Administration. 1968. Exploring space with a camera. Government Printing Office, Washington, D.C. 214 pp., illus.

National Research Council. 1974. Remote sensing for resource and environmental surveys: A progress review. National Academy of Sciences, Washington, D.C. 101 pp., multilithed.

Rib, Harold T., and Robert D. Miles. 1969. Automatic interpretation of terrain features. Photogrammetric Engineering 35:153-64, illus.

Sabins, Floyd F., Jr. 1973. Recording and processing thermal IR imagery. Photogrammetric Engineering 39:839-44, illus.

Thorud, David B., and Peter F. Ffolliott. 1973. A comprehensive analysis of a major storm and associated flooding in Arizona. University of Arizona Agricultural Experiment Station. Technical Bulletin 202, 30 pp., illus.

U.S. Departments of the Army, the Navy, and the Air Force. 1967. Image interpretation handbook, Vol. I. Government Printing Office, Washington, D.C. 7 chapters plus appendix, illus.

Welch, R. 1971. Earth satellite camera systems: Resolution estimates and mapping applications. *Photogrammetric Record* 7(38):237-46, illus.

Chapter 8

Land Information Systems and Land-Cover Mapping

Planning phases

The process of land-use planning may be arbitrarily divided into four chronological phases:

- Awareness and organization: The recognition that a problem exists and that detailed studies based on specific objectives will be required for successful planning.
- 2. **Inventory:** The collecting, collating, reporting, and analyzing of information on land and natural resources.
- 3. **Decision making:** Consideration of alternatives, evaluation of impacts of proposed actions, and resolution of land-use conflicts.
- 4. Action: The converting of plans to action programs in land-use management.

On the assumption that most governments have at least reached some stage within the first phase, this chapter is largely devoted to the second step, i.e., state or regional land information systems and land-cover mapping. Before we can manage our land resources effectively and plan for the future,

we must first understand the land-use patterns of past and present. And, to do this, we need vast amounts of information on land resources and related socioeconomic factors. Without a systematic means of tabulating, reporting, and updating land resource information, decision makers will realize that a nonstandard data base leads to inconsistencies or anomalies in the planning process—the very result that good planning attempts to avoid!

The need for land resource information

Land resources may be considered to include the surface, subsurface, and supersurface features of the earth as these affect the activities and environment of humans. These resources include soils, minerals, water, climate, and other earth features to the extent that they can be observed, classified, and spatially fixed.

In the years ahead, governments and planning commissions will need increasingly detailed knowledge of land resources, both in their natural aspects and as affected by humans, to guide public and private decisions. Shortages of natural resources and conflicts in land use attract worldwide attention, especially when societal pressures upon limited resources are accelerating. It is now recognized that the physical and economic supply of land resources is decreasing—at least in relation to continued impacts and demands. A major step toward assuring improved management of existing land resources is to make land information more accessible. This requires the systemization and storage of what is known and the provision for rapid information retrieval in forms acceptable to a broad array of users.

Technical characteristics of land information systems are given primary consideration here. The more philosophical questions relating to the sponsorship of, financing of, user access to, and control of such systems are left to the political scientist. However, it might be noted that the government unit or individual that has primary access to land information will also have an advantage in controlling land use. Hopefully, most regional systems will be designed for and accessible to all citizens, particularly those with decision-making responsibilities.

Features of land information systems

In the United States, almost every public agency has based its reports, maps, and related land resource data on a different format—and with different resource classification schemes. The need for a standardized data base is painfully obvious, and it will become a prime requisite as agencies face up to their land informational planning needs.

A major problem in establishing a regional land information system is that of assembling the desired data and then restructuring it to a standardized, computer-compatible format. A large amount of existing resource data is available, but it is rarely in a form that can be automatically computer coded and geographically referenced to a designated land area. The initial investment in labor required for standardization or reclassification of existing data will hopefully stimulate reporting agencies to perform this task themselves for future computer inputs and updating.

An information system can consist of a single map or a one-person filing cabinet operation. Or it might be comprised of a complex array of people and

machines costing millions of dollars. Any reliable system designed to serve its users must be capable of:

- 1. Accepting data inputs, including updated information, in one or more formats (e.g., digitized maps, tabulations, etc.).
- 2. Storing and maintaining information.
- 3. Processing data (search and retrieval, computations, etc.).
- 4. Presenting data outputs in one or more formats (e.g., tabulations, video displays, or computer maps).

An ideal system would be designed to serve a wide diversity of users; furthermore, it would be capable of continuous updating as new or supplementary land resource data became available. In view of the large volumes of land information potentially available, it is not surprising that most systems rely heavily on high-speed computers, digitized maps, and remote sensing technology (Figure 8-1).

Data bank interrogations

Initial inputs into a land resource data bank are physical resources data, often extracted directly from existing maps, aerial photographs, or satellite imagery. A large proportion of this kind of data base is location specific, measurable, and subject to scientific classification. If each category of land information is visualized as composing an overlay for a given base map, then each class of input data can be extracted for a specified locale. The computer search for such geographically referenced data is analogous to that of passing a needle through each map overlay (Figure 8-2).

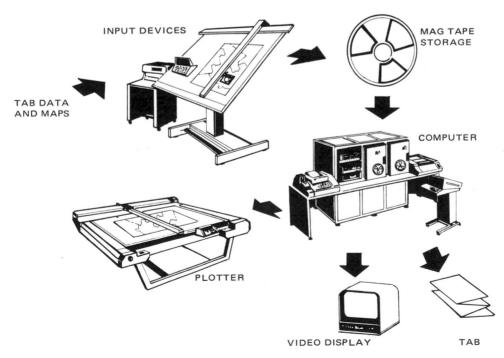

Figure 8-1. Schematic representation of a land information system. Courtesy Project LIST, Texas A & M University.

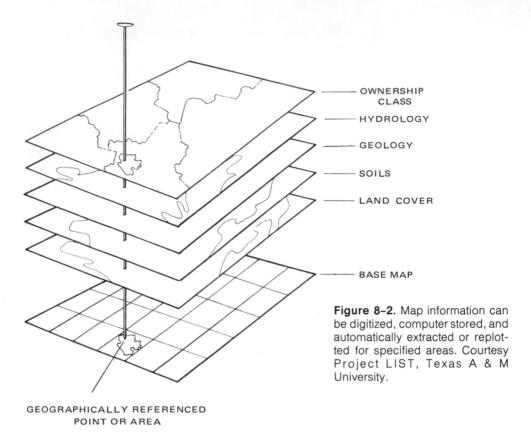

Following are a few examples of the types of questions that might be posed by land managers or planners:

- 1. What is the area of agricultural (arable) land in the southwest quadrant of the state that is not under cultivation? How much of this land could be irrigated, if irrigation were desired?
- 2. What is the area of eroded or understocked land that should be planted to trees? Is the annual precipitation adequate for the species being considered? Will some lands require site preparation? If so, which lands?
- 3. Which land areas within a 30-km radius of Capital City have expansive soils, poor internal drainage, or other characteristics that make them unsuitable for housing or industrial development?
- 4. What is the surface use of the land where the state has retained the mineral rights? Who owns the surface? How much land area is involved?
- 5. Where are the best sites for new industrial parks, regional airports, and major power plants?

Can a land information system provide useful answers to these questions? Certainly a data bank would prove helpful, if user questions could be anticipated so that pertinent resource information were available for computer storage. No system will have all the answers, for it would be impossible to envision all the questions and collect essential data in advance. As previously noted, most systems begin with simple land resource data and gradually add social or economic values as they become available and are requested by users.

Land use and land cover

Current land use or land cover constitutes a prime data base for all comprehensive land information systems. The two expressions are not necessarily synonymous. For example, the land cover for a given area might be classed as deciduous forest when the actual use is that of a wildlife refuge or mining operation (Figure 8-3). The distinction between the two terms is particularly important when such information is interpreted from aerial imagery.

Classification systems for description of land use and land cover have been the subject of extensive studies and symposia in Anglo-America. The outgrowth of this research has been the development of a recommended national system for the classification of land use and land cover from remote sensor data (Anderson et al., 1976).

Terminology and classification systems

The development and implementation of any rational land-use/land-cover classification system is fraught with difficulties. The planner or decision maker is primarily interested in land use, while information derived from remote sensor data is likely to represent land cover. When use and cover are not coincidental, expensive ground surveys may be required for reconciliation of differences, i.e., for ascertainment of the functions of observed patterns.

In any classification system, problems arise from differences in terminology. For example, the terms *cultivated*, *arable*, and *cropland* do not necessarily convey the same meaning to all image interpreters—nor to planners and user groups (Nunnally and Witmer, 1970). Furthermore, a single term such as open or *idle* may or may not include fallow cropland, abandoned land, or unimproved rangeland. Even though all classification schemes attempt to avoid such ambiguities, few have been entirely successful in this respect.

Classification systems attempt to group similar land-use/land-cover patterns in a rational linkage or hierarchy based on common attributes. A methodical classification system can be developed only through the establishment of hierarchies of classes, and such classes also permit inductive generalizations. One unfortunate feature of the "logical division" approach is that all possible features must be included; therefore the end result invariably includes a catch-all miscellaneous or other category.

Many attempts have been made to standardize land classifications, but no one system appears to be acceptable to all users. The hierarchical system devised by the Geological Survey (Anderson et al., 1976) represents the closest approach to a national system that has yet been proposed. Much of the remainder of this chapter is devoted to that system; for convenience it is referred to herein as the USGS system.

Features of the USGS system

This hierarchical system incorporates the features of several existing classification systems that are amenable to data derived from remote sensors, including imagery from satellites and high-altitude aircraft. The system at-

tempts to meet the need for current overviews of land use/land cover on a basis that is uniform in categorization at the generalized first and second levels. It is intentionally left open-ended so that independent agencies may have flexibility in developing more detailed land-use classifications at the third and fourth levels. Such an approach will permit various agencies to meet their particular needs and at the same time remain compatible with each other and with the national system (*Table 8-1*).

Table 8-1. Land-Use and Land-Cover Classification System for Use with Remote Sensor Data*

_	Level I (and map color)	Level II
1	Urban or built-up land (red)11	Residential
		Commercial and services
	13	Industrial
	14	Transportation, communications, and
		utilities
	15	Industrial and commercial complexes
		Mixed urban or built-up land
		Other urban or built-up land
2	Agricultural land (light brown) 21	
		Orchards, groves, vineyards, nurseries,
		and ornamental horticultural areas
	23	Confined feeding operations
		Other agricultural land
3	Rangeland (light orange)	
	32	Shrub and brush rangeland
		Mixed rangeland
4	Forest land (green)41	Deciduous forest land
		Evergreen forest land
		Mixed forest land
5	Water (dark blue)51	Streams and canals
		Lakes
		Reservoirs
	- E1	Paya and actuaries
6	Wetland (light blue)61	Forest wetland
	62	Nonforested wetland
7	Barren land (gray)71	
		Beaches
	73	Sandy areas other than beaches
	74	Bare, exposed rock
		Strip mines, quarries, and gravel pits
		Transitional areas
		Mixed barren land
8	Tundra (green-gray)81	
		Herbaceous tundra
		Bare ground tundra
		Wet tundra
		Mixed tundra
9	Perennial snow or ice (white) 91	
		Glaciers

^{*}Level I is based primarily on surface cover; level II is derived from both cover and use. Color codes are based on recommendations of the International Geographical Union.

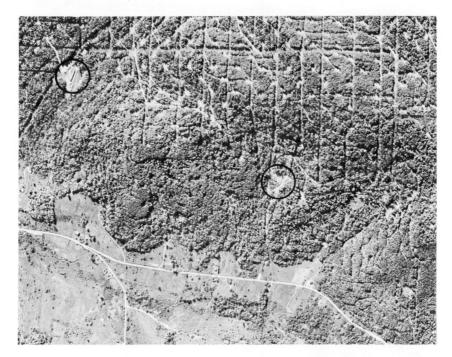

Figure 8–3. This quiltlike pattern of trees and small clearings connected by roads is an oil field in McKean County, Pennsylvania. Two pumping stations are encircled. The difference between older and newer drillings is shown by the regrowth of vegetation. Scale is 1:20,000. Courtesy U.S. Department of Agriculture.

The types of land-use and land-cover categorization developed in the USGS classification system can be related to systems for classification of land capability, vulnerability to certain management practices, potential for any particular activity, or land value, either intrinsic or speculative. The functions which lands currently fill will usually be associated with certain types of cover, e.g., forest, agricultural, or urban. Thus, the image interpreter attempts to identify land-cover patterns and shapes as a means of deriving information about land use (Figure 8-4).

Classification criteria

According to the USGS, a land-use/land-cover classification system which can effectively employ orbital and high-altitude remote sensor data should meet the following criteria:

- 1. The minimum level of interpretation accuracy in the identification of land-use and land-cover categories from remote sensor data should be 85 percent.
- 2. The accuracy of interpretation for the several categories should be about equal.
- 3. Repeatable or repetitive results should be obtainable from one interpreter to another and from one time of sensing to another.
- 4. The classification system should be applicable over extensive areas.

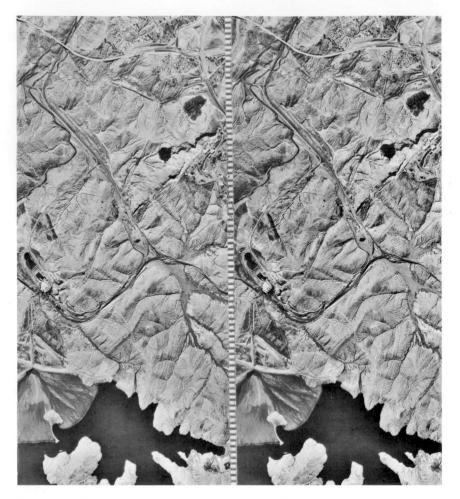

Figure 8-4. Stereogram of a copper-mining area in Tennessee. Most of the vegetation has been killed by smelter fumes, resulting in a barren landscape. Courtesy Tennessee Valley Authority.

- 5. The categorization should permit vegetation and other types of land cover to be used as surrogates for activity.
- 6. The classification system should be suitable for use with remote sensor data obtained at different times of the year.
- 7. Effective use of subcategories that can be obtained from ground surveys or from the use of larger-scale or enhanced remote sensor data should be possible.
- 8. Aggregation of categories must be possible.
- 9. Comparison with future land-use data should be possible.
- 10. Multiple uses of land should be recognized when possible.

For land-use and land-cover data needed for planning and management purposes, accuracy of interpretation at the generalized first and second levels is satisfactory when the interpreter makes the correct interpretation 85 to 90 percent of the time. Except for urban and built-up areas, this can often be achieved with satellite imagery. For regulation of land-use activities or for

tax assessment purposes, for example, greater accuracy may be required. And greater accuracy will normally imply higher cost factors.

The problem of classifying multiple uses occurring on a single parcel of land is not easily solved. Multiple uses may occur simultaneously, as in the instance of agricultural land or forest land being used for recreational activities, hunting, or camping. Uses may also occur alternately, as would be the case with a major reservoir that provided flood control during spring runoff and generated power during winter peak demand periods. All of these activities would not be detected on a single aerial image; thus the selected categorization may be necessarily based on the dominant or apparent use on the date of the sensor image (Figure 8-5).

Vertical arrangements of land uses above or below terrain surfaces produce added complexities for image interpreters. Mineral deposits under croplands or forests, electrical transmission lines crossing pastures, garages underground or on roofs of buildings, and subways beneath urban areas all exemplify situations which must be resolved by individual users and compilers of land-use data.

Figure 8-5. Stereogram of a section along the Mississippi River in Concordia Parish, Louisiana. Land use is predominantly agricultural, but the housing and boat docks along one shoreline would likely be classed as urban-residential or urban-recreational. Scale is about 1:24,000. Courtesy U.S. Geological Survey.

Minimum areas and image resolution

The minimum area that can be classified as to land use/land cover depends on (1) the scale and resolution of the original sensor image or data source, (2) the scale of data compilation or image interpretation, and (3) the final scale of the land-use information or map. When maps comprise the final data format, it is difficult to delineate and symbolize any map area smaller than 0.25 to 0.5 cm on a side. Actual ground area represented by such parcels will, of course, depend on the scale of the map.

A wide variety of remote sensing systems and imagery can be utilized for the different levels of land-use/land-cover classifications. Each sensor provides a degree of image resolution that is dependent upon flight altitude and effective focal length (or scale). For example, assuming a focal length of 15 cm, the following flight altitudes and image scales would be appropriate when manual (nonautomated) interpretation is anticipated.

Classification level	Sensor platform or altitudes	Approximate range of image scales
	Earth satellites	1:500,000 to 1:3,000,000
	9,000–12,000 m	1:60,000 to 1:80,000
	3,000–9,000 m	1:20,000 to 1:60,000
V	1,200–3,000 m	1:8,000 to 1:20,000

It should be stressed that the foregoing recommendations are approximate guidelines and not absolutes. With future technological advances, such tabulations will need to be revised. In fact, the entire classification system may undergo a complete metamorphosis as greater dependence is placed on automatic data analysis and automatic image interpretation.

Expanded classifications

One of the primary virtues of a hierarchical classification system is that it is structured for developing categories at more detailed levels. This feature also permits subsequent aggregation or disaggregation of land units without difficulty.

The USGS system is aimed at complete standardization at levels I and II only. Users of the system are encouraged to develop their own subcategories for levels III and IV. Following is an example of how residential land might be subdivided in a level III classification.

Level I	Level II	Level III
1 Urban or built-up land	11 Residential	111 Single-family units 112 Multifamily units 113 Group quarters 114 Residential hotels 115 Mobile home parks 116 Transient lodgings 117 Other

This particular breakdown of residential land employs criteria of capacity, type, and permanency of residence as the discriminating factors among classes. Criteria applied to other situations could possibly include density of dwellings, tenancy, age of construction, etc. Such a level III categorization would require use of supplemental information, i.e., data not wholly discernible from remote sensor imagery alone.

For detailed definitions of all level I and level II classifications, the reader is referred to Anderson et al. (1976).

Map codes and symbols

Sample maps based on the USGS classification system are presented in Figures 8-6 through 8-9. It will be noted that the various classifications are ordinarily coded numerically, with one to four digits, in accordance with the level of interpretation. This type of map coding is usually more economical of space than lettered codes, but either technique is acceptable.

Land-use/land-cover maps are often produced in the form of transparent overlays at the same scale as existing planimetric or topographic quadrangle maps. By this procedure, it is possible to avoid excessive cluttering of overlay detail, since major transportation routes, power lines, and prominent cultural features are already symbolized on the underlying base map. Some of the more common map symbols used in North America are shown in Figure 8-10.

Land-use data and analysis program

This USGS program, often termed LUDA, is aimed at providing a comprehensive collection of land-use/land-cover data for the United States. Products to be offered by the LUDA program are:

- Maps at 1:250,000 scale showing present land use and land cover at level II. For each of the land-use/land-cover maps produced, overlays will be compiled to show federal land ownership, river basins and subbasins, counties, and census county subdivisions.
- Selected experimental demonstration maps at 1:24,000 or 1:50,000. These
 will show how land-use and land-cover mapping at a regional scale such
 as 1:250,000 can be related to more detailed land-use and land-cover
 mapping at larger scales.
- 3. Computerized graphic displays and statistical data on current land use and cover.

Additional information on the status of land-use/land-cover mapping and the availability of current data may be obtained from:

Chief Geographer U.S. Geological Survey National Center Reston, Virginia 22092

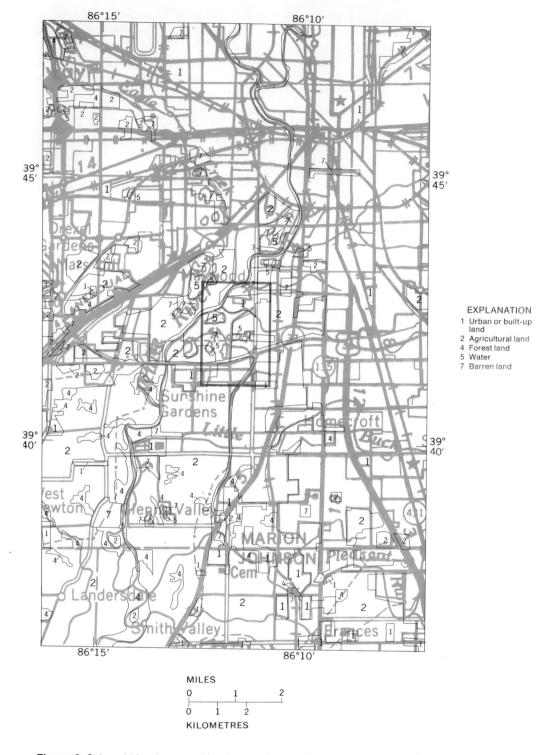

Figure 8-6. Level I land use and land cover in an enlarged part of the northeast quarter of the Indianapolis, Indiana-Illinois 1:250,000 quadrangle. The area outlined in the center of the map corresponds to the Maywood area shown in *Figures 8-8* and *8-9*. Polygons that are not numbered (near edges of map) are those that extend to adjacent map sheets. Courtesy U.S. Geological Survey and from Professional Paper 964 (Anderson *et al.*, 1976).

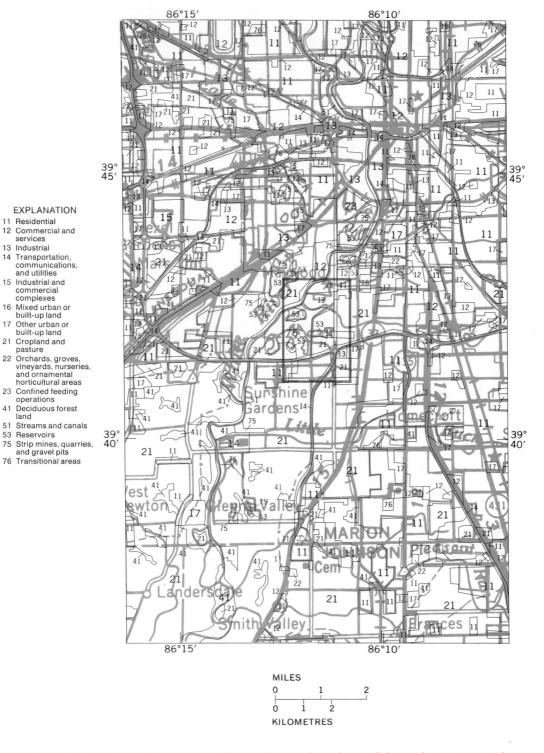

11 Residential

13 Industrial 14 Transportation,

and utilities 15 Industrial and commercial complexes 16 Mixed urban or built-up land Other urban or built-up land 21 Cropland and pasture

operations

53 Reservoirs

and gravel pits

41

Figure 8-7. Level II land use and land cover in an enlarged part of the northeast quarter of the Indianapolis, Indiana-Illinois 1:250,000 quadrangle. The area outlined in the center of the map corresponds to the Maywood area shown in Figures 8-8 and 8-9. Polygons that are not numbered (near edges of map) are those that extend to adjacent map sheets. Courtesy U.S. Geological Survey and from Professional Paper 964 (Anderson et al., 1976).

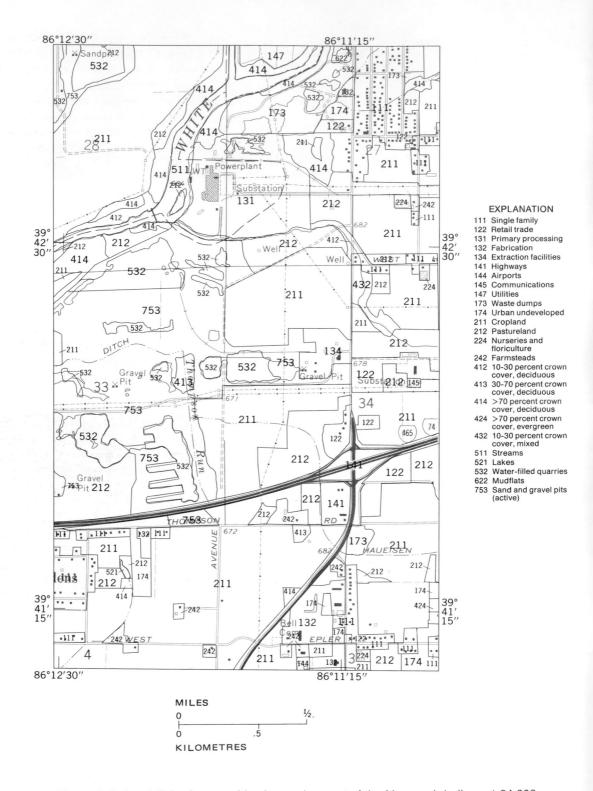

Figure 8-8. Level III land use and land cover in a part of the Maywood, Indiana, 1:24,000 quadrangle. Polygons that are not numbered (near edges of map) are those that extend to adjacent map sheets. Courtesy U.S. Geological Survey and from Professional Paper 964 (Anderson *et al.*, 1976).

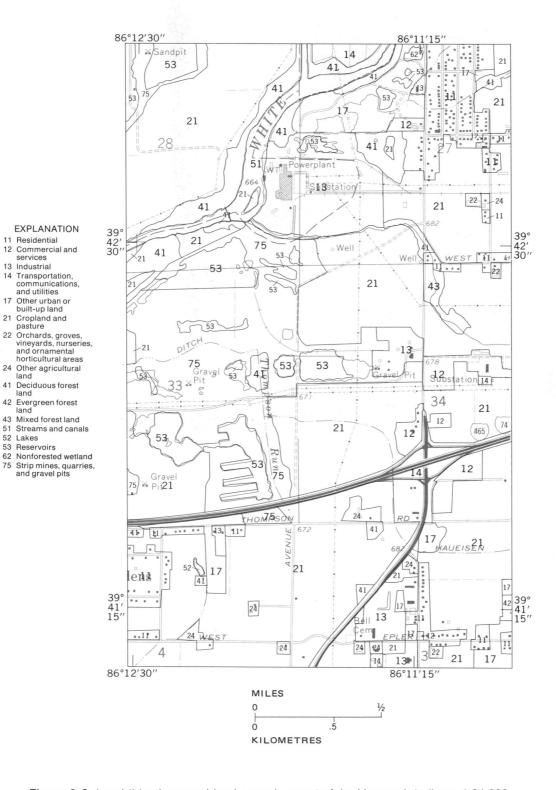

11 Residential

13 Industrial 14 Transportation,

land

land

52 Lakes 53 Reservoirs

41

and utilities Other urban or built-up land Cropland and pasture

Figure 8-9. Level II land use and land cover in a part of the Maywood, Indiana, 1:24,000 quadrangle. Polygons that are not numbered (near edges of map) are those that extend to adjacent map sheets. Courtesy U.S. Geological Survey and from Professional Paper 964 (Anderson et al., 1976).

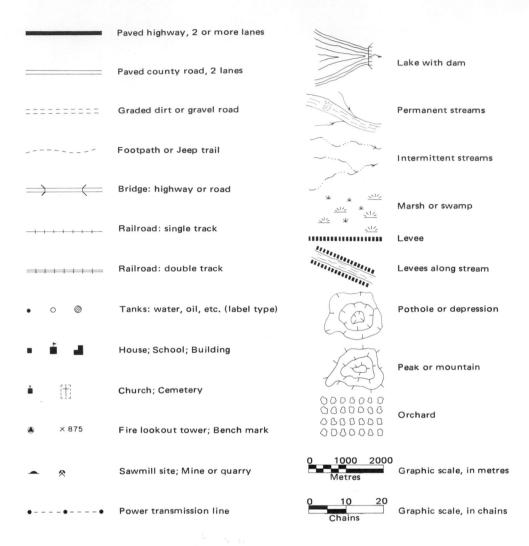

Figure 8-10. Common map symbols.

Land-use changes

In an analysis of the economic development of any area, land use provides one of the more valuable indicators of rural, urban, and industrial growth. Sequential aerial imagery makes it feasible for a trained interpreter to evaluate land-use patterns at two or more distinct points in time (Figures 8-11 and 8-12). Comparative coverage in the form of conventional photography is available for many sections of Anglo-America; some of these exposures date back to the early 1920's. And, since 1972, satellite imagery has been obtained at periodic intervals.

Land-use/land-cover classifications at levels I and II are usually adaptable for evaluation of past changes in land use. Problems arise when more detailed breakdowns are desired, because reliable ground checks cannot be made for the older sets of imagery; such verifications may require extensive supplementary surveys, including personal interviews with local residents.

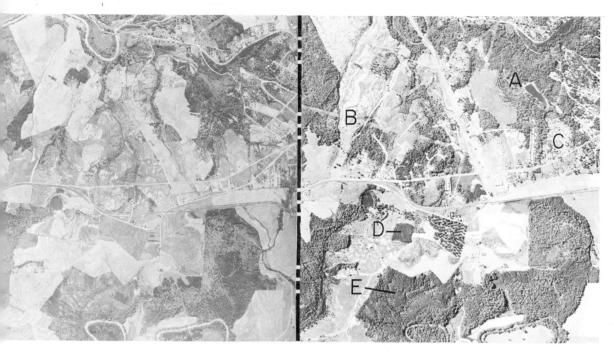

Figure 8–11. Rural area photographed before and after an interval of sixteen years. Among changes evident on the right exposure are: (A) a new pond; (B) a cleared right-of-way; (C) a new residential area; (D) a pine plantation; and (E) reversion of an abandoned field to forest land. Scale is about 1:24,000. Courtesy U.S. Department of Agriculture.

Significance of land-use patterns

The varieties of tones, patterns, and spatial arrangements depicted on aerial photographs reflect the combined works of nature and the cultural patterns of humankind. Human activities in settling, cultivating, mining, and exploiting various land resources have left characteristic marks upon the earth's surface. Many of the telltale markings are unattractive, undesirable, or completely out of phase with the concept of natural resources conservation. Still, much can be learned from studies of these indelible footprints, for certain land-use patterns are repeated wherever humankind vies with natural forces in shaping the environment.

In the early days on the American frontier, travel was usually by wagon road or along navigable streams; hence, the first settlements were found along these natural highways. The advent of systematic land surveys and the development of railroad networks resulted in new settlement patterns and methods of land exploitation. As rural populations migrated to expanding urban centers, transportation systems became dominated by private automobiles, multilane highway networks, and commercial aircraft. When these kinds of changes are recorded on film, the aerial photograph becomes a historical document of considerable value. Examples of changing land-use patterns due to residential growth are shown in Figures 8-13 and 8-14.

Figure 8–12. Aerial mosaics of Calgary, Alberta, Canada, in 1924 (left) and 50 years later, in 1974 (right). Much of the city is situated along the Bow River. Courtesy Kenting Earth Sciences, Ltd., and J. A. Cuvelier, Calgary.

Figure 8-13. Active sand dunes along the Lake Michigan shore in Porter County, Indiana. Much of the stabilizing native vegetation has been removed to make room for expanding residential properties. Scale is 1:20,000. Courtesy U.S. Department of Agriculture.

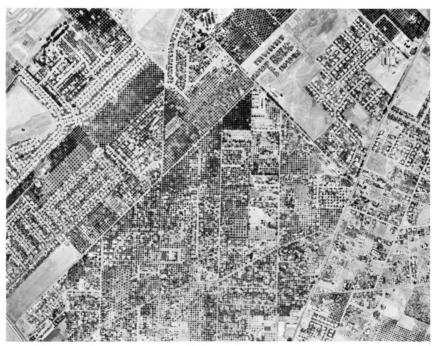

Figure 8-14. Encroachment of residential properties upon orchard lands in Contra Costa County, California. Scale is 1:20,000. Courtesy U.S. Department of Agriculture.

Problems

- 1. Investigate the status of a land resource information system in your region. Prepare a written report or classroom presentation on the capabilities of the system and the user groups that it is designed to serve.
- 2. Develop and test a set of level III and level IV classifications for at least two of the major categories of land in your region. Use these detailed classifications to prepare a land-use/land-cover map, as outlined in problem 3.
- 3. Obtain the most recent aerial imagery and topographic quadrangle map available for a local area that can be ground checked. Then:
 - a. Prepare a radial line plot to adjust the image scale to the scale of the base map (see Chapter 6).
 - b. Delineate the effective area of each image frame.
 - c. Interpret each frame of imagery and delineate current land-use/landcover classes. Be sure to include the expanded classes developed in problem 2.

Many interpreters have found the following sequence of interpretation to be best for minimizing errors:

1) Waterways and shorelines

5) Agricultural land

2) Rights-of-way

- 6) Rangeland
- 3) Urban and built-up land
- 7) Barren land

4) Forest land

8) Other categories

The exact sequence, of course, will depend on the predominant features and land-use classes actually present in a given locality.

- d. Ground check as many image classifications as possible, and make necessary corrections on each frame.
- e. Construct a planimetric map (in overlay form) at the exact scale of the topographic base map. Show major transportation routes and drainage features on the overlay.
- f. Use a sketchmaster or another device to transfer the land-use/land-cover delineations from the image frames to the planimetric overlay.
- g. Determine the area of each major classification (level I or level II). Present in tabular form on a separate sheet.
- h. Color the level I categories according to the system proposed in Table 8-1.
- i. Ink the final overlay and add the appropriate title and legend. Check the final overlay for errors and omissions by referring to the map correction sheet that follows.

Map Correction Sheet

	Name		
Item	n	Points	Points awarded
MAP BORDER ANI			
Border too wide Border too narrow Border margin incorrect Trim lines not erased	Border not straight Border not uniform width Paper incorrect size	(10)	
TIT	ΓLE	(/	
Letters too small Letters too large Lettering faulty Title incomplete Title misproportioned	Words misspelled Words not spaced evenly Abbreviations incorrect Date missing	(15)	
LEGEND: CLASSIFICA	TIONS AND SYMBOLS	,	
Symbols incorrect Symbol(s) omitted Symbols improperly aligned Words misspelled	Words improperly spaced Lettering faulty Type blocks faulty Wording poor	(20)	
THE MAP	PROPER		
Instructions not followed Property boundary wrong Streams incorrectly drawn Type lines improperly drawn Minimum areas incorrect Interpretation incorrect Coloring too light Coloring too heavy Wrong colors used Features not identified	Roads located incorrectly Roads variable in width Roads too wide or too narro Roads poorly drawn Lettering faulty Lettering misoriented Colors not uniform Symbols incorrect Areas unclassified	ow.	
Omissions		(30)	
MISCELLANEC	DUS FEATURES		
North arrow	Declination		
Graphic scale	Signature		
Drawn from			
Photographs taken (date)		(15)	
GENERAL A	PPEARANCE		
Pencil lines not erased Ink smeared, erasures present	Map soiled, torn, wrinkled Wrong kind of paper used		
Remarks			
		(10)	

TOTAL (100) _____

References

- Anderson, James R., Ernest E. Hardy, John T. Roach, and Richard E. Witmer. 1976. A land-use and land-cover classification system for use with remote-sensor data. U.S. Geological Survey, Reston, Va. Professional Paper 964, 28 pp., illus.
- Avery, T. E. 1974. A statewide land information system. Texas Assembly on Land Use, College Station, Tex. 9 pp.
- ——. 1965. Measuring land-use changes on USDA photographs. Photogrammetric Engineering 31:620-24, illus.
- Brown, L. F., et al. 1971. Resource capability units. University of Texas, Austin. Geological Circular 71-1, 22 pp., illus.
- Fish, E. B., and J. W. Kitchen. 1974. Pilot study of land-use classification for portions of Lubbock County, Texas. Texas Tech. University, Lubbock, Tex. 19 pp., illus.
- Hardy, E. E., and R. L. Shelton. 1970. Inventorying New York's land use and natural resources. New York's Food and Life Sciences 3:4–7, illus.
- Hoffer, Roger M. 1973. ADP of multispectral scanner data land-use mapping. Laboratory for Applications of Remote Sensing, Purdue University, West Lafayette, Ind. 23 pp., illus.
- Marchner, F. J. 1959. Land use and its patterns in the United States. Government Printing Office, Washington, D.C. U.S. Department of Agriculture, Agriculture Handbook 153, 277 pp., illus.
- Minnesota State Planning Agency. 1972. Minnesota land use: The Minnesota land management information system. University of Minnesota, Center for Urban and Regional Affairs, Minneapolis. 5 pp., illus.
- North Dakota State University. 1974. Land-use inventory and information systems. North Dakota State University, Fargo, N.D. Task force on land-use information systems, Report 1, 36 pp.
- Nunnally, Nelson R., and Richard E. Witmer. 1970. Remote sensing for land-use studies. *Photogrammetric Engineering* 36:449–53.
- Schneider, Sigfrid, and Erich Strunk. 1972. Deutschland neu entdeckt. Von Hase and Koehler Verlag, Mainz, West Germany. 96 sections, illus.
- Texas Water Development Board. 1973. Texas water-oriented data bank: System capabilities. Interagency council on natural resources and the environment, Austin, Tex. 25 pp., illus.
- University of Illinois. 1972. NARIS: A natural resource information system. University of Illinois, Center for Advanced Computation, Urbana, Ill. 15 pp., illus.
- Wiedel, Joseph W., and Richard Kleckner. 1974. Using remote sensor data for landuse mapping and inventory: A user guide. U.S. Geological Survey, Reston, Va. Interagency Report USGS-253, 12 sections, illus.

Chapter 9

Prehistoric and Historic Archeology

A new perspective

Remote sensor imagery is a vital tool of archeologists, historical geographers, and others who are concerned with the discovery, evaluation, and preservation of historic or prehistoric cultures and environments. Although many such sites are still being discovered by accident (e.g., during surveys for a new highway alignment), aerial imagery provides a systematic means of searching out features that may have gone unnoticed for centuries (Figure 9-1). Furthermore, the remote sensor imagery itself constitutes historical data; once acquired, it becomes an historical document of conditions that existed at a certain point in time and space.

In arid climates, the detection and delineation of archeological sites may be fairly simple, especially where vegetation is sparse or absent. By contrast, detection may be extremely difficult in high-rainfall regions such as tropical forests. Potential sites may not only be obscured by vegetation, but their ground scale alone may render them virtually invisible to terrestrial observers. The greater range and vertical perspective afforded by aerial

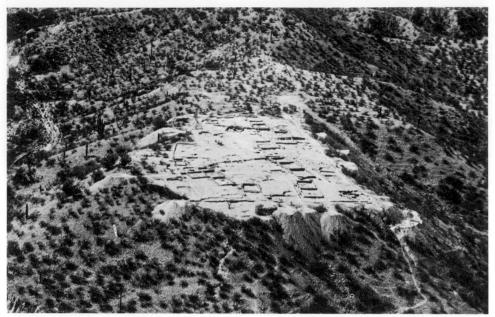

Figure 9-1. Oblique view of Indian habitation site (Second Canyon Ruin) in Pima County, Arizona. The village covers an area of about 150 by 300 m; the ruin was first discovered in 1969. Excavation revealed that the site was occupied during two different periods by Hohokam and Salado Indians (circa A.D. 700 to 1000 and A.D. 1250 to 1350). Courtesy Arizona Department of Transportation and the Arizona State Museum.

imagery thus provides a new dimension in the search for and delineation of archeological sites. Even when such sites are not clearly discernible, probable locales for detailed ground exploration may be predicted by image analysis of environmental and microenvironmental zones.

Site detection may be accomplished by visual aerial reconnaissance or by use of various remote sensors such as aerial photography, infrared scanners, and microwave (radar) imagery. This chapter describes techniques that might be used with any type of imagery, but emphasis is placed on conventional photography because of its superiority in terms of scale and resolution (Figure 9-2).

Early developments

Aerial reconnaissance and photographic interpretation have been tools of the archeologist for many years, and entire books have been devoted to the chronology of site discoveries from the air (Deuel, 1969). Several early findings were based on visual sightings of unusual ground markings by World War I pilots in the Near East. Such discoveries were later followed up with extensive airphoto coverage, and much of the pioneering work in photoarcheology was conducted in Europe, the Mediterranean region, and North Africa (Figure 9-3).

A contribution of special interest to historical geographers was the work of John Bradford, an English archeologist who was interested in reconstructing the rural landscape of the Romans. He found that aerial photography revealed the Roman system of dividing conquered territory into squares of 20 by 20 actus (710 by 710 m). In many instances, the land subdivisions were still

intact. Small-scale vertical airphotos made it possible to see more of the landscape in a single view and from a different perspective, thus revealing patterns of centuriated fields in areas where they had been previously unrecognized.

In 1922, the Englishman O. G. S. Crawford demonstrated the utility of patterns of various ground markings to delineate probable sites in the United Kingdom. His successes are exemplified by the fact that he discovered more Celtic, Roman, and "henge" sites in one year than had previously been found during a hundred years of ground reconnaissance. This work firmly established aerial techniques for archeological exploration in England.

In southern Peru, mysterious markings in the desert soil had been observed over a period of many years. The markings are scattered over an area of about 16 by 64 km and were formed by the piling up of exposure-darkened pebbles of the desert floor, which caused the lighter-colored soils underneath to be exposed. From aerial photographs, archeologists were able to discern patterns from the markings. Rectangles, trapezoids, and centers from which lines radiated were observed, as were giant effigies of birds and spiders. Due to the great size of the figures, their identities could not be determined from the ground. It is believed that the markings were made by Nazca Indians, but the significance of the figures has not been fully explained.

In spite of the foregoing examples of notable successes during the 1920's and 1930's, photoarcheological techniques were still somewhat limited

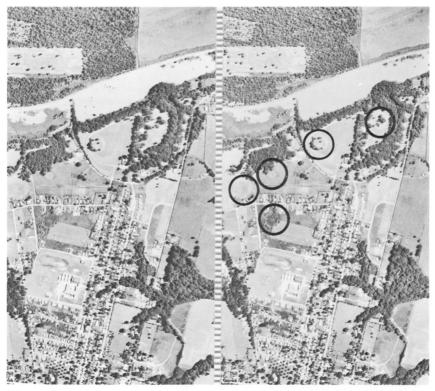

Figure 9–2. Marksville prehistoric Indian site in Avoyelles Parish, Louisiana, as pictured in 1968. Circled are some of the known and probable mound sites dating from the Burial Mound I and II Periods (1000 B.C. to A.D.700). Scale is about 1:20,000. Courtesy U.S. Department of Agriculture.

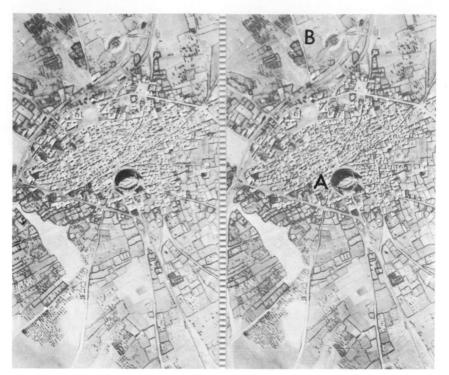

Figure 9–3. Ancient Roman ruins in North Africa. The coliseum at A dominates the contemporary mud and brick Arab homes and also serves as a focal point for roads that radiate outward from the village. This is a prime example of the influence of a past culture on a more recent settlement pattern; the present village has retained many of the spatial features of a typical Roman city.

Much of the original coliseum structure has remained intact. Just outside the village, at B, is evidence of an abandoned amphitheater, with trees growing on the floor of the ancient structure. Courtesy Henry Svehlak, from the Frank Beatty airphoto collection of North Africa.

during this period. This restraint was at least partially due to shortages in trained professional personnel and the reluctant acceptance of a new methodology by individuals and institutions that were in a position to support and use the results of significant discoveries. It is, therefore, not surprising that many early site discoveries were made by amateur archeologists, pilots, and aerial observers.

North American explorations

Early aerial explorations in North America include coverage of the Cahokia Indian mounds in western Illinois and both visual reconnaissance and photographic flights by Charles and Anne Lindbergh over the American Southwest and the Yucatan peninsula of Mexico (Figure 9-4). Early flights over tropical areas produced only limited successes because of insufficient advance planning and dense, masking ground cover. Nevertheless, a few important sites were located, and the attendant publicity generated induced several foundations and universities to send archeological expeditions into Mexico and South America. Since 1934, most of the site discoveries in these regions have been made through aerial reconnaissance or photographic interpretation.

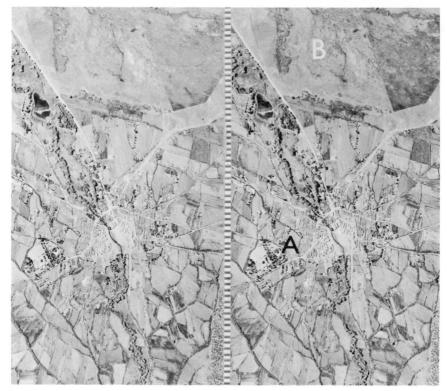

Figure 9-4. Large Indian pueblo village (A) near Taos, New Mexico, as photographed in 1962. The remains of an abandoned habitation site can be seen at B. Scale is about 1:20,000. Courtesy U.S. Department of Agriculture.

The following listing, though quite incomplete, provides examples of sites in the United States that have been discovered, delineated, or mapped through aerial techniques:

1922—Mapping of Cahokia Indian mounds in Illinois

1930—Lindbergh flights over pueblo ruins of Chaco Canyon, New Mexico

1932—Photographic evidence of effigy sites (giant Indian intaglios) on bluffs above the Colorado River near Blythe, California, and delineation of Hohokam Indian irrigation canals in southern Arizona

1948—Mapping of Zuni and Hopi Indian pueblos in Arizona and New Mexico

1953—Detailed site mapping of concentric banks of earthworks (part of mound complex) near Poverty Point, Louisiana

1959—Discovery of village sites in the Alaskan tundra

1965—Discovery and delineation of fortified village sites along the Missouri River in South Dakota

1968—Discovery of prehistoric Indian agricultural plots (by infrared scanning) in northern Arizona

1970—Discovery and mapping of ancient roadways and Indian pueblos in the vicinity of Chaco Canyon, New Mexico

In spite of technological advances, the applications of aerial archeology have been limited in the United States until the past few years. This may be a reflection of our greater interest in the present than in our ancestry, but there are probably other reasons also. Among these are (1) the relatively

short period of established human settlement, (2) the feeling that many, if not most, sites have already been described, and (3) the attitude that more impressive sites are likely to be found outside United States boundaries. Whether these are valid generalizations can only be determined by the future (Figures 9-5 and 9-6).

Site detection principles

The archeologist who relies on ground reconnaissance for the detection of archeological sites is limited to sites which are (1) small enough to be comprehended on the ground from visible remains, (2) accessible within practical and economical limits, (3) still visible in spite of modern-day cultivation and construction, and (4) recognizable, even though the erosional effects of nature may have been operating over a long period of time.

Fortunately, aerial discovery techniques are not as severely limited by the foregoing conditions. Remains of past landscapes which are too large to be comprehended from the ground, or which may have been incorporated into the present landscape and thus gone unrecognized, are often detectable on some form of aerial imagery. And the advantage of a greater range and vertical viewpoint, as depicted on an aerial view, helps our understanding of the patterns of things that are seen but not understood on the ground (Figures 9-7 and 9-8).

For example, subtle suggestions of buried landscapes are sometimes revealed on conventional aerial photographs by shadow patterns, variations in soil coloration, or differences in the height, density, or color of the plants that grow above the buried features. And some remote sensors operate outside the visible-portion of the electromagnetic spectrum, thus providing the archeologist with another eye into the past. For example, thermal infrared scanners react to emitted rather than reflected energy. These images record variations in heat waves emitted by the earth's surface. The structure of rock and soil beneath the surface affects the emissivity of these heat waves and thus may be revealed in the infrared image.

Shadow marks

Shadow marks are site indicators produced by the sun's rays falling obliquely on minor terrain configurations or irregularities. Such surface irregularities may have been caused by soil accumulations on the ground, by mounds of earth that resulted from older structures, or by buried remains of archeological value. Old earthworks, unnoticed banks and ditches, and other characteristics of previous landscapes may sometimes be discernible from shadow marks on aerial photographs—even though such features are virtually invisible to a ground observer (Figure 9-9).

Shadow marks denote variations in surface relief through contrasting tones of shadows, normal photographic tones, and highlighted areas. Since an oblique sun angle is ordinarily required for good shadow marks to be produced, photographic flights should be planned for early mornings or late afternoons. The lower the relief, the more oblique the sun angle must be for details to be discerned. Detection of very faint relief may also be aided by the presence of a light snow cover on the terrain.

The direction of the sun's rays and the altitude of the sun at the time of photography are important in that they produce diagnostic shadow marks.

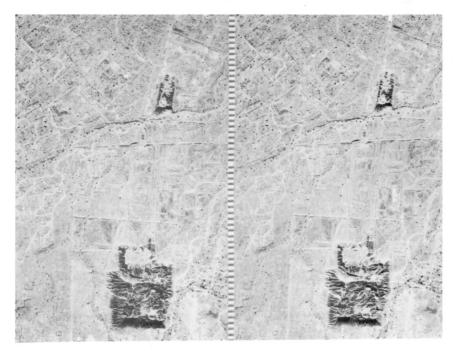

Figure 9-5. Ruins of pre-Inca pyramid, ancient walls, and related structures in Peru. Scale is approximately 1:6,000.

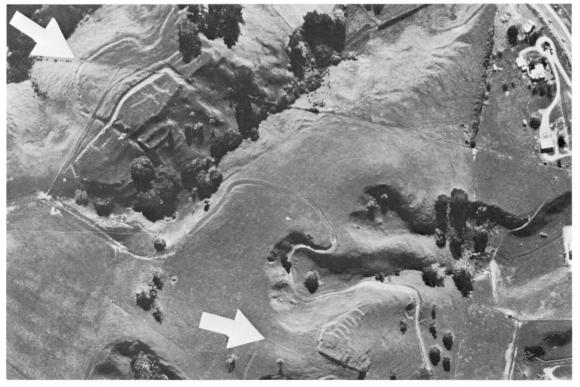

Figure 9–6. Remnants of *Maori* fortifications can be seen at the upper left and lower center of this vertical view taken near Maketu, New Zealand. Maketu was once the headquarters of the Arawa tribe; the ancestors of this tribe arrived from Hawaiki in the canoe Arawa about A.D. 1350. Courtesy New Zealand Aerial Mapping, Ltd.

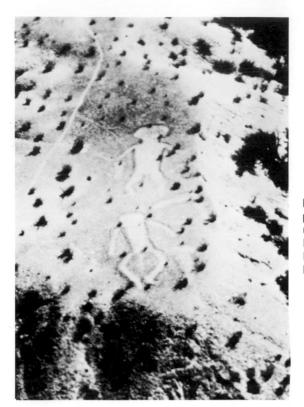

Figure 9-7. Intaglio Indian effigy, possibly representing mythical figures, on a bluff above the Colorado River near Needles, California. Bureau of Reclamation, photograph by Heilman.

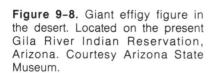

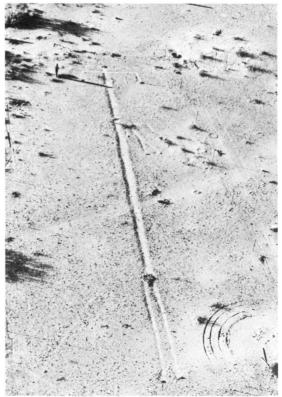

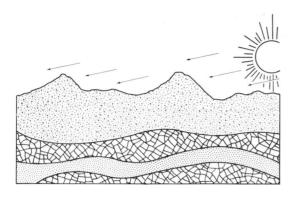

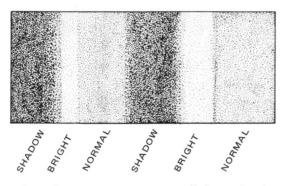

Figure 9-9. Profile of terrain model (above) showing the formation of shadow marks as a result of a low sun angle. The lower sketch represents the same terrain as seen in a vertical view.

When the sun's rays are parallel to a bank or ditch, the tone on the photograph may be perfectly uniform and nonrevealing. For the best contrast between light and shadow, the sun's rays should form an angle as close as possible to 90° with suspected linear relief features. In planning exploratory flights, it may therefore be necessary to photograph an area at different times of day or during different seasons. For oblique photography, the diagnostic effectiveness of shadows is improved when the camera tends to face into a low sun.

Additional problems in obtaining good shadow marks are caused by shadows of obscuring objects, such as hills, trees, and buildings. The masking of minor shadow marks by vegetation may be somewhat alleviated with dormant-season photography, i.e., photography when deciduous plants are leafless. And, in all instances, clear air and a minimum of atmospheric haze provide the best results (Figure 9-10).

Shadow marks have proven especially valuable for revealing old field systems in England. During the Celtic era, it was the practice to define ownership boundaries with ditches. A ditch was dug along the boundary by the two landowners, and a ridge of earth was thrown up on both sides. Remnants of these double hedgebanks, with a ditch in between, are often revealed by shadow marks.

Large earthworks of low relief may also be revealed from marks. It was this technique that led to the delineation of an extensive Indian village site on a presently cultivated floodplain area at Poverty Point, Louisiana. The site contains the remains of six concentric banks and ditches, each one more than 1 km in diameter. Cultivation and erosion had reduced the broad, low banks to a height of about 1.2 m, and they remained unrecognized for many years because of the sheer size of the earthworks (Figure 9-11).

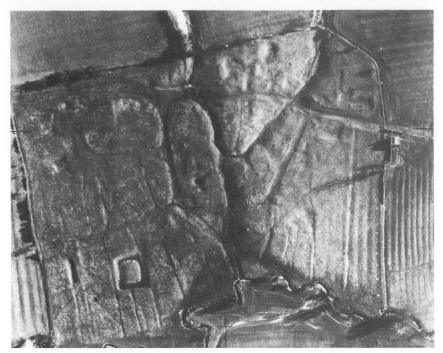

Figure 9–10. Shadow marks outlining an ancient medieval village site in England. Cambridge University Collection: copyright reserved.

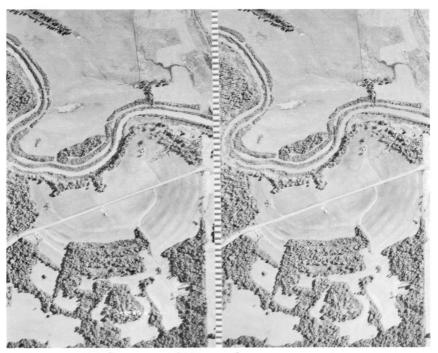

Figure 9–11. Poverty Point, an Indian village habitation site in West Carroll Parish, Louisiana, as pictured in 1969. Dating from the close of the Late Archaic Period, the principal remains consist of a concentric octagonal figure about 1,200 m across and composed of six rows of earth ridges. Site construction and occupation are estimated at circa 800 to 600 B.C. Scale is about 1:20,000. Courtesy U.S. Department of Agriculture.

Soil marks

Soil marks are variations in the natural color, texture, and moisture of the soil; these variations may result from man-made ditches and depressions, excavations, or earth fills. In many instances, the soil profile has been so severely disturbed that the original subsoil has become the present surface soil. The contrasts in photographic tones may be striking and quite definitive, even though such marks are rarely apparent to ground observers. Soil marks may permit the archeologist to distinguish layers of past human occupation and to detect architectural patterns, ditches, canals, or other human alterations of previous landscapes. Natural features such as abandoned streambeds may also be delineated from soil marks (Figure 9-12).

The type of subsoil present is an important factor in the production of soil marks. Light-colored subsoils in combination with dark surface soils provide excellent marks; for example, where a chalky subsoil contrasts strongly with a brownish surface soil, outstanding soil marks are rendered. In some regions of western Europe, definitive soil marks are closely associated with the distribution of loess; conversely, limestone subsoils appear to be poor for forming soil marks. The mark-producing capability of several soil types in West Germany has been summarized by Martin (1971).

Soil marks are most easily detected after the first plowing of a field that has gone uncultivated for a long period of time. Weathering tends to emphasize soil marks in fields that have been plowed and left fallow for several years. Soil marks may reappear annually upon plowing and gradually become less distinct. Eventually, as the surface soil becomes nearly uniform, the marks may disappear. Tractors that plow as deep as 40 to 50 cm can destroy soil marks that have persisted for hundreds, or even thousands, of years. Harrowing, drilling, and ridging practices are particularly destructive to soil marks.

NORMAL SOIL COLOR

MIXED TOPSOIL & SUBSOIL

SOIL COLOR

Figure 9–12. Profile of terrain model (above) showing the formation of soil marks. The lower sketch represents the same terrain as seen in a vertical view.

The best time for photographing soil marks is soon after plowing and following a heavy rainfall. At such times, distinctive marks may be produced by the differential drying rates of contrasting soil types or soil mixtures. When moisture variations constitute a major diagnostic factor, infrared films are preferred. However, where soil color differences are significant, panchromatic emulsions may be equally suitable or even superior for delineating soil marks (Figure 9-13).

Although many significant discoveries revealed by soil marks have been in the more arid regions, important discoveries have also occurred in humid areas. In certain sections of England, such as the Fen Basin and chalk regions, soil marks have revealed numerous remains of previous landscapes. And similar markings have also served to outline buried ditches enclosing ancient Roman fields.

Crop or plant marks

Cultivated crops and native plants (e.g., grasses) may reveal the existence of buried landscapes by variations in their color, density, or height. These variations, which may indicate differences in plant-root penetration, can result from the remains of such features as ditches, pits, or buried wall fragments. Plant marks may reappear year after year, even though the causal buried remains may lie well below all cultivation levels. And they may continue to show up long after all traces of soil marks have vanished.

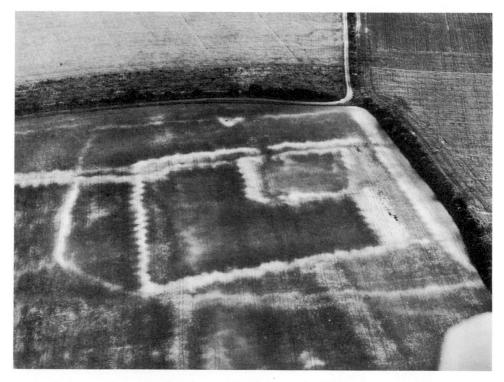

Figure 9-13. Oblique view of distinctive soil marks in an English field. Cambridge University Collection: copyright reserved.

Crop or plant marks may be classed as either positive or negative. Positive marks result where growth is stimulated by filled-in ditches, whereas negative marks (inhibited growth) can result from buried foundations and walls. Positive marks are the more common type. They are affected by the width and depth of the original excavation in the subsoil and are most pronounced when the excavation was large and deep. The minimum width of excavation required for the production of a plant mark is perhaps about 1 m. However, a plant or crop mark will seldom be as wide as the ditch or other feature beneath it.

For positive plant marks to be produced, the subsoil must be well drained. Thus, during dry periods, plants growing in deeper soil will be the only ones to flourish. Marks may not be present in areas with loose subsoils, because the roots of crops may extend as far down in undisturbed subsoils as in the loose silt of old excavations. The best subsoils for crop or plant marks are compact gravels, chalk, or silt. Limestone and sandy subsoils, along with loose gravels and clays, are generally unsuitable. Negative marks are usually independent of the subsoil, because buried foundations, walls, and roads almost always have an adverse effect on the crops growing above them (Figures 9-14 and 9-15).

In the production of crop marks, the type of plant cover is almost as important as the surface geology. Cereal crops are the best medium by which buried remains are revealed, but clover, sugar beets, and grass also give good results. In very dry weather, almost any type of vegetation may produce distinctive tonal signs; crop marks appear gradually, with the contrast and amount of detail steadily increasing. During periods of wet weather, color differences quickly vanish, but variations in plant height and density tend to remain. Also, wet-season plant marks may be visible for a longer period, because crops such as grains ripen more slowly and are harvested later.

Marks that result from plant density differences are best recorded on vertical photographs, whereas oblique views may be superior for detection of faint marks based on plant color or height differences. The oblique photographs are best obtained in mid-morning or mid-afternoon during the drier summer months, the time most suitable for detection of faint tonal differences and minor plant height variations.

Crop or plant marks have revealed evidence of past Roman landscapes in Great Britain. Numerous Roman military remains such as camps, forts, battlefields, and roads have been discovered by plant marks as registered on aerial photographs.

Site prediction possibilities

Although aerial photographs have long been used by archeologists for site discovery, applications for site prediction are less publicized. As an example, panchromatic photographs in central New Mexico have revealed the location of ancient beach terraces in an area where some of the earliest American inhabitants hunted large game animals. Photoanalysis resulted in the delineation of a large "peninsula" where such game might have been easily trapped; this delineation thereby restricted the ground search to a specific area. Surface explorations subsequently revealed several sites that are believed to be the remains of hunting camps dating back 9,000 or more years.

Figure 9-14. Diagrammetric representation of positive crop marks (above) and negative crop marks (below).

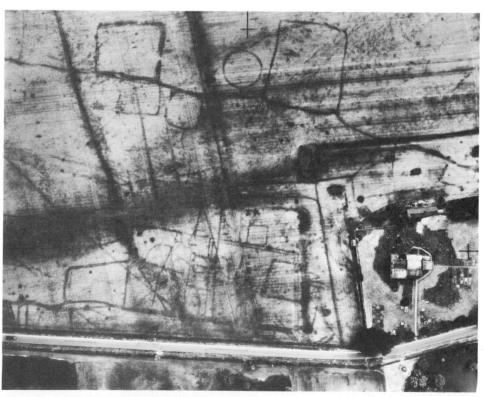

Figure 9–15. Vertical photograph of crop marks in a field in southern England. Cambridge University Collection: copyright reserved.

As another example, the ability of infrared color film to register vigorous plant growth in distinctive shades of red may be of assistance in the definition of shallow subsurface water in arid regions. Such areas, of course, may have formerly been sites of surface springs and favored locations for habitation and villages.

Site evaluations

For known historic or prehistoric sites, and particularly important for those that have not been excavated, aerial imagery can help determine the spatial extent, orientation, and significance of ancient structures (Figures 9-16, 9-17, and 9-18). From evaluations of aerial imagery it may be possible for archeologists to draw inferences about past cultures, environmental zones, and the levels of technology that prevailed at a given time and place.

The concept of spatial extent is exemplified by such findings as giant Indian pictographs or clusters of earth mounds that were sometimes built as ceremonial burial grounds, effigy sites, or religious temples. Large earthworks of low relief (e.g., the concentric banks at Poverty Point, Louisiana) may be incomprehensible without the perspective afforded by an aerial view.

Where exploratory flights reveal only minor indications of habitation sites, it may be feasible to make inferences about other features or structures that are not discernible but which could have been logically associated with

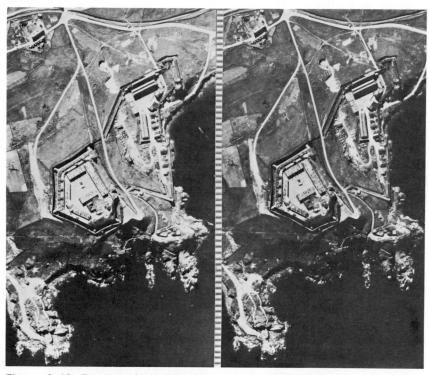

Figure 9-16. Fortress of Napoleonic era (circa 1800) at Alderney, a channel island off the Normandy Coast of France. This 1945 view also depicts more recent coastal defenses, since the fortifications were renovated and employed by the German Army during World War II. Courtesy Alberta Center for Remote Sensing.

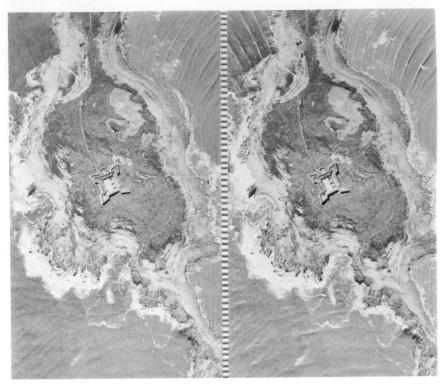

Figure 9–17. Fort Prince of Wales at the mouth of the Churchill River, Hudson Bay, Canada. The massive stone fortification was completed in 1772, some forty years after construction was initiated. Scale is 1:15,840. Courtesy Manitoba Center for Remote Sensing.

such sites. For instance, the discovery of an ancient Indian ball court (Figure 9-19) might lead an archeologist directly to an entire buried village.

For those features whose spatial extent is already known, aerial imagery and precise photogrammetric maps can be valuable in assessment of the significance, orientation, or original purpose of unusual structures. Stonehenge (Figure 9-20) and the Big Horn medicine wheel (Figure 9-21) are somewhat analogous structures of this type; both apparently functioned as early astronomical observatories.

The Big Horn medicine wheel reveals an especially interesting case study that has been documented by Eddy (1974). Constructed around A.D. 1700 at an altitude of nearly 3,000 m, it was first discovered by whites in the late nineteenth century. At that time, the local Indians interviewed were aware that the wheel existed, but none appeared to know its precise location or purpose. Since Indians tended to equate the word medicine with magic or the supernatural, the medicine wheel was long assumed to have served a religious or ceremonial function. It remained for astronomer Eddy, who worked with detailed photographs and field maps, to explain the orientation, solstitial alignments, and related functions of this primitive outdoor observatory.

Photogrammetric site mapping

In many instances, remote sensing procedures are more efficient than traditional methods for excavation cost estimating, site mapping, and detailed

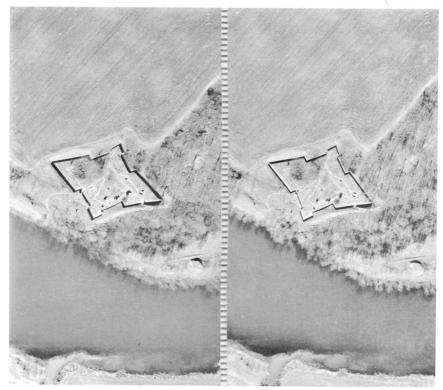

Figure 9–18. Fort Loudoun, a partially restored log palisade stronghold on the Little Tennessee River near Vonore, as seen in 1965. Completed in 1757, the fort was built to protect England's claims in the South and was the first British settlement in what is now the state of Tennessee. It was surrendered in 1760 as a result of a siege by Cherokee Indians. Scale is about 1:4,800. Courtesy Tennessee Valley Authority.

studies of large structures and relationships. Photogrammetric mapping, a standard technique of engineers for many years, is now employed in the preparation of archeological site plans (Figures 9-22 and 9-23).

Applications of data derived through photogrammetry are readily apparent. Precisely compiled site maps are invaluable for ruin reconstruction and stabilization. Areas of structural weakness are more easily recognized, and the volume of materials to be removed during excavation or restoration can be quickly estimated. The site maps and aerial photographs themselves provide a permanent record of the site, its dimensions, and its spatial characteristics. Finally, when photogrammetric data are computer digitized, automated plotters can quickly reproduce site plans or other graphic information in the form of precision-drafted maps, overlays, or video-screen displays.

Sequential photography

The step-by-step excavation or restoration of an historical site can be recorded by means of sequential photography. Such imagery may be obtained through conventional aerial techniques or through the use of ground-controlled camera platforms such as tripods, bipods, or captive balloons.

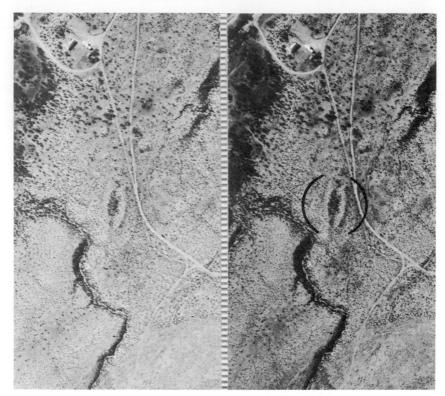

Figure 9–19. Prehistoric Indian ball court (unexcavated) in Pima County, Arizona. The estimated time of use by the Hohokam Indians (Santa Cruz-Sacaton phases) was A.D. 800 to 1000. Scale is approximately 1:6,000. Courtesy Arizona Department of Transportation.

For smaller sites and "spot" excavations, the ground-based tripod or bipod platform works well. Regular hand cameras or aerial cameras that use 70-mm film can be rigged to provide vertical photographs—either as single exposures or in stereoscopic pairs. When the selected cameras are manually operated, the photographer must have access to the camera platform in order to advance and change the film and possibly to cock and release the shutter. Therefore, such setups prove most efficient when the height of the camera above the site is less than 10 m.

For larger sites and where the camera must be suspended 10 to 300 m above ground, tethered balloons can be used in conjunction with remotely controlled cameras for sequential photography. The design and suspension of several camera mounts for use with tethered balloons has been outlined by Whittlesey (1970). Sequential exposures obtained at various levels of excavation provide permanent records for the study of previous landscapes at successive periods of occupation. Used in this context, such imagery would effectively serve as "time-lapse" photography of past cultures.

Obtaining aerial imagery

Numerous trials of photographic and nonphotographic sensors have been conducted in attempts to determine their suitability for archeological exploration. Since the major objective of each investigator tends to differ, how-

ever, a listing of rigid specifications cannot be set forth. On the other hand, there are general recommendations that can be made regarding imagery of ancient sites; those made here will refer to conventional optical imagery unless otherwise stated.

As a general rule, vertical photographs are preferred for reconnaissance flights and for the detailed photogrammetric mapping of known sites. Oblique photographs may be specified for detection of crop or plant marks, and they also provide important records during site excavation or restoration (Figure 9-24).

For the detection and evaluation of most archeological sites, dry seasons of the year are preferred over wet periods, because the loss or retention of moisture by various soils provides more striking tonal contrasts during dry seasons. Density and condition of covering vegetation are additional seasonal factors for consideration. It is obvious that growing-season photography is required for the detection and evaluation of crop or plant marks, for example.

Reconnaissance flights over humid regions are likely to be more successful when masking deciduous plants are leafless. And soil marks are most readily discernible after plowing but prior to the establishment of an agricultural crop. In summary, the photographic season must be selected on the basis of specific project objectives; there is no single period of the year that is best for all forms of archeological exploration.

Figure 9-20. Stonehenge, an ancient megalithic monument on the Salisbury Plain, Wiltshire, England. Solstitial alignments indicate that the circular feature was constructed as an astronomical observatory. Cambridge University Collection: copyright reserved.

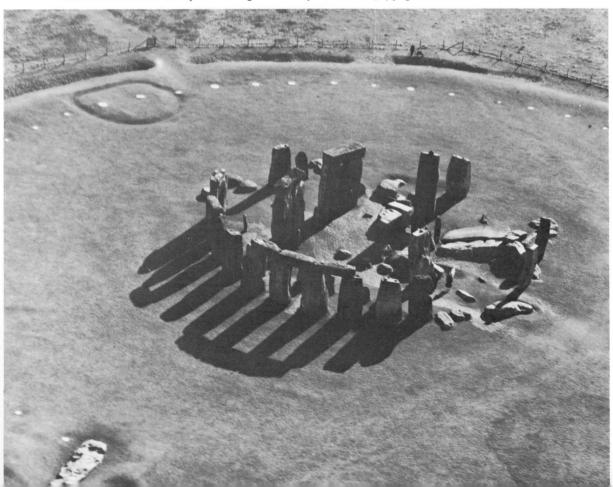

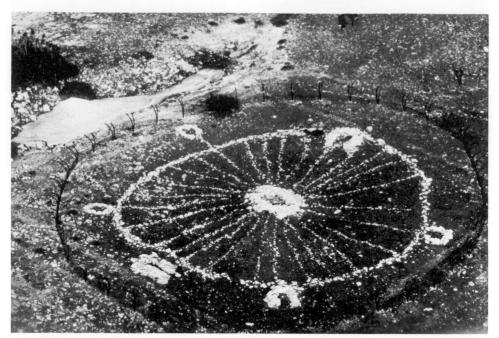

Figure 9-21. Oblique view of the Big Horn medicine wheel in northern Wyoming. Diameter is about 25 m. Built about A.D. 1700, the rock feature is believed to have served as a primitive astronomical observatory. Courtesy Roger M. Williams, District Ranger, U.S. Forest Service.

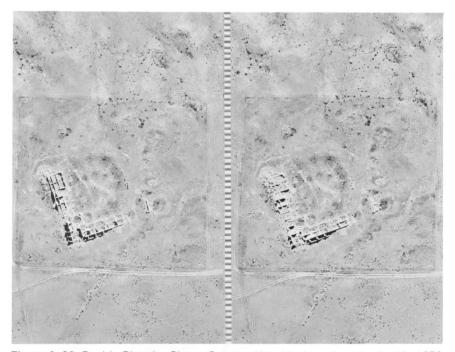

Figure 9–22. Pueblo Pintado, Chaco Canyon, New Mexico, photographed in 1973 at a scale of 1:3,000. The top of the photograph faces east. Several similar Anasazi pueblo sites, dating from about A.D. 900 to 1150, are situated in this part of northwestern New Mexico. Courtesy Koogle and Pouls Engineering and the Chaco Center, National Park Service and University of New Mexico.

Time of day

This specification is largely governed by the desired sun angle on the date of photography. For any given latitude and day of the year, the sun's declination can be determined in advance from a solar ephemeris or from special charts available from aerial film manufacturers.

The detection of shadow marks, as noted previously, may require a very low sun angle. When shadow marks are the objective, early morning or late afternoon photography may be required, especially at the lower latitudes. For most vertical reconnaissance photography, however, a high sun angle is desired, for it minimizes shadows and provides maximum illumination of terrain features. Adequate sunlight is especially important for producing correctly balanced color photographs.

During midday photographic flights at the lower latitudes, precautions should be taken (especially with wide-angle camera lenses) to avoid hotspots on the exposures. Such hotspots, or sunspots, result from the absence of shadows (light halation), and they may destroy the exposure detail on a portion of each photographic frame. Since hotspots occur near a prolongation of a line from the sun through the exposure station (camera lens), their probable occurrence can be predicted—and avoided—by careful planning and timing of flights.

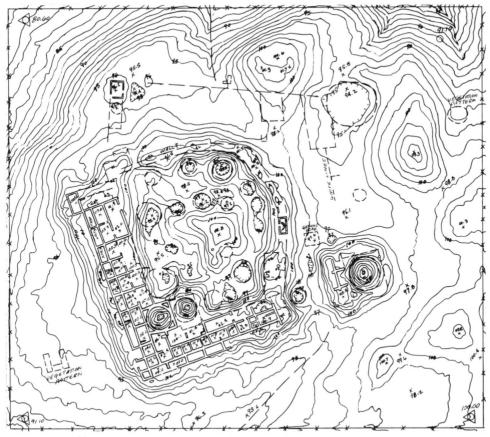

Figure 9-23. Planimetry and topography of Pueblo Pintado: Contour interval is 0.3 m. Courtesy Koogle and Pouls Engineering and the Chaco Center, National Park Service and University of New Mexico.

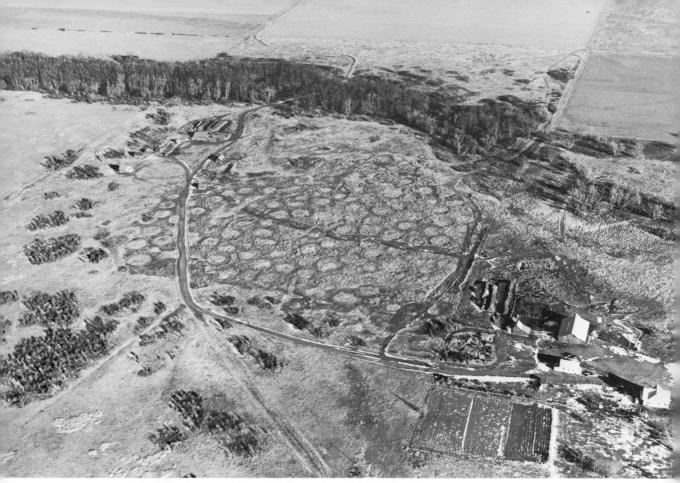

Figure 9-24. Locale of Big Hidatsa Indian village near Stanton, North Dakota, as it appeared in 1967. The circular depressions mark the sites of earth lodges that were located within a stockade. The village was occupied when Lewis and Clark explored the Missouri River (1804 to 1806) and continued in use until about 1845. Courtesy North Dakota Highway Department.

Photographic scale

In a consideration of photographic scale, we must distinguish between reconnaissance flights covering large regions and detailed photography of known or excavated sites. In the first instance, scales of 1:10,000 to 1:20,000 have been successfully employed in several countries. This could be due to the fact that existing black-and-white photography in this scale range is available at nominal cost in many parts of the world. Actually, on the basis of research reports, scales in the range of 1:3,000 to 1:10,000 appear to be preferred. The potential of very small scale imagery transmitted from earth-orbiting satellites has not been fully evaluated from the archeological viewpoint, but certain linear features such as ancient roadways and extinct stream channels have been discerned on such imagery.

For photographing known, exposed, or excavated sites, various investigations have used photographic scales of from 1:500 to 1:5,000. Here, the scale specified is governed by the physical extent of the site and the degree of detail required. Extremely large scales are usually limited to sites being excavated or photogrammetrically mapped, e.g., burial mounds, fortifications, small villages, or pueblos.

Type of film

Early archeological investigations used panchromatic black-and-white photography—probably because this was the least expensive and most common type of coverage available. Panchromatic exposures made with a minusblue filter are still considered quite useful and may be regarded as fairly standard for preliminary reconnaissance flights.

A number of investigators have reported tests that were conducted to compare color or infrared color exposures with black-and-white photography, but such comparisons have proven inconclusive due to differences in timing, scale, weather, or other noncontrolled experimental factors. There does seem to be general agreement that color exposures are superior to black-and-white photographs, even when that superiority is limited to a saving of interpretation time. And infrared color photography is especially favored for mapping of subsurface details, such as buried foundations, walls, and other covered features. It may also be surmised that color or infrared color exposures are superior for detection of soil marks and certain classes of crop or plant marks.

It is somewhat surprising that only a few experiments using infrared black-and-white emulsions have been reported. Since this film is useful for revealing buried pipelines (through soil marks), it should be more fully evaluated for other applications (Figure 9-25). There is obviously a need for the continued investigation of multispectral imagery and for comparison of film diapositives versus paper prints for detailed interpretation.

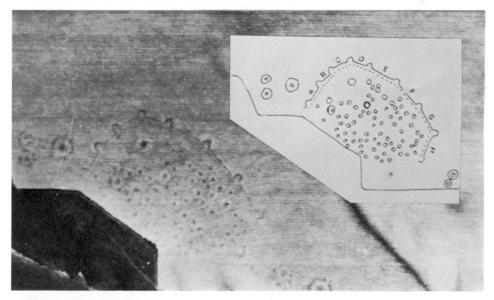

Figure 9–25. Vertical infrared photograph (1965) and sketch of a fortified village site along the Missouri River, 35 km south of Pierre, South Dakota.

The solid outer line on the sketch map marks the location of the moat; the dashed inner line represents the location of the palisade. The smaller circles indicate locations of older houses that were occupied at the time when the moat and palisade were actively defended. The larger, double circles show locations of more recent Indian earth lodges. Residual traces of these features can be seen in the photograph.

The presence and spacing of bastions, along with other evidence, indicate that the fortifications were built about A.D. 1200 to 1400. Scale is approximately 1:10,000. Courtesy Carl H. Strandberg.

Infrared scanner imagery

While there are several possibly useful nonphotographic remote sensors available to the archeologist, imagery from infrared scanners has received the most attention. Radar and ultraviolet sensors have been used in other scientific disciplines, but the infrared portion of the electromagnetic spectrum appears to have a greater potential for archeological reconnaissance. No matter what types of nonphotographic sensors are employed, the resulting imagery commonly supplements rather than replaces conventional photographic coverage.

The potential of infrared imagery is based on the fact that a buried or faintly visible feature may absorb or emit thermal energy in an amount that differs from that of the surrounding terrain, thus providing a spectral "signature" (i.e., tonal contrast) that may reveal a favorable site location. As an example, interpretation of infrared imagery led to the discovery of prehistoric agricultural plots in northern Arizona—a faintly linear feature that was barely visible on panchromatic aerial photographs. The thermal characteristics of these plots, located in an area of volcanic ash deposits, provided differential heat emissions that produced a definitive pattern on the scanner imagery (Figure 9-26).

The greatest disadvantage in the use of infrared and other nonphotographic sensors is the high cost involved in obtaining imagery. Scanner coverage must generally be obtained in addition to aerial photography, and interpretation can be hampered when the two types of imagery differ appreciably in terms of scale, date, or season. In brief, there is a bright future for nonphotographic sensors in aerial archeology, but conventional aerial photographs will continue to be preferred for single-coverage and reconnaissance flights.

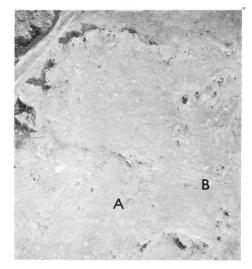

Figure 9-26. Infrared scanner image (left) and panchromatic photograph (right) of prehistoric agricultural plots in northern Arizona (1966). The areas of agricultural activity (A and B) are almost invisible on the conventional aerial photograph. From G. G. Schaber and G. J. Gumerman, 1966, Infrared Scanning Images: An Archeological Application, *Science* 164: 712–13. Copyright 1966 by the American Association for the Advancement of Science. Reprinted with permission.

Problems

- 1. There are important areas of prehistoric and historic interest in most parts of the world. Attempt to locate some of these sites on available maps and aerial photographs. Summarize your findings in a brief report.
- 2. Where would be the most *probable* areas in your region for the discovery of new sites? Why? Describe and illustrate (with photographs or sketches) the most important "find" in your locality during the past fifty years.
- 3. Locate a site that is currently being excavated or restored. Take your own low-altitude aerial photographs of the site or establish a ground-based camera station to obtain sequential photography as work progresses.
- 4. Attempt to locate shadow, soil, or crop marks on existing photography of your county or region. Explain, where possible, the origins of such marks (e.g., buried pipelines, filled-in canals, etc.).
- 5. Devise a single- or dual-camera setup to obtain (a) oblique stereoscopic photography or (b) vertical stereoscopic coverage from a ground-based tripod, a tethered balloon, or another type of platform.

References

Bradford, John. 1957. Ancient landscapes. G. Bell and Sons, London. 297 pp., illus. Carbonnell, Maurice. 1974. Historic center conservation. Photogrammetric Engineering 40:1059-70, illus.

Crawford, O. G. S. 1953. Archeology in the field. Praeger, New York. 280 pp., illus. de Leon, Porifirio García. 1974. Recuperación de datos y la fotografía aérea. XLI Congreso Internacional de Americanistas, Simposio de arqueología, Mexico City. 41 pp., illus.

Deuel, Leo. 1969. Flights into yesterday. St. Martin's Press, New York. 332 pp., illus. Eddy, John A. 1974. Astronomical alignment of the Big Horn medicine wheel. Science 184:1035–43, illus.

Gumerman, George J., and Thomas R. Lyons. 1971. Archeological methodology and remote sensing. Science 172:126–32, illus.

Gumerman, George J., and James A. Neely. 1972. An archeological survey of the Tehucan Valley, Mexico: A test of color infrared photography. *American Antiquity* 37:520–27, illus.

Lyons, Thomas R., B. G. Pouls, and R. K. Hitchcock. 1972. The Kin Bineola irrigation study: An experiment in the use of aerial remote sensing techniques in archeology. Proceedings of the Third Annual Conference on Remote Sensing in Arid Lands, University of Arizona, Tucson, pp. 266–83, illus.

Magnusson, Magnus. 1972. Introducing archeology. The Bodley Head, London. 127 pp., illus.

Martin, Anne-Marie. 1971. Archeological sites—Soils and climate. *Photogrammetric Engineering* 37:353—57, illus.

St. Joseph, J. K. S. (ed.). 1966. The uses of air photography. John Baker Publishers, London. 166 pp., illus.

Schaber, Gerald G., and George J. Gumerman. 1966. Infrared scanning images: An archeological application. *Science* 164:712–13, illus.

Strandberg, Carl H. 1967. Photoarchaeology. Photogrammetric Engineering. 33:1152—57, illus.

- Stuart, George E., and Gene S. Stuart. 1969. Discovering man's past in the Americas. National Geographic Society, Washington, D.C. 212 pp., illus.
- Vorbeck, Eduard, and Lothar Beckel. 1973. Carnutum: Rom an der Donau. Otto Müller Verlag, Salzburg. 114 pp., illus.
- Whittlesey, Julian H. 1970. Tethered balloon for archeological photos. *Photogram-metric Engineering* 36:181-86, illus.
- Willey, Gordon R. 1966. An introduction to American archeology, Vol. 1: North and Middle America. Prentice-Hall, Englewood Cliffs, N.J. 530 pp., illus.

Chapter 10

Agriculture and Soils

World food problems

The earth's agricultural base is vast, encompassing about four billion hectares of arable land, pasture, and rangelands. Annual (as opposed to perennial) crops occupy 95 percent of the cultivated lands. The principal crops grown are summarized in *Table 10-1*. It can be seen that grains and oilseeds are planted on 80 percent of the total cultivated area. Major types of farming in the United States are shown in Figure 10-1.

The principal objectives of modern agriculture are to cultivate the soil for increasing crop yields while protecting the land resource from erosion or misuse. One of the truly critical problems facing the world today is that of increasing agricultural production to feed a continually expanding population; it has been estimated that two-thirds of the world's people live in countries with nutritionally deficient diets. And by the year 2000 it is projected that the amount of arable land per capita will be only about 0.2 ha, as compared with about 0.5 ha in 1950.

Table 10-1. Generalized Breakdown of World Crops in Major Producing Countries

Agricultural crop	Percentage of total cultivated area
Grains, including wheat, rice, corn, millet, sorghum, barley, oats, rye Oilseeds, including soybean, peanut, sunflower Roots and tubers, including potatoes, yams, cassava. Pulses, including peas, beans, lentils Fibers, including cotton, flax, jute Fruits and vegetables Sugarcane and sugar beets Other crops, e.g., coffee, tea, tobacco.	. 73 . 7 . 5 . 4 . 4 . 3½ . 2
Total	. 1½ . 100*

From U.S. National Research Council and U.S. Department of Agriculture.

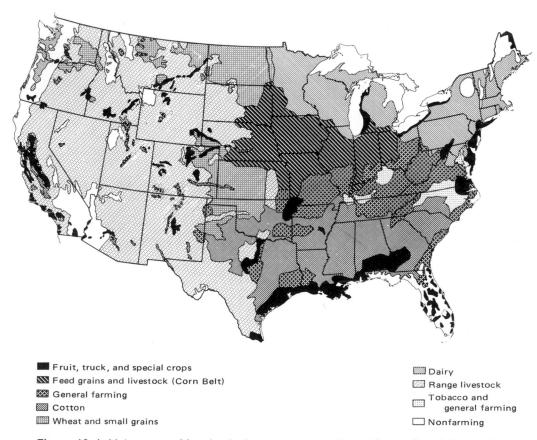

Figure 10–1. Major types of farming in the conterminous United States. Specialized agricultural production areas are largely an indication of the effects of climate, soil type, and site. Proximity to markets is also a contributing factor in the location of fruit, vegetable, and dairy industries. Courtesy U.S. Department of Agriculture.

^{*}Total approximate due to rounding of values.

Increases in crop yields will not solve the basic problem of unrestricted population growth. However, there is a definite need for international cooperation in the planning and administration of world agricultural programs. An important requirement for developing nations is a periodic agricultural census and inventory. Such information permits the monitoring of current production and the prediction of crop yields, so that serious food shortages or distribution problems can be recognized in time and corrective action can be taken. And, since some areas of the world have untapped agricultural resources, current inventories can assist in the search for unused but potentially arable lands.

The role of remote sensing

Because of the size, remoteness, diversity, variability, and vulnerability of the world's crops, accurate information on production during and following the crop season is limited to the crops grown in the more advanced countries. Even for these, the need for increased accuracy, timeliness, and detail of crop information is continually growing.

One promising means of meeting the current and future needs for crop information is remote sensing. Conventional, medium-scale aerial photographs have been used for decades in some regions for identification of major crops and monitoring of crop-area allotments. The use of more sophisticated techniques (e.g., high-altitude color photography, multispectral scanning and earth-satellite imagery) offers the potential of macroscopic agricultural surveys on a synoptic basis, along with detailed observations of selected croplands.

Remote sensing techniques applied to a global program of assessment of unused but potentially arable land resources can hasten the attainment of a better balance between food requirements and food production for the world. Surveys of agricultural land from space altitudes permit the identification of present use of the land and show population-settlement patterns and transportation networks. Such surveys also permit the identification of land characteristics, such as major soil types, drainage, and topographical relief patterns, as a basis for evaluating the best potential use of the land. The following listing includes some of the more common applications of remote sensors in agricultural surveys:

Assessment of potentially arable lands
Classification of agricultural lands
Identification and distribution of crops cultivated
Crop areas and predicted crop yields
Periodic changes in crops or farming patterns
Detection of crop damage
Evaluation of plant diseases and plant vigor
Surveys and mapping of agricultural soils
Analysis of terrain and soil-forming processes
Evaluation of wind and water erosion

Land and crop classifications

The first step in the classification of agricultural land is that of learning to recognize broad categories that are easily separable on conventional photo-

graphs (Figure 10-2). In many regions of the world, the following six categories can be identified: seasonal row crops; continuous-cover crops; improved pasturelands; fallow or abandoned fields, including unimproved grazing lands; orchards; and vineyards. It is also usually possible to differentiate between irrigated and dry farming areas.

The next step is to compile a listing of all crops that occur in each type within the land area of interest; this can be accomplished with the assistance of local agricultural scientists. Farming practices in a given region are fairly stable, and completely foreign crops are rarely introduced on a large-scale basis. Therefore, crop identification procedures can be developed with little concern that familiar crops will suddenly be replaced by entirely new plant species.

Once a crop listing has been made, it is recommended that the interpreter learn to identify each on the ground. Ground identifications should be recorded directly on a set of current aerial photographs for reference purposes. For the nonagriculturalist, it will also be helpful to obtain ground or aerial oblique photography of each crop at periodic intervals during the planting, growing, and harvesting seasons. Some interpreters will then wish to prepare selective photographic "keys" based on the combined vertical and oblique views of each crop.

Crop calendars

An intimate knowledge of the progressive development of each crop is essential if one is to make reliable identifications on aerial imagery at different points in time. This type of data can be summarized in the form of a

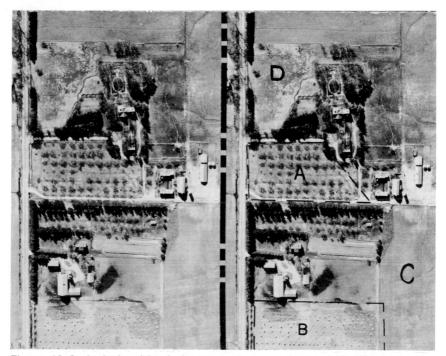

Figure 10–2. Agricultural land classes easily recognized on this Wisconsin farm include: (A) an orchard; (B) shocks of grain; (C) field used for annual row crops; and (D) pasture. Scale is about 1:7,200.

crop calendar, i.e., a detailed listing of the specific crops grown in an area, along with rotational cycles. The calendar determines which crops must be identified and the times of the year when they are visible and subject to discrimination. It may also be important to document the months during which a field changes from bare soil to crop A and then to crop B or back to bare soil.

Crop calendars can be used in conjunction with existing aerial photography to determine (1) whether there is a single date when certain crops can be distinguished from other crops or (2) what combinations of dates during the growing season will provide maximum crop discrimination. In many instances, unique spectral signatures will exist at one stage during the season, so that several individual crops can be separated. If a single date cannot be specified for a given kind of imagery, sequential photo coverage may be required. In this approach, crops are discriminated on the basis of changing patterns (e.g., bare soil to continuous-cover crop to bare soil) at particular dates throughout the year.

Table 10-2 describes monthly growth cycles for three major crops in the midwestern United States. It can be seen that one does not have to discriminate these crops when all are in a green-foliage condition. For example, fields where winter wheat is to be sown are bare in September at a time

Table 10-2. Crop Calendar for Three Major Crops in Ohio, Indiana, and Illinois

Month	Winter wheat	Corn	Soybeans Plowed or stubble	
January	Frozen or snow Vegetation brown	Plowed, pasture or corn stalks		
February	Frozen or snow Vegetation brown	Plowed, pasture or corn stalks	Plowed or stubble	
March	Ground with vegetation brown	Plowed, pasture or corn stalks	Plowed or stubble	
April	Becoming green to short green	Plowed, pasture or disked stalks	Plowed or stubble	
May	Green, medium to tall	Planting, May 5 to June 20	Planting, May 10 to June 30	
June	Yellow, harvest, June 20 to August 5	Short, green	Planting	
July	Harvest or stubble	Green, ground covered	Dark ground, short green in rows	
August	August 5—stubble or plowed	Green, full height	Green, ground essentially covered	
September	Planting, September 10 to November 1	Drying starts, green to dry	Drying starts, harvest September 10 to November 1	
October	Planting, dark soil and short green in drill rows	Harvest, September 25 to December 5	Harvest	
November	Dark soil and short green in drill rows	Harvest and/or corn stubble	Plowed or stubble	
December	Frozen or snow Vegetation green to brown	Corn stubble, some field cut for silo filling	Plowed or stubble	

From National Aeronautics and Space Administration and U.S. Department of Agriculture.

when corn is tall and yellow. A similar state of affairs will occur at different times in different latitudes. Thus, the differences in planting, maturity, and harvesting dates for various crops can aid in their identification on aerial imagery.

Single-date imagery

The reliability of crop identification on single-date photography can be improved by observance of the following rules:

- 1. Schedule aerial coverage during the month when the most important crops are distinctly separable.
- 2. When a given crop exhibits no unique spectral signature during the growing season, obtain aerial coverage during the time when the fewest other similar crops are present.
- 3. Use the critical bare soil months, or optimum crop discrimination periods, to predict the occurrence of the next crop in the rotational cycle.

Where interpretation is based solely on conventional panchromatic photography, crop identification is extremely difficult (Figure 10-3). During early phases of the growing season, spring-planted crops are almost identical in tone and general appearance. After harvesting begins in late summer, crop differentiation is again difficult, especially for small grains. In a study of farm crop identification in northern Illinois, the optimum conditions for recognition of crops on panchromatic photographs were found to occur be-

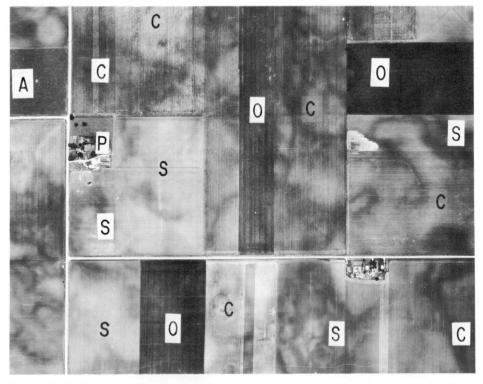

Figure 10–3. Panchromatic photograph taken on July 15 in McLean County, Illinois. Crops shown are alfalfa (A), corn (C), oats (O), pasture (P), and soybeans (S). Scale is about 1:7,200. Courtesy University of Illinois.

tween July 15 and July 30 (Goodman, 1959). During this brief period, cultivated crops, including alfalfa, wheat, corn, barley, oats, and soybeans, were identified.

Photographic tone and texture are the most important factors to be considered in recognition of individual crops on black-and-white prints. Local variations in farm practices, methods of plowing, and harvesting techniques have proved to be of limited value in the identification process. Tones may range from nearly black, in the case of oats and alfalfa fields, to almost white, as exhibited by stands of ripe wheat. Corn and soybeans are intermediate in tone by comparison with these extremes.

After corn and soybeans have begun to mature, they may be separated on the basis of texture and differences in height. The mottled texture (light and dark spots) seen on many photographs of agricultural land is usually due to differences in soil moisture. The drier portions of fields, i.e., higher elevations, tend to show up in light tones on panchromatic prints.

Irrigated or flooded crops such as rice are easily recognized by the presence of low, wavy terraces that show up as irregular lines on panchromatic film (Figure 10-4). Pasturelands can be detected by the presence of farm stock ponds or well-trodden lanes leading to and from barns or across roads that bisect fenced lands. Detailed studies of farmsteads and ranches on

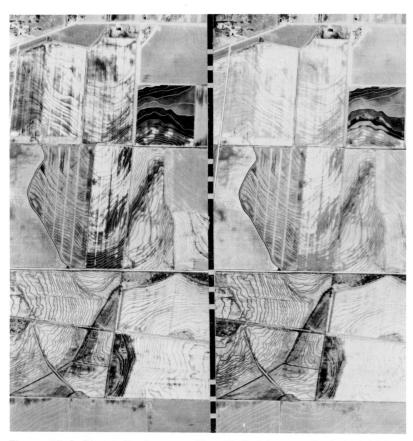

Figure 10-4. Rice cultivation near Pine Bluff, Arkansas. Scale is 1:24,000. Courtesy U.S. Department of Agriculture.

large-scale prints may also reveal the presence of dairy barns, horse stables, tent-shaped hog houses, and similar structures for animals (Figure 10-5).

Color and infrared color films, along with multispectral scanner imagery, appear to offer the greatest reliability for single-date crop discrimination. Limited studies employing radar imagery indicate that crops such as corn and sugar beets are easily separated. However, where several similar crops (e.g., grains) occur in the same area, the accuracy of identification from single-date imagery will rarely exceed 55 to 65 percent.

Multidate imagery

Optimum conditions for crop identification are found when imagery is available in more than one spectral band and on more than one date during the crop's rotational cycle. Under such circumstances, crop identification accuracy can sometimes exceed 80 to 90 percent.

As an example, a group of skilled interpreters were asked to classify 125 fields in the Mesa, Arizona, area into seven crop categories (Figure 10-6). Overall accuracy of identification on high-altitude, multidate, infrared color photography was 81 percent (Lauer, 1971). Multidate photography has also been employed for a semioperational inventory of wheat, barley, and alfalfa on approximately 200,000 ha of cropland in Maricopa County, Arizona. Accuracy achieved by three skilled interpreters using 1:120,000-scale multidate color photography approached 90 percent for the entire county.

Crop area and yield estimates

Information on crop areas and crop yields and forecasts during the growing season are of vital interest to agriculture. Techniques of area measurement are discussed in Chapter 4. It is worthy of mention that one of the principal reasons for the existence of the Agricultural Stabilization and Conservation Service in the U.S. Department of Agriculture is that agency's responsibility for the monitoring of crop areas.

Maintaining up-to-date checks of each farmer's annual planting allotment would be virtually impossible today without some form of aerial reconnaissance. Accordingly, almost all sizable agricultural areas of the conterminous United States are rephotographed for the Agricultural Stabilization and Conservation Service at scheduled intervals of about three to seven years. Photographic enlargements, rectified to an exact scale by ground checks, are used to determine each owner's field area planted to price-supported crops such as cotton, wheat, peanuts, and tobacco. Although a few citizens have professed to resent this "spy method" of crop monitoring, it remains the most efficient technique for the detection of overplanted areas and the maintenance of equitable allotments for a majority of the nation's farmers.

Predictions of crop yield are derived from the product of field area and sample-based estimates of yield per unit area. Randomized ground samples are preferably measured as each field nears maturity, so that yield differences due to density, vigor, or disease incidence are taken into account. Where fields appear to be of uniform health and density on aerial photographs, a minimum of ground plots will be required. For certain types of cropland (e.g., orchards and vineyards), it may be feasible to estimate yields solely from high-quality color imagery.

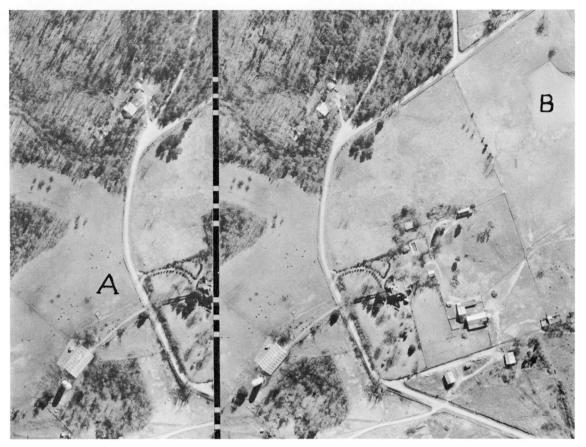

Figure 10–5. Cattle farm in eastern Tennessee. Note cattle grazing in improved pasture (A) and large stock pond (B). Scale is about 1:5,000.

Orchards and vineyards

As a rule, orchards are characterized by uniformly spaced rows of trees that give the appearance of a grid pattern. Orchards planted in regions of level terrain (as are pecan and citrus orchards) are usually laid out in squares so that the same spacing exists between rows as between individual trees in the same row. On rolling to hilly terrain, tree rows may follow old cultivation terraces or land contours (as in peach and apple orchards). On the latter type, the sinuous lines of trees, when viewed on small-scale photographs, tend somewhat to resemble fingerprints.

For most orchards, the key identification characteristics are row spacing, crown size, crown shape, total height, and type of pruning employed (often visible in shadow patterns on large-scale photographs). Whether the plants are deciduous or evergreen is also of assistance for some localities.

Vineyards present a uniformly linear pattern on aerial photographs. Because of the localization of grape cultivation and the wider spacing between individual rows, vineyards are not likely to be confused with corn or other row crops of similar height and texture. Grapes are grown locally over much of the eastern United States, but the largest production areas in Anglo-America are found in north-central California.

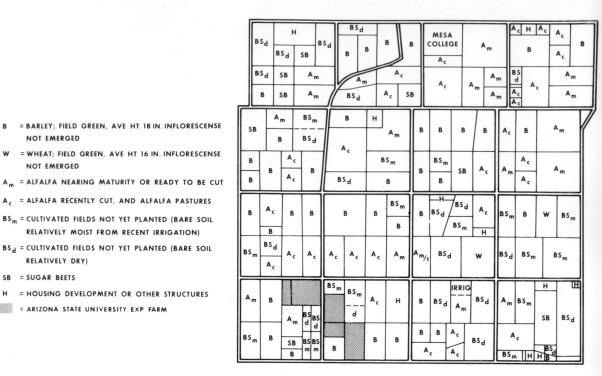

Figure 10-6. Agricultural test-site area, showing ground identifications of irrigated crop types near Mesa, Arizona. Most of the crops (depicted in mid-March) were alfalfa and barley; several of the bare fields were planted to cotton about one month later. Land area is approximately 42 km². Courtesy National Aeronautics and Space Administration.

Seasonal changes in farm patterns

Photographic comparisons of the same area taken during the four seasons show pronounced differences in the tones of soils, vegetation, and erosional features. Seasonal contrasts are particularly significant in mid-latitude regions that have humid-temperate climates. Where such areas are under intensive cultivation, changes can be detected not only in vegetation and soil moisture but also in the outlines of the fields themselves. These periodic changes, as depicted on panchromatic photography, may be summarized as follows:

Spring. Field patterns are sharp and distinct due to differences in the state of tillage and crop development. Mottled textures due to differences in soil moisture content are very distinct. High topographic positions, even those only a few centimetres above adjacent lower sites, tend to photograph in light tones. Low topographic positions photograph dark because of large local variations in soil moisture. Recently cultivated fields exhibit very light photo tones, which imply good internal soil drainage.

Summer. Photographs are dominated by dark tones of mature growing crops and heavily foliaged trees. Soil moisture content is normally low; therefore, bare soil tends to photograph light gray. Field patterns are somewhat subdued because of the predominance of green vegetation.

Autumn. Field patterns are relatively distinct because of various stages of crop development and harvesting. Differences in tone resulting from variations in soil moisture content are subdued.

NOT EMERGED

NOT EMERGED

RELATIVELY DRY)

SB = SUGAR BEETS

RELATIVELY MOIST FROM RECENT IRRIGATION)

= HOUSING DEVELOPMENT OR OTHER STRUCTURES

= ARIZONA STATE UNIVERSITY EXP FARM

Winter. Photographic tones are drab and dull, with some field patterns indistinct. Mottling due to variations in soil moisture is practically nonexistent, and bare ground tends to photograph in dark tones because soil moisture content is uniformly high. Low angle of incident light causes sharp shadow patterns in wooded areas, producing a distinctive form of flecked texture. Gullies are usually more pronounced in winter than in summer, because the low winter sun casts denser shadows and dormant, leafless vegetation does not mask the surface.

Sequential photographic coverage on an annual cycle provides a basis for detection of complete changes in land use, e.g., losses of agricultural lands due to highway construction, strip-mining, urbanization, and other factors. While such losses are not easily arrested, their adverse effect may be reduced by the selective allocation of less productive lands to some of these nonagricultural uses. Earth-satellite imagery holds great promise for making such evaluations on a periodic basis.

Large-scale aerial photographs can also be useful for livestock surveys, including counts by kind of animal, distribution of animals, and grazing preferences (Figure 10-7).

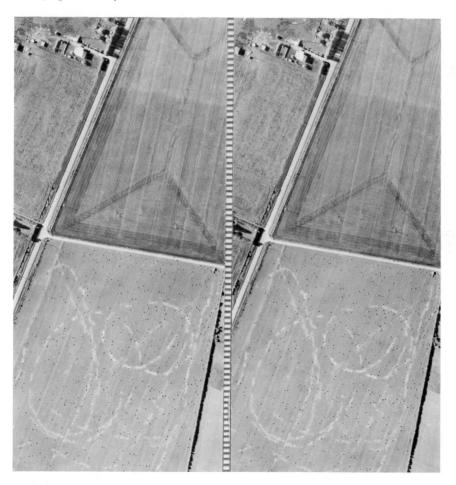

Figure 10-7. Sheep grazing in an improved pasture at South Canterbury, South Island, New Zealand. Scale is about 1:2,800. Courtesy New Zealand Aerial Mapping, Ltd.

Damage detection

Locating and mapping of natural disasters present problems for those in agricultural resources management. Among the major causes of damage to agricultural production are wind and water erosion, floods, fires, insects, and diseases. Knowledge of the extent and degree of damage is especially critical for those who must implement disaster relief. And, later on, crop losses must be assessed and provisions made for crop salvage or restoration.

During floods or extreme droughts, aerial coverage may indicate areas from which people and livestock should be rescued or relocated. In some instances, crop losses may be discernible directly from photography, along with damage to farm buildings, fences, corrals, and roads. Of course, the weather conditions accompanying some natural disasters (e.g., hurricanes) may prohibit aerial photography until the primary causal agent has subsided.

Plant disease detection

Losses due to floods, windstorms, or droughts are minor compared to those resulting from plant diseases. Damage may begin when the crop is planted, continue throughout its growing period, and persist after harvest, when products are transported and placed in storage. Unless diseases are prevented or controlled, there can be no sustained improvement in crop production.

The economic gain from early disease detection is that of effectively increasing agricultural productivity. To employ fungicides or herbicides effectively, the agriculturalist must have sufficient advance warning of disease incidence, severity, and rate of spread. This need for immediate diagnosis and control has resulted in numerous research studies aimed at previsual detection of losses in plant vigor.

Most successful experiments in the detection of plant vigor losses have used infrared color photography. The reason for this appears to be the fact that many diseases result in a decreased reflectance of plant foliage in the near-infrared portion of the spectrum. The explanation of this phenomenon, as detailed by the National Academy of Sciences (1970), is as follows:

The spongy mesophyll tissue of a healthy leaf, which is turgid, distended by water, and full of air spaces, is a very efficient reflector of any radiant energy and therefore of the near-infrared wavelengths. These pass the intervening palisade parenchyma tissue (which absorbs blue and red and reflects green from the visible). When its water relations are disturbed and the plant starts to lose vigor, the mesophyll collapses, and as a result there may be great loss in the reflectance of near-infrared energy from the leaves almost immediately after the damaging agent has struck a plant. Furthermore, this change may occur long before there is any detectable change in reflectance from the visible part of the spectrum, since no change has yet occurred in the quantity or quality of chlorophyll in the palisade parenchyma cells. To detect this change photographically, a film sensitive to these near-infrared wavelengths is used.

Plant diseases that are apparently susceptible to detection through infrared photography include stem rusts of wheat and oats, potato blight, leaf spot of sugar beets, bacterial blight of field beans, and "young tree decline" of citrus trees. As a general rule, aerial photography has proven most successful when image scales were 1:8,000 and larger. For the citrus survey mentioned, multispectral scanner imagery was obtained from an altitude of about 500 m.

Soil surveys

Soil surveys constitute essential information for sustained agricultural production. For all practical purposes, soil characteristics determine the type of crop that can be grown and the production potential of that crop. As outlined by the National Academy of Sciences (1970),

information on soils is particularly important in an area in which new land is being brought into production. In many areas, pressing agricultural development has taken place without the essential data on soils needed for assessing the potential for successful development. There are many examples of failures in draining or irrigating land not suitable for drainage and irrigation. In other situations, land suitable for forest was cleared, put into agricultural production, and then found to be too erodible for crop production.

Until recently, soil surveyors have relied on conventional panchromatic photography, in conjunction with large amounts of fieldwork, to delineate soil boundaries. However, more promising and reliable results are now being obtained with color photography and multispectral scanner imagery (Figure 10-8). Photo scales of 1:6,000 or larger are usually preferred, and aerial flights are ideally scheduled soon after agricultural fields have been plowed.

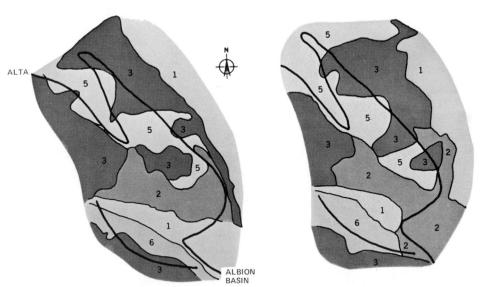

Figure 10–8. Soil survey maps prepared by Soil Conservation Service techniques (left) and by automated classification from multispectral scanner data (right). This portion of the Little Cottonwood Canyon (Utah) measures about 1 by 1.5 km. Classifications are:

- 1. Rockland and shallow soils
- 2. Deep gravelly and cobbly soils and rockland
- 3. Deep gravelly and cobbly soils
- 5. Deep gravelly and cobbly soils with dark surfaces and clayey subsoils
- 6. Deep gravelly and cobbly soils in park areas.
- Courtesy Earth Information Services, McDonnell-Douglas Corp.

Soil-forming processes

Terrain elements are the features, attributes, and materials that comprise a landscape. The more important factors to be considered in the evolution of landscapes and associated soils are topography, drainage patterns, local erosion, natural vegetation, and the works of humans. Topography is the result of the interaction of erosional and depositional agents, the nature of the rocks and soils, the structure of the earth's crust, and the climatic regime. The topographic surface is, in effect, a synthesis of all environmental elements into a single expression. As such, it plays an important role in soil surveys, because it provides a key for deducing the soil-forming processes at work in a given region (Figure 10-9).

A number of attempts have been made to classify drainage patterns into specific regional groupings. When this can be done, much can be inferred with regard to soil type, geologic structure, amount and intensity of local precipitation, and land tenure history. However, stream patterns are almost infinitely variable, and the various types often grade into one another so that no single pattern appears to predominate. In some instances, a large drainage system may display several subtypes of drainage simultaneously. For example, the gross drainage pattern of a region may be dendritic, while associated lesser stream patterns may be pinnate. This situation is quite common in areas of deep loess deposits.

Wind erosion

Features produced by wind and water erosion are important aids in photo interpretation because they are diagnostic of surface soil textures, soil profile characteristics, and soil moisture conditions. Specific implications of each type are discussed in the following paragraphs.

Evidences of wind erosion include blowouts, which are smoothly rounded and irregularly shaped depressions; sand streaks, which are light-toned but poorly defined parallel streaks; and sand blotches, which are light-toned and poorly defined patches. Evaluation of such features depends on a knowledge of prevailing wind direction, wind velocity, and the general climatic regime. Climate is important because it provides some indication of probable soil moisture conditions. Any surface unprotected by vegetation and not continuously moist may be eroded by the wind. Both local and regional topographic configurations should be kept in mind during the evaluation of eolian action, because mountains, hills, or other features may channel air movements in such a way that erosion is severe in one locality and insignificant in another.

Plowed fields, beaches, alluvial fans, and floodplains are examples of surfaces especially susceptible to wind erosion (Figure 10-10). In general, the finer the grain size, the greater the distance surface material is transported. As a result, a blowout with evidence of immediate deposition downwind implies relatively coarse-grained material, whereas a blowout without such evidence implies fine-grained material.

Figure 10–9. Soil-forming processes are based on the type of parent material, landform, drainage pattern, and local erosion (next three pages). Courtesy Purdue University and U.S. Department of Commerce.

BASALTS AND LAVAS Dark Gray IGNEOUS ROCKS Variable Depending on Clay Content Variable Depending on Clay Content GRAWITES GNEISS AND SCHISTS Highly Variable Depending on Clay Content METAMORPHIC ROCKS Medium Gray Where Exposed Dark Gray; Black Where Red Shales Outcrop SHALES Light to Drab Gray
Depending on Amount
of Red in Soil LIMESTONES SEDIMENTARY ROCKS Light to Drab Gray Depending on Amount of Red in Soil ONTAL SANDSTONES, SHALES, AND LIMESTONES Sandstones-Light; Shales-Dark; Limestones-Medium Gray TILTED EROSION COLOR LANDFORM DRAINAGE

AIRPHOTO ANALYSIS CHART—PART ONE RESIDUAL SOILS DERIVED FROM

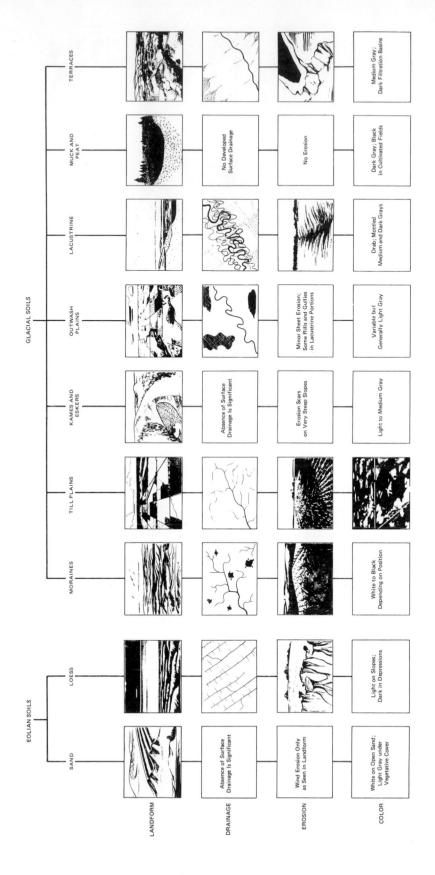

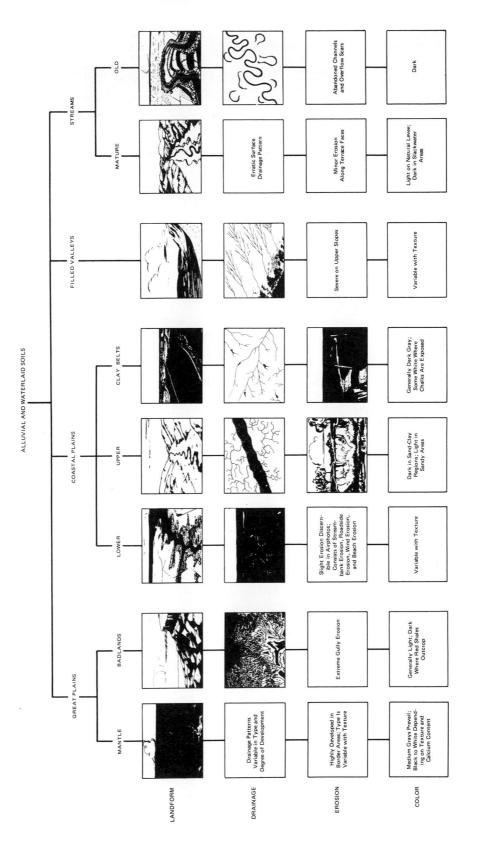

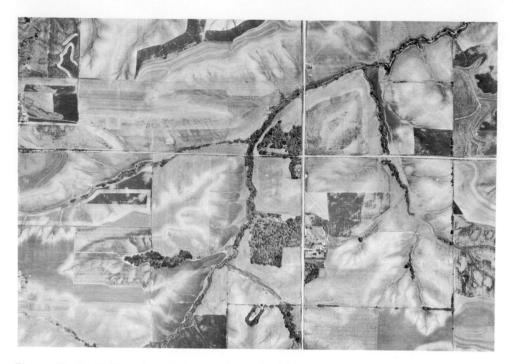

Figure 10–10. Cultivated portion of a dissected loess plain in Harrison County, Iowa. The fine-grained eolian soils, deposited from glacial outwash areas to the north, are easily eroded by wind and water. Corn is the leading crop in this rolling plains area, with livestock providing the bulk of the farm income. Scale is about 1:20,000. Courtesy U.S. Department of Agriculture.

Many small erosional forms resulting from wind action are difficult to identify on airphotos. As a rule only the larger blowouts are readily picked out. Evidence of deposition is more easily detected, because resulting dunes or sheets present distinctive shapes or light-toned streaks and blotches. These are of considerable significance in regional land-use studies. In any given locality, wind-deposited materials tend to be of uniform size, resulting in homogeneous soils. This, in turn, implies that agricultural conditions in any one locality will be approximately uniform, provided slope, vegetation, and moisture conditions are similar.

Water erosion

Moving water is the major active agent in the development of the earth's surface configuration. Despite its awesome power in the form of floods and tidal waves, moving water is delicately responsive to variations in environment, and modest changes in the material being eroded or the climatic regime can profoundly modify the surface expressions produced. Therefore, the landscape patterns produced through the action of moving water are of great importance to the photo interpreter (Figure 10-11). In addition, the interpreter should have a basic knowledge of the interrelations between climate, surface materials, surface configuration, and vegetation (Figure 10-12). The relative importance of various factors influencing runoff varies according to specific environmental conditions that occur in a given area.

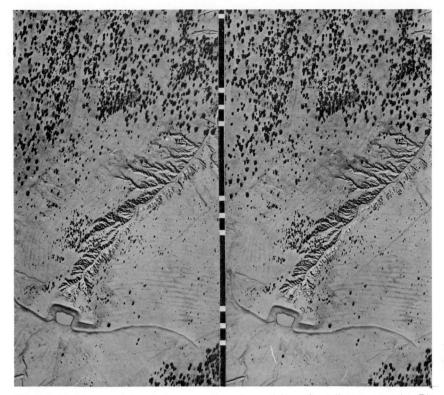

Figure 10-11. Dendritic drainage pattern formed in soft sediment near the Rio Grande in New Mexico. Scale is about 1:6,000. Courtesy Abrams Aerial Survey Corp.

Figure 10–12. French long-lot patterns in Assumption Parish, Louisiana. This pattern, found in several European countries, was brought over by early colonists, who depended on river transportation; each landowner thus had river frontage. Roads and dwellings are concentrated on artificial levees on either side of the river. The principal crops grown here are sugarcane, cotton, and rice. Courtesy U.S. Department of Agriculture.

Surface runoff is governed by the following general considerations:

- 1. The amount and intensity of rainfall determine the degree of runoff. A heavy rainfall of short duration may produce more runoff than the same amount over a longer period of time.
- 2. The amount of runoff is dependent upon the moisture in the soil prior to rainfall. A given rainfall on wet soil will produce more runoff than the same rainfall on dry soil. A proportion of the incident water will be stored by the dry soil, whereas the wet soil has less available storage capacity.
- 3. A noncohesive soil is eroded more readily than a cohesive soil.
- 4. The greater the permeability of a soil the less the surface runoff.
- 5. In general, the greater the density of vegetation the less the runoff for a given quantity of incident water.
- 6. The steeper the slope the greater the surface runoff.

Problems

- 1. Devise a crop calendar for the major crop types in your region. Obtain assistance, if necessary, from local agricultural agents or your state agricultural extension service.
- 2. Obtain aerial imagery of a local agricultural area on two or more dates during the growing season. Use your crop calendar, along with supplementary information on cultivation practices, to identify as many crop types as feasible. Then check your identifications by ground visits to the fields classified. Tabulate as follows.

Photo date:	Interpretation date:		Ground check date:	
Field	Photo evaluation		Ground identification	
number	Crop type	Field area	Crop type	Field area
1				
2			-	
3				
4				
5				
n				

Percentage of fields correctly identified

Area of fields correctly identified

Percentage of total area correctly identified

Percentage of correct identifications for various crop types:

Crop A	Crop B	Crop C	Crop D	Crop E	Crop F

3. If feasible, investigate the use of infrared color photography for the detection of crop diseases in your locality. Prepare a written and illustrated report (or a slide presentation) on your findings.

References

- Condit, H. R. 1970. The spectral reflectance of American soils. Photogrammetric Engineering 36:955-66, illus.
- Edwards, G. J., T. Schehl, and E. P. DuCharme. 1975. Multispectral sensing of citrus young tree decline. *Photogrammetric Engineering* 41:653-57, illus.
- Gerbermann, A. H., H. W. Gausman, and C. L. Wiegand. 1971. Color and color IR films for soil identification. *Photogrammetric Engineering* 37:359–64, illus.
- Goodman, Marjorie Smith. 1964. Criteria for the identification of types of farming on aerial photographs. Photogrammetric Engineering 30:984—90, illus.
- ——. 1959. A technique for the identification of farm crops on aerial photographs. *Photogrammetric Engineering* 25:131-37, illus.
- Hay, Claire M. 1974. Agricultural techniques with orbital and high-altitude imagery. *Photogrammetric Engineering* 40:1283–93, illus.
- Lauer, D. T. 1971. Testing multiband and multidate photography for crop identification. Proceedings of the International Workshop on Earth Resource Survey Systems, Government Printing Office, Washington, D.C., pp. 33-45, illus.
- Maurer, Hans. 1974. Quantification of textures—Textural parameters and their significance for classifying agricultural crop types from colour aerial photographs. Photogrammetria 30:21-40, illus.
- Meyer, M. P., and L. Calpouzos. 1968. Detection of crop diseases. Photogrammetric Engineering 34:554-57, illus.
- National Academy of Sciences. 1970. Remote sensing, with special reference to agriculture and forestry. Agricultural Board, National Research Council, Washington, D.C. 424 pp., illus.
- Parry, J. T., W. R. Cowan, and J. A. Heginbottom. 1969. Soil studies using aerial photographs. Photogrammetric Engineering 35:44-56, illus.
- Philpotts, L. E., and V. R. Wallen. 1969. IR color for crop disease identification. Photogrammetric Engineering 35:1116-25, illus.
- Steiner, Dieter. 1970. Time dimension for crop surveys from space. Photogrammetric Engineering 36:187-94, illus.

Chapter 11

Forestry Applications

Using photography in land management

Foresters and range managers use aerial photographs for preparing covertype maps, locating access roads and property boundaries, determining bearings and distances to field sample plots, and measuring areas. Skilled interpreters may also be adept at recognizing individual plant species and at appraising fire, insect, or disease damage by means of special photography. In addition to these applications, aerial photographs have proved valuable in range and wildlife habitat management, in outdoor recreational surveys, and in estimations of the volumes of standing trees.

In this chapter, emphasis is placed on recognition and classification of vegetative types, identification of plant species on large-scale imagery, forest inventory techniques, and detection of plant vigor. Although photo interpretation can make the land manager's job easier, there are limitations which must be recognized. Accurate measurements of such items as tree diameter or quantity of forage are possible only on the ground. Aerial photographs are therefore used to complement, improve, or reduce fieldwork rather than take its place.

The distribution of vegetation

The occurrence and distribution of native vegetative cover in a given locality are governed by such elements as (1) annual or seasonal rainfall, (2) latitude or elevation above sea level, (3) length of the growing season, (4) solar radiation and temperature regimes, (5) soil type and drainage conditions, (6) topographic aspect and slope, (7) prevailing winds, (8) salt spray, and (9) air pollutants. Within any given climatic zone, the distribution of available moisture can be as critical as the total amount. Temperature extremes are also controlling factors, because such extremes influence evaporation/transpiration ratios in various plant communities.

In some parts of temperate North America, notably the American Southwest, land elevation and precipitation are the two principal factors that determine the distribution of vegetative types. The controlling nature of these two elements in Arizona, for example, is illustrated by the listing that follows. This stratification is quite general, of course, and local variations will occur because of differences in soils, slope, and aspect.

Vegetation zone or cover type	Range of land elevation, in metres	Range of annual precip- itation, in millimetres
Sonoran desert	450-1,200	75–380
Chaparral	1,050-1,500	300-430
Pinyon & juniper	1,350-2,250	380-480
Ponderosa pine	1,800-2,550	500-660
Aspen & Douglas-fir	2,400-2,850	580-740
Spruce & fir	2,550-3,450	680-890
Timberline	3,450-3,600	700+

It can be seen that a sound knowledge of plant ecology and the factors controlling the natural evolution of plant communities are of inestimable value to interpreters of vegetative features. Armed with such background information, one may often *predict* the kinds of native vegetation that will be encountered under specified environmental conditions.

The classification of vegetation

The simplest classification method is one that merely discriminates vegetated from nonvegetated lands, followed by a subdivision of plant associations into productive or nonproductive sites. As an alternative, vegetated areas might be classed as one of the following basic ecological formations: desert scrub, grassland, chaparral, woodland, forest, or tundra. Such primary stratifications can sometimes be made from earth-satellite imagery.

Major problems one encounters in devising any rational classification system are (1) defining vegetative types so that the classes are mutually exclusive and (2) making allowance for handling of transition zones, i.e., areas where one plant community gradually changes to a different cover type. Wherever possible, it is desirable to adopt a standardized, hierarchical classification system that will be applicable across diverse geographic and political boundaries (see Chapter 8).

As an example of one type of classification approach, the following system has been proposed by the Food and Agriculture Organization of the United Nations (Lanly, 1973). It is designed for an area classification of existing land

use that could be employed for varied forest inventory projects, particularly those in tropical countries. The first step is the separation of land and water areas, followed by a breakdown of the total land area into these categories:

Forest area

- 1. Natural forests
 - a. Broad-leaved, excluding mangroves
 - b. Coniferous
 - c. Mixed broad-leaved and coniferous
 - d. Pure bamboo
 - e. Mangrove
 - f. Coastal and riverine palms
 - g. Temporarily unstocked
- 2. Man-made forests (items a through g above as applicable)

Other wooded area

- 1. Savanna: open woodlands
- 2. Heath: stunted and scrub forest
- 3. Trees in lines: windbreaks and shelterbelts
- 4. Other areas

Nonforest area

- 1. Agricultural land
 - a. Crops and improved pastures
 - b. Plantations
- 2. Other lands
 - a. Barren
 - b. Natural rangelands and grasslands
 - c. Swamp
 - d. Heath, tundra
 - e. Urban, industrial and communication
 - f. Other areas

As with any classification system, the foregoing types must be clearly defined in rigorous terms. Otherwise, the most elemental discriminations (e.g., what is forest land?) can result in inconsistent image interpretations.

Identifying cover types

As outlined earlier, interpreters of vegetation should be well versed in plant ecology and the various factors that influence the distribution of native trees, shrubs, forbs, and grasses. Field experience in the region of interest is also a prime requisite, because many cover types must be deduced or inferred from associated factors instead of being recognized directly from their photographic images.

The inferential approach to cover-type identification becomes more and more important as image scales and resolution qualities are reduced. Range managers may rely exclusively on this technique where they must evaluate the grazing potential for lands obscured by dense forest canopies.

The degree to which cover types and plant species can be recognized depends on the quality, scale, and season of photography, the type of film used, and the interpreter's background and ability. The shape, texture, and tone (color) of plant foliage as seen on vertical photographs can also be influenced by stand age or topographic site. Furthermore, such images may be

distorted by time of day, sun angle, atmospheric haze, clouds, or inconsistent processing of negatives and prints. In spite of insistence on rigid specifications, it is often impossible to obtain uniform imagery of extensive land holdings. Nevertheless, experienced interpreters can reliably distinguish cover types in diverse vegetative regions when photographic flights are carefully planned to minimize the foregoing limitations.

The first step in cover-type recognition is to determine which types should and should not be expected in a given locality. It will also be helpful for the interpreter to become familiar with the most common plant and environmental associations of those types most likely to be found. Much of this kind of information can be derived from generalized cover-type maps (Figure 11-1) and by ground or aircraft checks of the project area in advance of photo interpretation. And for limited regions, vegetative photo interpretation keys will be available.

The chief diagnostic features the interpreter uses in recognizing vegetative cover types are photographic texture (smoothness or coarseness of images), tonal contrast or color, relative sizes of crown images at a given photo scale, and topographic location or site. Most of these characteristics constitute rather weak clues when observed singly, but together they may comprise the final link in the chain of "identification by elimination." Several important cover types occurring in the United States and Canada are illustrated in Figures 11-2 through 11-7.

Identifying individual species

The recognition of an individual species on aerial imagery is most easily accomplished when that species occurs naturally in pure, even-aged stands. Under such circumstances, the cover type and the plant species are synonymous. Therefore, reliable delineations may be made from medium-scale imagery. As a rule, however, individual plants can be identified only on large-scale photography. The following listing, based on a synopsis of several research reports, illustrates the relationship between image scales and expected levels of plant recognition.

Type of imagery or scale	General level of plant discrimination
Earth-satellite imagery	Separation of extensive masses of evergreen versus deciduous forests
1:25,000-1:100,000	Recognition of broad vegetative types, largely by inferential processes
1:10,000-1:25,000	Direct identification of major cover types and species occurring in pure stands
1:2,500-1:10,000 1:500-1:2,500	Identification of individual trees and large shrubs Identification of individual range plants and grass- land types

Photographic identification of individual plants requires that interpreters become familiar with a large number of species on the ground. For example, there are more than a thousand species of woody plants that occur naturally in the United States; professional foresters and range managers rarely know more than a third of this number. In Australia there are more than eight hundred species of eucalyptus trees; many of these species are difficult to separate even when they are within arm's reach.

Figure 11-1. Forest regions of the United States, excluding Hawaii.

PRINCIPAL TREES OF THE FOREST REGIONS

ROCKY MOUNTAIN FOREST	PACIFIC COAST FOREST	CENTRAL HARDWOOD FOREST	NORTHERN FOREST
hern Portion (Northern Idaho and Western	Northern Portion (Western Washington and West-	Northern Portion:	Northern Portion:
ontana):	ern Oregon):	White, black, northern red, scarlet, bur, chest-	Red, black, and white spruces
Lodgepole pine	Douglas-fir	nut, and chinquapin oaks	Balsam fir
Douglas-fir	Western hemlock	Shagbark, mockernut, pignut, and bitternut	Eastern white, red ("Norway"), jack, and pitch
Western larch	Grand, noble, and Pacific silver firs	hickories	pines
Engelmann spruce	Western redcedar	White, blue, green, and red ashes	Hemlock
Ponderosa pine	Sitka and Engelmann spruces	American, rock, and slippery elms	Sugar and red maples
Western white pine	Western white pine	Hed, sugar, and silver maples	Beech
Western redcedar	Port Ortord cedar and Alaska cedar	Beech	Northern red, while, black, and scarlet baks
Grand and alpine firs	Western and alpine larches	Pitch, shortleat, and Virginia pines	Yellow, paper, sweet, and gray birches
Western and mountain hemlocks	Lodgepole pine	Yellow-poplar	Quaking and bigtooth aspens
Whitebark pine	Mountain nemlock	Sycamore	Basswoods
Balsam poplar	Oaks, ashes, maples, birches, alders, cotton-	Chestnut	Black cherry
ern Oregon, Central Idaho, and Eastern Wash-	woods, madrone	Black wainut	American, rock, and slippery eims
gton:	Southern Portion (California):	Lackbarr	Shaphark and pignit hickories
Ponderosa pine	Ponderosa and Jeffrey pines	Black cherry	Butterout
Douglas-fir	Sugar pine	Basswoods	Northern white-cedar
Lodgepole pine	Redwood and giant sequoia	Objobilokeve	Tamarack
Western larch	White, red, grand, and Shasta red firs	Fastern redoedar	
Engelmann spruce	California incense-cedar		Southern Portion (Apparachian Region):
Western redcedar	Douglas-fir	Southern Portion:	White, northern red, chestnut, black, and
Western hemlock	Lodgepole pine	White, post, southern red, blackjack, Shu-	scarlet oaks
White, grand, and alpine firs	Knobcone and Digger pines	mard, chestnut, swamp chestnut, and pin	Chestnut
Western white pine	Bigcone-spruce	oaks	Hemlock
Oaks and junipers (in Oregon)	Monterey and Gowen cypresses	Sweetgum and tupelos	Eastern white, shortleaf, pitch, and Virginia
ral Montana. Wyoming, and South Dakota:	Sierra and California junipers	Mockernut, pignut, southern shagbark, and	("scrub") pines
	Singleleat pinyon	shellbark hickories	Sweet, yellow, and river birches
Douglas-fir	Oaks, buckeye, California-laurel, alder, ma-	Shortleat and Virginia ("scrub") pines	Basswood
Ponderosa pine	grone	Ville, blue, and red ashes	Sugar and red mapies
Engelmann spruce	SOUTHERN FOREST	Black locust	Bod engine
Albine fir	Pine Lands:	First Iocust	Fraser fir
Limber pine	Shortleaf, loblolly, longleaf, slash, and sand	Svcamore	Yellow-poplar
Aspen and cottonwoods	pines	Black walnut	Cucumber magnolia
Rocky Mountain juniper	Southern red, black, post, laurel, cherrybark,	Silver and red maples	Black walnut and butternut
White spruce	and willow oaks	Beech	Black cherry
ral Portion (Colorado, Utah, and Nevada):	Sweetgum	Dogwood	Pignut, mockernut, and red hickories
	Winged, American, and cedar elms	Persimmon	Black locust
Foodbann and blue springes	Black, red, sand, and pignut hickories	Cottonwoods and willows	Tupelos ("black gums")
Albine and white firs	Eastern and southern redcedars	Eastern redcedar	Buckeye
Douglas-fir	Basswoods	Usage-orange	ALASKA FOREST
Ponderosa pine	Alluvial Bottoms and Swamps:	Texas Portion:	Coast Forest:
Aspen and cottonwoods	Sweetgum and tupelos	Post, southern red, and blackjack oaks	Western hemlock (important)
Pinyons	white pake	Eastern redcedar, Asne juniper	Sitka spruce (important)
Rictorge and limber pines	Southern cypress	FLORIDA AND TEXAS FOREST—TROPICAL	Western redcedar
Mountain-mahooany	Pecan, water and swamp hickories	Mangrove, false mangrove	Alaska cedar
	Beech	Royal and thatch palms; palmettos	Mountain nemiock
mern Portion (New Mexico and Arizona):	River birch	Florida yew	Black cottoowood
Ponderosa pine	Ashes	Wild figs	Red and Sitka alders
Vouglas-III White aloine and corkhark fire	Alluvial Bottoms and Swamps:	Seagrapes (pigeon pium)	Willows
Fnaelmann and blue spruces	Red and silver maples	Bahama Ivsiloma ("wild tamarind")	Interior Forest:
Pinyons	Cottonwoods and willows	Wild-dilly	White (important) and black spruces
One-seed, alligator, and Rocky Mountain	Sycamore	Gumbo-limbo	Alaska paper (important) and Kenai birches
junipers	Hopeviorist	Poisontree	Black cottonwood
Aspen and cottonwoods	Holly	Inkwood Button-manarova	Balsam poplar
Daks walnut sycamore alder boxelder	Redbay and sweetbay	False-mastic ("wild olive")	Aspen
Arizona cypress	Southern magnolia	Fishpoison-free ("Jamaica doowood")	Willows
	Pond and spruce pines	and the same and and the same a	lamarack
	Atlantic white-cedar		

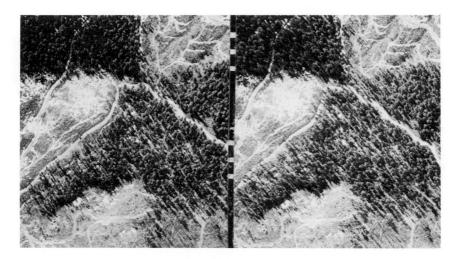

Figure 11-2. Panchromatic stereogram of a recently logged stand of Douglas-fir in Lewis County, Washington. Scale is about 1:6,000. Courtesy Northern Pacific Railroad.

Figure 11–3. Summer panchromatic stereogram of (1) balsam fir and (2) black spruce in Ontario. Scale is about 1:15,840. Courtesy V. Zsilinszky, Ontario Department of Lands and Forests.

Figure 11-4. Summer panchromatic stereogram of (1) aspen and white birch and (2) young beech stand in Ontario. Scale is about 1:15,840. Courtesy V. Zsilinszky, Ontario Department of Lands and Forests.

Figure 11–5. Summer panchromatic stereogram of red pine plantation (dark crowns) in the lower peninsula of Michigan. Scale is about 1:20,000. Courtesy Abrams Aerial Survey Corp.

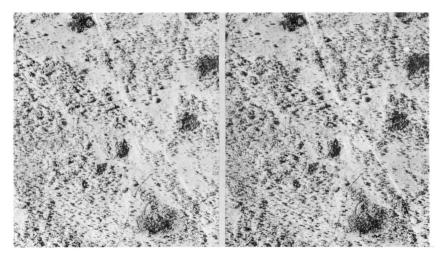

Figure 11–6. Fall modified infrared photography of longleaf and slash pines (light-toned crowns) in the Georgia coastal plain. The dark-toned, water-filled depressions are "ponds" of southern cypress. Scale is about 1:15,840.

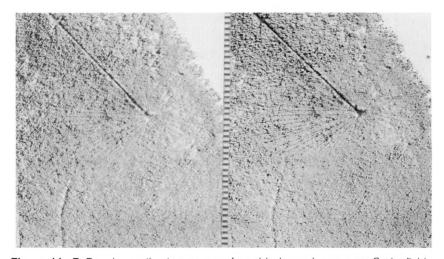

Figure 11–7. Panchromatic stereogram of a cable-logged area near Springfield, Louisiana. Principal cover types pictured are bottomland hardwoods and cypresstupelo gum. Scale is about 1:6,000.

Species identification characteristics

As a minimum, the interpreter should be familiar with the branching characteristics, crown shapes, and spatial distribution patterns of important species in the locality. Mature trees in sparsely stocked stands can often be recognized by the configuration of their crown shadows falling on level ground (Figure 11-8). And a familiarity with tree crowns as seen from above (Figure 11-9) can be of invaluable assistance when large-scale imagery is being interpreted.

Figure 11–8. Silhouettes of twenty-four forest trees. When tree shadows fall on level ground, they often permit identification of individual species.

Code No.	CC	NIFERS	Code No.	HARDWOOD	os
1.	Light tip to center of bole with fine texture	(0)	1.	Small light spots in crown	(000)
2.	Layered branches	多多	2.	Small clumps	2880 288890 288890 288880
3.	Wheel spokes	ENS SE			
4.	Columnar branches		3.	Small clumps with occasional long columnar branches (in young trees)	
5.	Layered triangular- shaped branches				(4 4 . K.)
6.	Small clumps		4.	Limbs show	4
7.	Small light spots in crown	(000)	5.	Large masses of foliage divide crown (large older trees)	
8.	Small starlike top	4	7.	Fine texture	
12.	Dark spot in center of small clumps	2500 2500 2500 2500	9.	Fine columnar branches	
16.	Fine texture with scraggly long branches	*	0.	coldinal branches	多种原

Figure 11-9. Sketches of overhead views of tree crowns for fourteen boreal tree species. Courtesy U.S. Forest Service Remote Sensing Project, Berkeley, California.

Species identification accuracy can usually be improved by use of conventional color or infrared color photography. In a study of Rocky Mountain rangelands, infrared color photography at scales of 1:800 to 1:1,500 proved superior to conventional color for the identification of shrub vegetation (Driscoll and Coleman, 1974). One experiment showed that seven of eleven shrub species could be identified 83 percent of the time; the diagnostic image characteristics employed by interpreters were as follows:

- 1. Plant height
 - $a. \ge 1.5 \, \mathrm{m}$
 - b. ₹ 1.5 m
- 2. Shadow
- - a. Distinct
 - b. Indistinct
- 3. Crown margin
 - a. Smooth
 - b. Wavy
 - c. Irregular
 - d. Broken
- 4. Crown shape
 - a. Indistinct
 - b. Round
 - c. Oblong

- 5. Foliage pattern
 - a. Continuous
 - b. Clumpy
 - c. Irregular
- 6. Texture
 - a. Fine
 - b. Medium
 - c. Coarse

 - d. Stippled
 - e. Mottled
 - f. Hazy
- 7. Color: Numerically coded according to standardized color charts

Since range plants progress through distinctive growth stages each year, the date of photography is of utmost importance for the identification of various species. Most studies have indicated that the time of near-maximum foliage development is the best time of year for detection of the kind and amount of forage through remote sensing.

Keys for species recognition

Photo interpretation keys are useful aids in the recognition of plant species, especially when such keys are illustrated with high-quality stereograms. Vegetation keys for Anglo-American species are most easily constructed for northern and western forests where conifers predominate. In these regions, there are relatively few species to be considered and crown patterns are fairly distinctive for each important group.

A sample elimination key for identification of northern conifers is reproduced here. In its original form, this tree species key was supplemented by descriptive materials and several illustrations. Selected examples of other tree species that may be identified on panchromatic stereograms are shown in Figures 11-10 through 11-13. A forest type map based on a classification scheme developed by the Society of American Foresters is presented in Figure 11-14.

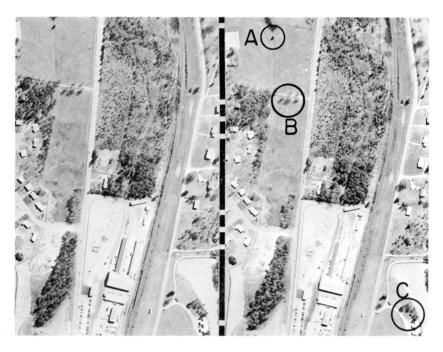

Figure 11–10. Winter stereogram taken near Charlotte, North Carolina, showing distinctive tree shadows of eastern redcedar (A), oaks devoid of foliage (B), and shortleaf pines (C). Compare with drawings in *Figure 11-8*. Scale is about 1:15,840.

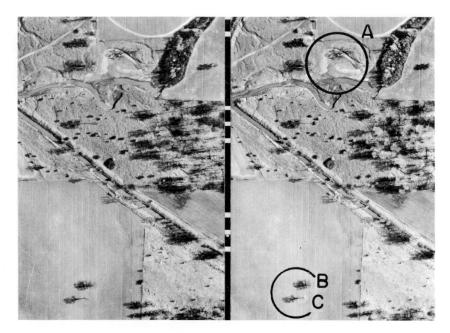

Figure 11–11. Winter stereogram taken near Grandville, Michigan, picturing distinctive tree shadows of American elm (A, C) and oak (B). Compare with drawings in *Figure 11–8*. Scale is about 1:6,000.

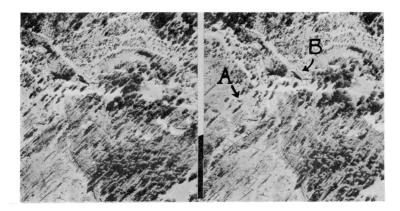

Figure 11–12. Stereogram from the Plumas National Forest, in California, illustrating the shadow pattern of a sugar pine (A). Compare with drawing in *Figure 11–8*. At B is an abandoned bridge with roadway approaches washed out by severe erosion. Scale is about 1:5,000.

Figure 11–13. Stereo-triplet on 70-mm panchromatic film from the Superior National Forest, in Minnesota. Species encircled are: (1) balsam fir; (2) trembling aspen; (3) paper birch; (4) red maple; (5) white spruce; (6) red pine; and (7) white pine. Scale is about 1:1,584. Courtesy U.S. Forest Service Remote Sensing Project, Berkeley, California.

	Key to the Northern Conifers	
1.	Crowns small, or if large then definitely cone-shaped	
	Crown broadly conical, usually rounded tip, branches not prominent	Cedar
	2. Crowns have a pointed top, or coarse branching, or both	
	Crowns narrow, often cylindrical, trees frequently grow in swamps	Swamp-type black spruce
-	Crowns conical, deciduous, very light toned in fall, usually associated with black spruce	Tamarack
	Crowns narrowly conical, very symmetrical, top pointed, branches less prominent than in white spruce	Balsam fir
	Crowns narrowly conical, top often appears obtuse on photograph (except northern white spruce), branches more prominent than in balsam fir	White spruce, black spruce (ex- cept swamp type)
	Crowns irregular, with pointed top, has thinner foliage and smoother texture than spruce and balsam fir	Jack pine
1.	Crowns large and spreading, not narrowly conical, top often not well defined.	
	3. Crowns very dense, irregular or broadly conical	
	 Individual branches very prominent, crown usually irregular 	White pine
	 Individual branches rarely very prominent, crown usually conical 	Eastern hemlock
	3. Crowns open, oval (circular in plan view)	Red pine

From Canada Department of Forestry.

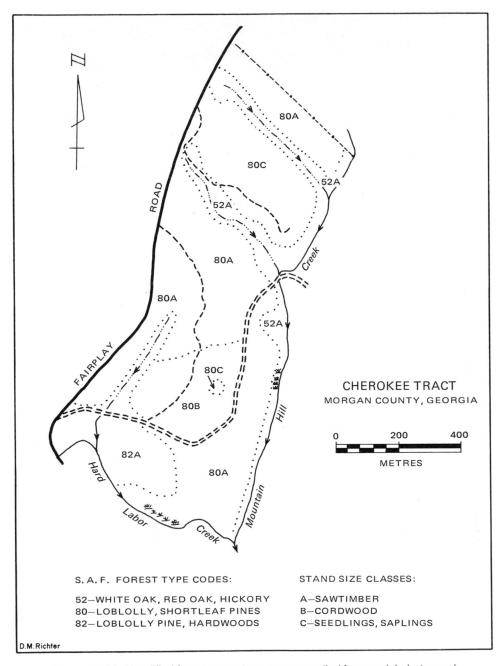

Figure 11-14. Simplified forest cover-type map compiled from aerial photographs.

Tree volume estimates

Where large-scale, stereoscopic photo coverage is available, it may be feasible to make direct estimates of individual tree volumes, by species or species groups. Sample-strip coverage obtained with 70-mm format cameras is often specified, at scales ranging from 1:1,000 to 1:5,000 (Figure 11-15). The

Figure 11–15. Panchromatic stereogram of a thinned radiata pine plantation near Rotorua, New Zealand. Tree counts, heights, and crown measurements can be made on such photographs. Scale is about 1:3,000. Courtesy New Zealand Forest Service and New Zealand Aerial Mapping, Ltd.

determination of the exact negative scale is ideally accomplished by employment of a radar altimeter in the photographic aircraft.

Panchromatic film has been used successfully for individual tree evaluations in northern boreal forests; in several photographic experiments, the fall season, i.e., after deciduous trees are leafless but prior to snowfall, has been specified. This timing is regarded as ideal for species recognition. In other regions, of course, different film/season combinations may be preferred. Regardless of the film emulsion specified, the use of positive transparencies will generally yield more reliable measurements than the interpretation of photographic prints.

A common approach to volume determination is to substitute photographic measures of crown diameter (or crown area) and total tree height for the usual field tallies of stem diameter (dbh) and merchantable height, respectively (Figure 11-16). Regression equations are then developed for each species or species group for use in volume estimation. For example, the generalized linear equation, $\hat{Y} = a + bX$, may be employed if a "combined-variable" (the product of crown and height measurements) is substituted as a value of X. Thus the general equation becomes:

$$\hat{Y} = a + b(cd^2h)$$
, or $\hat{Y} = a + b(cah)$

where: \hat{Y} is the tree volume, determined from a subsample of ground measurements in order to establish the regression coefficients a and b,

cd is the tree crown diameter.

ca is the tree crown area,

h is the total tree height.

Other, more sophisticated regression models may prove superior to the foregoing equation form.

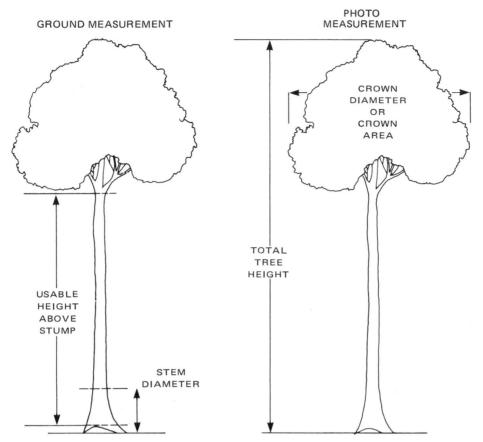

Figure 11–16. Comparison of ground and photographic measurements in the determination of individual tree volumes.

Crown diameters or areas

The value of crown measurements in tree volume prediction equations depends on the relationship that exists between crown dimensions and corresponding stem diameters or basal areas. High correlations of these variables can often be established for even-aged conifers that have not been subjected to undue suppression or stand competition; the relationship is usually linear for trees in the middle diameter or age classes.

The photographic determination of crown diameter is simply a linear measure, but measurements can be difficult because of the small sizes of tree images, the effects of crown shadows, and noncircular crowns (Figure 11-17). Various linear scales, magnifiers, and "crown wedges" are available for photographic measurements. Careful interpreters can measure to within ± 0.1 mm, so accuracy is dependent on image scale, film resolution, and individual ability.

Measurements of crown area offer an alternative to crown diameter evaluations. Area determinations can be made with finely graduated dot grids or can be calculated from stereoplotter coordinates of points along the crown perimeters. As more sophisticated image interpretation equipment becomes available, crown areas may entirely supplant crown diameters in tree volume prediction equations.

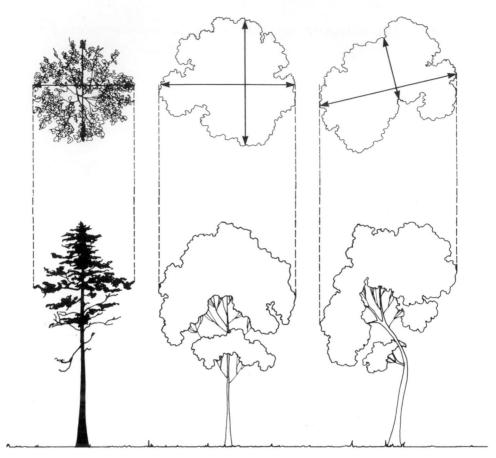

Figure 11-17. The shapes of tree crowns as seen from above can make crown diameter measurements difficult.

Tree volume tables

Aerial tree volume tables are often compiled from volume prediction equations based on crown and height measurements. However, since more interpretation time is required for measurement of heights than crowns, several single-entry volume tables (based on crown diameter or crown area alone) have been proposed. The approach is valid where tree heights are fairly uniform within specified crown classes. *Table 11-1* was formulated from existing tarif tables by the following steps:

- 1. A tree volume equation was produced from optical dendrometer measurements of fifty-eight standing trees; on the basis of this data, a tarif access table was derived.
- 2. An existing tarif table was selected for the area from which sample trees were drawn.
- 3. A crown diameter/stem diameter relationship, based on six hundred tree measurements, was established for the sample area.
- 4. The crown diameter/stem diameter relationship was used to convert the selected tarif table to a single-entry aerial volume table based solely on crown diameter.

Table 11-1. Tree Volume Table for Young-Growth Ponderosa Pine

Merchantable volume, in cubic metres, to a 10-cm top
0.0453
0.0821
0.1246
0.1813
0.2492
0.3086
0.3823
0.4673
0.5523
0.6457
0.7562
0.8638
0.9771

Adapted from Hitchcock (1974).

Although *Table 11-1* is applicable only to a limited area in northern Arizona, the *method* of constructing the single-entry table may be useful in other areas where crown and stem diameters are closely correlated.

Stand volume tables

Where only small-scale aerial photographs are available to interpreters, emphasis is on measurement of stand variables rather than individual tree variables. Aerial stand volume tables are multiple-entry tables that are usually based on assessments of two or three photographic characteristics of the dominant-codominant crown canopy—average stand height, average crown diameter (or crown area), and percentage of crown closure. These tables may be derived by multiple regression analysis; photographic measurements of the independent variables are made by several skilled interpreters, and a volume prediction equation is developed.

Crown closure

Crown closure, also referred to as *crown cover* and *canopy closure*, is defined by photo interpreters as the percentage of a forest area occupied by the vertical projections of tree crowns. The concept is primarily applied to even-aged stands or to the dominant-codominant canopy level of unevenaged stands. In this context, the maximum value possible is 100 percent.

In theory, crown closure contributes to the prediction of stand volume, because such estimates are approximate indicators of stand density, e.g., number of stems per hectare. Since basal areas and numbers of trees cannot be determined directly from small-scale photography, crown closure is sometimes substituted for these variables in volume prediction equations. Photographic estimates of crown closure are normally used, because reliable ground evaluations are much more difficult to obtain (Figures 11-18 and 11-19).

At photo scales of 1:15,000 and smaller, crown closure estimates are usually made by ocular judgment, and stands are grouped into 10 percent classes. Ocular estimates are easiest in stands of low density, but they

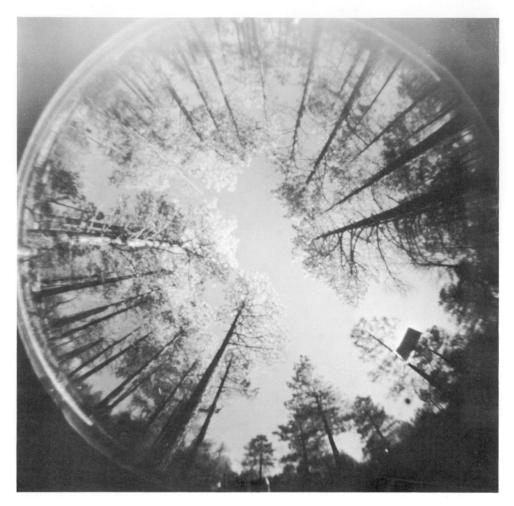

Figure 11–18. A ground view of crown closure as seen by a canopy camera. Courtesy U.S. Forest Service.

become progressively more difficult as closure percentages increase. Minor stand openings are difficult to see on small-scale photographs, and they are often shrouded by tree shadows. These factors can lead to overestimates of crown closure, particularly in dense stands. And, if ocular estimates are erratic, the variable of crown closure may contribute very little to the prediction of stand volume.

With high-resolution photographs at scales of 1:5,000 to 1:15,000 it may be feasible to derive crown closure estimates with the aid of finely subdivided dot grids. Here, the proportion of the total number of dots that falls on tree crowns provides the estimate of crown closure. This estimation technique has the virtue of producing a reasonable degree of consistency among various photo interpreters; it is therefore recommended wherever applicable.

A modification of the foregoing technique involves the copying of aerial imagery onto 35-mm slides or microfilm. The images are then enlarged by conventional projection or by use of a microfilm reader, and dot counts and crown closure estimates can be made.

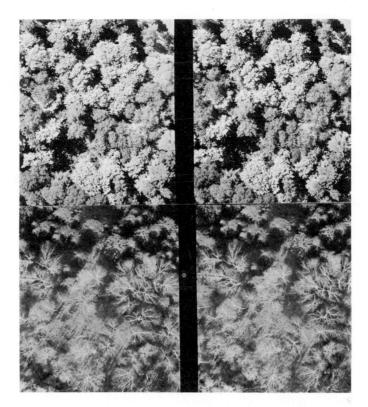

Figure 11–19. Crown closure estimates are difficult when foliage and shadows obscure canopy openings (above) or when deciduous trees are leafless (below). Scale is about 1:1,000. Courtesy Canada Department of Forestry.

Estimating stand volumes

Once an appropriate aerial volume table has been selected (or constructed), there are several procedures that can be employed in the derivation of stand volumes. One approach is as follows:

- 1. Outline tract boundaries on the photographs, using the effective area of every other print in each flight line. This assures stereoscopic coverage of the area on a minimum number of photographs and avoids duplication of measurements by the interpreter.
- 2. Delineate important cover types. Except where type lines define stands of relatively uniform density and total height, they should be further broken down into homogeneous units so that measures of height, crown closure, and crown diameter will apply to the entire unit. Generally, it is unnecessary to recognize stands smaller than 2 to 5 ha.
- 3. Determine the area of each condition class with dot grids or a planimeter. This determination can sometimes be made on contact prints.
- 4. By stereoscopic examination, measure the variables for entry into the aerial volume table. From the table, obtain the average volume per hectare for each condition class.

- 5. Multiply volumes per hectare from the table by condition class areas to determine gross volume for each class.
- 6. Add class volumes for the total gross volume on the tract.

Volume adjustment from field checks

Aerial volume tables and volume prediction equations are not generally reliable enough for purely photographic estimates, and some allowance must be made for differences between gross volume estimates and actual net volumes on the ground. Therefore, a portion of the stands (or condition classes) that are interpreted should be checked in the field. If field volumes average 60 m³/ha as compared with 80 m³/ha for the photo estimates, the adjustment ratio would be 60/80, or 0.75. When the field checks are representative of the total area interpreted, the ratio can be applied to photo volume estimates to yield adjusted net volume. It is desirable to compute such ratios by forest types, because deciduous, broad-leaved trees are likely to require larger adjustments than conifers.

The accuracy of aerial volume estimates depends not only upon the volume tables used, but also on the ability of interpreters who make the essential photographic assessments. Since subjective photo estimates often vary widely among individuals, it is advisable to have two or more interpreters assess each of the essential variables.

Photo stratification for ground cruising

A photo-controlled ground cruise combines the features of aerial and ground estimating, offering a means of obtaining timber volumes with maximum efficiency. Photographs are used for area determination, for allocation of field sample units by forest type and stand size classes, and for designing of the pattern of fieldwork. Tree volumes, growth, cull percentages, form class, and other data are obtained on the ground by conventional methods. A photo-controlled cruise may increase the efficiency and reduce the total cost of an inventory on tracts as small as 50 ha.

The approach to an inventory of this kind is largely dependent on the types of strata recognized and the method of allocating field sample units. The total number of field plots to be measured is determined by cost considerations or by the statistical precision required. Once the number has been determined, the individual sample units are commonly distributed among various photo classifications by the technique of stratified random sampling.

If type boundaries have been accurately delineated and stands are homogeneous within the recognized classes, field plots can sometimes be taken along routes of easy travel without much bias being introduced. Usually, however, some kind of coordinate system is designated as a sampling frame; then a random selection of sample units is made within each stratum. Field measurements are taken by conventional procedures. Cumulative tally sheets or point-sampling may be employed to speed up the tree tally. After the volume per hectare for each stratum has been determined by field sampling, the values are multiplied by the appropriate stand areas. The result is the total volume on the tract, by cover types.

Special uses of photographic coverage

Foresters and range managers have long used aerial photographs in various activities related to the prevention and control of wildfires. The potential fire danger in a given locality can be predicted by intensive analyses of seasonal changes in plant cover. These "forest fuels" are readily mapped by special photographic flights timed at known periods of critical fire danger.

Presuppression activities include aerial photo searches for reliable sources of water during expected drought periods. Advance photographic coverage also provides information on existing fire lines and makes it feasible to lay out new lines and timber access routes prior to the occurrence of wildfires. Woodlands subject to heavy use by recreationists, campers, hunters, and fishermen are sometimes critical fire danger spots, and these areas can be regularly monitored by means of up-to-date aerial photographs. The detection of wildfires by thermal imagery techniques has been previously outlined in Chapter 7.

Special-purpose photography may also be used to advantage by foresters in estimation of timber volumes removed during harvesting operations or in assessment of logging and wind damage to residual stands of timber. In Figure 11-20, for example, individual tree stumps may be counted and merchantable logs that were removed may be estimated by measurement of photo distances between paired stumps and undisturbed treetops. The shadows reveal that stumps were cut rather high—probably an indication of the predominance of swell-butted bottomland hardwood species. It will also be noted that the stand was rather heavily cut and that subsequent flooding of the river flat will probably result in severe soil erosion. An example of wind damage to a timber stand is shown in Figure 11-21.

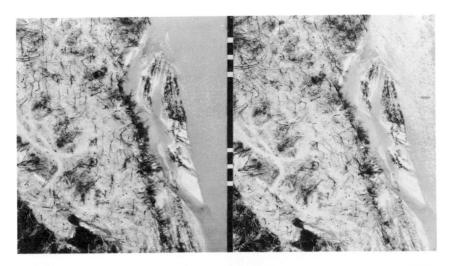

Figure 11–20. Site of a timber-harvesting operation near Newcomerstown, Ohio. Individual tree stumps and residual tops are discernible. It is also evident that the river flat has been subjected to periodic flooding in the past. Scale is about 1:3,000. Courtesy Abrams Aerial Survey Corp.

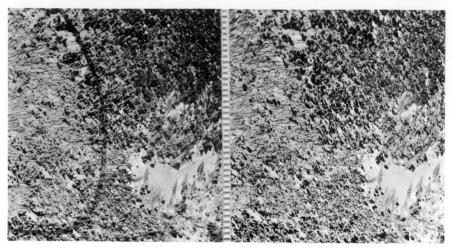

Figure 11-21. Timber blowdown on the Kaibab National Forest, in Arizona. Most down trees are ponderosa pines. Scale is about 1:5,000. Courtesy U.S. Forest Service.

Inventories of floating roundwood

Cut roundwood being rafted down rivers, towed in booms, or stored in ponds can be inventoried with fair success from large-scale aerial photographs. One technique for counting floating pulpwood sticks is based on a tally of individual bolts on sample "plots" that are randomly located in water-storage areas. The wood-storage perimeters are then delineated, and areas are determined with a dot grid or planimeter to provide expansion factors for the plot estimates. Photographic resolution and image size are major factors affecting the accuracy of such pulpwood stick counts.

Photography flown especially for inventories of floating roundwood should be taken when water areas are calm and when floating timber is spread out in a single layer. Where roundwood is piled high in several layers or covered by snow and ice, reliable counts are virtually impossible. The extremes in seasonal photographic coverage of floating roundwood are illustrated in *Figures 11-22* and *11-23*.

Detecting plant vigor and stress

Stress symptoms in vegetation result from a loss of vigor, which indicates an abnormal growing condition. Among the causal agents for loss of plant vigor are diseases, insects, soil moisture deficiencies, soil salinity, decreases in soil fertility, air pollutants, and so on. Since the symptoms of plant stress tend to be similar regardless of the causal agent, the agent itself must usually be determined by ground examination.

The primary role of remote sensing research is (1) to find the best combination of films, filters, and image scales for detection of damaged plants and (2) to ascertain whether plants under stress can be detected before visual symptoms of decline are apparent. There have been notable successes with the first objective but few real breakthroughs with the second.

When plant foliage suddenly changes over extensive areas, conventional color or infrared color films provide an effective sensor at scales of 1:4,000

Figure 11–22. Sawmill storage pond for logs in Lewis County, Washington. Average log length and a reliable log count can be determined from such photography. Scale is about 1:6,000. Courtesy Northern Pacific Railroad.

to 1:8,000. Skilled interpreters can then delineate the afflicted trees or shrubs, so that control or salvage operations can be planned. Losses from epidemics can also be quickly determined. However, this technique is limited, because the vegetation which has become visually detectable is already dying or dead. Control measures that can save such vegetation may thus be dependent on much earlier (previsual) detection—an achievement that has generally been unattainable with aerial films.

An attempt to generalize some of the research findings in plant stress detection resulted in the compilation of *Table 11-2*. It should be emphasized that this tabulation merely provides a few examples of reported research and that the results are necessarily condensed and generalized. For a more complete summary, readers are referred to the references at the end of the chapter. An excellent guidebook to forest damage assessment has been prepared by Murtha (1972).

Land capability for outdoor recreation

Existing techniques are readily available for the physical inventory of recreational sites; the real problem is that of establishing inventory criteria, i.e., standards based on what should be considered a recreational resource. The approach used for the Canada Land Inventory is quoted here.*

Seven classes of land are differentiated on the basis of the intensity of outdoor recreational use, or the quantity of outdoor recreation, which may be generated and sustained per unit area of land per annum, under perfect market conditions.

"Quantity" may be measured by visitor days, a visitor day being any reasonable portion of a twenty-four-hour period during which an individual person uses a unit of land for recreation.

^{*}Canada Land Inventory Report No. 6, "Land Capability Classification for Outdoor Recreation," Lands Directorate of the Department of the Environment, Ottawa, Canada, 1970.

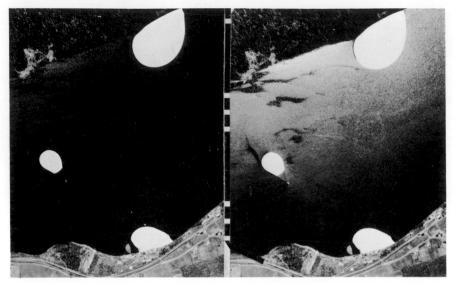

Figure 11–23. Storage of floating roundwood along river banks in Aroostook County, Maine. A boom of wood is also being towed across the river. The mantle of snow and ice on the wood prohibits a reliable inventory. Scale is about 1:20,000. Courtesy U.S. Department of Agriculture.

"Perfect market conditions" implies uniform demand and accessibility for all areas, which means that location relative to population centres and to present access do not affect the classification.

Intensive and dispersed activities are recognized. Intensive activities are those in which relatively large numbers of people may be accommodated per unit area, while dispersed activities are those which normally require a relatively larger area per person.

Some important factors concerning the classification are:

1. The purpose of the inventory is to provide a reliable assessment of the quality, quantity and distribution of the natural recreation resources within the settled parts of Canada.

2. The inventory is of an essentially reconnaissance nature, based on interpretation of aerial photographs, field checks, and available rec-

ords, and the maps should be interpreted accordingly.

3. The inventory classification is designed in accordance with present popular preferences in nonurban outdoor recreation. Urban areas (generally over 1,000 population with permanent urban character), as well as some nonurban industrial areas, are not classified.

4. Land is ranked according to its natural capability under existing conditions, whether in natural or modified state; but no assumptions are made concerning its capability given further major artificial

modifications.

5. Sound recreation land management and development practices are assumed for all areas in practical relation to the natural capability of each area.

6. Water bodies are not directly classified. Their recreational values accrue to the adjoining shoreland or land unit.

7. Opportunities for recreation afforded by the presence in an area of wildlife and sport fish are indicated in instances where reliable information was available, but the ranking does not reflect the biological productivity of the area. Wildlife capability is indicated in a companion series of maps.

,	Table 11-2. Sele	Table 11-2. Selected Examples of Plant Stress Detection	tress Detection	
Causal agent	Primary species affected	Imagery and scale	Results or detection accuracy	Reporting scientists
Balsam woolly aphid	Abies amabilis	IR color; 1:1,000	83% accuracy	Murtha and Harris
Black Hills beetle	Pinus ponderosa	Conventional color and IR color; 1:7,920 and smaller	80%-90% accuracy at 1:7,920 scale	Heller
Pine butterfly	Pinus ponderosa	IR color; 1:127,000	70% of area, as compared to visual/ ground survey	Ciesla
Douglas-fir beetle	Pseudotsuga menziesii	Conventional color and pan; 1:5,000-1:10,000	High accuracy; no numerical results	Wear, Pope, and Orr
Smog (air pollution)	Pinus ponderosa and Pinus jeffreyi	Conventional color; 1:8,000	80%-90% accuracy	Wert, Miller, and Larsh
SO ₂ fumes	Most forest vegetation and some shrubs	600–700 nm; satellite imagery	Delineation of damage zones	Murtha
Dutch elm disease	Ulmus americana	IR color; 1:8,000	90%-100% accuracy	Meyer and French

Recreational surveys

The objective of a recreational survey is to locate potential sites and transfer these areas to a base map of suitable scale. With up-to-date photographs in the hands of skilled interpreters, a preliminary recreational survey can be accomplished with a minimum of fieldwork.

Most types of photographic films are suitable, although color emulsions are generally preferred. Exposures should be planned during the dormant season when deciduous trees are leafless and/or during the season when the greatest numbers of people would be likely to use potential features. Photographic scales of 1:5,000 to 1:12,000 have been successfully employed; if large regions must be covered by a preliminary survey, the smallest scale that can be reliably interpreted should be chosen to avoid the handling and stereoscopic study of excessive numbers of exposures (Figure 11-24).

The photo interpretation phase will require the identification and delineation of such features as:

Natural vegetation Land-use patterns Scenic terrain features Water resources Beaches and inlets Potential docks or ramps Existing structures Historical features Access roads Paths or trails Soils and drainage Topography

Figure 11-24. Land-between-the-lakes area (Kentucky) where recreational facilities are highly developed. Scale is about 1:24,000. Courtesy Tennessee Valley Authority.

The more promising potential sites are then checked on the ground for verification of the interpreter's assessments of current land use, present ownership, site availability, and potentially undesirable features (e.g., polluted water, excessive noise, industrial fumes, or lack of suitable access).

After elimination of those areas that are unavailable or undesirable, a final report is prepared summarizing and ranking the recreational potential of each site recommended. The report should be accompanied by both ground and aerial photographs that have been annotated to emphasize salient features, needed improvements, and possible trouble spots.

Problems

- 1. Obtain the most recent aerial imagery available suitable for preparing a local cover-type map. Be sure that a planimetric or topographic base map is also available for the project area. Then:
 - a. Prepare a radial line plot to adjust the image scale to the scale of the base map (see Chapter 6).
 - b. Delineate the effective area of each image frame, or mark effective areas on alternate overlapping photographs if overlaps are sufficient.
 - c. Interpret each frame of imagery and delineate major forest and/or range cover types. Minimum areas recognized should be approximately 1 cm², depending on image and base map scales. The cover-type classifications used should be based on systems recommended by national mapping agencies or scientific organizations. Tree height or crown cover classes should also be recognized within each major cover-type group.
 - d. Ground check as many classifications as possible, and make corrections on each annotated frame.
 - e. Construct a planimetric (transparent) overlay at the exact scale of the base map. Show major drainages, transportation routes, etc., by use of standard mapping symbols.
 - f. Use a sketchmaster or another device to transfer the cover-type delineations from the annotated imagery to the planimetric overlay.
 - g. Ink the final overlay, and add the appropriate title, legend, and graphic scale. Check for errors and omissions by reference to the map correction sheet at the end of Chapter 8.
 - h. Color the major cover types according to a standardized system, or follow type-coding recommendations of your instructor.
- 2. Determine the land area of each major cover type shown on your finished overlay. Present in tabular form on a separate sheet, along with detailed definitions of each cover type.
- 3. Obtain seventy-five to a hundred photographic measurements of crown area and total height for a coniferous species. Determine ground volumes of the same trees and attempt to fit a regression equation to the data by the method of least squares. Then use the equation for volume prediction purposes in similar, adjacent stands.
- 4. Examine aerial photographs of an entire country at a local government agency or state highway department. Devise a set of inventory criteria and

then locate at least three new potential recreational sites. Visit the sites on the ground and assess their relative potential, availability, and access. Explain your method of selection and site evaluation in an illustrated report.

References

- Aldred, A. H., and J. K. Hall. 1975. Application of large-scale photography to a forest inventory. Forestry Chronicle 51(1):1-7, illus.
- Aldred, A. H., and L. Sayn-Wittgenstein. 1972. Tree diameters and volumes from large-scale aerial photographs. Canadian Forest Service, Ottawa. Information Report FMR-X-40, 39 pp., illus.
- Aldrich, Robert C. 1971. Space photos for land use and forestry. Photogrammetric Engineering 37:389-401, illus.
- Avery, T. E. 1975. Natural Resources Measurements. 2nd ed. McGraw-Hill Book Co., New York. 339 pp., illus.
- ———, and James Canning. 1973. Tree measurements on large-scale aerial photographs. New Zealand Journal of Forestry 18(2):252-64, illus.
- ——, and M. P. Meyer. 1959. Volume tables for aerial timber estimating in northern Minnesota. U.S. Forest Service, Lake States Forest Experiment Station. Station Paper 78, 21 pp., illus.
- Bonner, G. M. 1968. A comparison of photo and ground measurements of canopy density. Forestry Chronicle 44(3):12-16, illus.
- Brown, Harry E., and David P. Worley. 1965. The canopy camera in forestry. *Journal of Forestry* 63:674-80, illus.
- Carneggie, David M. 1968. Analysis of remote sensing data for range resource management. Annual progress report, Forestry Remote Sensing Laboratory, Berkeley, Calif. 62 pp., illus.
- Ciesla, W. M. 1974. Forest insect damage from high-altitude color-IR photos. *Photogrammetric Engineering* 40:683-89, illus.
- Driscoll, R. S., and M. D. Coleman. 1974. Color for shrubs. Photogrammetric Engineering 40:451-59, illus.
- Hegg, Karl M. 1966. A photo identification guide for the land and forest types of interior Alaska. Northern Forest Experiment Station, Juneau, Alaska. 55 pp., illus.
- Heller, Robert C. 1971. Detection and characterization of stress symptoms in forest vegetation. Proceedings of the International Workshop on Earth Resource Survey Systems, Government Printing Office, Washington, D.C., pp. 109–50, illus.
- ——, G. E. Doverspike, and R. C. Aldrich. 1964. Identification of tree species on large-scale panchromatic and color aerial photographs. Government Printing Office, Washington, D.C. U.S. Department of Agriculture, Agriculture Handbook 261, 17 pp., illus.
- Hitchcock, Harry C., III. 1974. Constructing an aerial volume table from existing tarif tables. *Journal of Forestry* 72:148-49, illus.
- Johnson, E. W., and L. R. Sellman. 1974. Forest cover photo-interpretation key for the Piedmont habitat region in Alabama. Forestry Department Series 6, Auburn University, Auburn, Alabama. 51 pp., illus.
- Kippen, F. W., and L. Sayn-Wittgenstein. 1964. Tree measurements on large-scale, vertical 70-mm air photographs. Forest Research Branch, Canada Department of Forestry. Publication 1053, 16 pp., illus.
- Lanly, J. P. 1973. Manual of forest inventory, with special reference to mixed tropical forests. Food and Agriculture Organization of the United Nations, Rome. 200 pp., illus
- Meyer, M. P., and D. W. French. 1967. Detection of diseased trees. Photogrammetric Engineering 33:1035-40, illus.

- Murtha, P. A. 1973. ERTS records SO $_2$ fume damage to forests, Wawa, Ontario. Forestry Chronicle 49(6):251-52, illus.
- ——. 1972. A guide to air photo interpretation of forest damage in Canada. Canadian Forestry Service, Ottawa. Publication 1292, 63 pp., illus.
- ——, and J. W. E. Harris. 1970. Air photo interpretation for balsam wooly aphid damage. *Journal of Remote Sensing* 1(5):3–5, illus.
- Myers, B. J. 1974. The application of color aerial photography to forestry: A literature review. Forestry and Timber Bureau, Commonwealth of Australia, Canberra. Australian Department of Agriculture, Leaflet 124, 20 pp., illus.
- Nielson, U. 1971. Tree and stand measurements from aerial photographs: An annotated bibliography. Canadian Forestry Service, Ottawa. Information Report FMR-X-29, 111 pp.
- Null, William S. 1969. Photographic interpretation of canopy density—A different approach. *Journal of Forestry* 67:175-77, illus.
- Society of American Foresters. 1964. Forest cover types of North America, exclusive of Mexico. Committee on Forest Types, Washington, D.C. 67 pp., illus.
- Stellingwerf, D. A. 1969. Kodak Ektachrome infrared AERO film for forestry purposes. International Training Centre, Enschede, The Netherlands. 17 pp., illus.
- Wear, J. F., R. B. Pope, and P. W. Orr. 1966. Aerial photographic techniques for estimating damage by insects in western forests. U.S. Forest Service, Pacific Northwest Forest and Range Experiment Station. 79 pp., illus.
- Wert, S. L., P. R. Miller, and R. N. Larsh. 1970. Color photos detect smog injury to forest trees. *Journal of Forestry* 68:536-39, illus.
- Zsilinszky, Victor G. 1966. Photographic interpretation of tree species in Ontario. 2nd ed. Ontario Department of Lands and Forests, Toronto. 86 pp., illus.

Chapter 12

Landforms and Physiographic Features

Applications of photogeology

The use of aerial photographs to obtain both qualitative and quantitative geologic information is referred to as photogeology. Geologists commonly use photographs for structural mapping, fuel and mineral exploration, and general engineering surveys. Geologic interpretation is based on the fundamental recognition elements of photographic tone, color, texture, pattern, relationships of associated features, shape, and size. Although oblique photographs are often of value to the photogeologist, most detailed analyses make use of vertical photography.

The quantity of geologic information that can be obtained from aerial photographs is dependent on the type of terrain, climatic environment, and stage of the geomorphic cycle. Because features are more readily recognized where strong differences exist in the erosional resistance of adjacent rocks, sedimentary terrain may be expected to yield the greatest amount of information from aerial photographs. Metamorphic terrain may yield the least information, because metamorphic processes tend to destroy differences that may have existed in the unmetamorphosed rocks.

In petroleum exploration, aerial photographs provide a wealth of information with regard to potential structural traps. Folds may be interpreted from a study of strike and dip of bedding or from stream patterns. Anomalous stream characteristics, such as deflections, may suggest subsurface structures. The variety of photographic criteria that suggests faults permits aerial photographs to be of particular use in ore-deposit studies. Analysis of soil patterns yields information regarding permeability of the surficial materials that are a concern of the engineering geologist (Ray, 1960).

Although detailed analyses of geomorphology and stratigraphy require professional training in geology, skilled interpreters may develop a high degree of proficiency in recognition of broad lithologic units and identification of distinctive landforms or surface features (Figure 12-1). Thus, the objective of this chapter is to provide the nongeologist with a simple introduction to the study of landforms and physiographic features through a series of aerial photographic examples. The serious student of photography should supplement this material by studying additional texts on physiography and geomorphology, such as those listed at the end of this chapter.

Lithologic units

It is usually valuable for the interpreter to be able to classify rock with respect to its general geologic type, that is, whether the rock was formed directly from a molten mass (igneous), by the deposition of rock grains transported by water or wind (sedimentary), or by the action of heat or pressure on previously existing rock (metamorphic). Landforms composed of these rock classes often show up with striking clarity on aerial photographs; in many instances, key physiographic signatures will reveal their lithologic composition to the practiced interpreter.

Igneous surface materials that may be directly recognized or identified by inference include granite, basalt, lava flows, volcanic glass (obsidian), and pumice. In the case of sedimentary materials, it may be possible for the interpreter to recognize gypsum sand, quartz sand, sandstone, dolomite, and limestone deposits. Gneiss is the principal metamorphic rock that is commonly observed, although the presence of such rocks as marble may be detected in open quarries. Simple inferences regarding surficial deposits can be of considerable economic importance to the engineering geologist in search of materials such as sand or gravel for construction purposes (Figure 12-2).

The climate and stage of erosion are important influences on rock appearance. Since the climate controls the amount of moisture in a region, it directly influences soil formation, the depth of weathering, the amount of vegetative cover, and the rate of erosion. The stage of erosion reflects the extent to which the earth's surfaces have been dissected and weathered. Among early, middle, and late stages of erosion, the middle stage is the time of greatest topographic relief. As a rule, erosional patterns are more easily interpreted in arid regions, where vegetative cover is sparse or absent.

Strike and dip determinations

Patterns of fractures, faults, and dikes, usually discernible on aerial photographs, are important in mineralogical exploration. Inclined beds of

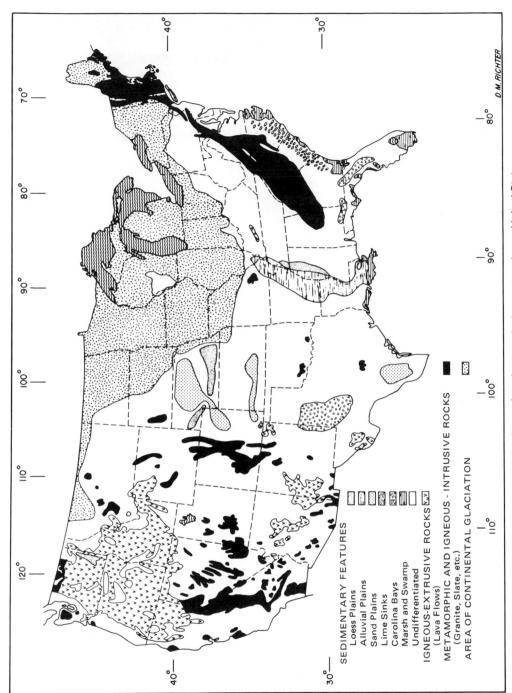

Figure 12-1. Distinctive surface features in the conterminous United States.

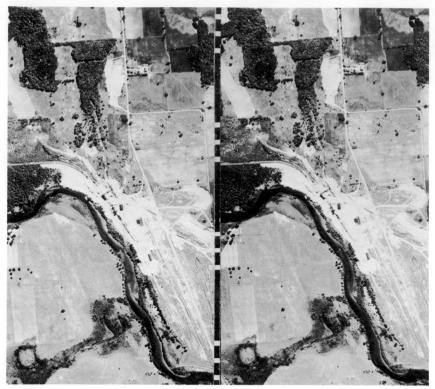

Figure 12-2. A knowledge of the depositional characteristics of flowing streams led to the discovery of this sand deposit along a Michigan river. Scale is about 1:20,000.

sedimentary rock may also reveal structural anomalies that indicate possible mineral deposits. On high-quality photographs of the proper scale, it is possible to obtain quantitative information on tilted sedimentary beds by direct measurements of dip (the angle of a geologic surface with respect to the horizontal) and strike (the bearing of the line of intersection of an inclined geologic surface with the horizontal). Stated in another way, dip is the angle in which the inclined bed disappears beneath the ground, and strike is the true compass bearing of a line along the edge of the exposed dipping bed (Figure 12-3).

In some instances, the direction of the dip angle is also required for a complete description of the plane of contact between rock bodies. As stated by Dort (1964), "Dip is the angle and direction down which a mine would be excavated in order to follow a layer of coal. The strike is the direction along which that layer of coal would be exposed across a flat field."

When bedding surfaces coincide with topographic surfaces, the dip angle can be determined by measurement of the height difference between two points, one directly downslope from the other. Such height differences can be derived from measurements of stereoscopic parallax as described in Chapter 3. After the horizontal distance between the same two points is determined, the dip angle can be computed by this trigonometric relationship:

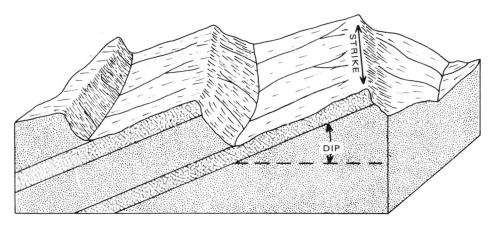

Figure 12-3. Illustration of strike line and dip angle for gently dipping beds of sedimentary rocks.

If relief in an area is low, the horizontal distance may be scaled directly from a single photograph without significant error in computation of the dip. However, when relief is moderate or high, a correction for the relief displacement of the upper point with respect to the lower point should be made. In the unique circumstance where the strike is radial from a photograph center, or the surface on which the dip to be measured is near a photograph center, there is little or no relief displacement in the dip direction, and no correction in scaling the horizontal distance need be made (Ray, 1960).

The strike line generally can be determined with a protractor by inspection of the stereoscopic model and notation of two points of equal altitude on a bed. Where dips are low, however, tilt in the photographs will affect the direction of strike. The lower the dip, the greater the effect on the change in azimuth of the strike line.

Analysis of drainage patterns

As was pointed out in Chapter 10, the type of drainage pattern prevailing on a given landform surface is often indicative of the kind of soil, parent material, and underlying lithologic structure. The absence of an integrated drainage system also provides information of significance. For example, the lack of a well-defined drainage network might indicate the presence of porous rock, such as basaltic lava, where surface water percolates downward to the water table through cracks and cavities. In other instances, soluble rocks such as limestone may absorb runoff through sinkholes and underground solution channels. And there are minor watersheds, such as dikes and drumlins, that may be too small to collect enough water for the establishment of a drainage pattern. Generally speaking, however, large landforms develop some detectable drainage system that may approximate one of the types pictured in Figure 12-4.

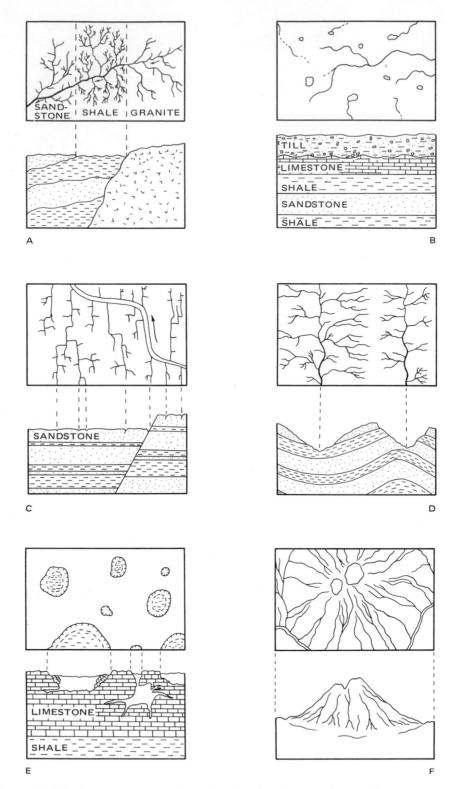

Figure 12-4. Drainage patterns and associated profiles for several types of landforms. Drainage types are: (A) dendritic; (B) deranged; (C) angular-rectangular; (D) trellis; (E) sinkhole; and (F) radial-annular. Drawn by Douglas E. Grant.

The dendritic, or treelike, pattern is a well-integrated pattern formed by the tributaries of a main stream as it branches and rebranches freely in all directions. This type of pattern implies that the area was originally flat and is composed of relatively uniform materials. Flat-lying beds of sedimentary rocks tend to develop dendritic drainage, as do areas of glacial till, tidal marshes, and localized areas in sandy coastal plains. The difference in texture (density) of a dendritic pattern may aid in identification of the surficial material; granitic areas, for example, exhibit a fine-textured dendritic pattern with repetitious curving tributaries outlining circular, domelike hills. The tributaries, as a result of steep slopes in granite hills, join each other at right angles. They appear pincerlike on photographs.

The trellis pattern, which resembles a vine trellis, is characteristic of folded or dipping rocks. The trellis pattern is developed over tilted sedimentary beds, and it results from rocks originally folded in parallel waves and then dissected. Parallel patterns consist of streams flowing side by side in the direction of the regional slope. The greater the slope, the more nearly parallel the drainage and the straighter the flow. Local areas of lava flows often have parallel drainage, even though the regional pattern may be radial. Alluvial fans may also exhibit parallel drainage, but the pattern may be locally influenced by faults or jointing. And coastal plains, because of their slope toward the sea, develop parallel drainage over broad regions.

Rectangular patterns, characterized by abrupt bends in streams, develop where a treelike drainage pattern prevails over a broad region but the pattern is locally influenced by faults, joints, or folds of rock. Metamorphic rock surfaces, particularly those comprised of schist and slate, commonly have rectangular drainage. Slate possesses a particularly fine textured system. Its drainage pattern is extremely angular and has easily recognizable short gullies that are locally parallel.

Radial and centripetal patterns are characteristic of domes or depressions. For example, the sides of a dome or volcano might have a radial drainage system, while the pattern inside a volcanic cone or a dry lakebed (playa) might be centripetal, i.e., converging toward the center of the depression. Granitic dome drainage channels may follow a circular path around the base of the dome when it is surrounded by tilted beds. These channels form an annular pattern, which is a modified form of radial drainage.

No system of landform grouping or lithologic classification is perfectly suited for photogeologic study. Any given photograph is likely to show two or more rock types, drainage patterns, structures, or depositional features. Therefore, it should be recognized that the classification scheme which follows is somewhat arbitrary and that other methods of grouping may also be appropriate.

Flat-lying sedimentary rocks
Tilted sedimentary rocks
Igneous rocks
Metamorphic rocks
Fluvial landforms

Beach ridges and tidal flats Glacial landscapes Eolian features Miscellaneous landscapes

Flat-lying sedimentary rocks

Sedimentary rocks are the most widely distributed surface materials in the world; as a result, they comprise the principal lithologic features seen on aerial photographs. Sedimentary rocks are originally deposited as horizontal beds, but they may later become tilted or inclined as a result of folding and faulting. As used in this section, the term flat-lying beds refers to those sedimentary deposits that are tilted no more than a few degrees. Sedimentary rocks are of three basic types: sandstone, limestone, and shale. Such materials were formed from water-deposited materials associated with lakes or oceans. Almost all igneous or metamorphic landforms are in contact with one or more kinds of sedimentary rock (Figure 12-5).

Sand grains originally deposited along shorelines and later cemented together have resulted in sandstone beds up to 10 m thick in some parts of the world. Sandstone is a weather-resistant but porous material; as a consequence, the rock is a prime source of water in arid regions. The characteristic drainage pattern is dendritic to rectangular, depending on the presence of faults, fractures, and joints. Sandstone boundaries adjacent to lowland areas

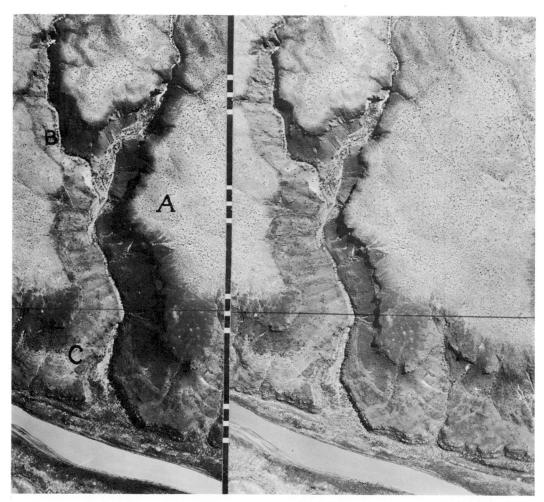

Figure 12-5. Basaltic lava flow (darkest tones) overlying gently dipping beds of sedimentary rock in New Mexico. Note semidesert vegetation (A), joint-controlled rectangular drainage (B), and sedimentary beds in contact with lava cap rock (C). Scale is about 1:6,000.

typically exhibit sharp, vertical cliffs because of the jointed but resistant qualities of the beds. When sandstone borders other sedimentary formations, the contact is commonly linear, because the more weather-resistant sandstone becomes a cap rock. Sandstone deposits photograph in light tones on panchromatic photographs due to the development of a thin mantle of sand and silt (Figure 12-6).

Shale is formed from the alternating deposition and compaction of water-borne silts and clays. Shale is an impervious rock, but it has low strength qualities and is easily eroded. Drainage patterns are typically dendritic, and stream courses are meandering. In humid regions, rounded hills are characteristic of shale deposits, and photographic tones are mottled because of variations in moisture and the presence of organic material. Shale topography in arid regions exhibits minutely dissected hills with steep slopes, light photographic tones, and streams that are usually well entrenched in valley

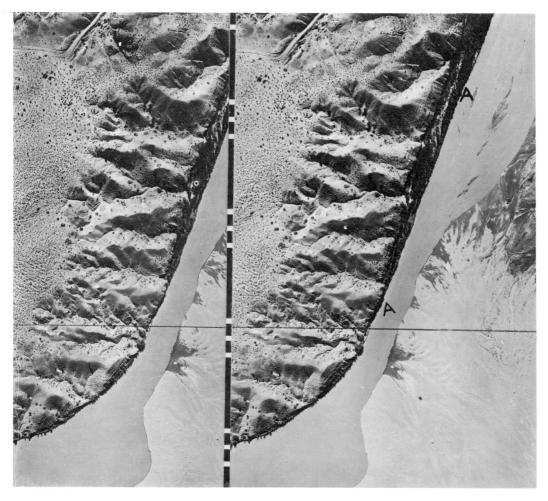

Figure 12–6. Rectangular-dendritic drainage pattern on flat-lying sandstone-shale beds along the Rio Grande in New Mexico. The sharp cliffs and unusually straight river channel (A) suggest that the shoreline is structurally controlled. Scale is about 1:6,000.

floors. Shale is commonly found as horizontal layers interbedded with sandstone or limestone (Figure 12-7). Such formations result in a stairstepped topography that appears banded because of selective differences in vegetative growth.

Limestone is a sedimentary rock formed by the consolidation of calcareous shells of marine animals or by the chemical precipitation of calcium carbonate from seawater. Limestone plains are easily recognized by their concentrations of circular sinkholes that result from underground solution in stream channels. Where beds of limestone are inclined, sinkholes are somewhat elliptical in shape and may be exposed along bedding planes. Small amounts of water pass through these sinkholes, and, as solution takes place, an underground drainage system is developed. These underground channels are connected by vertical channels which show up as circular depressions on the surface (Figure 12-8). Limestone areas are generally light toned on photographs, except where sinkholes are filled with water. In well-developed limestone topography, there is little or no local surface drainage pattern, and few major streams are found.

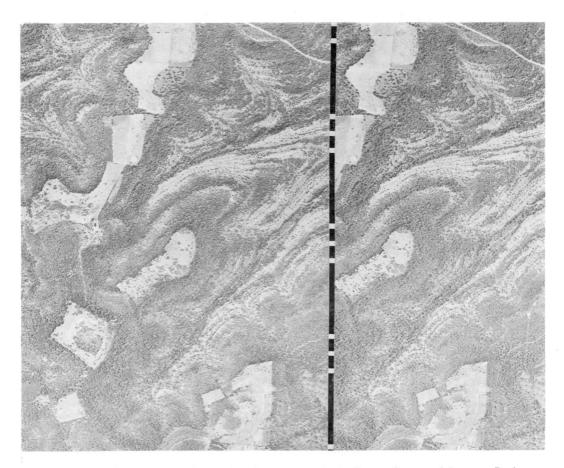

Figure 12–7. Flat-lying, interbedded sedimentary rocks in Baxter County, Arkansas. Dark bands supporting heavier vegetation are sandstone; lighter-toned bands are mainly shale or limestone deposits. Surface drainage is not well developed, and few gullies are found. The cap rock is principally sandstone here. Scale is about 1:20,000.

Figure 12–8. Rolling upland limestone ridge in Polk County, Florida. Numerous lakes (lime sinks) are found in this humid, subtropical karst region devoted to citrus orchards. Scale is about 1:20,000.

Tilted sedimentary rocks

Horizontally deposited beds of sedimentary rock may become tilted or deformed through the development of faults and folds (Figure 12-9). Tilted strata, especially when composed of two or more rock types, show up as a series of nearly parallel continuous or broken ridges that may be either closely spaced or separated by valleys. Ridges may be of any height, and they are likely to exhibit a steeper slope on one side than on the other (Figure 12-10). In terms of weathering and erosion, sandstone appears as sharp ridges, shale is typified by well-dissected valleys, and limestone topography has rounded hills and numerous sinkholes. Drainage systems usually form a trellis pattern, and large streams occur mainly in areas of shale deposits.

Alternating anticlines and synclines, along with parallel banding of rocks, are the chief identifying features of inclined, interbedded sedimentary rocks (Figure 12-11). In humid climates, massive ridges indicate cap rocks of resistant sandstone; steep sides of ridges are usually covered by forest vegetation (Figure 12-12). As a rule, ridges are more rounded in humid climates. In arid regions, ridge lines have sharper crests, and vegetative cover is confined to stream valleys or sandstone-limestone outcrops.

The contact zone between tilted sedimentary rocks and flat-lying beds takes the form of a transition area where dip angles vary from steep to gen-

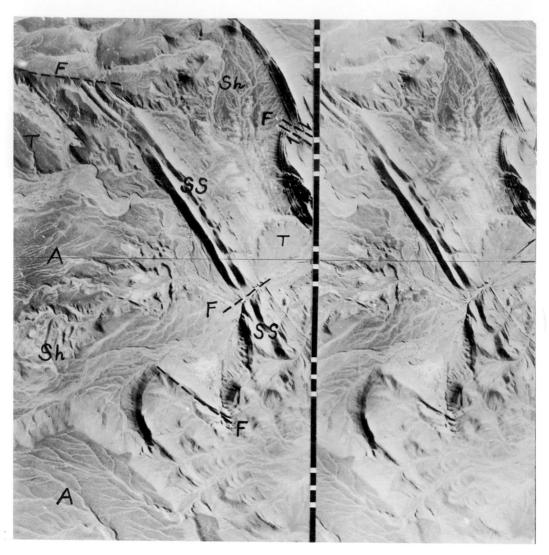

Figure 12-9. Inclined sedimentary rocks and fault zones in the Northern Sahara. Clearly discernible are sandstone *hogbacks* (SS), shale deposits (Sh), fault zones (F), alluvial fans (A), and terraces of granular deposits (T). Scale is about 1:40,000. Courtesy U.S. Air Force.

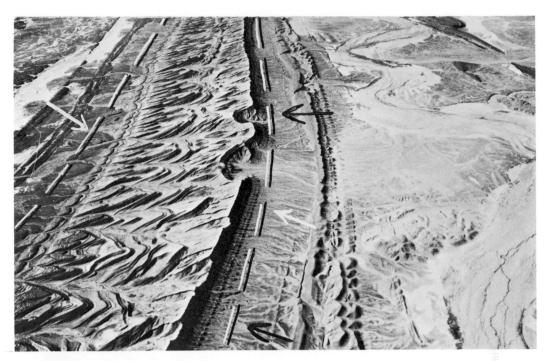

Figure 12–10. Oblique view of gently dipping beds of sandstone and shales in the Atlas Mountains of Mauritania, North Africa. Shale valleys are eroded and partially covered with alluvium. Courtesy U.S. Air Force.

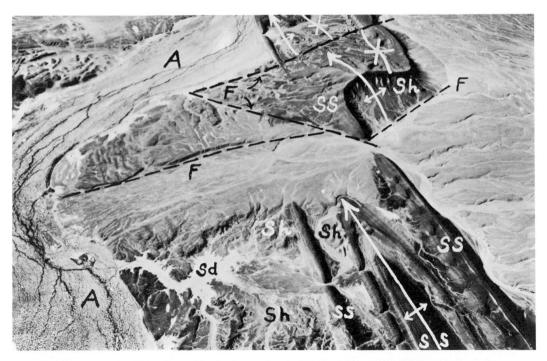

Figure 12–11. Oblique view of faulted anticline in North Africa. Note dark sandstone ridges (SS), shale with dendritic drainage (Sh), fault zones (F), alluvium (A), and sand (Sd). Courtesy U.S. Air Force.

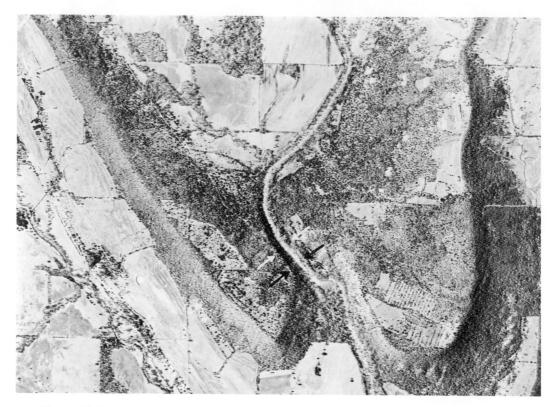

Figure 12-12. Escarpment face of a plunging syncline in a humid region (Logan County, Arkansas). Arrows indicate a water gap eroded through the relatively soft sediments by Petit Jean Creek. Scale is about 1:20,000.

tle. By contrast, sedimentary contacts with igneous intrusions or faults are denoted by distinct, linear boundaries.

With flat-lying sedimentary rocks, stratigraphic thicknesses of exposed beds can be determined directly by measurements of stereoscopic parallax. If beds are inclined, however, the angle of dip must first be determined and then corrections must be made for relief displacement and for the effect of dip on the stratigraphic thickness (Figure 12-13).

Remote sensing finds its greatest application in structural geology, i.e., the expression and configuration of geologic features shaped by deformation. Folded sedimentary beds are the most important structural features from an economic viewpoint. Many of the largest oil-producing areas are associated with folded sections of sandstone, limestone, and shale.

Relative ages of rocks can be determined from folding. Where the folded strata have been sufficiently eroded to produce their characteristic patterns, the age sequence of anticlines and domes is oldest-to-youngest, from the center outwards.

Faults and joints are fractures in rock. The presence of tectonic forces causes strain, stress, and even failure of affected rocks. Faults are planes along which movement has taken place (Figure 12-14). Joints are usually smaller than faults, with no movement accompanying them. Faults can occur singly but are commonly found in large numbers as fracture belts or fault

Figure 12-13. Relationship of measurements needed for calculation of the thickness of dipping beds.

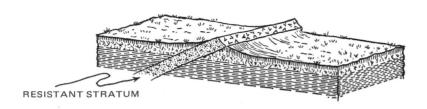

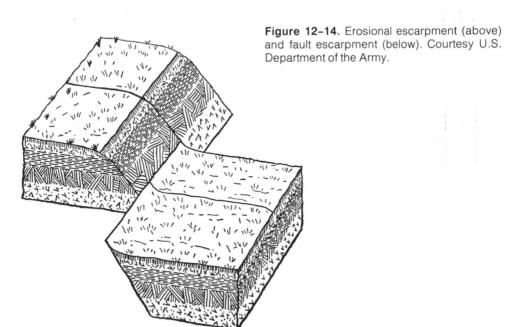

systems. They can be tens of kilometres wide and hundreds of kilometres long. The analysis of such systems on aerial imagery provides a quick and effective means of evaluating the extent and effects of displacement.

Table 12-1 provides a comparison of common sedimentary and igneous rocks for purposes of photographic interpretation.

Table 12-1. Rock Type Comparison Chart

Sedimentary rocks Climate		Landforms	Drainage pattern	Photo tone	Construction material source
Sandstone and conglom- erate	Arid	High relief, bold cliffs, massive, angular	Dendritic, angular, trellis	Light	Excellent
	Humid	High relief, massive, rounded	Dendritic, trellis	Light to medium	Crushed rock, fill, rip rap
Limestone	Arid	High relief, angular	Dendritic, trellis, angular	Light	Excellent
	Humid	Intermediate to low relief, rounded	Internal, dendritic, trellis	Light to medium	Crushed rock, cement
Shale	Arid	Low relief, slopes and valleys, angular dissection	Dendritic, parallel	Medium to dark	Poor
	Humid	Low relief, valleys smooth and rounded	Dendritic, parallel	Medium to dark	Poor
Igneous rocks					
Intrusive	Arid	Massive outcrops, bald domes	Dendritic, angular, annular, radial	Light, uniform	Excellent building stone and fill
	Humid	Rounded outcrops, subdued topography	Dendritic, angular, radial	Light, uniform	
Extrusive	Arid	Inclined flows, flat-topped plateaus, cliffs	Dendritic, parallel	Dark	Excellent crushed rock and fill
	Humid	Subdued and undulating topography	Dendritic	Dark	,

Igneous rocks

Igneous rocks are classed as being either intrusive or extrusive. Intrusive rocks are formed by molten materials that are slowly cooled and solidified within the earth's crust. These rocks, such as granite, diorite, and gabbro, may later be exposed by erosion of overlain surface materials and often appear as large domes or as narrow belts (Figure 12-15).

Extrusive rocks are formed by the quick cooling and solidification of molten matter after it breaks through the earth's crust. This molten matter may flow over the surface, or it may be explosively ejected as fragments. Common types of extrusive rocks are basalt, rhyolite, andesite, and obsidian. Ejected fragments occur as volcanic ash or volcanic breccia.

Granite is one of the most frequently encountered intrusive rocks. Granitic surfaces, except for impermeable domes or jointed areas, have well-developed dendritic drainage patterns. Photographic tones are light in color, and the absence of stratification prevents confusion of granite with sedimentary rocks.

The most widely distributed extrusive rock is basaltic lava, which is emitted from volcanic cones or fissures and flows over the adjacent surfaces as it cools and solidifies (Figure 12-16). A basaltic lava landform was illustrated earlier by Figure 12-5; topography may be flat or hilly, and minor sur-

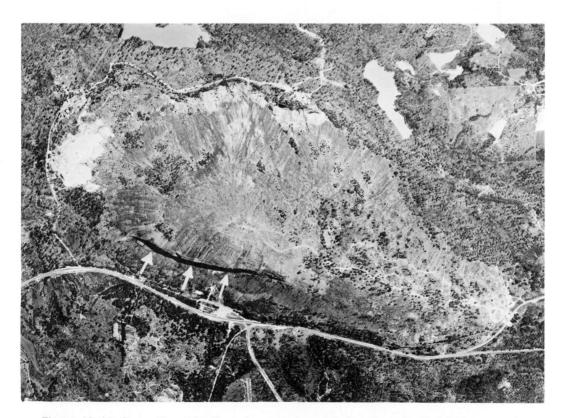

Figure 12–15. Stone Mountain, Georgia, a granite exfoliation dome located 24 km east of Atlanta. The monadnock is about 11 km in circumference and rises 360 m above an ancient peneplain. Arrows indicate the location of a Civil War carving on the steepest side. Scale is about 1:20,000.

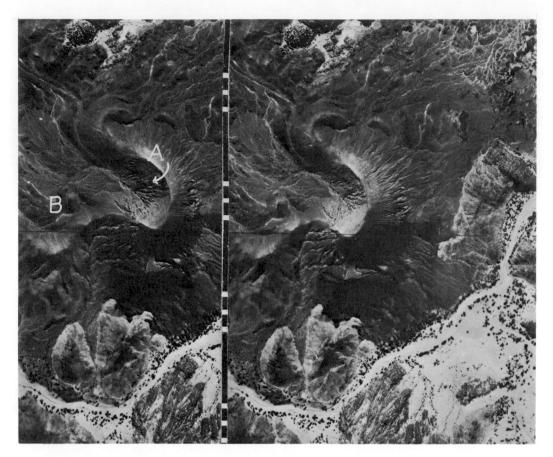

Figure 12–16. Inactive volcanic cone (A) breached by a subsequent basaltic lava flow (B). Note radial drainage pattern on side of cone. Location: Africa. Courtesy U.S. Air Force.

face irregularities are common. Canyon wall slopes are nearly vertical when breached by rivers, and both stratification and columnar jointing may be encountered. If a lava flow ends at an escarpment face or along a body of water, a distinct outline with serrated or ragged edges denotes the cliff boundary.

On panchromatic aerial photographs, basaltic lava appears in very dark tones; regional drainage patterns are likely to be of the parallel type because of slopes developed during original flows. In areas of predominantly igneous rock, basaltic lava may form resistant dikes or sills that are easily traced on aerial photographs (Figure 12-17).

Metamorphic rocks

When diastrophic forces of extreme heat and pressure alter the chemical and structural composition of igneous or sedimentary rocks, the resultant materials are known as metamorphic rocks. Among the more common metamorphic rocks are gneiss, schist, and slate.

Gneiss has a chemical composition similar, but not identical, to that of granite. Component minerals have a laminated arrangement that produces a

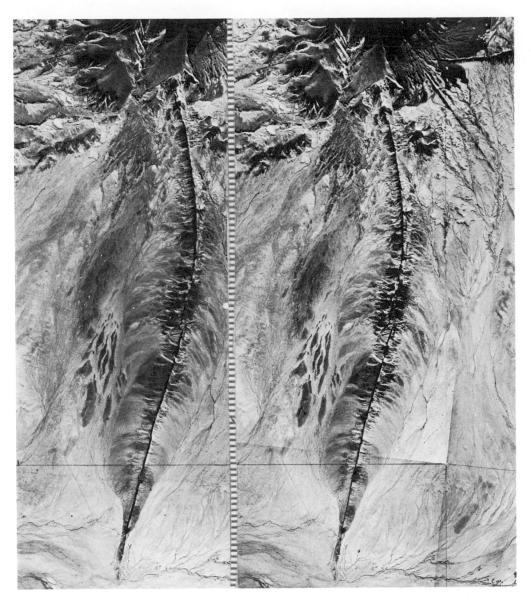

Figure 12–17. Large dike of basaltic lava radiating from Shiprock, an ancient volcanic structure in San Juan County, New Mexico. Scale is about 1:20,000. Courtesy U.S. Department of Agriculture.

banded appearance in the rock. Drainage patterns are angularly dendritic as a result of fractures, foliation, and possibly glaciation. Gneiss formations characteristically exhibit highly dissected hills that may occur as roughly parallel ridges (Figure 12-18).

Schist is a laminated rock largely composed of quartz, mica, and horn-blende. In arid regions, these rock surfaces are likely to be weathered into jagged outcrops (Figure 12-19). Covering soils may obscure the laminated structure in humid areas, but underlying schist formations may be revealed by a structurally controlled, rectangular drainage pattern. Parallel gullying is common on these easily eroded soils.

Figure 12–18. Oblique view of glaciated gneiss in Canada. Angular drainage, angular water boundaries, and parallel ridges serve to differentiate this metamorphic rock from granite.

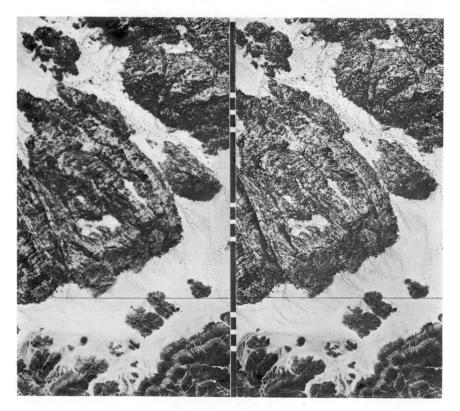

Figure 12-19. Dark-toned, laminated pattern of schists in Arabia. The sharp and rugged appearance results from alternating layers of hard and soft materials that are tilted upward, jointed, and weathered. Scale is about 1:40,000. Courtesy U.S. Air Force.

Slate is formed from metamorphosed shale. Topography is typically rugged in all climates, and the drainage pattern is rectangular and more highly developed than in shale or schist soils. Slate tends to photograph in a light gray tone on panchromatic film.

Fluvial landforms

As defined here, fluvial landforms refer to those features shaped by stream erosional and depositional processes. Included are floodplains, filled valleys, alluvial fans, and deltas.

Earlier illustrations have depicted portions of the Mississippi alluvial valley. Meander floodplains are formed by streams subject to periodic flooding. During overflow periods, stream deposits on adjacent surfaces result in the formation of a broad plain of low relief. Such floodplains are characterized by channel scars, oxbow lakes, meander scrolls, slip-off slopes, and cut banks. This plain is composed of fine materials. Streams flow in single channels during flood stages, but at low water they may flow in braided channels (Figure 12-20).

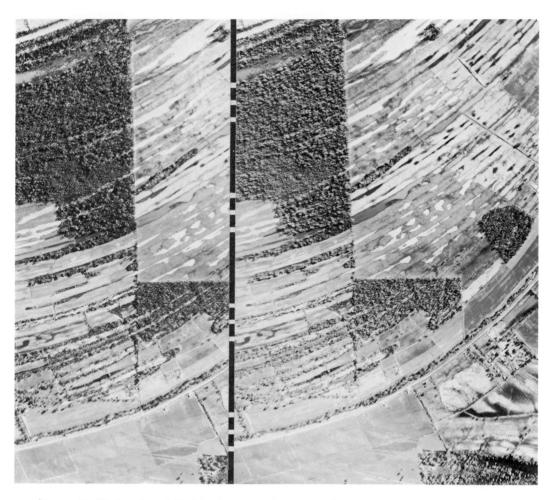

Figure 12–20. A series of filled-in river meander scars in Concordia Parish, Louisiana. This is a common pattern in floodplain areas such as the Mississippi Valley. Scale is about 1:22,000.

Covered plains are constructed by floods which build up deposits, primarily in a vertical dimension, and form natural levees, slack-water deposits, and backswamps. The deposited material is generally fine grained and thick. The covered plains may form over a meander plain because of a change in flood type of the parent river.

Alluvial fans are formed by the action of running water when the velocity of a loaded stream is reduced and the coarser part of the stream load is deposited. This action results in a sloping, fan-shaped deposit. The head of the fan is at the mouth of the highland stream, and its borders spread out into surrounding flat zones. In arid and semiarid areas, the texture of fan materials is predominantly coarse due to rapid weathering and torrential flooding. Dry channels are common (Figure 12-21).

Filled valleys are found in arid and semiarid regions in intermountain lowlands that have accumulated materials washed down from the mountains. They can be identified by their light tones, braided stream channels, lack of vegetation, and sharp topographic contrast to surrounding peaks.

Deltas are formed when flowing streams enter calm bodies of water such as lakes or oceans. Reduced stream velocity results in buildups of sediments at the mouth of the river (Figure 12-22). The arc-shaped (triangular) delta is most commonly observed. The delta of the Nile River is a prime example of this type. Stream channels may shift over the sand and silt surface, extending a delta seaward in all directions.

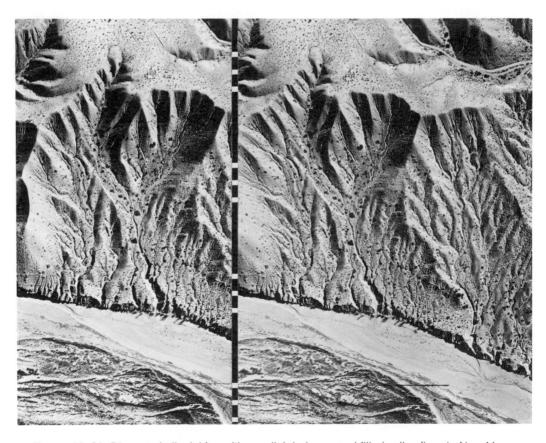

Figure 12–21. Dissected alluvial fan with parallel drainage and filled valley floor in New Mexico. Dry streambed has braided channel characteristics. Scale is about 1:6,000.

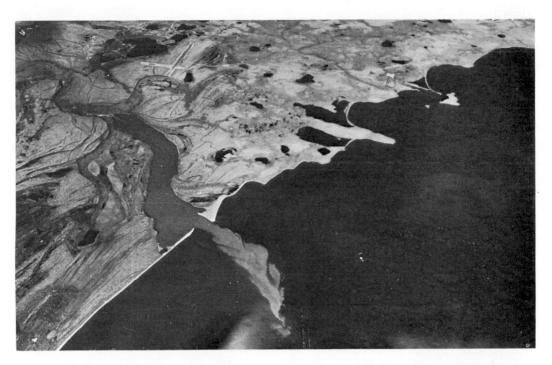

Figure 12–22. Oblique view of a delta forming at Iliamna Lake, Alaska. Note the barrier beach across part of the mouth of the river. Courtesy U.S. Air Force.

One of the outstanding characteristics of deltas is their level surface. Differences in elevation caused by stream channels, natural levees, lakes, and backswamps are minor when the extent of the delta is considered. Slight slopes may occur in very small deltas or in delta fans that are composed of coarse materials.

Beach ridges and tidal flats

Beach ridges are formed when the level of a lake or an ocean is constant and wave action sorts and transports granular deposits of material. If the water level is slowly lowered, or if wave action is climatic, a series of ridges may develop. These ridges are usually found along the present-day shoreline but may be far inland if the water level or land surface changes drastically over a period of time.

The outline of beach ridges is roughly rectangular and nearly parallels the shoreline. The boundary is smoothly curving to straight on the seaward side and less distinct or irregular to the landward side (Figure 12-23).

Tidal flats are formed along coastlines that are protected from wave action by sandbars, barrier beaches, or offshore islands (Figure 12-24). Lagoons or bays thus enclosed are filled with sediments and organic matter when streams empty into them. As a consequence, marshes subject to tidal fluctuations are formed. Tidal flats have an imperceptible amount of relief, and they become partially submerged at high tide. Mud flats are almost devoid of vegetation, but marshes may support dense growths of low marsh grass. Figure 5-8, presented earlier, illustrates the intricate drainage pattern characteristic of tidal marsh flats. Beach ridges are also clearly pictured on this photograph.

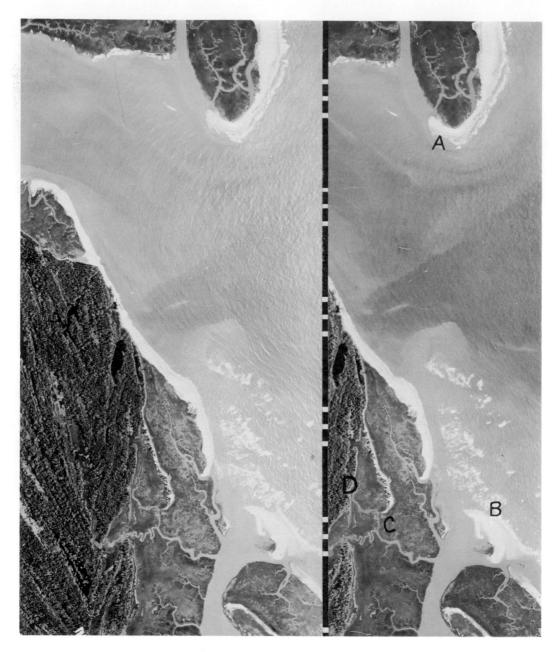

Figure 12-23. Littoral features near Beaufort, South Carolina, include: (A) a sand spit or hook, in a formative stage; (B) a barrier beach; (C) a tidal flat; and (D) beach ridges. Scale is about 1:20,000.

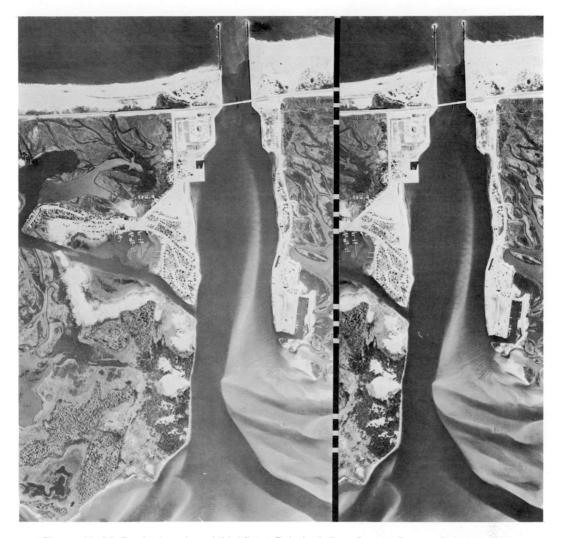

Figure 12–24. Barrier beach and tidal flat at Rehoboth Bay, Sussex County, Delaware. Note sand deposits in ship channel. Scale is about 1:20,000.

Glacial landscapes

The extent of continental glaciation in the United States was shown by Figure 12-1. Continental glaciers did not cover Alaska, but there were many local mountain glaciers there. Glaciers exerted great pressure on the land they overrode, profoundly modifying the bedrock landscape. Transported boulders, soil, disintegrated rock, and fresh rock were distributed throughout the glacial mass, especially in the bases of glaciers. As the ice masses melted, glacial drift was deposited over the landscape, thereby mantling it with debris.

Glacial drift is an all-inclusive term applied to soil or rock mixtures moved by ice or meltwaters. This drift may or may not be water-sorted. Unsorted mixtures are called glacial till and are composed of a heterogeneous mixture of particle sizes. Water-sorted materials are called stratified drift and are composed of layered sands and gravels.

There are two distinct types of glaciation—mountain and continental. Certain landforms, such as till plains, lakebeds, and drumlins, are almost exclusively due to continental glaciation. Erosional features such as cirques, horns, and large U-shaped valleys are exclusively due to mountain glaciers (Figure 12-25). Three selected glacial features (eskers, till plains, and drumlins) are briefly discussed here.

Eskers are narrow, serpentine ridges of sand and gravel that were formed by glacial meltwater streams flowing in tunnels within or under immobile ice, by streams flowing on glacial surfaces, or by deposits in crevasses of glacial ice. They are distinctive and easily recognized on aerial photographs (Figure 12-26).

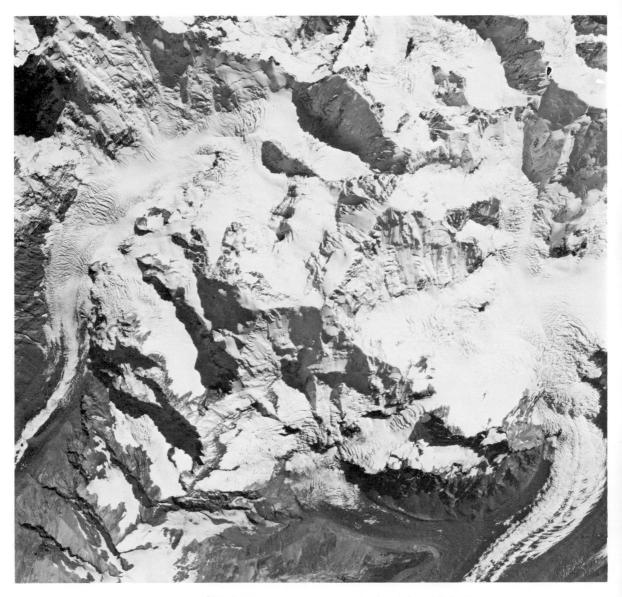

Figure 12–25. Glacial landscape in the vicinity of Mount Cook, South Island, New Zealand. Scale is about 1:63,000. Courtesy New Zealand Department of Lands and Survey.

Till plains are composed of sorted and unsorted stratified glacial materials; the mixture was deposited over the original land surface during a uniform retreat movement of glaciers. The till may be a thin veneer insufficient to obliterate the influence of the bedrock, or it may be thick enough to completely cover the bedrock. Layers of well-sorted sands and gravels may be found in deep vertical cuts of till.

Young till plains have an undulating land surface which appears in mottled tones on panchromatic photographs (Figure 12-27). Other characteristics are field and road patterns that form nearly perfect rectangles. Old till plains have a level land surface and a well-developed dendritic drainage system. These areas show a lack of morainic topography and little or no tonal

mottling on aerial photographs.

Drumlins are elliptical ridges 15 to 45 m high, 150 to 300 m wide, and up to 2 km in length. They are composed of glacial till and are oriented with their long axes parallel to the direction of glacial movement. Drumlins taper in one direction; the head end usually points northward, and it is steeper and broader than the tail end (Figure 12-28). Generally, there is no drainage development on drumlins. However, there may be a few small gullies and mud-flow scars on the steepest slopes. Cultivated fields on drumlins are parallel to the long axis, and orchards are sometimes planted on these formations. If drumlin side slopes are steep, the formation may be densely timbered or in pasture.

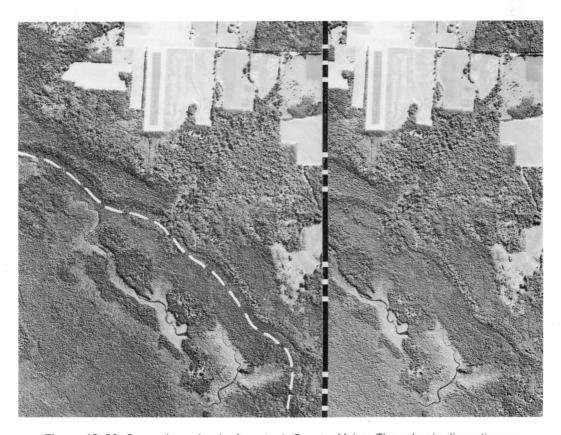

Figure 12–26. Serpentine esker in Aroostook County, Maine. The esker is discontinuous, but various segments are part of the same ridge. Scale is about 1:20,000.

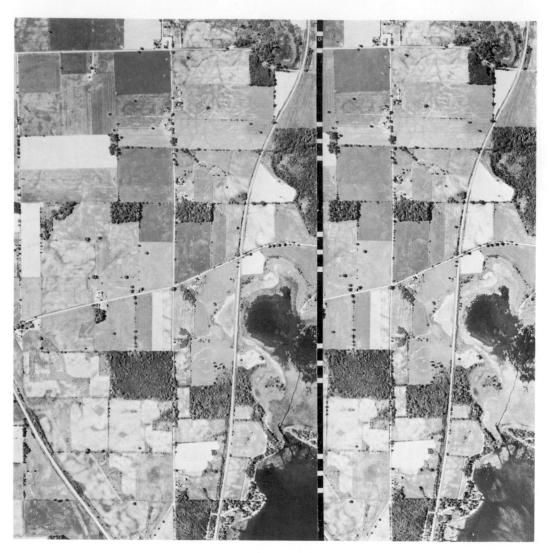

Figure 12–27. Young glacial till plain in La Porte County, Indiana. Light, mottled tones result from soil removal at higher ground elevations. Scale is about 1:20,000.

Eolian features

Wind-deposited materials are commonly classified as either sand dunes or loess deposits. Sand dunes, most often found near shorelines or in desert areas, are formed by wind movement of granular material; the deposits are built up along obstructions or behind the protective cover of rocks and bushes. The three main types of dunes are barchan, longitudinal, and transverse.

Barchan dunes, the most common, are crescent-shaped and are the basic unit for most dunes. They occur most frequently in inland areas where winds are strong and sand supply is meager. Barchan dunes with well-developed forms are not common. The horns of distinct barchan dunes point downwind. Longitudinal dunes are ridges which extend downwind from an obstruction. Their length is in line with the direction of the prevailing wind. Transverse

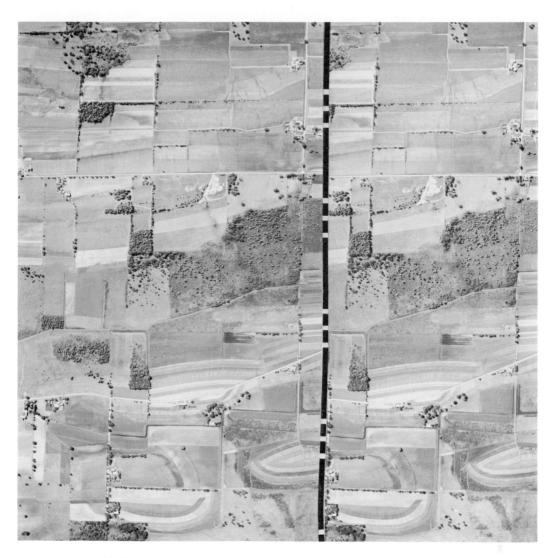

Figure 12–28. Control of agricultural patterns by drumlins in Jefferson County, Wisconsin. Scale is about 1:20,000.

dunes, common in arid areas, are formed by gentle winds blowing over areas of abundant sands. These dunes are scalloped ridges perpendicular to the direction of the wind, and they tend to migrate forward (Figure 12-29).

Dunes are mostly composed of quartz sand, though gypsum dunes occur in a few regions. Photographic tones are very light, except when dunes are covered by vegetation. Little or no surface drainage is apparent, because dunes are very porous and too small to provide full-fledged watersheds.

Loess is a windborne deposit of silt normally found to the leeward side of deserts and glaciated regions. Windlaid silts that form loess deposits may be suspended in the air as dust and deposited on surfaces far from the silt origin. Deposits of loess may present a rolling or, when adjacent to streams, a highly dissected topography. If the loess mantle is thin, subdued features of the underlying landform will be dominant. Loess deposits provide good soils for agricultural purposes (Figure 12-30).

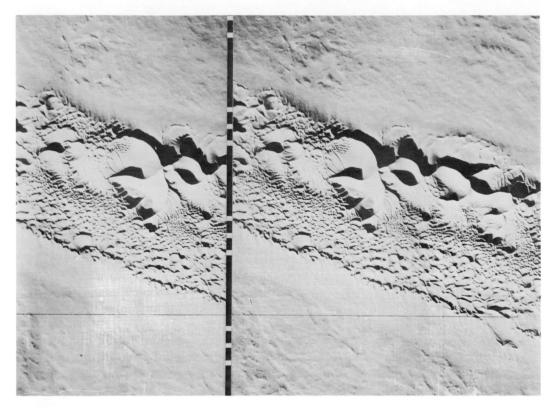

Figure 12–29. Transverse sand dunes in Algeria. The dunes are being held in place by an escarpment. Scale is about 1:40,000. Courtesy U.S. Air Force.

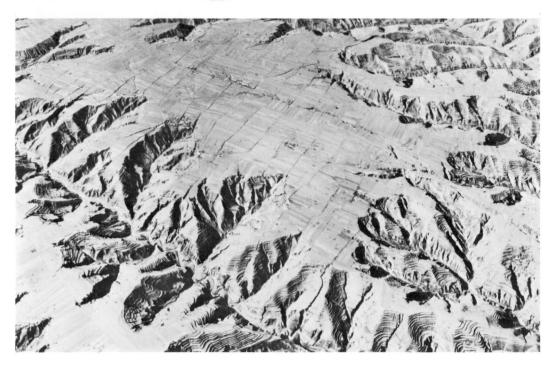

Figure 12–30. Oblique view of a heavily eroded loess deposit near the Ching-Ho River in China. The U-shaped gullies are terraced and intensively cultivated. Courtesy U.S. Air Force.

Vertical bluffs and steep-sided, U-shaped gullies are the prime criteria for identification of loess deposits on aerial photographs. On a regional basis, the prevailing drainage pattern is dendritic (Figure 12-31). The boundary of loess is insignificant because a wide transitional zone usually exists between loess deposits and adjacent landforms. When these deposits are bounded by streams or floodplains, they form steep cliffs that follow the general outline of valleys.

Miscellaneous landscapes

Unusual landscapes such as Meteor Crater in Arizona and Mount Capulin in New Mexico have been illustrated in an earlier chapter. Pictured in this section are Carolina bays (Figure 12-32) and part of a salt dome (Figure 12-33).

The Carolina bays are shallow, elliptical depressions of unknown origin that occur at low elevations in a belt of the Atlantic Coastal Plain from New Jersey to Georgia. The greatest concentrations of bays are located in North

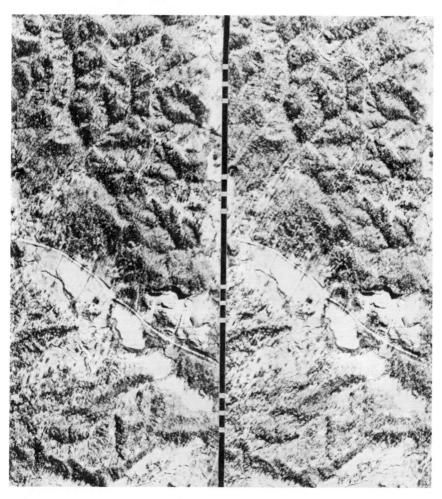

Figure 12–31. Eroded loess bluffs near Natchez, Mississippi. Loess deposits border the Mississippi River on the east from Natchez to Wisconsin. The source for these fine-textured deposits was alluvial material of glacial origin. In many places, the bluffs rise 60 m above adjacent alluvial plains. Scale is about 1:22,000.

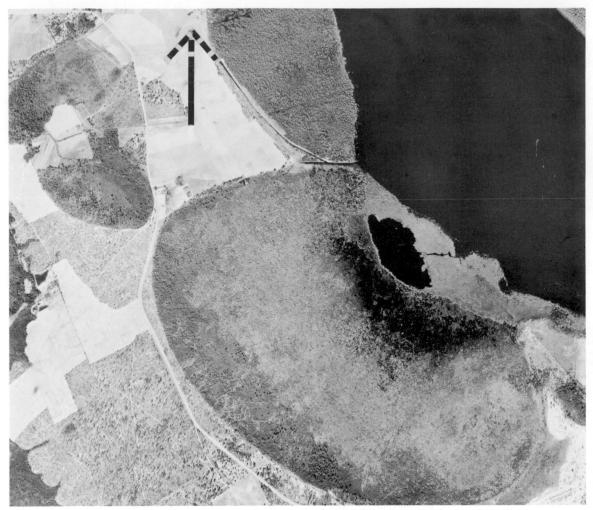

Figure 12–32. Intersecting Carolina bays in Cumberland County, North Carolina. Such depressions are oriented northwest-southeast. They are usually deeper at the southeast end, and sandy rims occur along southeastern edges. Arrow indicates north direction. Scale is about 1:20,000.

Carolina and South Carolina; it is estimated that the total number of these oval swamps may exceed one million. Locally, the bays may be referred to as "pocosins," an Indian term denoting a swamp on a hill, i.e., having no external drainage system.

Most of the bays are shallow basins with poor, internal drainage; local relief is normally less than 2 m. All are oriented in a northwest-southeast direction, and low, sandy rims are commonly found around the deeper, southeasterly edges. These characteristics have led to speculation that the bays were originally formed by intensive showers of meteorites from the northwest or by shock waves formed just ahead of meteorites that burned up as they entered the earth's atmosphere.

Most geomorphologists discount the theory of meteoritic origin, however. It is more commonly believed that the bays were originally formed by a series of complex, interacting processes involving underground solution and surface subsidence as found in limestone sink areas. The sinkholes may have

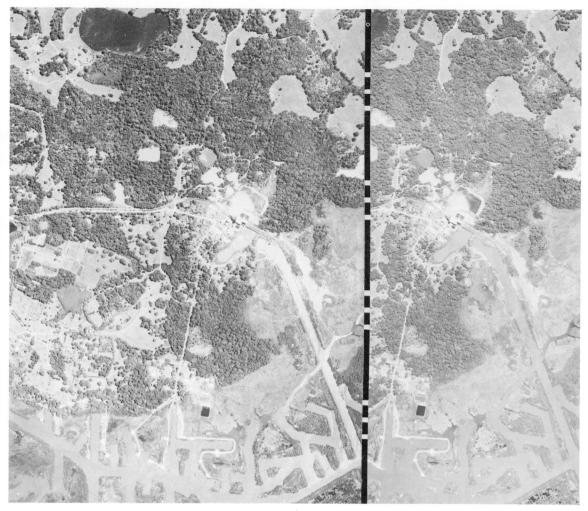

Figure 12–33. Portion of a large salt dome in Iberia Parish, Louisiana. A processing plant may be seen near the center of the stereoscopic view. Scale is about 1:20,000.

been later elongated and rimmed with sand by wave action during interglacial periods. In some instances, the sandy rims may be the result of eolian processes. Regardless of origin, the Carolina bays constitute a unique and dominating feature of the Atlantic Coastal Plain.

In certain parts of the world, salt concentrated in closed-off basins reaches such high levels that it is precipitated along with other chemicals found in seawater. These deposits can attain large proportions, and they assume the shape of irregular subsurface patches along coastlines of emergence. Salt deposits are covered by impermeable clays or shales, which prevent solution by rain and seawater. In some cases, structural processes result in the formation of salt plugs; when these plugs appear near the surface, a domelike landform may be observed.

Radial drainage patterns are characteristic of salt domes. Various anomalies in stream patterns as seen on aerial photographs have led to the discovery of deep-seated salt domes along the Gulf Coast of the United States. The salt dome pictured here is one of the largest in North America.

Nonphotographic imagery

Certain structural geologic features may be more readily recognized on side-looking airborne radar (SLAR) images than on conventional aerial photographs. Low relief and subdued features are accentuated when viewed from the proper direction. Runs over the same area in significantly different directions (more than 45° from each other) show that images taken in one direction may highlight features that are not emphasized on images taken in the other direction. Optimum direction is determined by those features which need to be delineated for study purposes (Figure 12-34).

The major contribution of satellite imagery to geology is its capability of detecting new linear features of the earth's surface. Lineaments ranging in length from hundreds of kilometres to less than a kilometre are being disclosed. In some areas of the world poorly mapped in the past, the numbers of hitherto undetected linears have increased by factors of 2 to 5 or more. Even in well-mapped regions, new satellite-based maps are far more detailed than those from previous efforts. This substantial improvement in detection of linear features is of great importance in the refinement of models for tectonic deformation, in association of earthquakes with their causative sources, and in the setting forth of new "targets" to be explored for minerals whose emplacements were fracture-controlled (Figure 12-35).

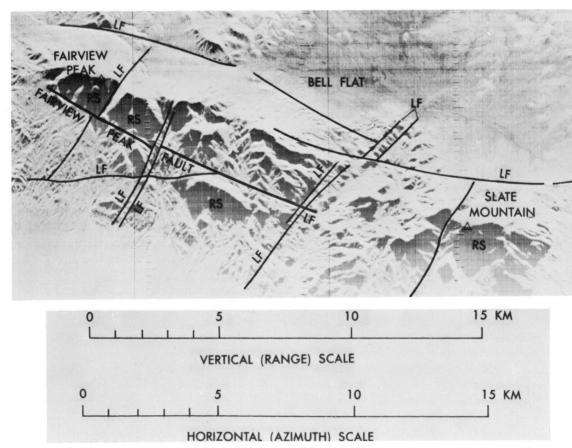

Figure 12–34. SLAR imagery over a portion of Nevada. Letters indicate possible faults (LF) and radar shadows (RS). Courtesy R. G. Reeves, U.S. Geological Survey.

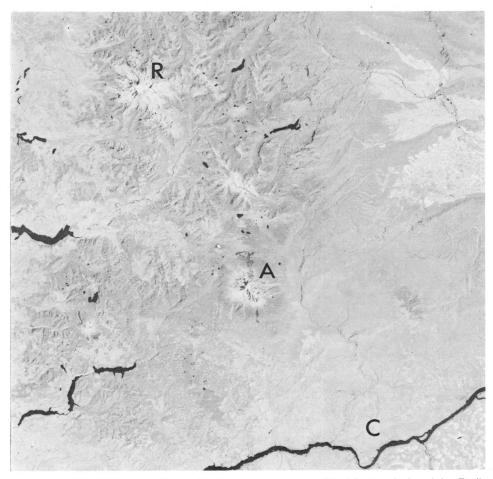

Figure 12-35. MSS (band 7) satellite image over eastern Washington during July. Easily recognized are Mount Rainier (R), Mount Adams (A), and the Columbia River (C). Scale is about 1:1,000,000. Courtesy U.S. Geological Survey.

Geologic maps and symbols

A geologic map shows the horizontal positions (planimetric detail) of rock units as they crop out at the earth's surface. The rock units are usually called formations, and their limits are arbitrarily selected for mapping (Figure 12-36). Boundaries between rock units are called contacts, and the traces of contacts when shown on maps are called contact lines. The areas of formational outcrop may be shown in various colors or by some ruled pattern; the colors or patterns are generally overprinted on a topographic base map. A geologic map without topographic contours is called a contact map.

Geologic maps (in color) are issued by the U.S. Geological Survey and by most state geological agencies. On such maps, the various rock units may be identified by a series of commonly accepted symbols (Figure 12-37). Most maps will also include a detailed legend which describes the meaning of each symbol and "stacks" the geologic units up in correct age sequence, with the oldest on the bottom of the "stack" or column.

Common symbols used for structural maps are shown in Figure 12-38.

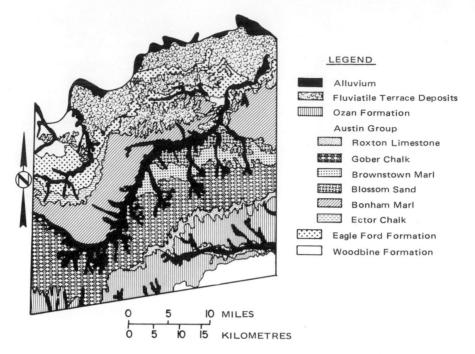

Figure 12–36. Geologic map of Fannin County, Texas. Courtesy Texas Bureau of Economic Geology and Purdue University.

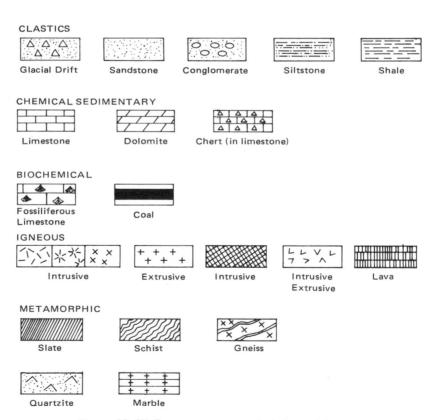

Figure 12-37. Some common symbols for rock types.

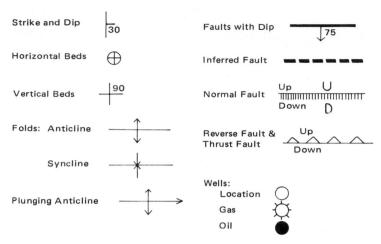

Figure 12-38. Some common symbols for structural features on geologic maps.

Problems

1.	Study a set of aerial photographs and corresponding topographic maps for a portion of your own county. Complete the following form as a means of summarizing the physiography and surface geology:				
	a.	Principal landforms			
	b.	Stream drainage patterns (primary and secondary)			
	C.	Stream drainage texture			
	d.	Major vegetative cover types			
	e.	Photo tones of major outcrops or surficial deposits			
	f.	Climate and annual precipitation			
	g.	General rock types present			
	h.	Specific rock types present			

2. Obtain a stereoscopic pair of aerial photographs showing dipping beds of sedimentary rocks in an arid region. Determine the strike and dip of the

- most prominent beds and (if feasible) measure the thicknesses of the upper beds.
- 3. Prepare a simple photo overlay for a local area to show surficial rock types by standard geologic symbols.
- 4. Prepare a simple structural map (in overlay form) for a set of photographs supplied by your instructor. Indicate the axes of major folds, fault lines, escarpments, joints, and other structural features by standard geologic symbols. Describe the principal drainage pattern of the area and its relation to the structural development.

References

- Bascom, Willard. 1960. Beaches. Scientific American reprint, W. H. Freeman and Co., San Francisco. 12 pp. illus.
- Denny, Charles S., et al. 1968. A descriptive catalog of selected aerial photographs of geologic features in the United States. U.S. Geological Survey, Reston, Va. Professional Paper 590, 79 pp., illus.
- Dort, Wakefield. 1964. Laboratory studies in physical geology. 2nd ed. Burgess Publishing Co., Minneapolis. 226 pp., illus.
- Gimbarzevsky, Philip. 1966. Land inventory interpretation. *Programmetric Engineering* 32:967-76, illus.
- Hamblin, W. K. 1975. The earth's dynamic systems. Burgess Publishing Co., Minneapolis. 578 pp., illus.
- ——, and J. D. Howard. 1975. Exercises in physical geology. 4th ed. Burgess Publishing Co., Minneapolis. 233 pp., illus.
- Kiefer, Ralph W. 1967. Landform features in the United States. Photogrammetric Engineering 33:174-82, illus.
- Lattman, L. H., and R. G. Ray. 1965. Aerial photographs in field geology. Holt, Rinehart and Winston, New York. 221 pp., illus.
- Ray, Richard G. 1960. Aerial photographs in geologic interpretation and mapping. U.S. Geological Survey, Reston, Va. Professional Paper 373, 230 pp., illus.
- Reeves, Robert G. 1969. Structural geologic interpretations from radar imagery. Geological Society of America Bulletin 80:2159—64, illus.
- Shelton, John S. 1966. Geology illustrated. W. H. Freeman and Co., San Francisco. 434 pp., illus.
- U.S. Department of the Army. 1968. Rock types. U.S. Army Engineer School, Ft. Belvoir, Va. 44 pp., illus.
- ——. 1967. Granular and fine-grain material. U.S. Army Engineer School, Ft. Belvoir, Va. 53 pp., illus.
- U.S. Department of Commerce. 1960. The identification of rock types. Government Printing Office, Washington, D.C. 17 pp., illus.
- U.S. Naval Photographic Interpretation Center. 1956. *Military geology*. Government Printing Office, Washington, D.C. 174 pp., illus.
- von Bandat, Horst F. 1962. Aerogeology. Gulf Publishing Co., Houston. 350 pp., illus.
- Wanless, Harold R. 1965. Aerial stereo photographs. Hubbard Scientific Co., Northbrook, Ill. 92 pp., illus.
- Warren, Charles R., et al. 1969. A descriptive catalog of selected aerial photographs of geologic features outside the United States. U.S. Geological Survey, Reston, Va. Professional Paper 591, 23 pp., illus.
- Way, Douglas S. 1973. Terrain analysis: A guide to site selection using aerial photographic interpretation. Dowden, Hutchinson, and Ross, Stroudsburg, Penn. 392 pp., illus.

Chapter 13

Engineering Applications and Mining Patterns

Construction materials surveys

Today almost all major highways, railroads, airfields, canals, and pipelines are planned and constructed on the basis of information derived through aerial surveys. Construction engineers rely on photogrammetric techniques to evaluate alternative locations for levees, dams, and hydroelectric structures, to conduct water pollution and stream siltation studies, to search for construction materials such as sand or gravel, and to measure stockpiles of raw materials (Figure 13-1).

Although construction materials such as aggregate and compacted fill material are usually regarded as low-cost resources, their presence or absence can significantly affect urban and industrial activity. Most contractors depend on local sources for construction materials, and considerable funds may be expended in searching for economical deposits of aggregate and fill material.

With regard to granular materials, their location and type depends on the geology and physiography of an area, both of which can be assessed from aerial photography. It is possible to tell whether a deposit is sand or gravel,

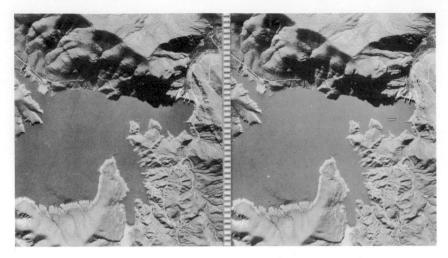

Figure 13–1. Dam on San Carlos Lake, Arizona. Construction materials are not easily obtained for most sites in mountainous terrain. Scale is about 1:42,000.

and it may also be possible to determine the presence and types of overburden. In short, the aerial photograph provides a reliable means of locating and determining the areal extent of granular deposits.

In a materials survey, it is often desirable to make a comparative analysis of two or more potential construction sites; this analysis can be largely accomplished through photographic interpretation. While it may not be possible to predict the suitability of materials for cement or concrete, it is possible to identify a given deposit as sand or gravel and to determine whether a large amount of fines is to be expected.

Photographic specifications for materials surveys vary from one region to another. Black-and-white exposures at a scale of 1:15,000 to 1:25,000 are often suitable in arid environments, but infrared color is the preferred sensor in most other regions.

Highway location studies

In spite of global problems of overpopulation, there are still many regions of the world that are almost undeveloped. Before such areas can be made suitable for exploitation, economic development, and human habitation, highways, railroads, and other access routes must be developed and maintained. In addition, new or enlarged transportation arteries are being designed and built each year in advanced countries, and photogrammetric surveys are playing an increasingly important role in these projects (Figure 13-2).

Although there are notable differences, photographic interpretation techniques used in route location studies are similar to those employed for other engineering projects. The scientific evaluation of alternative routes requires studies of rather large areas, with emphasis on the analysis of surface soils, drainage characteristics, and searches for aggregate materials. It is, therefore, advantageous to have such projects staffed by engineers with geological training or by engineering geologists with a working knowledge of soils.

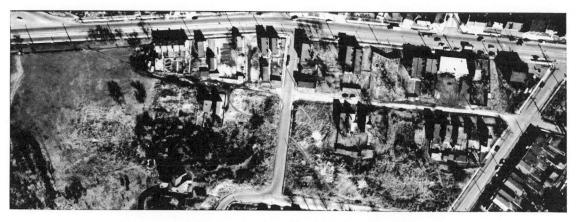

"P & P" SHEETS ARE WIDELY USED IN CONNECTION WITH PIPELINE LOCATION, HIGHWAY DESIGN, TRANSMISSION LINES, MICROWAVE TOWER LOCATION, AND MANY OTHER ENGINEERING PROBLEMS. THE SCALE AND THE ORDER OF VERTICAL ACCURACY ARE INDIVIDUALLY DESIGNED TO MEET THE REQUIREMENTS OF THE SPECIFIC PROJECT.

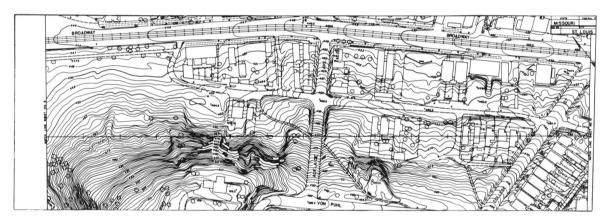

THIS PLAN SHEET, WITH 1-FT (0.3 m) CONTOURS, COVERS THE SAME AREA AS THE AERIAL PHOTOGRAPH SHOWN ABOVE.

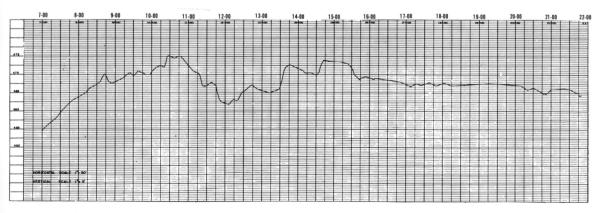

THE PROFILE OF THE LINE MARKED ON THE PHOTO AND PLAN.

Figure 13–2. Example of a plan-and-profile sheet compiled for an engineering survey. Courtesy Jack Ammann Photogrammetric Engineers, Inc.

The uses of aerial photographs for the development of a new highway or railroad route may be conveniently organized into three distinct stages or phases, namely, (1) reconnaissance surveys and regional exploration, (2) preconstruction studies and comparisons of feasible routes, and (3) intensive study of the best route. Each phase refines the route location to a higher degree than the preceding stage. The basic task in location is the fitting of the road or railroad structure to the natural features of an area in a manner that will be most economical in construction and operation. This demands that natural features be effectively assessed, and aerial photographs provide an efficient means of meeting this objective. Natural features to be evaluated in a location study are topography, drainage, property values, soils and geology, borrow sources, vegetation, and special trouble areas. Imposed upon this information about the natural features of the area is the engineer's competence in determining the length, grade, and alignment of the route and the type of structures needed.

The principal physiographic features that ultimately determine the loca-

tion and cost of a new transportation route are:

1. Steepness and irregularity of the terrain.

2. Soil composition, depth, and moisture content.

3. Prevailing drainage characteristics.

4. Limiting features, such as mountain passes, sites available for bridges or tunnels, box canyons, large cemeteries, etc.

5. Availability of granular construction materials near the proposed corridor.

The reconnaissance survey

The primary objective of a reconnaissance survey is to choose several corridors between the terminals which appear to be technically feasible routes. An area having a width of 30 to 50 percent of the distance between terminals is studied on available maps and aerial photographs. If recent stereoscopic coverage of a suitable scale is not available, special photographic flights may be required. Depending on local topographic relief and intensity of land use, photographic scales may range from 1:10,000 to 1:50,000. It is desirable to use the smallest scale practical, because fewer stereoscopic setups are needed to encompass a given corridor area—with commensurate savings in time and money.

Where topographic maps have not been previously compiled for an area, the land surface may be evaluated solely through stereoscopic study of photographs. Spot elevations can be obtained by parallax measurements, followed by form-line sketches of terrain. Form lines on individual contact prints may then be transferred to photo index sheets for a composite view of the various corridors in terms of drainage, broad soil groupings, land-use patterns, and rough comparisons of property values.

Comparisons of feasible routes

In this second stage, the small-scale photographs used for reconnaissance may be unsuitable, because the principal corridors should be covered by recent mapping photography that will produce contour intervals of 2 or 3 m. Print scales may range from about 1:2,500 in heavily populated urban areas

to about 1:12,000 in rural areas where land use is less intensive and right-of-way costs are likely to be lower.

From this large-scale photography, topographic maps are prepared of each corridor; single-strip maps at a scale of 1:2,500 to 1:5,000 have often proved suitable in the United States. Such maps are commonly tied to existing horizontal and vertical control for refinement and reliability in evaluation of alternate routes; whenever possible, state systems of plane coordinates are used in plotting of the base maps. Preconstruction studies of alternative routes also require a close scrutiny of soil types, aggregate materials sources, vegetation obstacles such as muskeg or large timber reserves, and engineering problems such as hard rock cuts, tunnels, or landslides.

Plan-and-profile sheets are plotted, and proposed highway cross sections are computed at stations established along each feasible route. Every route location is examined with regard to drainage, intersections, right-of-way costs, and road-user benefits; this procedure narrows the choice of locations to perhaps two or three alignments. These remaining alignments are then replotted to show traffic lanes, along with the profiles and grades of primary intersections. Positions and sizes of culverts are determined, and the extent of channel work is shown. Preliminary design work on large structures (e.g., bridges) may also be initiated.

For final cost comparisons, grading contours of the highway-to-be, based on the recommended grade, are superimposed on the map. Amounts of cut and fill are determined by planimetering of areas of horizontal sections (defined by each grading contour and the original ground contour) and multiplication of those results by the contour interval. This method gives a graphic picture of the finished highway from which work limits, lengths of structures, and extent of seeding, as well as right-of-way and grading, are determined.

Survey of the best route

In the third phase, the photo interpretation task involves a more detailed study of drainage, soils, geology, and property values for the selected construction route. Large-scale photography of the chosen corridor is used in the preparation of topographic strip maps 0.1 to 1 km wide along the path of the proposed highway. Map scales and contour intervals required in this engineering stage range from about 1:500 with 0.5-m intervals to 1:5,000 with 3-m intervals. The highway centerline is located on the strip maps and then staked out on the ground for preliminary grading. This sets the stage for actual road construction to begin (Figure 13-3).

Through the combination of aerial photographs and reliable strip maps, the construction engineer can be confident that all feasible routes have been given due consideration. Such assurances were acquired only via tedious and time-consuming ground survey methods prior to the adoption of photogrammetric surveys by highway designers and engineers.

Bridge construction

Bridges for highways and railroads assume a wide variety of shapes and designs in accordance with cost considerations, type and intensity of traffic, load limits, availability of local construction materials, and considerations of minimum spans or clearances for underpassing automobiles, trains, or ships.

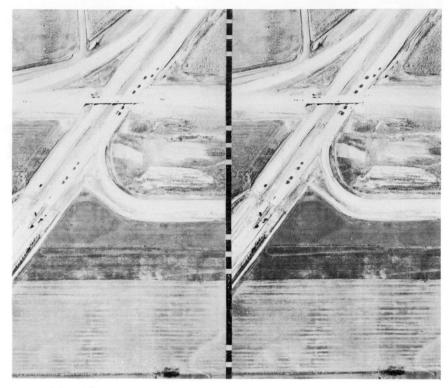

Figure 13-3. Construction of a divided, limited-access highway in Michigan. Several loaded dump trucks and some grading equipment are discernible. Note that bridges or overpasses are usually completed prior to road surfacing. Scale is about 1:6,000.

A vertical stereogram of parallel highway and railroad bridges is shown in Figure 13-4.

In regions of steep topography, bridging costs may constitute the largest single expenditure for new railroad or highway routes. Once they are constructed and placed in service, the replacement or modification of heavily traversed spans becomes a major engineering problem. As indicated earlier, bridges are normally completed first in the construction of new transportation arteries. The logic of this established procedure is illustrated by the construction of limited-access highways through populated regions; overpasses must be built at an early stage to avoid interference with existing traffic on intersecting roads and to permit uninhibited work on the new right-of-way.

When new highway bypasses are planned through urban or industrial areas, existing spans or trestles may require modification because of insufficient clearances. Figure 13-5 provides an apt example. Stereoscopic study of this photograph reveals that the old railroad trestle is supported by very closely spaced piers that will not permit the passage of automobile traffic underneath. Thus the construction of the new roadway requires that a wide-span railroad trestle be built to replace the older structure.

Hydroelectric dams and reservoirs

The distribution of hydroelectric facilities in the conterminous United States is governed largely by topography and amount of rainfall. The greatest

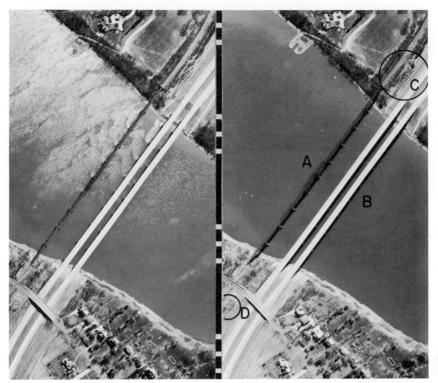

Figure 13-4. Steel truss-frame railroad bridge (A) and dual-lane concrete highway bridge (B) at Toledo, Ohio. Note that supporting piers for all three spans are aligned to allow easy passage of small craft underneath. Power transmission towers are circled on opposite river banks (C, D). Scale is about 1:7,920.

waterpower potential is to be found in mountainous regions where stream gradients are high and precipitation is heavy (Figure 13-6). In dry climates, especially where stream gradients are low, hydroelectric capacities are minimal; in fact, the impoundment of sufficient water supplies for human consumption is often a matter of grave concern to inhabitants (Figure 13-7). To assist the neophyte interpreter in recognizing the components of hydroelectric installations, the basic nomenclature of a low-pressure dam is presented in Figure 13-8.

In many instances, human and industrial needs for clean water supplies are most critical in regions where ground and surface water sources are inadequate. The state of California, with its rapidly expanding economy and population, is a case in point. Several large urban centers, notably Los Angeles, receive a large proportion of their water supply via aqueducts from sources hundreds of kilometres away. Still, the basic problem of obtaining increasing quantities of unpolluted water for persons residing in precipitation-deficient regions remains largely unsolved.

To increase supplies of surface water, reservoirs have been constructed near urban communities by impoundment of rivers and streams. Unfortunately, watershed conservation practices have often lagged far behind engineering construction, with the consequence that hastily conceived reservoirs often have a short, finite life expectancy due to rapid sedimentation. As a general rule, large reservoirs should not be constructed unless administrative controls over the entire watershed can be exercised; only in this way can

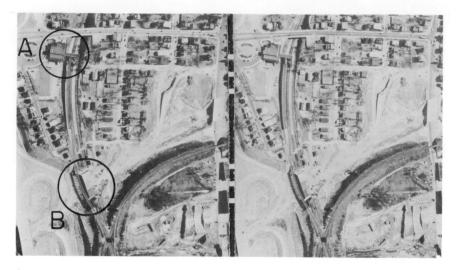

Figure 13–5. Railroad passenger station (A) and construction of a highway overpass for trains (B). Note planned extension of new highway through residential area. Scale is about 1:7,920.

vegetative cover be maintained properly for the interception of precipitation, reduction of surface erosion, and minimization of sedimentation. Aerial photography obtained at regularly scheduled time intervals offers an efficient means of monitoring water levels and checking periodic fluctuations in reservoirs (Figure 13-9). Panchromatic photographs usually provide good information on siltation levels, while shorelines and small tributaries are more distinctive on infrared or infrared color exposures.

Aerial detection of water pollution

Water pollution studies are concerned with the changing characteristics of water that render it unfit or undesirable for human consumption, aquatic life, and industrial use. Among the principal sources of water pollution are sewage and oxygen-consuming wastes, industrial by-products dumped into streams and lakes, radioactive substances, and agricultural pesticides. Increases in the temperature of water as a result of its use for industrial cooling purposes may also be regarded as a form of pollution when the aquatic environment is endangered as a result (Figure 13-10).

Aerial photographs provide a means of detecting and assessing the extent of some forms of water pollution. Although infrared color films and image-producing thermal sensors are often desirable for making detailed lake and stream surveys, some types of water pollutants can be discerned on panchromatic film exposed through a minus-blue filter. Under most circumstances, stream pollutants enter bodies of water from man-made "point sources" or from diffused sources that may be either natural or man-made. Point sources such as sewage outfalls are easier to find on aerial photographs because of sharp tonal contrasts between concentrated effluents and the receiving waters (Figures 13-11 and 13-12).

Organic and inorganic industrial effluents include vegetable processing wastes, pulp and paper residues, sulfuric acid, metallic salts, and petrochemical wastes. Since industrial effluents are commonly discharged into streams

Figure 13–6. Niagara Falls, New York. Waterpower facilities are intensively developed in this region. Scale is about 1:20,000.

and estuaries through piped outlets, the concentrated pollution trouble spots are easily seen on aerial photographs. In the vicinity of seacoasts, these wastes may be responsible for huge areas of foul-smelling water that extend into the ocean for several kilometres. Oil slicks and petroleum effluents, which are not easily dissipated, are extremely detrimental to waterfowl populations (Figure 13-13).

A large amount of remote sensing research has been devoted to studies of water quality. As a rule, emphasis has been on those kinds of pollutants that result in gross changes in the physical appearance or temperature of water as registered by a particular sensor. The source and areal extent of water pollutants may thus be readily ascertained, but measurements of such values as chemical concentrations and exact water temperatures must still be obtained by field sampling.

Figure 13–7. Low-pressure dam on the Rio Grande in New Mexico. In this dry area, stream gradients are low, precipitation is meager, and occasional flash floods result in severe soil erosion. The problem of siltation behind the dam is evident here. Scale is about 1:6,000. Courtesy Abrams Aerial Survey Corp.

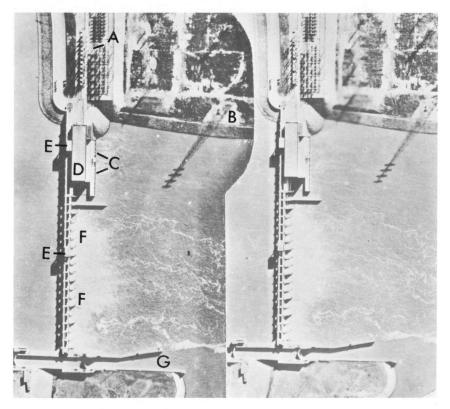

Figure 13–8. Features easily recognized in this stereogram of a low-pressure dam include: (A) the transformer and switching yard; (B) the transmission tower; (C) tail races; (D) the generator hall; (E) traveling gate cranes; (F) the dam gates; and (G) a lock for ships. Courtesy U.S. Air Force.

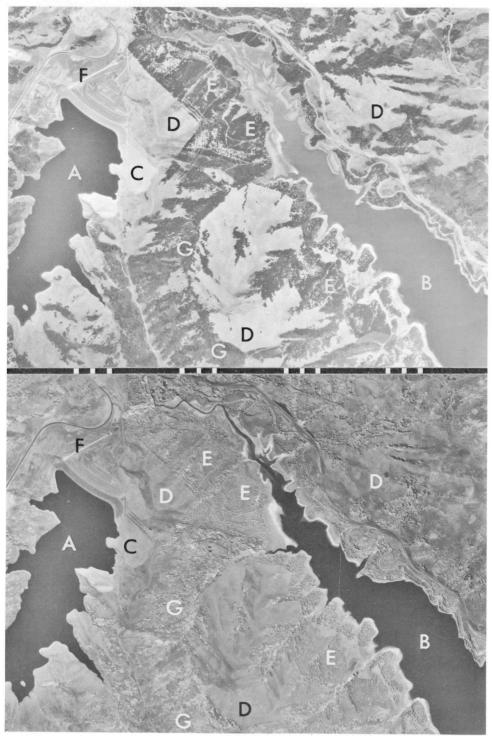

Figure 13–9. Panchromatic (above) and infrared (below) photographs of the Briones (A) and San Pablo (B) reservoirs in Contra Costa County, California. The Briones reservoir has a new earth dam and a low degree of sedimentation; the San Pablo reservoir has a much higher degree of sedimentation. Also discernible are: (C) exposed soil; (D) annual grasslands; (E) Monterey pine; (F) spillway; and (G) mixed hardwoods. Scale is about 1:33,500. Courtesy U.S. Forest Service Remote Sensing Project, Berkeiey, California.

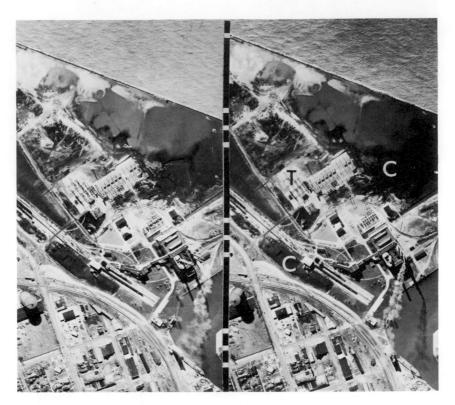

Figure 13–10. Thermal electric power plant along the shore of Lake Michigan. Piles of coal (C) and the transformer unit (T) are easily picked out. Such plants use large amounts of water for cooling purposes. The water used for cooling is returned to the lake at a higher temperature than it possessed when it was removed. Scale is about 1:15.840.

Color or infrared color films at scales of 1:5,000 to 1:10,000 are often recommended for studies of water quality. Conventional color appears to be preferred for detection of turbidity, sedimentation, and sewage outfalls, while infrared color is recommended for evaluations of thermal pollution. There are indications that nonphotographic sensors such as multispectral and thermal scanners may prove ideal for monitoring of water quality. For example, oil slicks are clearly registered on thermal scanner imagery in the 8 to $14\mu m$ band of the spectrum.

Surveys of coastal wetlands

Coastal zones include shorelines and beaches, tidal areas, marshes, and associated wetlands. Many large United States cities and about one-third of the population are concentrated near wetlands, and this impact has often resulted in a severe deterioration of fragile coastal environments. The belated realization of the economic and esthetic value of coastal areas has finally led to programs of wetlands management and rejuvenation; remote sensing therefore has a role in the inventorying and periodic monitoring of such environments.

Both color and infrared color photography, at scales of 1:10,000 to 1:20,000, have proven valuable for such tasks as:

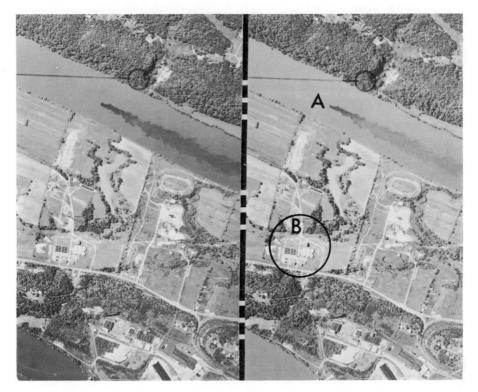

Figure 13–11. A sewage outfall below the surface of the Tennessee River produced the dark pollution pattern (A) on this photograph taken near Chattanooga; the sewage treatment plant is encircled (B). The dark coloration of the effluent is an indication of low levels of dissolved oxygen, a situation detrimental to fish and other aquatic life. Scale is about 1:20,000. Courtesy U.S. Department of Agriculture.

- 1. Monitoring coastal erosion and vegetative destruction.
- 2. Evaluating changes in sedimentation of streams and estuaries.
- 3. Detecting water pollution and the deterioration of shellfish, sports fish, and wildlife habitats.
- 4. Documenting cultural and environmental changes due to dredging, land filling, land clearing, waste disposal, construction, etc.

One method of monitoring beach erosion is based on a network of inland ground control points that can be located on photographs taken at annual or semiannual intervals. Ground distances between these permanent control points and selected points along the coastline (at a specified tide stage) are measured so changes over the years can be detected. Conventional color photography is preferred, where available, because of its superior water-penetration qualities.

Periodic inventories and mapping of wetlands areas are preferably accomplished with infrared color photography. As a minimum, such inventories commonly require (1) the determination of the mean high-water line so that riparian rights can be established, (2) the location of upper wetlands boundaries, and (3) the detailed mapping of vegetation (major cover types) down to a minimum area of 2 to 4 ha. In several coastal states, more detailed inventories have been completed, and wetlands are scheduled for remapping at periodic intervals.

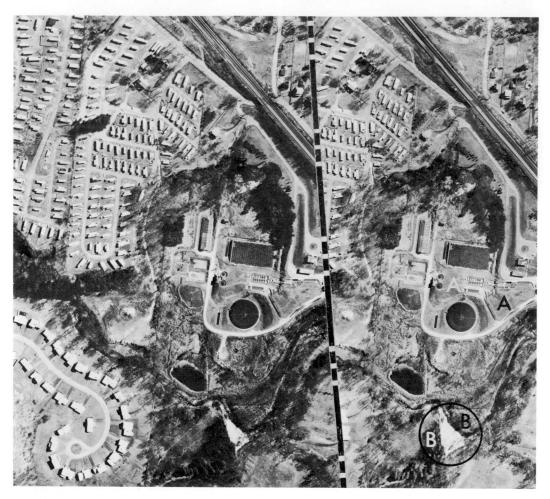

Figure 13–12. Sewage treatment plant (A) and eventual discharge of effluent into stream (B) in Monroe County, New York. The desirability of the new residential area (lower left) is probably questionable on certain days when wind currents are unfavorable. Scale is about 1:6,000.

Disaster surveys

Certain aspects of fires and pestilence have been discussed in earlier chapters; here, essential surveys following such catastrophes as floods and earthquakes are given consideration. Although the prospects of major floods can often be predicted with a high degree of reliability, this fact has not served as a deterrent to the human occupation of floodplains and low-lying coastal areas. Similarly, settlements in known earthquake zones (e.g., along the San Andreas fault) continue to expand in total disregard of past and future dangers. It is certain that there will be major calamities at some time in the future, and remote sensing can be of assistance following severe disasters.

An initial problem is that of obtaining aerial coverage as soon as possible following a catastrophe—and possibly at regular intervals for weeks afterwards. Where weather conditions prohibit immediate photographic surveys, SLAR imagery may be initially specified and used to advantage.

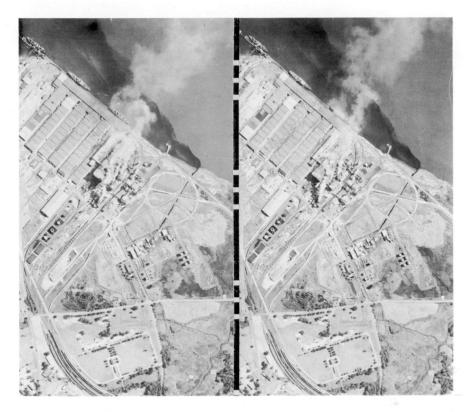

Figure 13–13. Discharge of petrochemical wastes into a large river near the Charleston, South Carolina, naval shipyard. Scale is about 1:20,000.

Some of the major items that may be evaluated through analysis of large-scale (1:4,000 to 1:8,000) aerial imagery include:

- 1. Drinking water supplies, the condition of utilities such as electrical and gas service systems, availability of heating or cooking fuels, condition of telephone and communications systems, etc.
- 2. Damages to critical structures such as hospitals, food warehouses, residential housing, water purification plants, sewage disposal facilities, foodprocessing industries, etc.
- 3. Evacuation routes such as railroads, highways, and airfields.
- 4. General support and logistical planning for relief teams moving into affected areas.
- 5. Soil and terrain damage, including the location and distribution of geologic faults and fractures.
- 6. Reconstruction planning.

Surface mining patterns

Periodic inventories of mine-disturbed lands are needed for monitoring of environmental damage and for planning or assessment of reclamation efforts. Most surface and some underground mining operations exhibit characteristic patterns or signatures that permit their identification on medium-scale photography.

Several examples of mining operations are pictured in Figures 13-14 through 13-21; minerals involved are sulfur, phosphates, bauxite, lead and zinc, copper, gold, coal, and petroleum. These stereograms are on panchromatic film, although it will be obvious to the reader that color films are preferred wherever available.

Almost all domestic sulfur is mined from deposits in Texas and Louisiana. Sulfur may be found in nearly pure form as crystals and powders, or it may occur in combination with metals, e.g., iron sulfide or pyrite. Most of the industrial production in the United States is consumed in the form of sulfuric acid. Phosphates are mined in the southeastern and western states; more than three-fourths of the total production is used for commercial fertilizers. The distinctive pattern of open-pit phosphate mines is easily recognized on aerial photographs.

Bauxite mining in the United States is concentrated in central Arkansas, although commercial deposits are also exploited in Alabama, Georgia, and Virginia. Imports of bauxite (aluminum ore) largely come from Jamaica and South America. The deposits in this country occur near the surface, so openpit mining is common; resulting photographic patterns are somewhat similar to those produced by the extraction of sand, gravel, and limestone.

Lead and zinc ores are found in a number of states, but United States deposits are rapidly becoming depleted. Copper is in short supply, and much of the country's consumption of this important metal has been imported in the past. Gold may be found in underground deposits in association with quartz or combined with copper, silver, lead, or zinc. It also occurs in gravel deposits near the surface and may be placer-mined as free gold by means of dredges and hydraulic devices which wash through large quantities of coarse, granular materials.

Deep, underground deposits of coal are tapped by vertical shafts or by horizontal extraction through bedding exposures in side hills. Flat-lying coal deposits nearer the surface are strip-mined; vegetation is cleared and the bedrock is fractured by systematic blasting. Then the overburden is removed by large draglines, and power shovels scoop the uncovered coal into trucks. The resulting landscape is often a series of elongated piles of waste material (overburden) that is methodically placed in previously dug trenches as the stripping progresses.

Reclamation of strip-mined lands and reestablishment of vegetative cover are difficult and costly undertakings. Coal resources are widely distributed throughout the United States, and the locations of steel-production plants are normally governed by the proximity of coal, limestone, and iron ore deposits. Baltimore, Birmingham, Cleveland, Detroit, and Pittsburgh are among the larger steel-manufacturing centers.

Petroleum exploration may produce a variety of surface patterns as seen on vertical aerial photographs; two such variations are illustrated in this volume. In forested regions, a patchwork mosaic of small clearings connected by a grid system of access roads is a common indicator. Shadows of drilling rigs, oil derricks, and pumping stations aid in the identification process. As successful wells are brought into production, small, dark-toned sludge ponds may be seen, along with oil storage tanks. The leading oil-producing fields in the United States are found in the mid-continent region, which includes such states as Kansas, Oklahoma, Texas, and Louisiana.

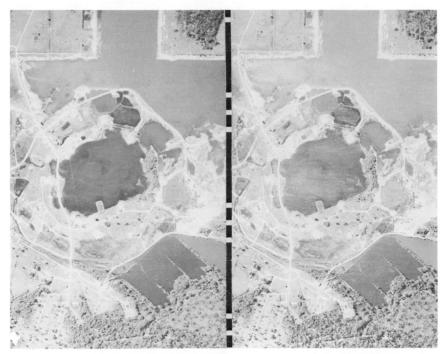

Figure 13–14. Mining of sulfur in Calcasieu Parish, Louisiana. Deposits are underground here, so the surface features remain relatively undisturbed around the structural dome. Scale is about 1:20,000. Courtesy U.S. Department of Agriculture.

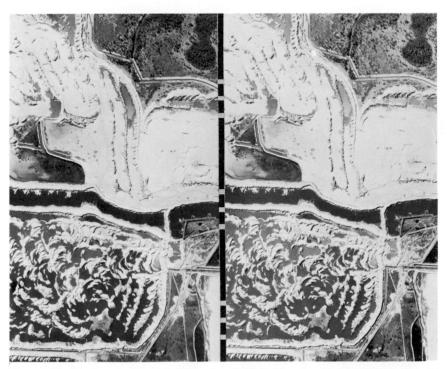

Figure 13–15. Open-pit phosphate mine in Polk County, Florida. Unless drastic land reclamation measures are taken here, these scars will blot the landscape for years. Scale is about 1:20,000. Courtesy U.S. Department of Agriculture.

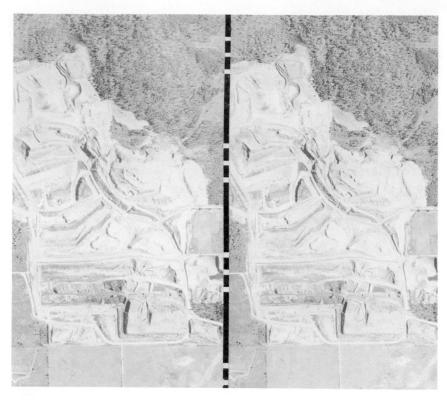

Figure 13–16. Bauxite surface mine in Saline County, Arkansas. Note the light tones produced by aluminum ore. Scale is about 1:20,000. Courtesy U.S. Department of Agriculture.

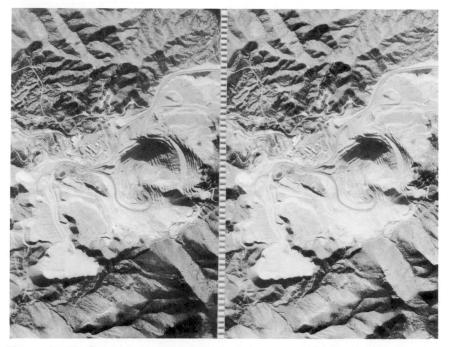

Figure 13-17. Open-pit copper mining in the vicinity of Miami, Arizona. Scale is about 1:42,000.

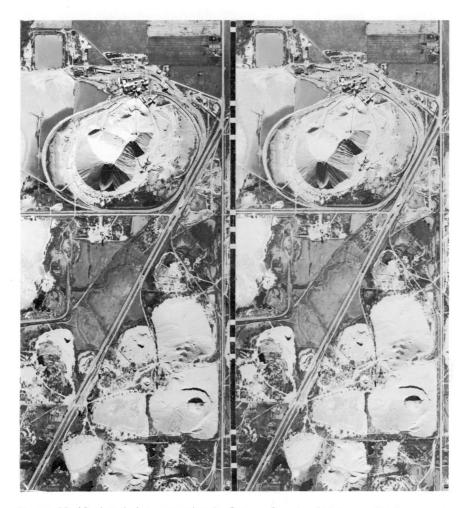

Figure 13–18. Lead-zinc extraction in Ottawa County, Oklahoma. Underground deposits are being brought to the smelter shown at the top of the photograph. Scale is about 1:20,000. Courtesy U.S. Department of Agriculture.

Stockpile inventories

Huge stockpiles of raw materials such as coal, limestone, mineral ores, fertilizers, and pulpwood chips must be periodically measured for inventory and cost-accounting purposes. In earlier days, such inventories were accomplished by laborious plane-table surveys or ground cross-sectioning; today, cubic volumes of materials 25 m or more in height and covering 20 ha may be determined accurately and efficiently by photogrammetric methods.

In the photographic approach, piles are contoured at 0.5-m intervals on the slopes and a 25-cm auxiliary on the tops. This is accomplished photogrammetrically by stereoscopic plotting of the contours of each pile from large-scale (e.g., about 1:400) aerial photographs. After contouring, the area of each contoured layer or slice is determined by planimetry and the cubic volume is computed.

When weight conversions per cubic metre or per cubic yard are known, volumes of piles may be converted to weight values (*Table 13-1*). Corrections

should be made for variations in density for different piles of the same materials, because settling or compression will result in significant changes in volume-weight ratios. In summary, the photogrammetric method of stockpile inventory has these advantages:

- 1. It is more accurate, economical, and convenient.
- 2. The cut-off time for inventories can be set for one date, because all pictures can be obtained in one day.
- 3. Ground control need be established only once.
- 4. The method provides a permanent record of the size of the pile at the time the picture was taken, and volume can be checked at any future time if any question arises as to the accuracy of the record.
- 5. No bulldozing or pile dressing is required, whereas these operations are usually necessary in the cross-section method.

Table 13-1. Approximate Weights of Materials in Metric and English Units

Material	Weight, in kilograms per cubic metre	Weight, in pounds per cubic yard
Cement, Portland, loose	1,506	2,538
Concrete, 1:2:4 mixture		
Trap rock	2,385	4,020
Gravel	2,341	3,945
Limestone	2,308	3,890
Sandstone	2,237	3,770
Cinder	1,697	2,860
Clay, dry, loose	1,009	1,700
Clay, damp, plastic	1,691	2,850
Clay and gravel, dry	1,602	2,700
Earth, dry, loose	1,172	1,975
Earth, moist, loose	1,252	2,110
Earth, moist, packed	1,537	2,590
Earth, mud, flowing	1,730	2,916
Earth, mud, packed	1,839	3,100
Garbage	400-801	675-1,350
Riprap, limestone	1,543-1,955	2,600-3,295
Riprap, sandstone	1,442	2,430
Riprap, shale	1,679	2,830
Rubbish, including ashes	128	216
Sand and gravel, dry, loose	1,442-1,679	2,430-2,830
Sand and gravel, dry, packet	ed 1,602-1,922	2,700-3,240
Sand and gravel, wet	2,017	3,400
Snow, fresh-fallen	80-193	135-325
Snow, wet	240-320	405-540
Coal, anthracite, natural	1,554	2,620
Coal, bituminous, natural	1,347	2,270
Coal, lignite, natural	1,252	2,110
Coal, anthracite, piled	753-930	1,270-1,567
Coal, bituminous, piled	641-866	1,080-1,460

English weights from International Harvester Company. Metric values were obtained by use of a multiplying factor of 0.5933.

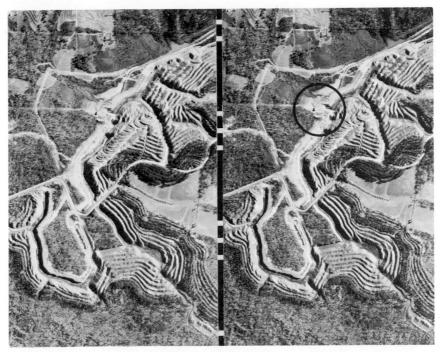

Figure 13-19. Strip-mining of coal in Walker County, Alabama. A power shovel working a seam of coal is encircled. Scale is about 1:20,000. Courtesy U.S. Department of Agriculture.

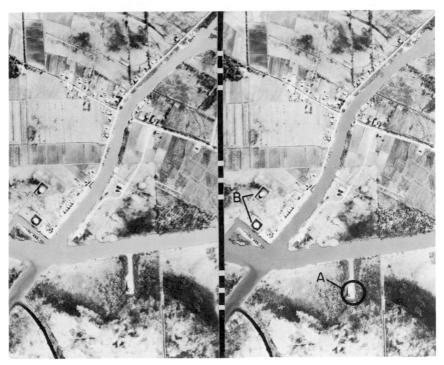

Figure 13-20. Oil extraction in Lafayette Parish, Louisiana. Pictured here are a floating drilling rig (A) and oil storage tanks (B). In areas where canals are common, drilling equipment is easily barged from one location to another. Scale is about 1:20,000. Courtesy U.S. Department of Agriculture.

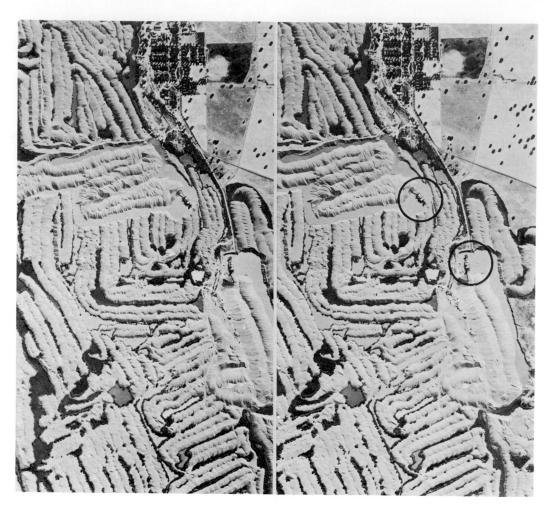

Figure 13–21. Placer-mining of gold in Yuba County, California. Dredges may be seen in the circled areas. Scale is about 1:20,000. Courtesy U.S. Department of Agriculture.

Problems

- 1. Plan and conduct an engineering materials survey for granular materials in your locality. Use existing aerial photographs, soils maps, geologic maps, and topographic quadrangle sheets as aids. Prepare a written report on your findings.
- 2. Plan and conduct an aerial survey (based on visual reconnaissance or photographs) of the prominent sewage outfalls in your county. How many municipalities (if any) discharge untreated sewage into lakes and streams? Are there ordinances that prohibit such practices? Investigate.
- 3. Are there rivers in your county subject to flooding at periodic intervals? Consult with local planners or construction engineers to verify your findings. From a study of aerial photographs, can you suggest measures that would minimize the damage from future floods?

4. Make a complete aerial inventory of all active surface mines (including gravel and borrow pits) in your county. Classify by type of material extracted, areal extent, and potential impact on surrounding land values. Are steps being taken to restore landscapes after mines are worked out? Summarize your findings in a written, illustrated report.

References

- Anderson, R. R., and F. J. Wobber. 1973. Wetlands mapping in New Jersey. Photogrammetric Engineering 39:353-58, illus.
- Dumbleton, M. J., and G. West. 1970. Air photograph interpretation for road engineers in Britain. Reed Research Laboratory, Crowthorne, Berkshire, England. 25 pp., illus.
- Garofalo, Donald, and F. J. Wobber. 1974. Solid waste and remote sensing. Photogrammetric Engineering 40:45—59, illus.
- Klooster, S. A., and J. P. Scherz. 1974. Water quality by photographic analysis. Photogrammetric Engineering 40:927–35, illus.
- Massa, William S. 1958. Inventory of large coal piles. Photogrammetric Engineering 24:77-81.
- Piech, K. R., and J. F. Walker. 1972. Outfall inventory using airphoto interpretation. *Photogrammetric Engineering* 38:907–14, illus.
- Stafford, D. B., and J. Langfelder. 1971. Air photo survey of coastal erosion. Photogrammetric Engineering 37:565-75, illus.
- Strandberg, Carl H. 1967. Aerial discovery manual. John Wiley and Sons, New York, 249 pp., illus.
- Waelti, Hans. 1970. Forest road planning. Photogrammetric Engineering 36:246-52, illus
- Wobber, F. J. 1971. Imaging techniques for oil pollution survey purposes. Photographic Applications in Science, Technology and Medicine 6(4):16-23, illus.

Chapter 14

Urban-Industrial Patterns

The airphoto approach to urban planning

Urban planning may be defined as the orderly regulation of the physical facilities of a city to meet the changing economic and social needs of a community, including the development of plans for future industrial expansion. Although city managers have long relied upon large-scale maps for zoning and urban renewal projects, the widespread use of photo interpretation techniques by municipal organizations represents a comparatively recent trend. It is now recognized, however, that properly timed aerial photography offers a unique and efficient means of studying such critical municipal factors as population growth, transportation networks, real estate assessment, and recreational needs. Aerial photographs provide the administrator with a complete perspective view of the city and its environs. As a result, the administrator is better equipped to analyze socioeconomic patterns, residential distributions, industrial requirements, and the need for extension of public utilities and services.

The intense competition for space between residential, industrial, recreational, agricultural, and transportation interests presents a continual series

of problems to the urban planner. Whenever any portion of a city's limited environment is allocated to one of these interests, careful consideration must be given to the probable impact of that allocation on each of the other competing interests and on the residents of the area.

Sequential aerial photography is now available for many cities in Anglo-America (Figure 14-1). Through the study of comparative photographs taken at intervals of several years, it is possible to determine the effects of major decisions made by previous municipal managers during the growth of a city. Accordingly, an excellent file of case histories is made available to incumbent urban planners who wish to capitalize on both the good and bad decisions of their predecessors.

A systematic guide to urban analysis

A series of eleven topical guides designed to aid geographers in the systematic study of aerial photographs has been prepared by Stone (1964). These guides are postulated on the theory that photo interpretation is largely a deductive rather than an inductive process and, therefore, analyses should proceed from the known parts of a topic to the unknown. If interpretation activities are organized for working from general patterns toward specific identifications or inferences, stereoscopic study will begin with the smallest scale of photography and end with prints of the largest scale available. A topical outline for the interpretation of urban features is presented here. In using prepared guides of this type, the interpreter must realize that positive identifications are rarely possible for all urban patterns; thus, listings of uncertain areas should be accompanied by several possible identifications based on the concept of associated features.

- 1. Outline built-up areas having urban characteristics.
- 2. Mark the major land and water transportation lines passing through the city (Figure 14-2).
- 3. Mark the principal commercial airports (Figure 14-3).
- 4. For the built-up area, outline subareas to show types of water bodies, drainage systems, terrain configuration, and natural vegetation.
- 5. Divide the built-up area into subareas with differing street patterns.
- 6. Outline the older and newer parts of the city.
- 7. Identify the principal transportation lines within the city.
- 8. Mark the minor land and water transportation lines passing through the city.
- 9. Circle the places where there is a change in the type of transportation (Figure 14-4).
- 10. Outline the primary commercial subareas in the central business district and in the suburbs.
- 11. Outline principal industrial subareas, including municipal utilities.
- 12. Outline subareas of warehouses and open storage.
- 13. Mark the recreational areas.
- 14. Mark the cemeteries.
- 15. Outline sections of the residential subareas by differing characteristics of the residences and lots and their relative locations to other functional subareas.
- 16. Mark the principal administrative and government buildings.

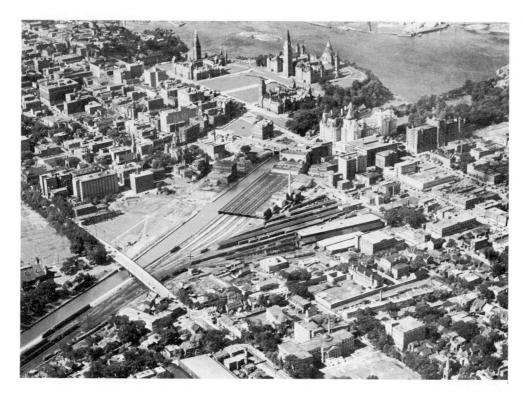

Figure 14–1. Oblique views of downtown Ottawa, Canada, in 1928 (above) and in 1964 (below). Parliament buildings are near top center of each photograph. Courtesy Surveys and Mapping Branch, Canada Department of Energy, Mines, and Resources.

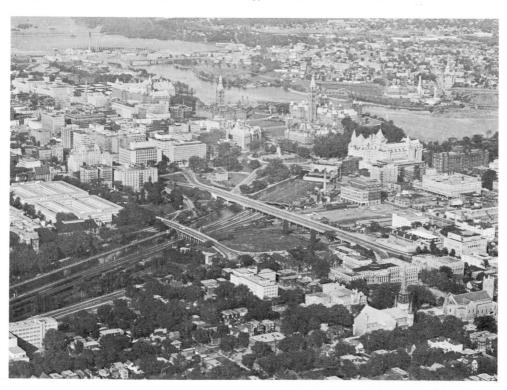

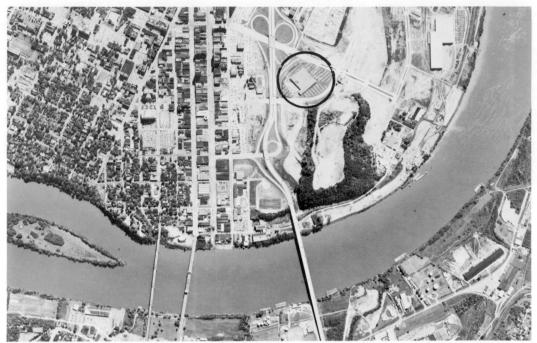

Figure 14–2. Interstate highway bypassing the central business district of Chattanooga, Tennessee. Although some added parking areas are evident between the highway interchanges and the downtown section, shopping centers such as the one circled pose an economic threat to downtown merchants. This type of problem confronts many cities. Scale is about 1:20,000.

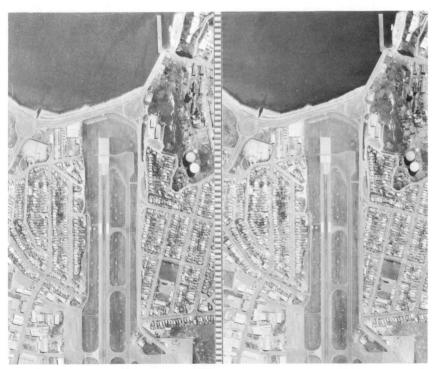

Figure 14–3. Portion of the municipal airport at Wellington, New Zealand. Scale is about 1:20,000. Courtesy New Zealand Department of Lands and Survey.

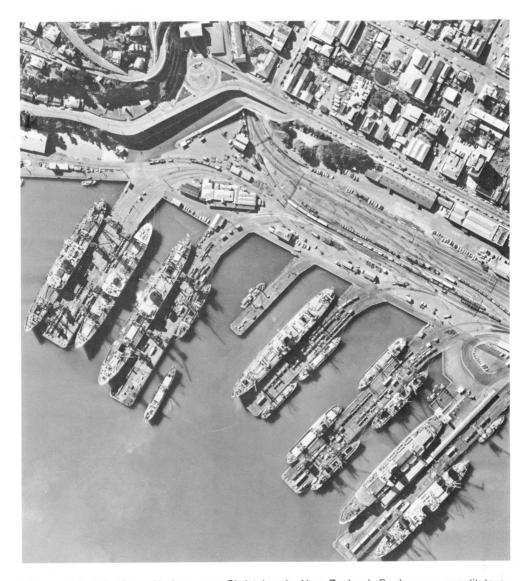

Figure 14-4. Lyttleton Harbor, near Christchurch, New Zealand. Such areas constitute a focal point for water, rail, and auto transportation. Courtesy New Zealand Department of Lands and Survey.

- 17. Mark the secondary commercial centers.
- 18. Mark the isolated industrial plants.
- 19. Mark the probable locations of light industrial establishments.

Information accumulated for a given urban area becomes the basis for more detailed studies. For example, in planning for future expansion of public facilities, correlations might be established between information on population density, number of automobiles per dwelling unit, or water use per capita and such planning multiplier factors as roadway capacity or area of recreational land per thousand persons.

Parking and transportation studies

Special photographic flights made during peak traffic periods are ideal for discovering bottlenecks in automobile flow patterns. Similarly, coverage of congested business districts can quickly reveal diurnal parking patterns and the locations of districts having shortages or surpluses of parking spaces during each hour of the day. Law enforcement officers have also found sequential, low-altitude photographs to be of assistance in pinpointing areas where cars are habitually parked in restricted zones.

Individually painted parking spaces can be easily discerned and counted at photographic scales of 1:6,000; at larger scales, the size and type of vehicle can also be assessed (Figure 14-5). In a few cities, aerial surveys of parking facilities have revealed that there is sufficient unused space in vacant backyards and alleys within the business district to make available more than double the existing parking capacity. Photographs also revealed that traffic would be able to reach parking lots behind shops if only a few new access streets were opened to handle the traffic flow. In other urban areas, aerial photographs have indicated that more parking facilities than were originally allotted will have to be provided; additional spaces are often needed to supply legal parking for vehicles that previously used loading zones and other nonallocated spaces.

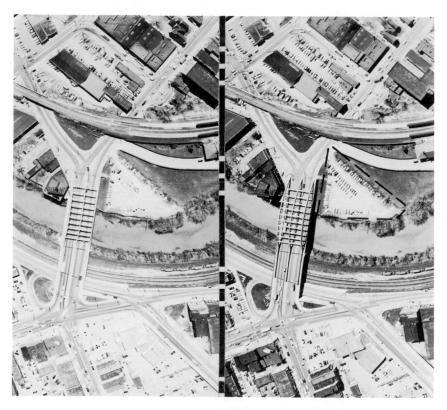

Figure 14–5. Large-scale view of parking lots in Youngstown, Ohio, at about 11 A.M. Note concentrations of vehicles in some lots and surplus spaces in others. Buses, trucks, and compact cars can be distinguished from standard-sized automobiles here. Scale is about 1:3,960.

When the time interval between successive, overlapping aerial exposures is known, speeds of vehicles imaged on adjacent prints can be computed (Figure 14-6). Such information can be of considerable utility in analyses of traffic flows during rush-hour periods. For some European countries, closerange terrestrial photographs made with stereometric cameras provide permanent pictorial records of traffic accidents. The precision of photogrammetric determinations of such items as tire marks, vehicle positions, and collision damage has been firmly established, so that photographic evaluations are commonly admissible as court evidence. The photogrammetric technique provides more reliable measurements than ground taping of distances, and the accident scene can be reexamined from files of four or five carefully oriented stereopairs. Furthermore, the stereometric process shortens the investigation time at the accident scene, with the result that roadways can be cleared for regular traffic with a minimum of delay.

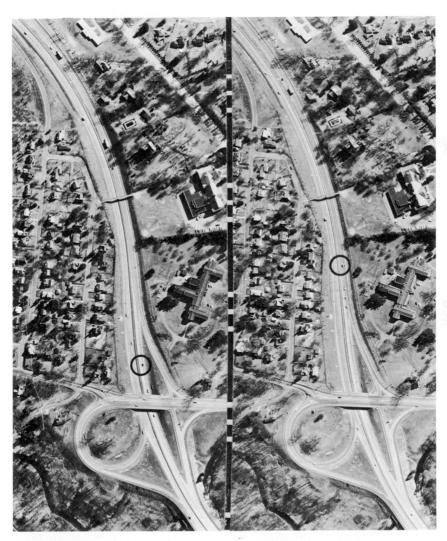

Figure 14–6. The speed of the circled vehicle may be computed from a knowledge of the time interval between photo exposures. What would be the auto's rate of speed if the exposure interval were 12 seconds? Scale is about 1:6,000.

Patterns of residential development

Many urban planners believe that the only answer to the control of haphazard urban sprawl is a rigidly administered property zoning system. Certainly there are valid arguments favoring the orderly regulation of community development; otherwise smoky industrial plants may force down property values in exclusive suburbs, and taverns might be constructed adjacent to school buildings.

The suburbanite who wishes to reside in an area free from polluted air, speeding automobiles, and supersonic aircraft may be hard-pressed to find solace in today's metropolis. Nevertheless, interpreters of urban features have found that residential property is one of the key indicators of a family's socioeconomic status and that a person's address often reveals much more about an individual than just where he or she lives. One might, for example, reflect upon the social or economic status associated with a residence on San Francisco's Nob Hill around 1900. Residence location has meaning not only in terms of real estate cost or rental, but also in terms of occupation, educational level, income class, nationality group, cultural attributes, and even religious preferences.

Even though the typical single-family dwelling in America has grown larger and more luxurious, the high cost and scarcity of building sites results in more and more houses being built on smaller parcels of real estate. The confining atmosphere and unimaginative landscaping that results are painfully illustrated by Figures 14-7 and 14-8.

Figure 14–7. Large ranch-style residences being constructed close together on small lots in Milwaukee, Wisconsin. As is commonly seen in new subdivisions, sod, topsoil, and trees have been scraped away to make for more efficient materials handling. The monotony of this scoured landscape will remain for years to come. Scale is about 1:4,800.

Indicators of housing quality

Information is required periodically on residential housing quality for evaluation and mapping of neighborhoods that need remedial action and for allocation of housing improvement funds. Among the factors obtainable from remote sensor data, the following appear to be positively correlated with residential housing quality:

- 1. Availability of on-street parking
- 2. Freedom from loading and parking hazards
- 3. Ample street width
- 4. Freedom from traffic hazards
- 5. Minimal amount of refuse
- 6. Moderate street grades
- 7. Easy access to buildings

Figure 14–8. In many seacoast areas, one may dig a canal, use excavated materials to fill in lowlands, and create a subdivision with waterfront residences. Here in Dade County, Florida, excavated sand (A) is transported to adjacent development areas (B, C). In anticipation of advance residential sales, four model homes are already open to customers (D). The final result will seemingly appear somewhat similar to the mill-town arrangement at the extreme left edge of the picture. Scale is about 1:10,000.

Most evaluations of such diagnostic characteristics have used conventional large-scale (1:5,000 to 1:10,000) aerial photography. However, one interesting application of thermal infrared scanners may be cited: the heat loss from homes and office buildings with poor insulation can be readily distinguished on infrared imagery.

In areas of high population density, it has also proven possible to estimate the number of dwelling units from infrared color photography at a scale of 1:20,000. From such estimates, additional inferences can be made about pop-

ulation density and the total population of selected urban areas.

Urban recreational planning

The failure of many large cities to make early provision for parks, golf courses, and other outdoor recreational facilities has resulted in tremendous pressures on existing lands as populations have increased. Notable examples of foresight by city planners would include such urban oases as Central Park in Manhattan, Rock Creek Park in Washington, D.C., and City Park in New Orleans. In many other heavily populated regions, however, carefully maintained havens of grass and trees may be sorely inadequate or wholly lacking.

When open areas are not reserved for public use at an early stage in a city's growth, rising real estate values may effectively block the establishment of large municipal parks and athletic facilities at a later date. As a result, private country clubs, concentrated tourist attractions, or spectator sports may offer the only alternatives to local residents (Figures 14-9 through

14-12).

Surveys of population pressures on existing recreational areas and inventories of potential recreational sites are often aided by intensive study of large-scale aerial photographs. Diagnostic factors that are commonly evaluated to indicate areas of high recreational potential include the following:

1. Population center factors, such as building density, existing recreational opportunities, kind and direction of urban expansion, etc.

2. Current land use, including factors that might limit or prohibit recreational development, e.g., undesirable industries nearby

3. Characteristics of potential water-based recreational sites, e.g., size, shape, shoreline configuration, depth, water quality, etc. 4. Existing and potential roads for access to new sites and for use by hikers,

skiers, or horseback riders

5. Character and appeal of tree and shrub vegetation on potential sites

Legal applications of remote sensing

Following is a partial listing of the types of legal problems for which remote sensor imagery might play a vital part:

1. Discovery and assessment of taxable property

2. Establishment of boundary lines in ownership disputes

- 3. Appraisal of lands to be condemned under states' rights of eminent domain
- 4. Discovery and evaluation of the illegal deposition of fill dirt or waste materials on private property

Figure 14–9. Recreational facilities near a residential development in Milwaukee, Wisconsin. Items designated are: (A) a "go-cart" track; (B) trampoline pits; (C) miniature golf; (D) a drive-in restaurant; (E) a roller rink or dance hall; (F) a gas station; and (G) billboards. The dumped fill material (H) possibly came from basements excavated for new houses. Note that lots in the lower part of the picture are so narrow that many homes are of the "shotgun" design, with no space for driveways. Scale is about 1:5,000.

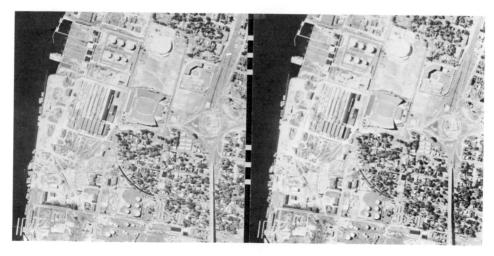

Figure 14–10. Stadium in Jacksonville, Florida, where the annual Gator Bowl football game is held (near center of photograph). Scale is about 1:16,000.

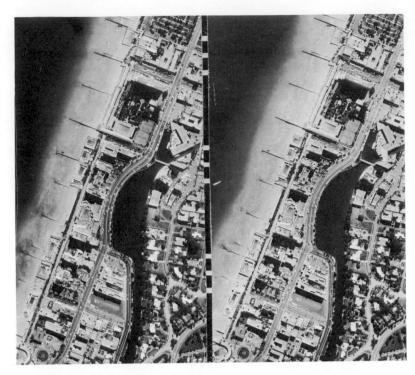

Figure 14-11. Hotels along Miami Beach, Florida, represent intensively developed recreational facilities for tourists. Scale is about 1:10,000.

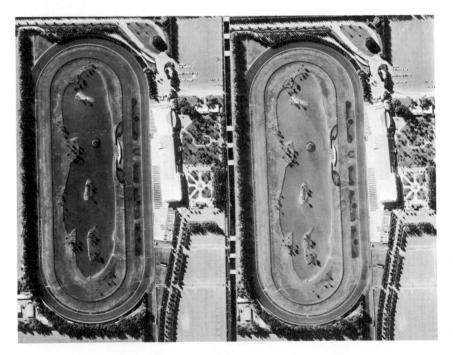

Figure 14–12. Horse racing, one of America's leading spectator sports, attracts many thousands to Hialeah Park in Miami, Florida, each year. Palm trees and a central lake add to the esthetic value of the location. Scale is about 1:10,000.

- 5. Auto, railway, and airline accidents
- 6. Inventory of damages from fires, hurricanes, floods, and other disasters
- 7. Evaluation of vegetation killed by noxious fumes from industrial point sources
- 8. Timber trespass

The discovery and assessment of taxable property (e.g., improvements to single-family residences) may be cited as an application of remote sensing techniques. Recent improvements shown on property record files can be checked against "apparent" improvements as determined from the interpretation of large-scale aerial photographs; discrepancies are then crosschecked against building permit files. Irregularities that cannot be reconciled are subsequently scheduled for ground check or appraisal. The kinds of improvements most easily found on aerial photographs are additions to existing residences, new garages, swimming pools, apartment buildings, and commercial blacktop areas.

Recognition of industrial features

The general classification or specific identification of certain industrial features is of vital concern to photo interpreters engaged in urban planning, control of water and air pollution, or military target analysis. In a few instances, unique structures or rooftop signs can make the task exceedingly simple (Figures 14-13 and 14-14). In other cases, however, the correct categor-

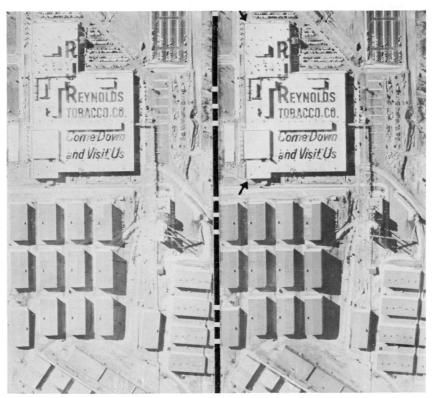

Figure 14–13. Cigarette-manufacturing plant (above) and tobacco warehouses (below) in Winston-Salem, North Carolina. Scale is about 1:7,920.

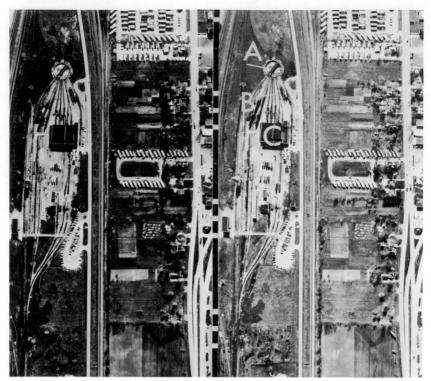

Figure 14–14. If one can recognize a railroad turntable (A) and locomotives (B), then it can be deduced that the engines are being shunted into a repair or maintenance shop (C). This heavy fabrication industry is located at New Haven, Indiana. Scale is about 1:7,920.

ization may require a sound background knowledge of industrial components, a high degree of deductive reasoning, and one or more photo interpretation keys. The more one knows about industrial processing methods, the more success one will have in recognizing those same activities on vertical aerial photographs.

As pointed out by Chisnell and Cole (1958), each type of industrial complex has a unique sequence of raw materials, buildings, equipment, end products, and waste that typify the industry. Many of these components can be seen directly on aerial photographs; others (those that are obscured or are inside structures) must be detected by inference from the images of minor associated components. By studying the distinctive shapes, patterns, or tones of raw materials, for example, one may frequently deduce the kinds of processes or equipment that are hidden from view. Arrangements of chimneys, stacks, boilers, tanks, conveyors, and overhead cranes may also provide essential identification clues. And, finally, the finished product can occasionally be seen as it emerges from an assembly line or is stored in open yards awaiting shipment.

A number of photo interpretation guides for use in identification of general classes of industries have been compiled by or for various military agencies. One of these selective keys (see p. 335) is based on general industrial categorizations of extraction, processing, and fabrication. If industries are imaged on photographs at a scale of about 1:20,000 or larger, it has been

shown that relatively unskilled interpreters can use such a key to categorize various industries, even though a specific identification may not be possible. Because industrial components tend to exhibit common images irrespective of geographic location, this key is applicable in many parts of the world.

To use the various recognition features to categorize an industry from its image components, follow the procedure recommended here:

- 1. Decide whether it is an extraction, processing, or fabrication industry.
- 2. If it is a processing industry, decide whether it is chemical, heat, or mechanical processing—in that order.
- 3. If it is a fabrication industry, decide whether it is light or heavy fabrication.

Industrial Classification Key

Extraction industries are characterized by these features: excavations, mine headframes, ponds, and derricks; piles of waste; bulk materials stored in piles, ponds, or tanks; handling equipment, e.g., conveyors, pipelines, bulldozers, cranes, power shovels, or mine cars; buildings that are few and small.

Processing industries are characterized by these features: facilities for storage of large quantities of bulk materials in piles, ponds, silos, tanks, hoppers, and bunkers; facilities for handling of bulk materials, e.g., conveyors, pipelines, cranes, and mobile equipment; large outdoor processing equipment, e.g., blast furnaces, cooling towers, kilns, and chemical processing towers; provision for large quantities of heat or power as evidenced by boiler houses; oil tanks, coal piles, large chimneys or many smokestacks, or transformer yards; large or complex buildings; piles or ponds of waste. Three types of processing industries may be recognized:

- Mechanical processing is typified by few pipelines or closed tanks, little fuel inevidence, few stacks, and no kilns.
- 2. Chemical processing is typified by many closed or tall tanks, gasholders, pipelines, and much large, outdoor processing equipment.
- 3. Heat processing is typified by few pipelines or tanks, large chimneys or many stacks, large quantities of fuel, and kilns.

Fabrication industries are characterized by these features: few facilities for storing or handling bulk materials; a minimum of outdoor equipment except for cranes; little or no waste; buildings may be large or small and of almost any structural design.

- 1. Heavy fabrication plants are typified by heavy steel-frame, one-story buildings, storage yards with heavy lifting equipment, and rail lines entering buildings.
- Light fabrication plants are typified by light steel-frame or wood-frame buildings and wall-bearing, multistory structures, lack of heavy lifting equipment, and little open storage of raw materials.

From Thomas C. Chisnell and Gordon E. Cole, 1958, Industrial Components—A Photo Interpretation Key on Industry, *Photogrammetric Engineering* 24:590-602. Copyright 1958 by the American Society of Photogrammetry. Reprinted with permission.

Examples of industrial categories

Extraction industries, typified by oil drilling, rock quarries, gravel pits, and mining operations, are among the easiest types of industries to classify. They may be recognized by the presence of excavations, ponds, mine shafts, and earth-moving equipment; buildings are usually small and often of tem-

porary construction. Frequently, such operations appear to be rather disorganized as viewed on aerial photographs, even though extracted materials are mechanically handled by conveyors or stored in ponds, tanks, or bins. In some cases, the interpreter must exercise special care in distinguishing waste piles from usable materials. The surface mining patterns that were illustrated in Chapter 13 provide appropriate examples of the extraction industries.

Processing industries are divided into three subclasses: mechanical, chemical, and heat processing. Mechanical processing industries are those that size, sort, separate, or change the physical form or appearance of raw materials. Industries that are typical of this category are sawmills, grain mills, and ore concentration plants; utilities in the same grouping would include hydroelectric power plants and water purification and sewage disposal installations. Several of these types of industries were also illustrated in Chapter 13.

Chemical processing industries are those that employ chemicals to separate, treat, or rearrange the constituents of raw materials. Among representative chemical processing industries are sulfuric acid production, aluminum production, petroleum refining, wood pressure treatment, and byproducts coke production (Figures 14-15 through 14-17).

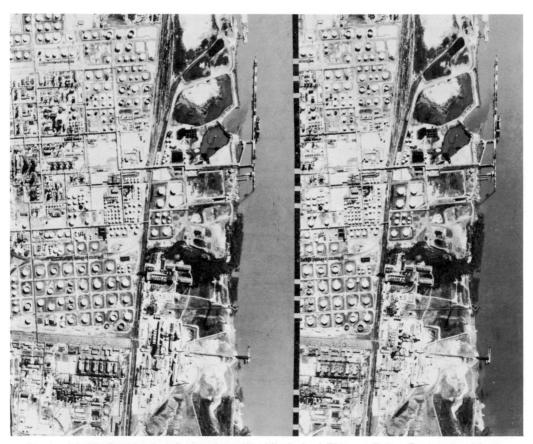

Figure 14–15. Petroleum refinery along the Mississippi River at Baton Rouge, Louisiana. Although this chemical processing industry is pictured at a scale of about 1:25,000, it is a sufficiently distinctive complex to be categorized by use of the industrial classification key.

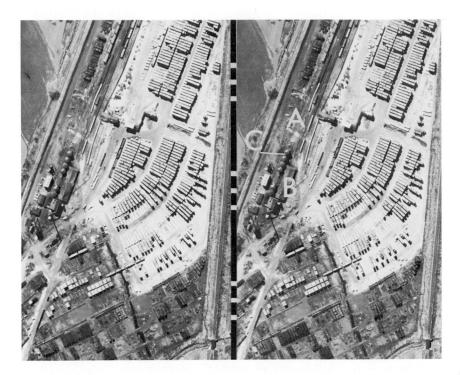

Figure 14–16. This chemical processing plant near Milwaukee, Wisconsin, is engaged in the preservative treatment of wood materials with creosote. Both untreated stacks of wood (light tones) and treated materials (dark tones) are visible in the storage yard. Tram cars of untreated materials (A) may be seen lined up for movement into the pressure cylinder (B). Liquid preservatives are stored in cylindrical tanks (C). Scale is about 1:4,800.

Heat processing industries use heat to refine, divide, or reshape raw materials or to produce energy from raw materials. Large quantities of fuel are required, waste piles are common, and blast furnaces or kilns are often in evidence. Thermal electric power production is included in this category, along with cement production, clay products manufacturing, iron production, and copper smelting (Figures 14-18 through 14-20).

Fabrication industries are those that use the output of processing plants to form or assemble finished products. Although a majority of all industries are of the fabrication type, they are the most difficult to identify specifically because most of the activities are hidden from view by well-constructed buildings and enclosures. There is little outdoor equipment in evidence except for large cranes; bulk materials, waste piles, and storage ponds are usually absent. Heavy fabrication industries include structural steel production, shipbuilding, and the manufacture or repair of railroad cars and locomotives (Figure 14-21). Typical of the light fabrication industries are aircraft assembly, canning and meatpacking, small boat construction, and the manufacture of plastics products (Figures 14-22 and 14-23).

Most interpreters find that the best way to identify an industrial complex is by looking for components that are key recognition features of the classification in which the industry falls. While one or two components may not provide a specific identification, associations with other features will usually provide the missing link in the recognition chain. Knowledge of the photo-

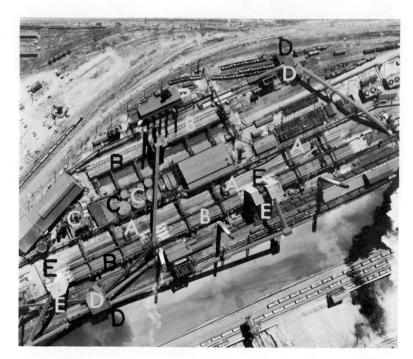

Figure 14–17. By-products coke production in Youngstown, Ohio. Components labeled are: (A) pushing rams to move coke from ovens into quenching cars; (B) long coke ovens; (C) tank storage of tars and other coal by-products; (D) buildings where coal is washed; and (E) towers where coal is fed into coke ovens. Scale is about 1:3,960. Although this would usually be classed as a chemical processing industry, heat processes are also in evidence at installations such as this.

graphic scale and the exact geographic locale of photography are additional factors that are of primary importance in recognition of industries. When available, current sets of county maps, topographic quadrangle sheets, stereogram files of representative industries, and a recent commercial atlas are valuable reference aids to photo interpreters.

Capacities of storage tanks

The capacity of any cylindrical storage tank can be determined from measurements of its inside diameter (d) and height (h). These values are merely substituted into the formula for the volume of a cylinder:

Volume =
$$\frac{\pi d^2}{4}$$
 (h), or 0.7854d²(h)

When cylinder diameters and heights are measured in metres, volumes will be derived in cubic metres. Where the dimensions are in feet, volumes will be in cubic feet. Depending on whether stored materials are in solid or liquid form, cubic volumes may be subsequently converted to weight values or to other measurement units (see *Table 13-1* and appendix tables).

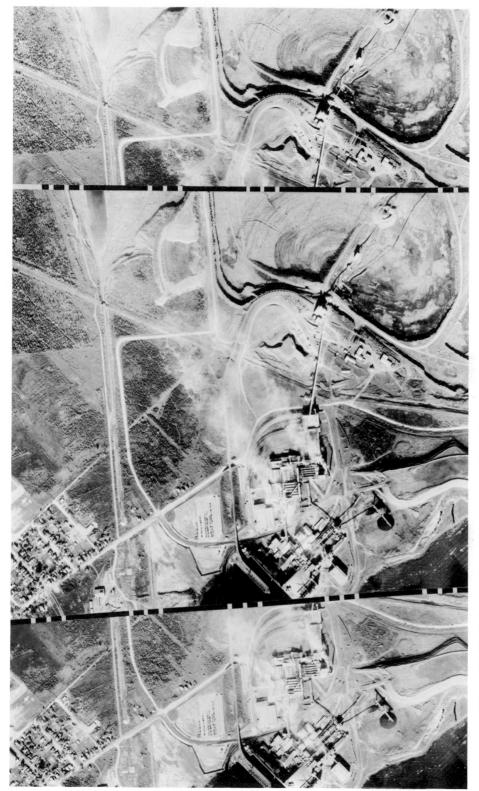

Figure 14-18. Both extraction and heat processing industries are pictured in this stereo-triplet of a Michigan cement plant.

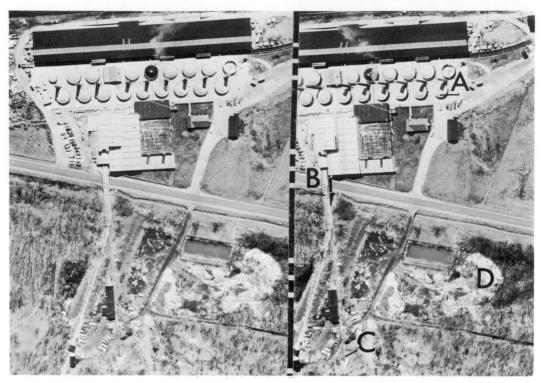

Figure 14–19. Clay products constitute the output of this heat processing industry at Newcomerstown, Ohio. Key components include: (A) clay kilns; (B) tram cars of raw materials; (C) a hillside tunnel to a clay mine; and (D) waste materials. Scale is about 1:3,000. Courtesy Abrams Aerial Survey Corp.

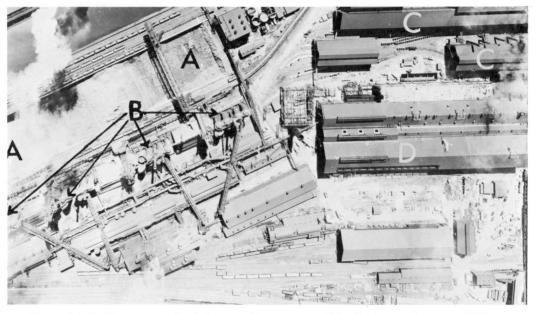

Figure 14–20. Heat processing industry at Youngstown, Ohio. Designated here are: (A) limestone and iron ore storage bins; (B) blast furnaces that use coke, iron ore, and limestone to produce pig iron; (C) buildings housing open-hearth furnaces; and (D) iron-rolling mills. Scale is about 1:3,960.

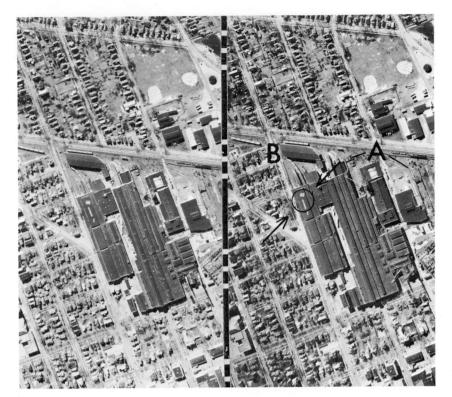

Figure 14–21. Railroad Pullman cars are manufactured at this heavy fabrication plant in Michigan City, Indiana. Visible are storage yards with overhead cranes (A) and rail lines entering the building (B). Painted on the roof is the name of the city and its longitude and latitude. Scale is about 1:15,840.

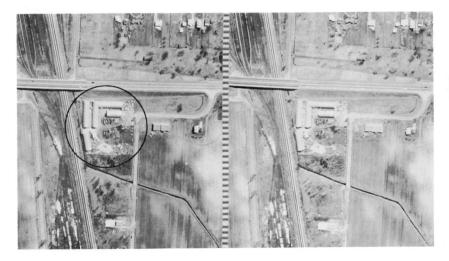

Figure 14-22. Small boat factory near Toledo, Ohio. Scale is about 1:7,920.

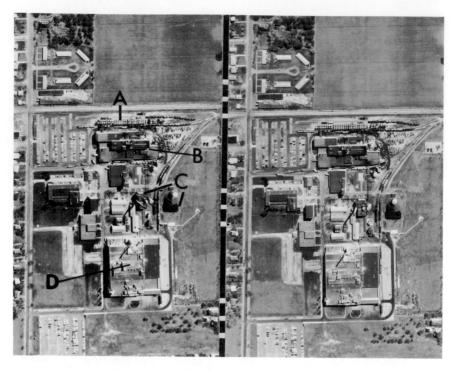

Figure 14–23. This plastics plant in Toledo, Ohio, apparently combines both chemical processing and light fabrication activities. Identified are: (A) liquid chemical storage tanks; (B) a chemical processing building; (C) a power plant and coal piles; and (D) a multistory fabrication building. Scale is about 1:7.920.

Problems

- 1. Make a systematic urban analysis of a nearby metropolitan area by following the interpretation guidelines described in this chapter. Then, based on your analysis, attempt to formulate answers to these types of questions:
 - a. Has recent economic growth been mainly in the central business district (CBD) or in outlying areas?
 - b. In which principal *direction* has growth proceeded? Is the direction due largely to topography, available surface transportation routes, water routes, or other factors? List, in order of importance.
 - c. Has the CBD been rejuvenated with new office buildings, parks, civic centers, or a stadium? Locate such developments on your photographs, and explain how they have affected downtown parking and access to key areas of the city.
- 2. Assume that you have a high-altitude photograph (or photo mosaic) of a city that is unknown to you. Attempt to list no more than five to ten diagnostic features that you consider to be unique or key identification elements, e.g.:

- a. The predominant pattern of land subdivision or street layout
- b. Presence of coastal shorelines, bays, major rivers, canals, or lakes, along with their shapes and orientations
- c. Location and configuration of major commercial and/or military airports
- d. Presence of city parks, golf courses, athletic fields, institutional campuses, fairgrounds, etc.
- e. Location and configuration of major highways and/or railways
- f. Location and general types of major industries
- g. An estimate of the population

When your list of key features is completed, rank them in order of presumed importance. Then attempt to list all those cities that (to your knowledge) have the critical attributes. If an identification has not been made at this point, consult an atlas for the final determination. Could you now devise a simple photo identification key for the largest twenty cities in your state or country?

- 3. Using photographs supplied by your instructor, classify at least ten different industrial sites by using the key provided in this chapter.
- 4. Determine the cubic capacities of several storage tanks (or similar structures) from photographic measurements. Check your results by ground measurements, and explain reasons for differences.

References

- Chisnell, Thomas C., and Gordon E. Cole. 1958. Industrial components—A photo interpretation key on industry. *Photogrammetric Engineering* 24:590–602, illus.
- Davis, Jeanne M. 1966. Uses of airphotos for rural and urban planning. Government Printing Office, Washington, D.C. U.S. Department of Agriculture, Agriculture Handbook 315, 40 pp., illus.
- Horton, Frank E. 1971. The application of remote sensing techniques to urban data acquisition. Proceedings of the International Workshop on Earth Resources Survey Systems, Government Printing Office, Washington, D.C., pp. 213–23.
- Lindgren, David T. 1971. Dwelling unit estimation with color-IR photos. *Photogrammetric Engineering* 37:373-77, illus.
- Lindsay, John J. 1969. Locating potential outdoor recreation areas from aerial photographs. *Journal of Forestry* 67:33-35.
- Rex, R. L. 1963. Evaluation and conclusions of assessing and improvement control by aerial assessment and interpretation methods: A case history. Sidewell Studio, Chicago. 15 pp., illus.
- Richter, Dennis M. 1969. Sequential urban change. Photogrammetric Engineering 35:764-70, illus.
- Stone, Kirk H. 1964. A guide to the interpretation and analysis of aerial photos. Annals of the Association of American Geographers 54:318–28.
- Wolf, Alfred L. 1967. Aerial photography as a legal tool. Reprint of Eastman Kodak Co., Rochester, N.Y. 4 pp., illus.
- Wray, James R. 1971. Census cities project and atlas of urban and regional change. Proceedings of the International Workshop on Earth Resources Survey Systems, Government Printing Office, Washington, D.C., pp. 243-59, illus.

Chapter 15

Air Intelligence and Military Target Analysis

The need for intelligence systems

Intelligence activities may be defined as the process of gathering a myriad of facts and bits of information, making a coherent pattern of them, and drawing inferences from that pattern. In the American concept of intelligence, emphasis is on the use of overt or open sources of data, i.e., information that is legitimately available from foreign newspapers, military and scientific journals, foreign political discussions or debates, encyclopedias, radio broadcasts, and statistical compilations (Orlov, 1963). By contrast, certain other nations place primary reliance on covert sources of intelligence information. Such tactics may involve undercover agents, spies, and paid informants who employ the more direct approach of infiltrating a key facility with the singular purpose of stealing or copying documents of high strategic value. From a purely objective viewpoint, both approaches have obvious advantages and limitations.

In international affairs, intelligence is foreknowledge, and foreknowledge is a powerful peacetime tool for making advance predictions of a hostile nation's reactions to varying political, economic, and military crises. In times of all-out war, a superior intelligence system may hold the balance of power

and the key to ultimate victory. As an illustration, skillful photo reconnaissance work by British interpreters during World War II led to the destruction of launching sites for German V-bombs on the continent; as a result, a long-range attack which might have been catastrophic was averted (Figure 15-1).

The gathering of intelligence information is a cyclic and continuing process. It begins with a listing of data requirements, followed by the location and exploitation of information sources, and leads finally to the dissemination of the intelligence report or estimate. National security interests require that United States intelligence agencies maintain an alert and flexible aerial reconnaissance posture at all times. A strong reconnaissance capability can inhibit the outbreak of hostilities if aggressors know that their actions are fully seen, analyzed, and understood, because they have thus been denied the singular advantage of surprise. During wartime operations, an established capability in intelligence and photo reconnaissance can help assure an early victory by supplying up-to-date information on enemy forces, terrain factors, communications systems, weaponry installations, and weather conditions.

The U.S. Central Intelligence Agency

The inadequacy of early intelligence systems in the United States was revealed by the 1941 Japanese attack at Pearl Harbor. The critical intelligence requirements of World War II led to the creation of the Office of Strategic Services, an organization which later evolved as the present U.S. Central Intelligence Agency. A book summarizing CIA activities has been written by former CIA director Allen Dulles (1963). The following description of CIA functions is quoted from a brochure on employment opportunities issued by the Agency:

Established by Congress as an independent civilian agency of the United States Government through passage of the National Security Act of 1947, the Agency was placed under the National Security Council and made accountable to the President, with Congressional review to be exercised through select committees.

The Director of Central Intelligence, head of the Central Intelligence Agency, is also coordinator of the total American intelligence effort and intelligence advisor to the President. The principal functions of the Central Intelligence Agency can be summarized as follows: (1) to perform the specialized intelligence collection and analysis functions that the National Security Council determines can best be performed centrally; (2) to correlate and evaluate all intelligence pertaining to the national security; and (3) to perform such other functions as the National Security Council may from time to time direct.

Overseas, ČIA has responsibilities for the collection of intelligence. Just as one dimension of intelligence is collection, so is another research and analysis. Major contributions to the foreign intelligence effort are made by CIA in the fields of economic research, geographic research, and scientific and technical research. Reports, monographs, and studies are regularly produced by CIA and other analysts in the intelligence community in support of the integrated political, military, and economic estimates and surveys prepared for the President and National Security Council.

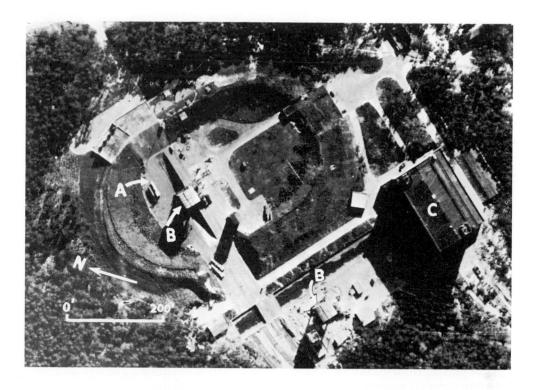

Figure 15–1. Top view, taken in 1944 at Peenemunde, Germany, shows elliptical earthwork feature where rockets were tested. Shown are: (A) V-2 rockets; (B) cranes; and (C) assembly shop. Lower view shows the same installation after an air strike. Courtesy U.S. Air Force.

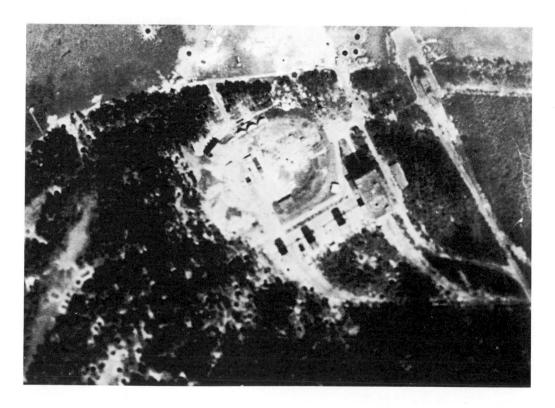

Covert operations: A two-edged sword

Powerful nations such as the United States like to regard themselves as both champions of the oppressed and dominant forces in the shaping of world policy. Consequently, there is an inevitable, ideological conflict between intelligence-gathering agencies and a democratic society. Tensions run particularly high whenever it is inadvertently revealed that a covert operation has been conducted for the purpose of influencing another nation's political system by paramilitary means. The result may be an effort by Congress, private citizens, or the press to reduce the budget, manpower, and operational role of agencies such as the CIA.

As a rule, the clamor for tighter controls over the CIA follows the public exposure of a covert operation that failed in some respect, e.g., the U-2 flights over the U.S.S.R., the Pueblo incident, the Bay of Pigs, or Project Jennifer (which involved the raising of a sunken Russian submarine). In fact, the very disclosure of such operations indicates a degree of failure, because intelligence agencies function optimally only when secrecy is absolute—

their most notable successes are never publicized.

The collection of covert intelligence can be a two-edged sword. Spying is not a nice business, and any secret organization will suffer when its activities are spotlighted in the midst of an international controversy. Its contacts will suddenly disappear and even "friendly" nations will refuse to assist such an agency. The future role of United States "spy operations" will ultimately depend on our responses to a number of fundamental questions:

1. Must we conduct covert operations in foreign nations?

- 2. What should be the functions and limitations of an intelligence organiza-
- 3. Should intelligence operations be approved by "watchdogs" other than Congressional committees and the President?

4. What is the general public's "right to know"?

5. Do we need or want a strong foreign intelligence agency? Can we survive as a nation without it?

The nature of military intelligence

The technique of obtaining military intelligence by use of aircraft equipped with cameras and other remote sensing devices is termed photo reconnaissance. Military photo reconnaissance differs from other forms of interpretation in two important respects. First, reconnaissance photography is usually obtained without the consent of those who control the target areas in fact, reconnaissance efforts are likely to be systematically obstructed by those who risk being exposed by overflights. Also, camouflage may be employed to hide critical targets, and dummy constructions may be thrown up to confuse image interpreters. Secondly, aerial photo reconnaissance and interpretation must be fitted into their military place. They must be accommodated to each phase of warfare. The practical value of the interpretation is heavily dependent on rapid results; the time factor is so important that photographic coverage must often be scheduled without regard to optimum exposure conditions.

Camouflage experts regard photo reconnaissance efforts as a personal challenge, and continued improvements in camouflage techniques make target detection increasingly difficult for the military interpreter. Consequently, images of higher resolution are demanded by interpreters, and larger negative scales are required, entailing a significant increase in the number of photographs to be studied. Furthermore, when a given target is covered by ordinary film exposures as well as a camouflage-detection emulsion, the number of photographs to be examined is again greatly increased.

With low-altitude reconnaissance, each photograph spans such a small area that large numbers of prints are required in order for a given target to be covered. Nevertheless, the advantages of low-level imagery produced from supersonic photo reconnaissance flights have been clearly demonstrated. The 1962 detection of medium-range ballistic missiles on the island of Cuba constitutes a prime example of precision, low-altitude photo reconnaissance. High-flying U-2 aircraft first discovered the presence of Soviet missiles in Cuba, watched their emplacement, and confirmed their hurried departure. However, the bulk of the detailed photography made available to military interpreters was obtained from tactical, fighter-type jet aircraft that operated at treetop levels to avoid enemy radar detection and various forms of anti-aircraft fire. The clarity and sharpness of such photographs are shown by Figures 15-2 through 15-5.

In the best of the Cuban photographs, missiles and launching devices can be recognized by untrained observers. However, only highly skilled personnel can identify minor components of such installations and make rational inferences from the various stages of construction pictured. Military interpreters are trained to look for subtle hints that lead indirectly to important hidden information, e.g., vehicle tracks leading into apparently impenetrable swamps, trucks assembled where no roads are visible, or oil slicks on remote lagoons. A careful analysis of such clues will sometimes reveal skillfully camouflaged strongpoints such as radar installations, missile-storage caves, revetted gun emplacements, or underground ammunition dumps. When recent or unusual patterns are imaged, their ages can be estimated by reference to earlier photographic or nonphotographic coverage of the same area.

Photo reconnaissance of Cuba and other potential hotspots around the globe is a continuing process. Though sometimes labeled as overt espionage, aerial reconnaissance is a vital contributor to national security in peace as well as in war. As outlined earlier, foreknowledge is the foundation of sound political and military decisions in the free world.

Selecting and training interpreters

Military photo intelligence work is the responsibility of a relatively small group of highly trained specialists. They must be able to seek out or recognize significant intelligence information and be able to collate, evaluate, and report their findings within a minimal period of time. The range of required background knowledge makes photo intelligence work both interesting and exceedingly complex. Because the prime objectives of aerial reconnaissance missions may be unattained unless interpreters are adept, mentally alert, and properly motivated, only the most promising candidates are selected for extensive photo intelligence training. The question is: How does one distinguish the most promising candidates?

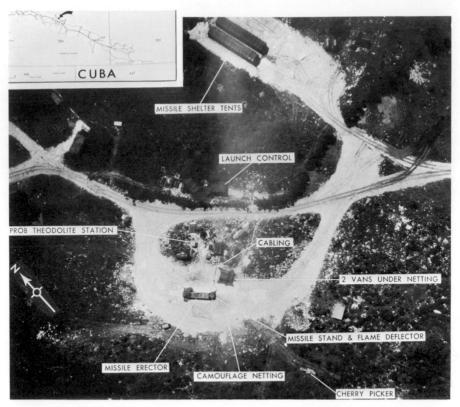

Figure 15–2. Vertical photograph of a medium-range ballistic missile site taken over Cuba on October 23, 1962. All elements necessary to launch an MRBM are present. A special effort is being made to camouflage activities; all major components are under canvas, and camouflage netting is stretched out near the missile erector prior to being strung across the site. Courtesy U.S. Air Force.

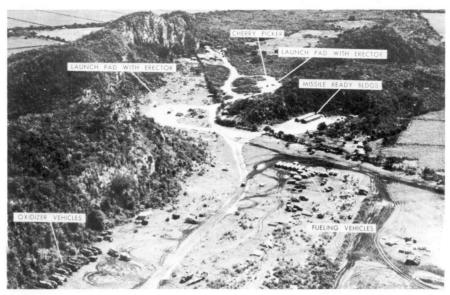

Figure 15-3. Oblique view covering the same area shown in *Figure 15-2*. Courtesy U.S. Air Force.

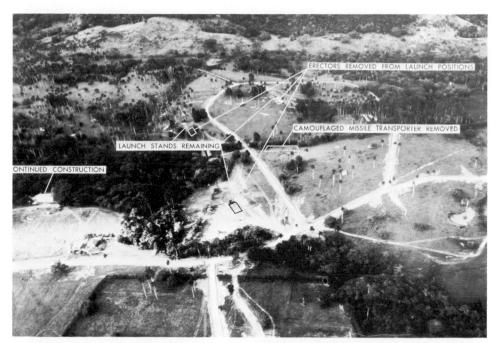

Figure 15–4. Oblique view of a Cuban MRBM site following removal of launch erectors and a missile transporter. On this date, launch stands were still in place and construction was under way on the nuclear warhead storage facility at the left. Courtesy U.S. Air Force.

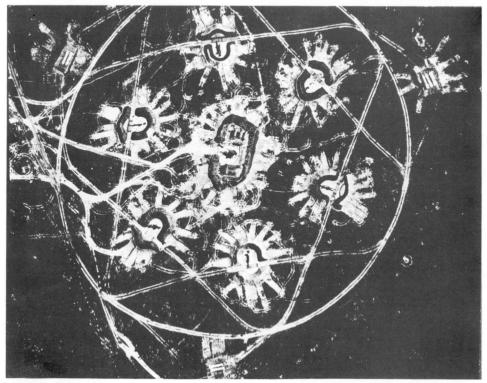

Figure 15-5. Surface-to-air missile site at La Coloma, Cuba, in November, 1962. Courtesy U.S. Air Force.

It is generally agreed that candidates to be trained as photo interpretation specialists should possess such attributes as visual acuity, a sound educational background, imagination, patience, judgment, high perceptual or learning capacity, and proper motivation. Reliable and objective techniques are available for evaluation of stereoscopic vision and color perception, but only a few attempts have been made to evaluate the potential interpretation ability of trainees prior to specialized instruction.

In a research study conducted by the author and involving ninety-nine university students, relatively high correlations were established between scores on screening tests administered at the onset of training and final performance ratings based on visual search ability and recognition of urbanindustrial features. Results of this experiment have been reported in *Photogrammetric Engineering* (Avery, 1965). Further attention should be devoted to the matter of personnel selection and training; the importance of the interpreter's role in the overall intelligence picture is emphasized by the following passage extracted from the *Photographic Interpretation Handbook* (1954):

In the last analysis it is the skill and experience of the interpreter that determines to a very large degree the success or failure of the work. The interpreter must know what to look for; he must be able to identify what he finds; he must know the significance of an object in its location; he must be able to utilize effectively information from other sources; he must know how to use comparative photo coverage; and he must know the enemy, his equipment, and his order of battle. To these general requirements may be added many more specific ones, depending on the particular kind of interpretation involved. For example, an interpreter preparing detailed reports on industrial installations should have experience in important industries significant to a war economy. He should have an understanding of industrial processes, common industrial components, and the principles of industrial organization and management. With a good background for his work, an interpreter will, by induction and deduction, accurately associate visible features with others that do not appear on the photography. The skill of a photo interpreter arises not only from his capability for reading aerial photos but also from his background experience. This factor cannot be overemphasized, for an interpreter cannot be expected to analyze correctly a small-scale, plan-view photo image of an object he could not recognize even if he were on the site.

As examples of somewhat unfamiliar aerial views, the reader is referred to Figures 15-6 and 15-7.

Airborne sensors for photo reconnaissance

To reduce the risk from anti-aircraft fire and surface-to-air missiles, today's photo reconnaissance planes are usually modified fighter-type aircraft that are operated at extremely fast speeds. As a rule, they are either restricted to very high altitudes, where interception is less likely, or to very low altitudes, where detection by enemy radar and other tracking devices is more difficult. Because these altitude restrictions present problems beyond the capability of a single camera, newer aircraft are designed for all-weather, multisensor reconnaissance.

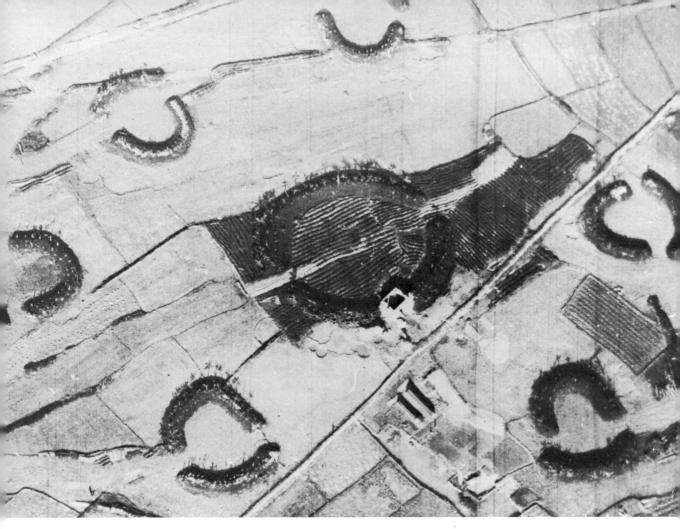

Figure 15–6. Abandoned surface-to-air missile site in North Vietnam. Part of the area has been returned to cultivation. Courtesy U.S. Air Force.

Reconnaissance aircraft equipment includes framing and panoramic cameras for vertical and oblique photography, thermal infrared scanners for terrain mapping, multispectral scanners, side-looking radar, and television cameras. The various types of sensor information may be imaged on film for later analysis or transmitted directly to ground stations and mobile-unit monitors.

Since modern SLAR systems are capable of looking sideways into enemy territory, it is not necessary for pilots to fly directly over anti-aircraft emplacements to obtain detailed imagery. For example, flights that parallel international boundaries can provide SLAR imagery 50 to 150 km inside areas where overflights are forbidden.

High-altitude reconnaissance aircraft may be exemplified by the Lockheed SR-71 Blackbird, the successor to the U-2. This Mach 3 plane can operate at altitudes of 30,000 m; it has been flown from New York to London in less than two hours.

In addition to manned aircraft, drones or remotely piloted vehicles (RPV) can be utilized as camera and sensor platforms. The jet-powered drones can be launched from land or sea; they are radio controlled during flight and can

be recovered by parachute. They can be equipped with day or night sensors and can remain in the air for an hour or more. Thus the RPV is ideal for obtaining target imagery when weather conditions or enemy air defenses restrict manned aircraft flights.

Target priorities

On any given wartime operation, there is a tremendous number of possible targets in relationship to the available striking force. Accordingly, the enemy's total resources must be very carefully analyzed when target priorities are being established. Specialists known as target analysts study all aspects of the opposition's war economy and industrial potential, so that available air power can be directed toward destruction of those targets whose loss will cripple or impair the military offensive of enemy forces. The rapidity with which bombed installations can be repaired or rebuilt determines how often strikes must be rescheduled in a specific theater of operations. The photo interpreter, although not always directly involved in rating the importance or vulnerability of specific targets, must be constantly aware of the existing priority system and capable of identifying primary and secondary targets even when they are poorly imaged or camouflaged.

From a purely military view, the logistics of rating targets are elemental. First hit should be the enemy's military forces and installations capable of retaliation, followed by armament storage areas and essential industries, and transportation-communications networks. In keeping with this line of reasoning, possible targets are grouped here under three major headings. No relative ranking within groups is implied, because such priorities will obviously change with time, place, operational objectives, and political considerations.

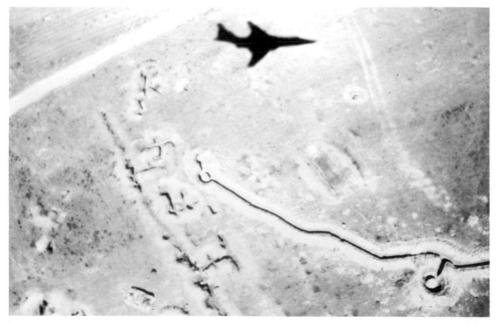

Figure 15–7. Anti-aircraft gun site in North Vietnam. At top center is the shadow of a reconnaissance plane. Courtesy U.S. Air Force.

1. Military targets with retaliatory power

Missile-launching sites (Figures 15-8 and 15-9) Anti-aircraft emplacements Bomber bases and military airfields Shipyards and submarine bases Military posts and troop concentrations Supply trucks and convoys

2. Armament storage areas and industries producing war materials

Ammunition dumps and supply depots

Armament-manufacturing plants, including plants that manufacture nuclear materials

Ship repair facilities (drydocks) and barge-manufacturing plants

Aircraft factories

Vehicle assembly plants

Petroleum, oil, and lubricants (POL) refineries and storage areas

Steel mills and machine-tool plants

Other metals industries

Chemical production plants

Cement plants

Food production plants and water supplies

3. Transportation-communications networks

Highways, railroads, bridges, tunnels, and ferries Shipping lanes and harbor facilities Canals and locks Electrical power plants and hydroelectric dams Radio and radar installations Telephone lines and underground cables Power transmission lines and transformers

The photo reconnaissance mission

The two basic requirements of a successful photo reconnaissance mission are (1) to obtain desired coverage of terrain and target areas and (2) to assure the safe return of the reconnaissance aircraft. Therefore, penetration aids are used where appropriate, and routes to and from the target area are planned to avoid known air defense detection devices and weapons (Figure 15-10). The choices of high- or low-altitude regimes and type of aircraft used for a given mission are determined by such items as the specific purpose of photography, the location and distance to the target, enemy defenses, the terrain, the weather, the time of day, aircraft performance, and navigation capability. The size and shape of target areas also have an influence on the type and number of aircraft deployed.

Whenever feasible, flight lines are oriented parallel to the long dimension of the target area, and flights are made downwind to shorten the time over the target and to minimize drift. Such recommended procedures may be altered in the event of extremely heavy enemy resistance or partial cloud cover over the target. High-speed vertical or oblique camera runs at low altitudes over heavily defended areas are referred to as dicing runs; these are usually made by supersonic fighter-type aircraft for obvious reasons of safety (Figure 15-11).

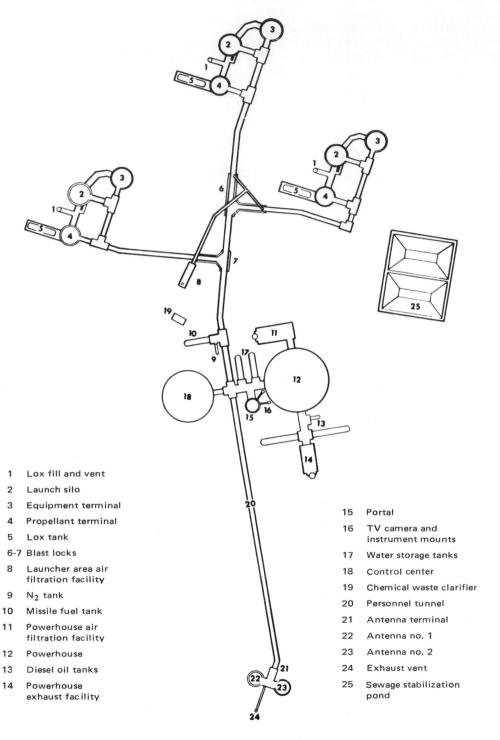

Figure 15–8. Schematic diagram of underground silo complex and missile-launching center. Courtesy U.S. Air Force.

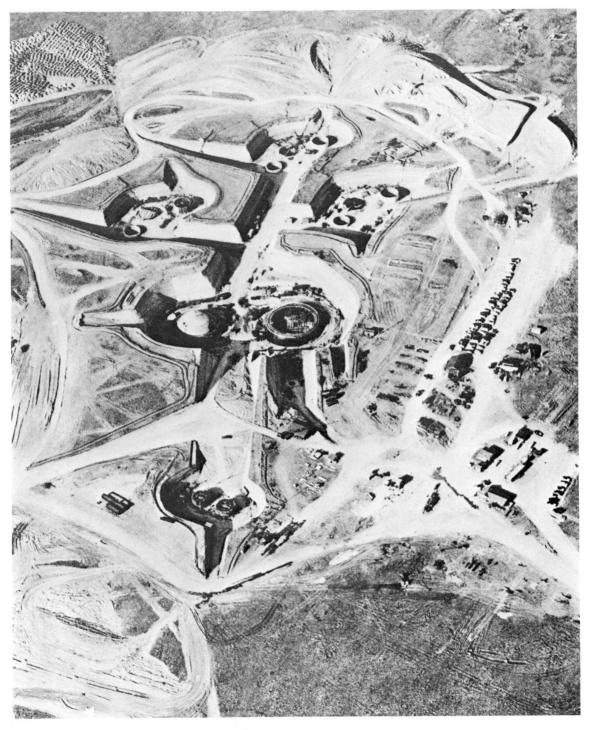

Figure 15–9. Construction of an underground silo complex and missile-launching center. Compare with *Figure 15–8.* Courtesy U.S. Air Force.

With conventional camera coverage, the time of photography depends on the amount of available light and special considerations, e.g., the need for photographing potential beach landing sites at low tide levels. Ideally, most visible-light photography is obtained at least two hours after sunrise and two hours before sunset. Color films are preferably exposed during midday hours for best tonal renditions.

The time of photography is also dependent on the exact objectives of the sortie or mission. For enemy terrain not previously covered, prestrike sorties must be timed so that maximum information on both primary and secondary targets as well as data on the intensity and distribution of target defenses are obtained. Camouflage detection may require sequential coverage at different hours so that target shadows can be analyzed. Damage-assessment missions should be scheduled as soon as smoke clears following a bombing run or strike.

For each roll of film exposed during a mission, a photo intelligence data card should be completed to show the following information:

- 1. Geographic region and specific location of target area
- 2. User's file number and security classification of film
- 3. Date and time of photography
- 4. Sortie number and designation of film-processing unit
- 5. Map references to photographic coverage
- 6. Camera designation and focal length
- 7. Camera position, e.g., vertical or oblique angle
- 8. Flight altitude above mean sea level
- 9. Inclusive print numbers
- 10. Notes on photographic quality or missing coverage

Terrain analysis and trafficability

The military interpreter's primary task begins with the successful completion of the photo reconnaissance mission. The interpreter may be called upon to evaluate terrain conditions, identify key military or industrial targets, detect camouflaged installations, or recognize warships and military aircraft. Finally, the interpreter's analyses must be summarized in clear, concise photo intelligence reports. Accordingly, these activities are discussed in the sections that follow.

The primary objective of military terrain analyses is that of predicting trafficability, i.e., the effects of terrain on the movements of land-based military troops and vehicles. In addition to slopes that are too steep to be readily climbed, there are four principal elements of the landscape that produce obstacles to movement. These are surface irregularities or microrelief, vegetation, hydrologic features, and cultural phenomena. A surface irregularity is considered a configuration of the terrain that is of such magnitude as to interfere with troop or vehicular movement. Examples include boulders that are found in many deserts and glaciated regions, potholes, streambeds, and hummocks such as those occurring in arctic regions.

In many parts of the world, plants grow so large and close together as to make vehicular movement impossible. However, even when trees are so spaced that movement between them is possible, the necessary maneuvering may severely impede forward progress, not only because of the increased path length, but also because turning forces exert a higher load on the soil

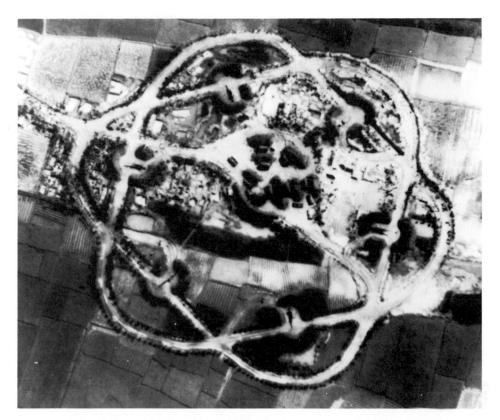

Figure 15–10. Surface-to-air missile site near Hanoi, North Vietnam. The installation contains six launching pads; five SAMS are visible. Courtesy U.S. Department of Defense.

Figure 15–11. Low oblique view of MIG fighter planes parked in protective revetments near Hanoi, North Vietnam. Such imagery is necessarily obtained on high-speed dicing runs; hence there is some loss of photographic sharpness. Courtesy U.S. Department of Defense.

than those generated in a straight-line movement. Thus the soil strength requirements for a given vehicle are greater when the vehicle is maneuvering than when it is moving forward on a straight path.

Hydrologic occurrences include all bodies of water that impede military movement. Such features constitute obstacles whenever the water becomes deep enough or turbulent enough to threaten the safety or operation of military vehicles. Cultural features of the terrain that would restrict vehicle travel or necessitate maneuvering include items such as walls, hedgerows,

ditches, dikes, embankments, and deep gullies.

The major problem in the forecast of terrain trafficability by use of aerial photographs is the determination of the soil type. This cannot be done directly; instead, the soil type must be deduced from photographic evidence of the type, together with drainage, vegetation, topography, climate, and geological history. While this knowledge does not result in a direct inference of the soil type, it produces estimates of fundamental soil properties such as texture, soil moisture, plasticity, density, and internal drainage. With such information, the soil can then be fitted into an existing classification. Evidence must therefore be sought on aerial photographs that will permit reliable evaluations of fundamental soil properties.

Target identification and analysis

The identification of various physical, cultural, and industrial features has been stressed in several previous chapters of this volume. It should be obvious that the military interpreter requires a knowledge of economic and industrial geography and must also be prepared to work closely with intelligence specialists in these and other fields. Industrial analysts can be especially helpful in functional appraisals, i.e., determinations of "what goes on" inside a large factory or a group of innocuous-looking buildings. Without their assistance, the interpreter might be able only to guess at the purpose and importance of certain structures; with special help, the possible or probable presence of a given target may be translated into a confirmed identification. A complete functional analysis not only provides target identification but also results in a detailed report that includes a numerical referencing system for the target components. One of the key features of such reports is a building-by-building survey of all facilities identified, e.g., the listing of industrial components as described and illustrated in Chapter 14.

Following the identification and functional analysis of a target complex, it is often necessary to make a structural analysis of features involved. Structural analyses are especially valuable when the target is a substantial engineering structure or a well-buttressed building that houses an industrial operation. The purpose of a structural analysis is to determine the relative vulnerability of the target, the type and tonnage of explosives needed to destroy it, and the most effective aiming point for pilots and bombardiers. For large industrial targets, the center of a circle having a radius of 150 to 300 m might be selected as the aiming point; the exact size of the circle would be based on the area of the target complex and the expected pattern and precision of bomb drops. For small or linear targets such as bridges or canal locks, the circle of error must be much smaller in order for significant damage to be inflicted. Highly precise bomb drops would be necessary to incapacitate the canal locks pictured in Figure 15-12, for instance; near misses

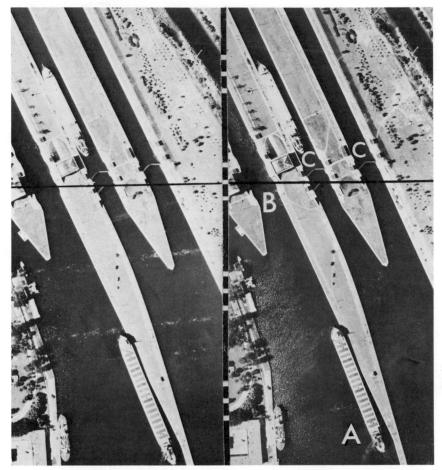

Figure 15–12. Stereogram of the Soo Locks, Sault Ste. Marie, Michigan. The ore boat (A) is moving toward the open lock (B). Two closed locks are also clearly visible (C). Scale is about 1:4.800. Courtesy Abrams Aerial Survey Corp.

here would do only limited damage to this seaway installation. A different kind of target problem is presented by the ammunition dump shown in *Figure 15-13*. The underground storage of explosives in scattered, underground bunkers would probably require either pinpoint bombing of each storage cell or the use of incendiaries that might trigger a chain of explosions fed by the stored munitions. An example of a bomb-drop pattern is illustrated by *Figure 15-14*.

Camouflage detection

Camouflage is a means of protecting important targets by concealing or disguising various activities and installations. Within the broad spectrum of camouflage techniques are also included the use of decoys and dummy targets that are intended to confuse or mislead the photo interpreter, the aerial observer, and the bombardier. The ability to detect camouflaged objects rapidly is vital to the interpreter, because air strikes cannot be directed against targets that pass unnoticed. Undetected targets can cause field commanders to misdirect troop movements and possibly lead to an enemy

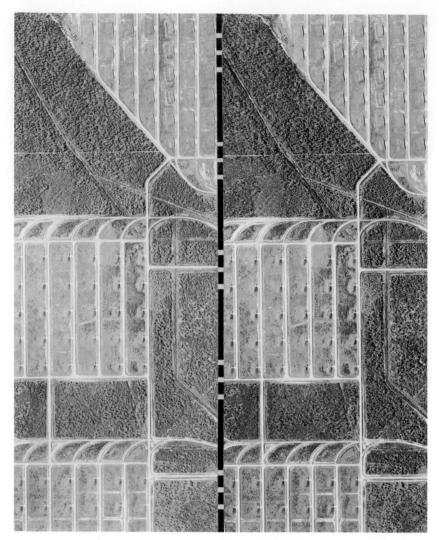

Figure 15–13. Ammunition storage in Calhoun County, Arkansas. Each storage cell is covered by several metres of earth material. Scale is about 1:20,000. Courtesy U.S. Department of Agriculture.

ambush. The interpreter should also realize that the more elaborate the camouflage, the more important is the hidden facility, because extensive and detailed concealment efforts are necessarily limited to the most critical installations.

Diversified concealment techniques may make use of natural cover, cut vegetation, bombed-out structures, or artificial "blending devices" such as nets, drapes, paints, and artificial toning schemes (Figure 15-15). In other instances, bridges that have been destroyed by air strikes may be rebuilt just beneath the surface of a river to escape aerial detection, or dummy anti-aircraft emplacements may be set up to confuse and divert pilots on bombing missions.

Dummies or decoy targets are often cleverly constructed so that pilots and bombardiers will be lured into wasting their efforts by striking these unimportant installations. In other cases, dummies may be made obviously asym-

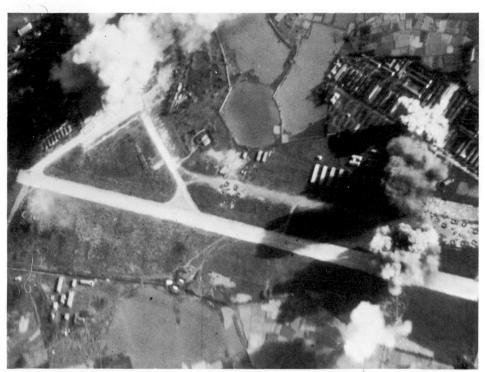

Figure 15-14. Bombing hits over an airfield near Hanoi, North Vietnam. Courtesy U.S. Air Force.

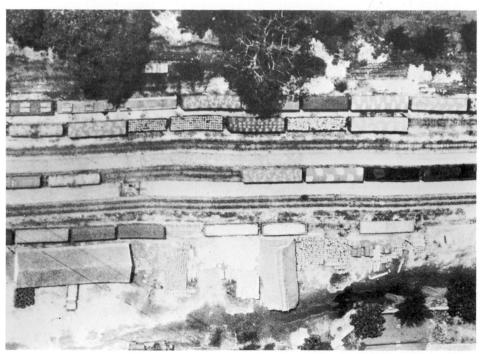

Figure 15–15. Camouflaged railway rolling stock in North Vietnam. While such crude attempts at concealment may be scorned by a skilled interpreter, they can be quite effective against visual observation from fast-moving aircraft. Courtesy U.S. Air Force.

metrical so that the opposition will recognize them as decoys and will therefore carefully avoid bombing or strafing the pseudotarget. It then becomes feasible to store vital supplies of petroleum or ammunition underground beneath such dummies, with a reasonable assurance that they will remain safe from air strikes (Figure 15-16).

For detection of buildings concealed by camouflage, the stereoscopic study of shadows is an important tool of the photo interpreter. Although carefully disguised features may not be readily discernible on a single print, the three-dimensional view quickly separates real buildings from two-dimensional shadows or camouflage. This technique is especially effective for picking out such items as false roads painted across buildings or camouflage that is designed to simulate roof damage on intact structures.

Whenever it is available, stereoscopic coverage should always be used in the search for camouflaged targets. Sequential photography is also of considerable value for making comparisons of terrain at different points in time. In areas where cut vegetation or infrared-absorbing paints are used for concealing installations, photographic coverage with camouflage-detection or infrared color film may be used to advantage.

Interpreters of camouflage must constantly look for subtle changes in terrain features such as apparently harmless clearings, excavations or debris piles that denote new construction, or vehicle tracks that seemingly lead nowhere. If certain installations are unusually conspicuous, they may be recognized as dummy targets; hence they must be carefully studied to determine whether they were purposely designed to be recognized or whether they merely represent unskilled attempts at disguise.

Finally, searches should be made continually in the vicinity of heavy defense installations. When anti-aircraft batteries or surface-to-air missiles are heavily concentrated in areas that seem to have no need for such protection, it may be an indication of a skillfully camouflaged industry or a troop concentration center. Or it could be a carefully set trap to lead pilots over a worthless target and into a ring of flak. The task of the camouflage interpreter obviously entails responsibilities that cannot be minimized.

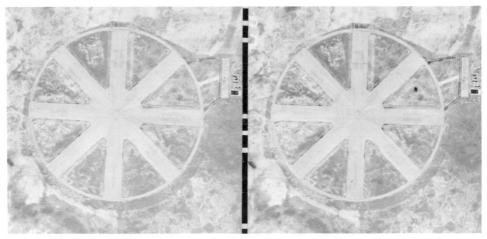

Figure 15–16. To an untrained observer, this wagon-wheel pattern might appear to be a dummy or decoy target laid out by a diabolical camouflage expert. Actually, it is a multirunway airfield used by carrier-based pilots for practicing short takeoffs and landings. Location is Broward County, Florida. Scale is about 1:20,000.

Recognition of warships and aircraft

Activities in the vicinity of shipyards, drydocks, and military airfields can be regularly monitored by the interpreter who receives frequent comparative coverage of such facilities. It is therefore important that interpreters be able to recognize the main types of warships and airplanes that are apt to come under their surveillance. A comprehensive treatment of this subject is beyond the scope of this volume, because coverage here is limited to unclassified information.

Drawings that illustrate ship nomenclature and four general types of vessels are reproduced in Figures 15-17 and 15-18. The fastest means of identifying the type of ship being studied is the discriminating length-to-beam ratio. Overall size and hull shape are also important clues for recognition. In the identification of specific classes of ships, the number and position of gun turrets, masts, and stacks, the type of superstructure, and aircraft-launching catapults are salient features to be considered. Military interpreters are supplied with reference manuals and up-to-date photo interpretation keys that permit rapid identification of ships and aircraft carriers.

Most United States vessels, with the exception of new super carriers, have a beam (width) that does not exceed 33 m. This limitation has been historically imposed upon shipbuilders because of the width of locks in the Panama Canal. Stereograms from three different United States shippards are presented in Figures 15-19 through 15-21.

Proficiency in aircraft recognition requires the photo interpreter to remain constantly aware of new designs and modifications that are rapidly made operational, especially during times of war. In essence, aircraft types are differentiated on the basis of fuselage length, wing span, wing shape, stabilizer design, and number and position of engines. Most military aircraft are now powered by jet engines (Figure 15-22).

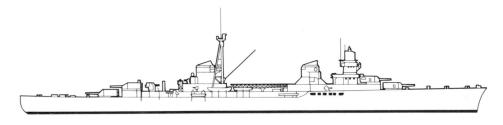

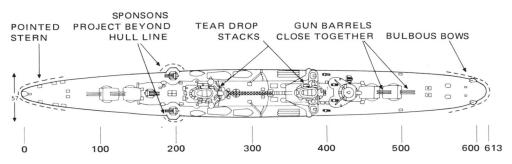

Figure 15-17. Nomenclature for a Russian light cruiser. Courtesy U.S. Department of the Navy.

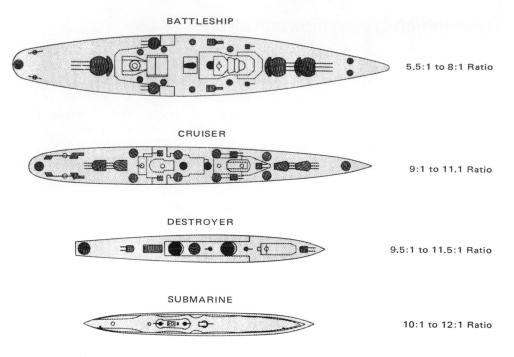

Figure 15–18. Four general types of United States vessels. Numbers indicate length-to-beam ratios for each type. The number and arrangements of gun turrets and stacks and the superstructure design are useful clues in recognition of types of warships. Courtesy U.S. Department of the Navy.

Image intelligence reports

As with most forms of paperwork, image intelligence reports tend to proliferate. Consequently, some interpreters spend as much time preparing intelligence reports as they devote to analyzing imagery.

Since the exact formats and details of image intelligence reports undergo frequent changes, it is inappropriate to list the specifics here. As a general rule, all reports include certain standard information such as the name of the reporting organization, the date of the report, a geographic description of the target area, the organizational unit that obtained the imagery, and map references. Some reports may be prepared directly on photographic prints for distribution (Figure 15-23).

When new missile sites are detected through image interpretation, the following Tactical Air Command checklist is used by some reporting units:

- 1. Missile type: Offensive or defensive
- 2. Missile site: Permanent or temporary
- 3. Launching site:
 - a. Number of firing points or pads
 - b. Type of construction (concrete, revetted, etc.)
- 4. Auxiliary equipment: Transporters, movers, launchers, etc.
- 5. Number and type of antennas: Guidance and/or acquisition radar, etc.
- 6. Side defenses: Kind and number of emplacements

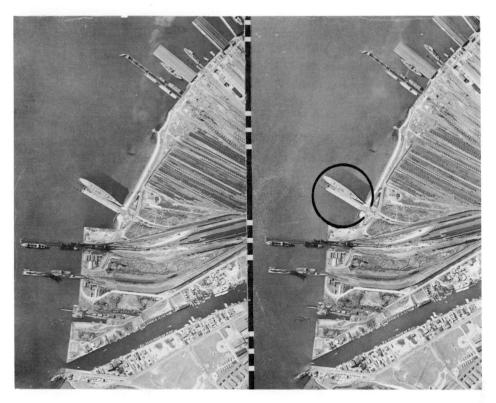

Figure 15–19. This 1953 stereogram from Newport News, Virginia, shows a "mothballed" battleship of the Missouri class. Scale is about 1:20,000. Courtesy U.S. Department of Agriculture.

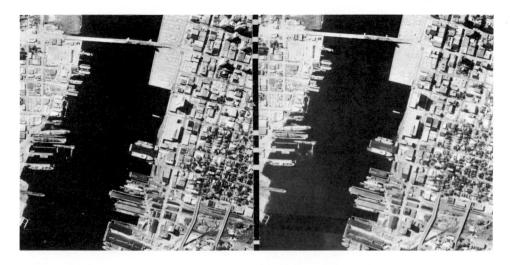

Figure 15–20. Ships on the St. John's River at Jacksonville, Florida. Scale is about 1:20,000. Courtesy U.S. Department of Agriculture.

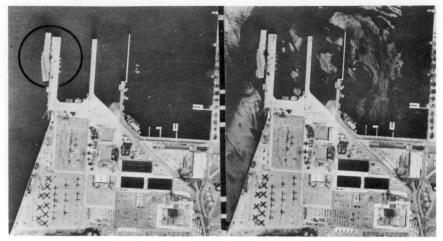

Figure 15–21. This 1959 view of the U.S. Naval Air Station at Alameda, California, includes a canted-deck aircraft carrier. Note also the variety of propeller-type aircraft in this view. Scale is about 1:20,000.

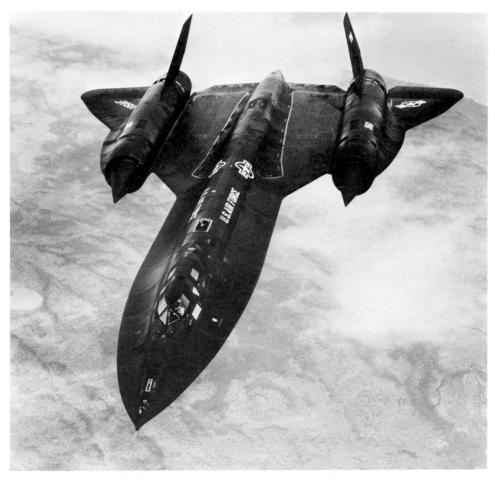

Figure 15–22. The SR-71 Blackbird, a U.S. Air Force strategic reconnaissance aircraft. Courtesy Lockheed Aircraft Corporation.

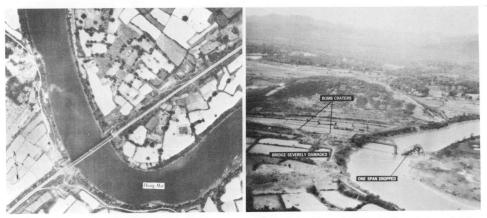

Figure 15–23. An immediate photo intelligence report based on this prestrike and poststrike photography would include the mission or sortie number, dates of photography, photo scales or flight altitudes, and the extent of damage to the North Vietnam railroad bridge pictured. In this instance, photographs were made just five days apart. Courtesy U.S. Department of Defense.

Poststrike damage assessment

The principal objectives of poststrike damage assessment are (1) to estimate the amount of production loss to industries or the degree of destruction to structures, (2) to determine the need for additional strikes on certain targets, and (3) to analyze the effectiveness of various types of bombs and weapons used in aerial attacks. By necessity, appraisal of damage from poststrike aerial photographs is based on average ratios between visible damage and actual damage for different classes of targets.

Damage to structures such as bridges, ammunition dumps, and airport runways can be quickly and reliably assessed from various types of aerial imagery, whereas the effects on an industrial production line can only be estimated from an analysis of damage to the building which houses the industrial operation. Prestrike and poststrike photographs and standard damage symbols are shown in Figures 15-24 through 15-27.

Missile observation satellites

"For every action, there is an equal and opposite reaction." Newton's law of motion appropriately describes the arms race among major world powers and the attempts of each to stay one step ahead. Thus, for every new intercontinental ballistic missile (ICBM), there is an anti-missile, and for every anti-missile, an anti-anti-missile. Strategic arms limitation talks (SALT) between the United States and the U.S.S.R. restrict each nation to two major anti-ballistic missile (ABM) launching sites. One such site is located near Grand Forks, North Dakota. Others have been proposed, but it is unlikely that another will be constructed in the United States.

The verification of SALT agreements requires some form of mutual inspection—a condition that does little to ease international tensions. Since nations do not react kindly to foreign aircraft overflights, the monitoring of ICBM and ABM sites is largely accomplished by the deployment of reconnaissance or missile observation satellites (MOS's). The nations involved

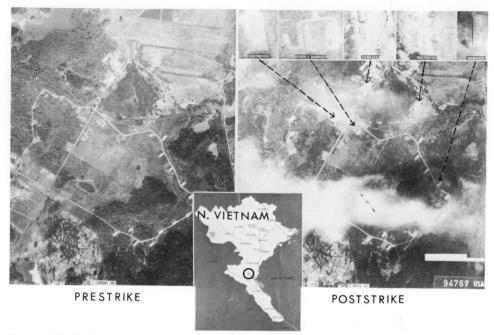

Figure 15–24. Prestrike and poststrike views of an ammunition depot in North Vietnam. Damages can be more easily assessed on exposed targets of this type than on operations housed inside substantial industrial buildings. Courtesy U.S. Department of Defense.

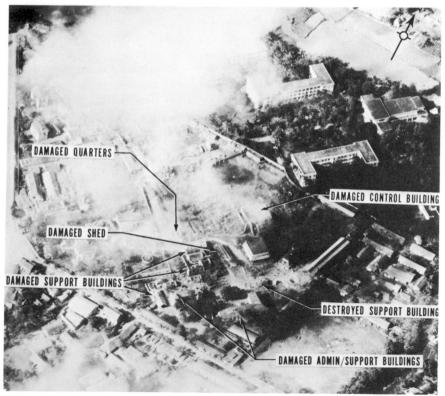

Figure 15-25. Assessment of air strike damage to a RADCOM station at Hanoi, North Vietnam. Courtesy U.S. Department of Defense.

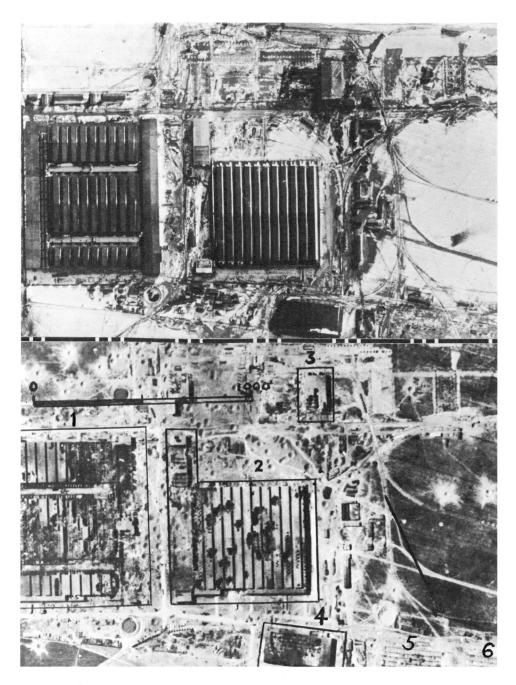

Figure 15–26. Prestrike and poststrike views of a European aircraft factory during World War II. Component shop (1) is largely destroyed, and subassembly shop (2) is heavily damaged. Small buildings (3) and hangar (4) are demolished. Construction of other hangars (5, 6) was never completed. Courtesy U.S. Department of Defense.

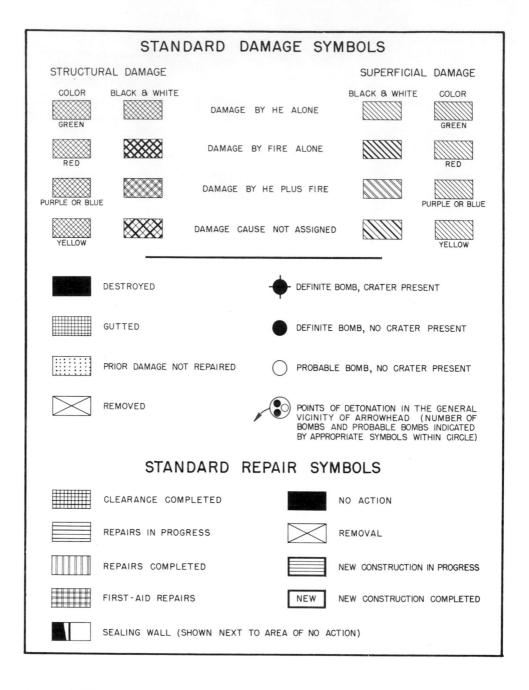

Figure 15–27. Symbols for photo reconnaissance damage assessment. Courtesy U.S. Department of the Navy.

have agreed not to interfere with each other's MOS's and not to camouflage or conceal their agreed-upon allocations of missile-launching sites (Figure 15-28).

Satellite technology provides a reliable means of verifying land-based missile sites with a minimum of aggravation and territorial intrusion. In addition, MOS's are capable of detecting underground nuclear tests, since such explosions usually result in large, telltale subsidence craters at the surface. However, satellites are not effective in locating missile-equipped submarines.

MOS's operating at orbital altitudes of 125 to 250 km contain optical systems that can resolve ground objects of small dimension. Exact capabilities are classified, but claims that automobile license plates can be read appear to be realistic. The satellites are also equipped with infrared scanners and radar systems for a day/night operational mode. Sensor data can be transmitted to earth electronically or can be imaged on film or video tape; the film packets are subsequently ejected and recovered in midair by high-altitude aircraft. Television cameras have been utilized on some MOS's but they have been generally regarded as secondary systems because of their relatively poor ground resolution.

Future military reconnaissance operations will undoubtedly place greater reliance on nonphotographic and/or nonimaging sensor systems. There will certainly be less emphasis on the interpretation of imagery that is several days old. As radar, video, and electronic surveillance systems achieve increased capabilities, it will be possible for an interpreter to sit at a ground console and view aircraft or satellite imagery on a real-time basis.

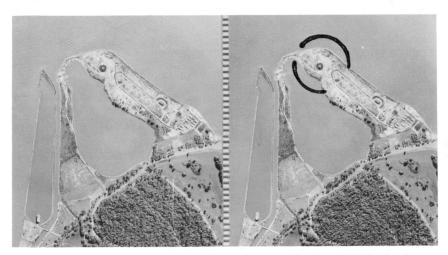

Figure 15–28. Missile-launching site in Wayne County, Michigan (1957). Scale is about 1:20,000. Courtesy U.S. Department of Agriculture.

Problems

1. Attempt to devise a comprehensive screening test for evaluating the potential of image interpreters. Include questions on object recognition, map reading, mathematics, logic, and inference. Administer the test to at least twenty persons and prepare a report on the adequacy of the questions for personnel selection.

- 2. Obtain a recent set of aerial photographs for a large, industrialized city. Identify the principal military "targets" and assign a priority rating to each. Be able to explain the rationale underlying your rating system.
- 3. Obtain photographic coverage and a soils map for a nearby county. Then classify the terrain according to trafficability (on a scale of 1 to 10, for example). Explain how the ease of troop or vehicular movement for a given terrain class will change with wet versus dry soil conditions.
- 4. Prepare a simulated image interpretation report for a large industrial complex in your locality. Include a written description of the facility and its "critical" components, some annotated photographs, and a topographic map of the surrounding terrain.

References

- Alsop, Stewart. 1968. The center. Popular Library, Harper and Row, New York. 365 pp. American Society of Photogrammetry. 1975. Manual of remote sensing, 2 vols. American Society of Photogrammetry, Falls Church, Va. 2, 144 pp., illus.
- Avery, T. E. 1965. Evaluating the potential of photo interpreters. Photogrammetric Engineering 31:1051-59, illus.
- Babington-Smith, Constance. 1957. Air spy: The story of British photo intelligence in World War II. Ballantine Books, Harper and Brothers, New York. 190 pp., illus.
- Dulles, Allen. 1963. The craft of intelligence. Harper and Row, New York. 277 pp., illus.
- Goddard, George W., and Dewitt S. Copp. 1969. Overview: A life-long adventure in aerial photography. Doubleday and Co., Garden City, N.Y. 415 pp., illus.
- Greenwood, Ted. 1973. Reconnaissance and arms control. Scientific American 228(2): 14–25, illus.
- Griffith, Samuel B. 1963. Sun Tzu: The art of war. Oxford-Clarendon Press, London. 197 pp.
- Klass, Philip J. 1971. Secret sentries in space. Random House, New York, 236 pp.
- Orlov, Alexander. 1963. Handbook of intelligence and guerrilla warfare. University of Michigan Press, Ann Arbor, Michigan. 187 pp.
- Powers, Francis Gary, with Curt Gentry. 1970. Operation overflight. Holt, Rinehart and Winston, New York. 375 pp., illus.
- Stringham, J. Alfred. 1974. Automated imagery processing. Photogrammetric Engineering 40:1191-96, illus.
- U.S. Department of the Army. 1971. Camouflage techniques. U.S. Army Engineer School, Ft. Belvoir, Va. 33 pp.
- U.S. Departments of the Army, the Navy, and the Air Force. 1967. Image interpretation handbook, Vol. I. Government Printing Office, Washington, D.C. 7 chapters plus appendix, illus.
- ——. 1954. Photographic interpretation handbook. Government Printing Office, Washington, D.C. 303 pp., illus.

Appendix 1

Glossary of Photogrammetric Terms

Additive color viewer: Projector for positive transparencies obtained through multiband photography. Each image is superimposed by use of a different colored light.

Air base: The line joining two aerial camera stations. (MPI)

Altitude: Height above a datum. The datum is usually mean sea level. (MPI)

Anaglyph: A stereogram in which the two views are printed superimposed in complementary colors. A three-dimensional image is rendered when the stereogram is viewed through spectacles having filters of the same two colors (usually red and green).

Angle of coverage: The apex of the cone of rays passing through the front nodal point of a lens. Normal-angle lens—a lens having an angle of coverage up to 75°; wide-angle lens—a lens having an angle of coverage of 75° to 100°; ultrawide-angle lens—a lens having an angle of coverage greater than 100°. (MP)

Many of these terms are taken from the Manual of Photogrammetry and the Manual of Photographic Interpretation by permission of the American Society of Photogrammetry. These terms are identified, respectively, as MP and MPI.

- **Aperture, relative:** The ratio of the equivalent focal length to the diameter of the entrance "pupil" of a photographic lens. Expressed *f*:4.5, etc. Also called *f*-number, stop, aperture stop, diaphragm stop, speed. (MPI)
- **Band, spectral:** A set of adjacent wavelengths in the electromagnetic spectrum with a common characteristic, such as the visible band.
- **Base, film:** A thin, flexible, transparent sheet of cellulose nitrate, acetate, or similar material which is coated with a light-sensitive emulsion and is used for taking photographs. (MPI)
- **Base, photo:** The distance between the principal points of two adjacent prints of a series of vertical aerial photographs. It is usually measured on one print after transfer of the principal point of the other print. (MPI)
- Camera calibration: The determination of the focal length, the lens distortion in the focal plane, and the location of the principal point with respect to the fiducial marks. The settings of the fiducial marks and the positioning of the lens are ordinarily considered "adjustments," although they are sometimes performed during the calibration process. In a multiple-lens camera, the calibration also includes the determination of the angles between the component units. (MPI)
- Camera magazine: The removable part of a camera in which the unexposed and exposed portions of film are contained. (MPI)
- **Camera station:** The point in space, in the air or on the ground, occupied by the camera lens at the moment of exposure. Also called the exposure station. (MPI)
- Cathode-ray tube (CRT): A vacuum tube that generates a focused beam of electrons which can be deflected by electronic and magnetic fields. The terminus of the beam is visible as a spot or line of luminescence on the sensitized screen of the tube.
- **Contact print:** A print made from a negative or a diapositive in direct contact with sensitized material. (MPI)
- **Contrast, subject:** The difference in light intensity between the brightest highlights and the deepest shadow.
- **Control point:** A reference point precisely located on a photograph and on the ground; used in assembly of photographs for map compilation.
- **Coverage:** The ground area represented on aerial photographs, photomosaics, or maps. (MPI)
- **Crab:** 1. (Aerial photography)—The condition caused by incorrect orientation of the camera with respect to the track of the airplane, indicated in vertical photography by the sides of the photographs not being parallel to the principal-point base line. See also *drift*.
 - 2. (Air navigation)—Any turning of an airplane which causes its longitudinal axis to vary from the track of the plane. (MPI)
- **Datum:** A reference element, such as a line or plane, in relation to which the positions of other elements are determined. Also called the reference plane or datum plane. (MPI)
- **Dense negative:** A negative of which all parts have high opacity as a result of overexposure. (MPI)
- **Densitometer:** A device for measuring the image density of a transparency or print. The instrument measures the magnitude of the light transmitted through the film exposure.

- **Density:** The comparative amount of silver deposited by exposure and development in a given area. It is expressed in terms of the percentage of light passing through the area. (MPI)
- **Depth of field:** The distance between the points nearest to and farthest from the camera that are in focus and acceptably "sharp."
- **Diapositive:** A positive photographic print on a transparent medium—usually glass. Most commonly used in stereoplotting instruments.
- **Displacement, relief:** The difference in the position of a point above or below the datum, with respect to the datum position of that point, owing to the perspective of an aerial photograph. Relief displacement is radial from a point on the photograph corresponding to the ground position vertically beneath the camera. In vertical photography, relief displacement is radial from the principal point of the photograph. (MPI)
- **Distance**, hyperfocal: The distance from the camera lens to the nearest object in focus, when the camera lens is focused at infinity.
- **Dodging:** The process of holding back light from certain areas of the sensitized paper in making a print in order to avoid overprinting those areas. In projection printing, it is accomplished by insertion of an opaque medium of proper shape and size between the lens and the easel, and, in contact printing, either by variation of the illumination in given areas of the negative or by insertion of translucent or opaque paper between the light source and the negative. Dodging may also be performed automatically by means of specially designed electronic or fluorescent printers. (MPI)
- Drift: 1. (Air navigation)—The horizontal displacement of an aircraft, under the action of the wind, from the track it would have followed in still air.
 2. (Aerial photography)—Sometimes used to indicate a special condition of crab in which the photographer has continued to make exposures oriented to the predetermined line of flight while the airplane has drifted

from that line. (MPI)

- Effective area: For any aerial photograph that is one of a series in a flight strip, that central part of the photograph delimited by the bisectors of overlaps with adjacent photographs. On a vertical photograph, all images within the effective area have less displacement than their conjugate images on adjacent photographs. (MPI)
- **Emissivity:** The amount of energy given off by an object relative to the amount given off by a "black body" at the same temperature. Normally expressed as a positive number between 0 and 1.
- **Emulsion:** A suspension of light-sensitive silver salt, usually silver chloride or silver bromide, in a colloidal medium, usually gelatin, used for coating photographic films, plates, or paper. (MPI)
- **Enhancement, image:** Any of several processes that might improve the interpretation quality of an image. Such processes include contrast improvement, greater resolution, special filtering, and so on.
- **Exposure:** The total quantity of light received per unit area on a sensitized plate or film. Also, the act of exposing a light-sensitive material to a light source.
- **Ferrotype:** To burnish photographic prints by squeegeeing wet upon a japanned sheet of iron or stainless plate and allowing to dry. This produces a harder, glossier surface on the photographic print. (MPI)

Fiducial marks: Index marks, rigidly connected with the camera lens through the camera body, which form images on the negative. The marks are adjusted so that the intersection of lines drawn between opposite fiducial marks defines the principal point. (MPI)

Filter: A transparent material used in the optical path of a camera lens to absorb a certain portion of the spectrum and prevent its reaching the

sensitized photographic film. (MPI)

Focal length, equivalent: The distance measured along the lens axis from the rear nodal point to the plane of best average definition over the entire field used in the aerial camera. (MPI)

Focal plane: The plane (perpendicular to the axis of the lens) in which

images of points in the object field of the lens are focused. (MPI)

Fog: A darkening of negatives or prints by a deposit of silver which does not form a part of the image. Fog tends to increase density and decrease contrast. It may be caused by exposure to unwanted light, exposure to air during development, forced development, impure chemicals, etc. (MPI)

Glossy print: Print made on photographic paper with a shiny surface. (MPI)

Hotspot (sunspot): The destruction of fine image detail on a portion of a wide-angle aerial photograph. It is caused by the absence of shadows and by halation near the prolongation of a line from the sun through the exposure station.

Index, photo: An index map made by assembly of the individual photographs into their proper relative positions and photographic copying of the assembly at a reduced scale. (MPI)

Intervalometer: A timing device for automatically operating the shutter of a camera at any predetermined interval. (MPI)

Isocenter: The point on a photograph intersected by the bisector of the angle between the plumb line and the photograph perpendicular. The isocenter is significant because it is the center of radiation for displacements of images owing to tilt. (MPI)

Line, flight: A line drawn on a map or chart to represent the track over which an aircraft has been flown or is to fly. The line connecting the principal

points of vertical aerial photographs. (MPI)

Map, flight: A map on which are indicated the desired lines of flight and/or positions of exposures for the taking of aerial photographs, or the map on which are plotted, after photography, selected air stations and the tracks between them. (MPI)

Map, planimetric: A map showing only the horizontal positions of drainage and cultural features.

Map, topographic: A map showing correct horizontal and vertical positions of features represented.

Marks, static: Marks on a negative caused by discharges of static electricity, particularly when the unexposed negatives are handled rapidly under dry conditions. The marks are of many different types. Some are easily recognized as branching or treelike static, and some are distinctive, more or less sharply defined as dots. (MPI)

Matte print: Print made on photographic paper with a dull finish; more

suitable for pencil or ink annotations than a glossy print. (MPI)

Mosaic: An assemblage of overlapping aerial photographs whose edges have been matched so that they form a continuous photographic representation of a portion of the earth's surface. (MPI)

Multispectral sensing: Employment of one or more sensors to obtain imagery from different portions (bands) of the electromagnetic spectrum.

Nadir, photograph: That point at which a vertical line through the perspective center of the camera lens pierces the plane of the photograph. Also referred to as the *nadir* point. (MPI)

Negative titling: Information (e.g., sortie number, camera, date, height, etc.) recorded on the negative for identification. (MPI)

Optical-mechanical scanner: A system utilizing a rotating mirror and a detector, in conjunction with lenses and prisms, to record reflected and/or emitted electromagnetic energy in a scanning mode along the flight path.

Orthophotograph: A photographic copy prepared from a perspective photograph, in which the displacements of images due to a tilt and relief have been removed.

Overdevelopment: The result when film or paper is permitted to remain in the developer too long, causing excessive contrast or fog. (MPI)

Overexposure: The result when too much light is permitted to act on a light-sensitive material, with either too great a lens aperture or too slow a shutter speed or both. Causes excessive image density. (MPI)

Overlap (photography): Amount by which one photograph overlaps the area covered by another, customarily expressed as a percentage. The overlap between aerial photographs in the same flight is distinguished as the endlap, and the overlap between photographs in adjacent parallel flights is called the sidelap. (MP)

Parallax: The apparent displacement of the position of a body with respect to a reference point or system, caused by a shift in the point of observation. (MPI)

Photogrammetry: The science or art of obtaining reliable measurements by means of photography. (MPI)

Photographic day: One with good visibility, bright sunlight, and less than 10 percent cloud cover.

Photographic interpretation (photo interpretation): The act of examining photographic images for the purpose of identifying objects and judging their significance. (MPI)

Picture element (pixel): A unit whose first member is a resolution cell and whose second member is the gray shade assigned by a digital image to that resolution cell.

Plate, pressure: A flat plate, usually of metal but frequently of glass or some other substance, which, by means of mechanical force, presses the film into contact with the focal plane plate of the camera. (MPI)

Processing: The operation necessary for the production of negatives, diapositives, or prints from exposed film, plates, or papers. (MPI)

Rectification: The process of converting a tilted or oblique photo to the plane of the vertical.

Representative fraction (RF): The relation between map or photo distance and ground distance, expressed as a fraction (1/25,000) or often as a ratio (1:25,000, or 1 mm on map = 25,000 mm on the ground). Also called scale. (MPI)

Resolution: The ability of the entire photographic system, including lens, exposure, processing, and other factors, to render a sharply defined image. It is expressed in terms of lines per millimetre recorded by a particular film under specified conditions. (MPI)

Resolving power: A mathematical expression of lens definition, usually stated as the maximum number of lines per millimetre that can be resolved (that is, seen as separate lines) in the image. (MPI)

Run: The line a photographic aircraft follows in making a photo strip. (MPI) Semi-matte print: A print intermediate in glossiness between a matte and a glossy print. (MPI)

Sensitivity, color: The sensitivity of a photographic emulsion to light of various wavelengths. (MPI)

Shrinkage, differential: The difference in unit contraction along the grain structure of the material as compared to the unit contraction across the grain structure; frequently applied to photographic film and papers and to mapping papers in general. (MPI)

Shutter, between-the-lens: A shutter located between the lens elements of a camera and usually consisting of thin metal leaves which open and close or revolve to make the exposure. (MPI)

Shutter, focal plane: A shutter located near the focal plane and consisting of a curtain with a slot which is pulled across the focal plane to make the exposure. (MPI)

Signature: The characteristics or patterns of physical features that permit objects to be recognized on aerial imagery. A category is said to have a signature only if the characteristic pattern is highly representative of all units of that category.

Soft: A term applied to a print or negative of relatively low contrast; also applied to a picture which is not sharply focused. (MPI)

Spectrophotometer: Device for the measurement of spectral transmittance, spectral reflectance, or relative spectral emittance.

Spectrum, electromagnetic: An array of all electromagnetic radiation that moves with the constant velocity of light in a harmonic wave characterized by wavelength, frequency, or amplitude.

Strip: Any number of photos taken along a photo flight line, usually at an approximately constant altitude. (MPI)

Templet (template): A device used in radial triangulation to represent the aerial photograph; the templet is a record of radial directions taken from the photographs.

Texture: In a photo image, the frequency of change and arrangement of tones. Some descriptive adjectives for textures are fine, medium, coarse, stippled, or mottled. (MPI)

Tilt: The angle between the optical axis of the camera and the vertical. (MPI) **Tone:** Each distinguishable shade variation from black to white. (MPI)

Underdevelopment: Insufficient development, due to developing either for too short a time or in a weakened developer, or occasionally at too low a temperature. (MPI)

Underexposure: The result when light is allowed to pass through the lens either for too short a time or in an amount insufficient to produce all the tones of an image. (MPI)

Vignetting filter: A filter which gradually decreases in density from the center toward the edges. It is used sometimes in photography or printing processes to produce a photograph of uniform density. (MPI)

Appendix 2

Approximate Conversions for Metric and English Units

Length	1 centimetre	=	0.3937	inch
	1 metre	=	3.2808	feet
	1 metre	=	1.0936	yards
	1 kilometre	=	0.6214	mile
	1 inch	=	2.54	centimetres
	1 foot	=	0.3048	metre
	1 yard	=	0.9144	metre
	1 mile	=	1.6093	kilometre
Area	1 square centimetre	=	0.155	square inch
	1 square metre	=	10.764	square feet
	1 square metre	=	1.196	square yards
	1 square kilometre	=	0.3861	square mile
	1 hectare	=	2.471	acres
-	1 square inch	=	6.4516	square centimetres
	1 square foot	=	0.0929	square metre
	1 square yard	=	0.8361	square metre
	1 square mile	=	2.59	square kilometres
	1 acre	=	0.4047	hectare

Volume	1 cubic centimetre 1 cubic metre	= 0.061 cubic inch = 35.315 cubic feet
	1 cubic inch 1 cubic foot	= 16.3871 cubic centimetres = 0.02832 cubic metre
Mass	1 kilogram 1 metric ton 1 metric ton 1 metric ton 1 metric ton	= 2.205 pounds = 1.102 short tons = 0.9842 long ton = 19.684 hundredweight (of 112 pounds) = 22.046 hundredweight (of 100 pounds)
	1 pound 1 short ton 1 long ton 1 hundredweight (of 112 pounds) 1 hundredweight (of 100 pounds)	= 0.4536 kilogram = 0.9072 metric ton = 1.016 metric ton = 0.0508 metric ton = 0.04536 metric ton
Density	1 kilogram per cubic metre	= 0.06243 pound per cubic foot
	1 pound per cubic foot	= 16.018 kilograms per cubic metre
Other	1 square metre per hectare 1 cubic metre per hectare	= 4.356 square feet per acre = 14.291 cubic feet per acre
	1 square foot per acre 1 cubic foot per acre	= 0.2296 square metre per hectare = 0.07 cubic metre per hectare

Appendix 3

Sample Short-Course Outline

Introduction

The following outline provides an example of assignments and time allotments for a five-day short course in airphoto interpretation and remote sensing. In this introductory course, two days are devoted to general concepts and measurement techniques, two days are spent on applications to various disciplines, and the final day includes a field trip.

Experience has shown that classes of from fifteen to twenty-five students are the optimum size for most short courses and that one instructor is needed for each five to eight participants. Courses that stress do-it-yourself exercises and seminar-type discussions usually prove more successful than those which rely heavily on lengthy and theoretical lectures.

The kinds of equipment and supplies needed by each participant have been outlined in Chapter 2. If feasible, the maps and aerial imagery supplied to each student should be of the locality where the instruction takes place. This permits easy field checking of photographic measurements and interpretations.

Topical sequence and daily assignments

Monday	
8:30-9:00	Workshop objectives; introduction of participants; issuing of
	course outlines
9:00-9:30	Distribution of photos and maps, equipment, name tags
9:30-10:00	Discussion:
	Proper use of various stereoscopes
	Preparation of photos for stereo viewing
10:00-10:30	Break
10:30-12:00	Lab:
	Stereo-perception tests
	Preparation of photos for stereo viewing
12:00-1:00	Lunch
1:00-2:00	Discussion:
	Photo scales; area measurements
2:00-2:30	Break
2:30-3:30	Lab:
	Proper photo setup for stereo viewing
	Determination of photo scales and conversions
3:30-4:30	Lab:
	Measurement of areas on orthophotoquads with dot grids
4:30-5:00	Lab:
	Time for completion of assignments

Tuesday

8:30-9:30	Discussion:
	General photography; photographic films and filters
9:30-10:00	Break
10:00-11:00	Discussion:
	The photographic mission; flight planning; mapping techniques
11:00-12:00	Lab:
	Exercise on flight planning or comparison of films and filters
12:00-1:00	Lunch
1:00-2:00	Discussion:
	Photogeometry; stereoscopic parallax
2:00-2:30	Break
2:30-4:30	Lab:
	Measurement of heights of objects with parallax devices
4:30-5:00	Lab:
	Time for completion of assignments

Wednesday

8:30-9:30	Discussion:
	Agricultural and land-use patterns
9:30-10:00	Break
10:00-11:00	Discussion:
	Urban-industrial features

	Exercise (large-scale photos) on agricultural, urban, and industrial features in local area; changes in land use
12:00-1:00	Lunch
1:00-1:30	Lab:
	Completion of morning exercise
1:30-2:30	Discussion:
	Landforms and physiography
2:30-3:00	Break
3:00-4:30	Lab:
	Exercise on recognition of landforms on aerial photographs
4:30-5:00	Lab:
	Time for completion of assignments
Thursday	
8:30-9:30	Discussion:
	Water resources
9:30-10:00	Break
10:00-12:00	
	Exercise on water resources and related geology
12:00-1:00	Lunch
1:00-2:00	Discussion:
	Natural vegetation of local area or region
2:00-2:30	Slides:
	Vegetative types
2:30-3:00	Break
3:00-4:30	Lab:
	Exercise on recognition of vegetation on aerial photographs
4:30-5:00	Lab:
	Time for completion of assignments
Friday	
8:00-12:00	Field trip:
	Verification of photo interpretation exercises (emphasis on land
	use, landforms, vegetation)
	Lunch
1:00-2:00	Discussion:
	Thermal infrared scanners and side-looking airborne radar
2:00-2:30	Slides or exhibits:
	Examples of infrared and SLAR imagery
2:30-3:00	Break
3:00-3:45	Discussion:
	Sources and ordering of photographs, maps, and photo inter-
	pretation equipment
3:45-4:15	Lab:
	Completion of course evaluation forms by participants
4:15-5:00	Lab:
	Course critique; questions and answers

11:00-12:00 Lab:

Sample course evaluation form

Please answer completely and make comments. Your signature is optional.
ccupation:
rrent activity or assignment:
As a general rule, I felt that the caliber of instruction during the course was: ExcellentGoodAbout averagePoor.
Comments:
The instructional materials that were supplied or displayed during the course were: Completely adequate. Good, but we needed: Poor! We should have had these items instead:
I would have preferred to spend more, less, or the same amount of time on: Photo measurements (scale, areas, parallax, etc.). Sources of photos, maps, and equipment. Agricultural and land-use patterns. Urban-industrial features. Geology and landforms. Water resources. Natural vegetation. Discussion of thermal infrared scanners and images. Discussion of side-looking airborne radar.
I feel that the field trip should be:EliminatedChanged to a walking tour near the classroomKept about the sameModified as follows:

	I would add the following topics:
6.	The principal benefits I gained from the course were:
7.	My general comments (please give your own impression of the course, along with suggestions for possible future courses) are:

Index

Absolute stereoscopic parallax, 52-53 Aerial photographs care of, 35 contracting for, 81-82 helicopter, 96 inspection of, 90-92 ordering, 97-99 specifications for, 82-92 Aerial reconnaissance, 355, 358 Aerial volume tables, 241-48 Agricultural crops, 205-7 Agricultural Stabilization and Conservation Service, 99 Aids, photo interpretation, 28-31 Aircraft recognition, 365-66 Air intelligence, 345-74 Alignment of photographs, 33-35 American Society of Photogrammetry, American Standards Association, 5 Angles, camera, 4-5, 82 Angular elevation of sun, 70-72 Apertures, relative, 4 Archeology, 179-204 early developments in, 180-84 site detection in, 184 site evaluation in, 193-94 site mapping in, 194-95, 199 site prediction in, 191-93 Area measurements, 73, 76-78

Areas, crop, 212 Assessing bomb damage, 369-72 Assessing taxable property, 330, 333 Automatic image interpretation, 146, 152 Azimuths, 73, 75

Bar, parallax, 57
Base maps
planimetric, 101-2
topographic, 115-19
Beach ridges, 281-82
Bearings, compass, 73, 75
Bedding, dip of, 260-63
Black-and-white films, 8-10
Bomb damage, assessment of, 369-72
Bridge construction, 301-2

Calendars, crop, 208-10
Camera, aerial, 82, 87, 89
simple, 3
stereoscopic, 27-28
Camouflage detection, 11-12, 361-64
Canada, prints from, 99
Canadian Aeronautics and Space Institute, 17
Capacity, tank, 338
Central Intelligence Agency, 346
Changes in land use, 170-73
Checklist of features, 24-25

Classifications farm crop, 207-12 forest cover-type, 229-30 industrial, 333-38 landforms, 261, 265 land-cover, 159-65 tree species, 230-40 Color films, 11-13 Conifers, key for identifying, 240 Conjugate principal points, 31, 33 Contours, 115-20 Contract aerial photography, 81-82 Control, ground, 115 Counts, object, 73-74 Course evaluation form, 386-87 Course outline, sample, 383-85 Covert operations, 348 Crops, farm, 205-7 Crown closure, 245-46 Crown diameter, 243

Damage assessment, poststrike, 369-72 Dams and related structures, 302-4 Density, crown, 245-46 Detail, transfer of, 112-15 Detection, camouflage, 11-12, 361-64 Developing and printing, 6 Diameter, crown, 243 Diaphragm, lens, 3 Differential parallax, 52-54 Dip and strike, 260-63 Disaster surveys, 310-11 Diseased plants, detection of, 216-17, 250-51, 253 Displacement, image, 45-50 Do-it-yourself photography, 94-96 Dot grids, 76-77 Drainage patterns, 263-65

Emulsion, film, 5
Engineering, construction, 297-98
English and metric conversions, 381-82
Eolian features, 286-89
Equipment for photo interpretation, 28-31
Erosion
water, 222-24
wind, 218, 286-89
Estimates
crop-yield, 212
timber-volume, 245-48
Exposure index, aerial, 13

Farm crops, 205-7
Farm patterns, seasonal changes in, 214-15
Film, photographic, 5
Films and seasons, photographic, 8-13
Filters, haze, 7-8
Flight planning, 81-96
Floating roundwood, inventories of, 250

Fluvial landforms, 279-81 Forest cover types, identification of, 229-30 Form lines, 119 f/stop, 3-4

General Land Office plats, 102-3 Geology, applications of, 259-60 Glacial landscapes, 283-85 Glaciation, continental, 261 Glossary, photogrammetric, 375-80 Grids, dot, 76-77 Ground control, 115

Haze filters, 7-8
Heights
from parallax measurements, 54-59
from shadow measurements, 68-72
from single prints, 50-52
Highway location, 298-302
History of photography, 2
Housing quality, 329-30
Hydroelectric dams, 302-4

Igneous rocks, 274-76 Image displacement, 45-50 Image interpretation, automatic, 146, Imagery, radar, 135-43 infrared, 130-34, 202 satellite, 143-51 Individual tree volumes, 241-45 Industries, recognition of, 333-38 Infrared films, 8-10 Infrared imagery, 130-34, 202 Infrared radiation, 128-29 Inspection of contract photography. 90 - 92Intelligence nature of, 348-49 need for, 345-46 reports of, 366 International Institute for Aerial Survey, 17 Interpretation, automatic, 146, 152 Inventories floating roundwood, 250 stockpile, 315-16 Isocenter, 48

Keys classes of, 25-26 industrial, 335 tree-species, 238-40

Land, agricultural, 206 Land-cover mapping, 159-69 Landforms eolian, 286-89 fluvial, 279-81 glacial, 283-85

marine, 281-82 miscellaneous, 289-91 types of, 261, 265 Land information systems, 155-58 Land use, changes in, 170-73 Lens angles, 4-5, 82 Light sensitivity, 6-7 Lithologic units, 260 Manufacturing, types of, 335 Map Information Office, 97 Map projections, 103-9 Maps geologic, 293-95 land-cover, 159-69 planimetric, 101-2 topographic, 115-19 Map symbols, 165, 170 Marks crop or plant, 190-91 shadow, 184, 187 soil. 189-90 Measurements area, 73, 76-78 height, 50-59, 68-72 scale, 43-47 Metamorphic rocks, 276-78 Metric and English conversions, 2, 381-82 Military intelligence, 348-49 Military targets, 360-61 Mining, surface, 311-18 Missile-launching center, 356-57 Mission, reconnaissance, 355, 358

Nadir, 49 Nonphotographic imagery, 125-53, 292

Mosaics, preparation of, 119-21

Object counts, 73-74
Object recognition, 21-24
Orchards, 213
Ordering aerial photographs, 97-99
Orientation of photographs, 31-35
Orthophotography, 122

Panchromatic film, 8
Parallax
absolute stereoscopic, 52-53
differential, 52-54
direct measures of, 54
heights from, 54-59
Parking studies, 326-27
Patterns
drainage, 263-65
mining, 311-18
residential, 328-30
Photo base length, 33, 53-54
Photogeology, 259-60
Photogrammetric training, 17
Photogrammetry, development of, 13-15

Photographic tilt, 48 Photography, archeological, 195-201 Photography films and seasons for, 8-13 history of, 2 Photo intelligence reports, 366 Photo interpretation, development of, Photo interpretation equipment, 28-31 Photo interpreters, selection of, 349, Photo reconnaissance, military, 355, 358 Planimeters, 77-78 Planimetric base maps, 101-2 Planning recreational, 251-55, 330 urban, 321-25 Plant vigor, detection of, 250-51, 253 Plats, General Land Office, 102-3 Plotters, stereoscopic, 116, 119 Pollution, water, 304-8 Poststrike damage assessment, 369-72 Precision of height measurements, 57-59 Principal point, 31 Print quality, 91, 92 Projections, map, 103-9 Projector, reflecting, 115, 116 Property, assessment of, 330, 333

Quadrangle maps, 115-19 Quality housing, 329-30 photographic, 91, 92 of water, 304-8

Radar, types of, 138-41 Radar imagery, interpretation of, 141-43 Radar systems, capabilities of, 135-38 Radial line triangulation, 109-13 Radiation, infrared, 128-29 Recognition of ships and aircraft, 365-66 Reconnaissance, military, 352-54 Recreational inventories, 251-55 Reflecting projector, 115, 116 Relief displacement, 48-50 Remote sensing, definition of, 1 Reports, intelligence, 366 Reservoirs, 302-4 Residential patterns, 328-30 Resolution, 6 Rocks igneous, 274-76 metamorphic, 276-78 sedimentary, 265-74

Satellite imagery, 143-51 Satellites earth-observation, 143-46 missile-observation, 369, 373 Scale, photographic, 43-47 Season of photography, 85-88 Sections and townships, 102 Sedimentary rocks, 265-73 Selecting interpreters, 349, 352 Sensors, types of, 125-28 Shadow heights, 68-72 Ship nomenclature, 365-66 Short course, outline for, 383-85 Shutter-speed, camera, 3-4 Silo, missile, 356-57 Sketchmaster, vertical, 113-14 Slotted templets, 110-11 Soil erosion, 218-24 Soil-forming processes, 218-21 Soil surveys, 217 Species identification of trees, 230-40 Specifications for aerial photography, 82-92 Spectral reflectance, 6-7 Speed, film, 5 Stereo cameras, ground, 27-28, 65-68 Stereograms filing of, 68-69 ground, 66-68 preparation of, 63-65 Stereometers, functions of, 54-56 Stereoscope lens, 29-30 mirror, 30-31 Stereoscopic acuity, 35-38 Stereoscopic plotters, 116, 119 Stockpile inventories, 315-16 Storage tanks, capacities of, 338 Stratification, photographic, 248 Strike and dip, 260-63 Sun, angular elevation of, 70-72 Surface mining, 311-18 Survey, aerial, 87-92 of disaster, 310-11 for highway locations, 300-301 recreational, 254-55 Symbols damage assessment, 372 geologic, 293-95 mapping, 165, 170

Tanks, capacities of, 338 Target identification, 360-61 Target priorities, 354-55

Taxable property, assessment of, 330. Templets, slotted, 110-11 Terminology, photogrammetric, 375-80 Terrain analysis, 218-21, 358, 360 Tests, stereoscopic, 36-38 Thermal imagery, 130-34 Three-dimensional viewing, 26-28 Tidal flats, 281-82 Tilted photographs, 48 Timber types, 228-30 Topographic maps, 115-19 Townships, 102 Trafficability of soils, 358, 360 Training interpreters, 17, 349, 352 Transects, 78 Transportation studies, 326-27 Tree crown closure, 245-46 Tree crown diameter, 243 Tree species, identification of, 230-40 Tree volumes, 241-45 Triangulation, radial line, 109-13 Types, forest cover, 229-30

U.S. Central Intelligence Agency, 346 U.S. Public Land Survey, 102 Units of measure, English and metric, 381-82 Urban analysis, 321-25

Vegetation classification of, 228-29 distribution of, 228 Vertical sketchmaster, 113-14 Vineyards, 213 Volumes individual tree, 241-45 stand, 245-48

Water erosion, 222-24, 279-81 Water pollution, 304-8 Wedge, parallax, 56 Weights of materials, 316 Wetlands, coastal, 308-9 Wind erosion, 218, 286-89

Zones, vegetation, 228-29